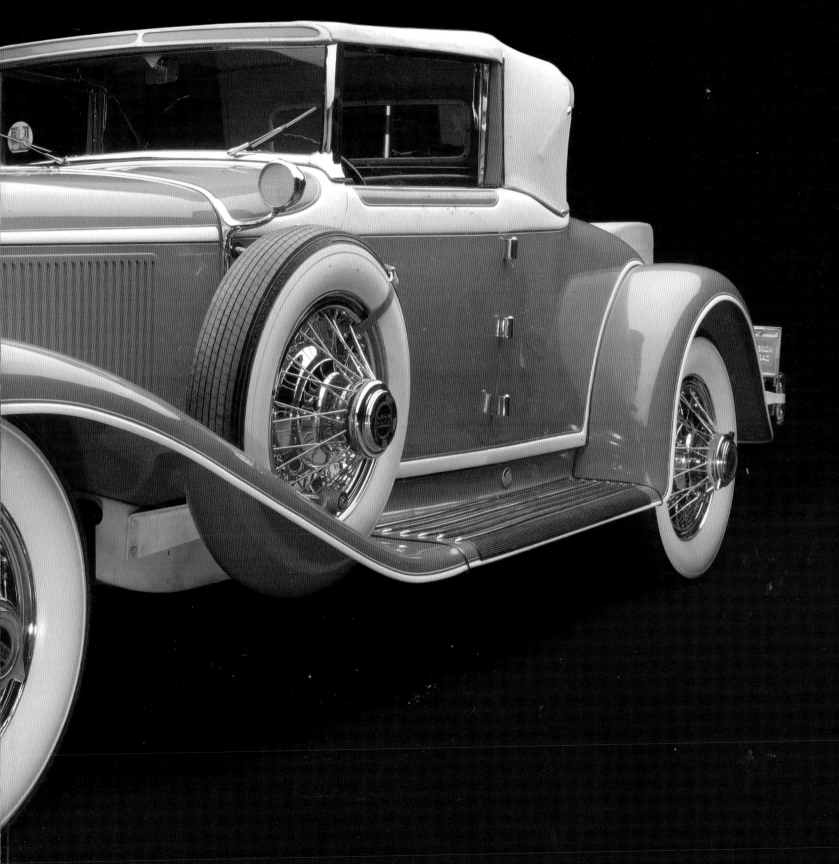

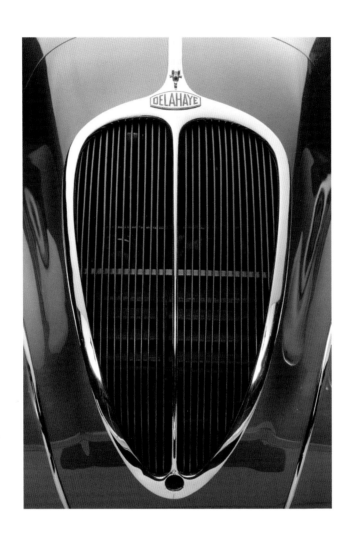

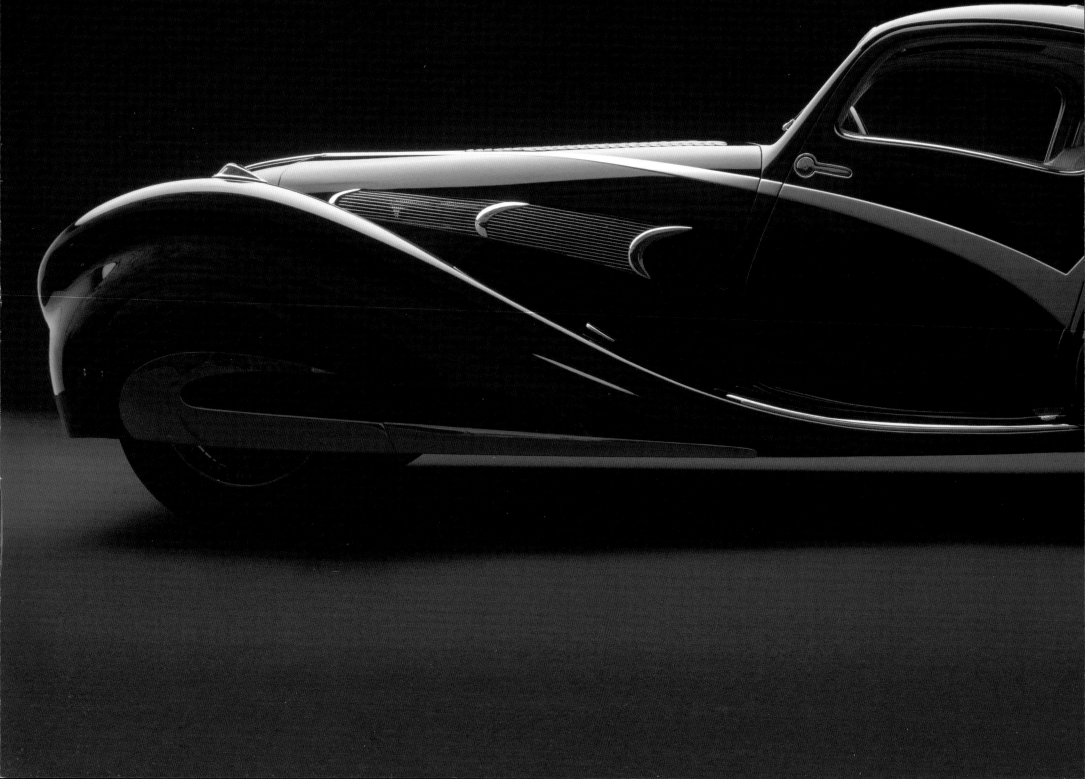

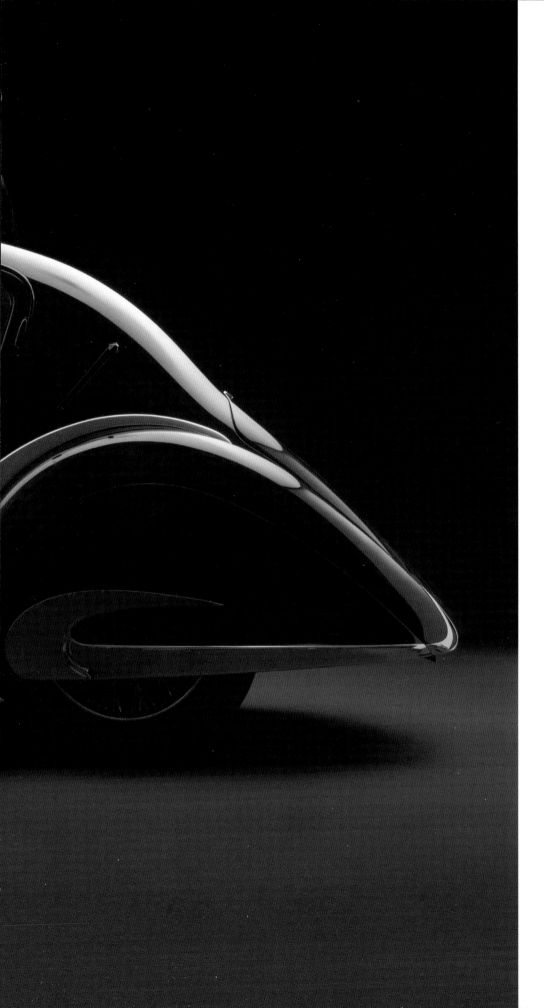

ART OF THE
CLASSIC
CAR

PHOTOGRAPHY BY
PETER HARDOLDT

WORDS BY
PETER BODENSTEINER

motorbooks

Contents

———◆———

Introduction

◆

What is a classic car? The Classic Car Club of America has its definition, the Antique Car Club of America has its definition, and your insurance company, state, or country may have one as well. In this book, we're not concerned about these—instead, we take a step back, look at a variety of body styles, builders, and countries of origin, and strive simply to deliver a selection of interesting and often beautiful cars, ones that I think any red-blooded car enthusiast should want to know more about. In other words, we are defining "classic" in a broad sense, using the word to indicate cars that are worth remembering years and decades later.

It is true that the majority of these cars were likely built before you and I were born. While enthusiasts gravitate toward vehicles that were popular when we were young and impressionable, for most of us, none of the cars here fit that description. In any case, if you are already a car enthusiast, the chances are that you have a particular area of interest, and it's likely that you're most interested in more recent vehicles than those depicted here.

Don't be too hasty to disregard these cars, though, even if they seem to be quite different from your favorites. I invite you to read an entry or two in this book, gaze at the beautiful photographs, and see if you can't spark a new automotive interest.

The same motivations that caused engineers and designers to create the cars you already love also drove the men who built the automobiles found in *Art of the Classic Car*. The creators of these classic cars had the same goals as car builders from any era—to make more

power, improve handling, or to make an impactful statement with color and shape. The creativity visible in the cars these early automotive proponents built is just as impressive as that employed in any other era—or even more so, given the technological constraints of earlier times.

Are you a fan of light, nimble sports cars? Check out the Mercer Raceabout for a truly bare-bones driving experience, or the Alfa Romeo 8C2900B for a more elegant approach. Do you like big horsepower? Take a look at the big V-12 engines in the Packard Model 1106 Sport Coupe or the Pierce-Arrow Silver Arrow. Hot rodders will like the Edsel Ford Speedster, built on a modified '34 Ford chassis.

Do you like forced induction? Early auto-makers often turned to superchargers in an era when turbochargers (or more accurately, turbosuperchargers) had yet to be become prevalent. Cars like the Duesenberg SJ and the Mercedes-Benz 540K used supercharging to provide some boost. Lovers of big land yachts should check out what Cadillac was up to in the early 1930s. Racing fans are sure to find some inspiration in the *Mormon Meteor I* or the Stutz Bearcat, cars that achieved a great degree of success in land-speed and circuit racing, respectively.

It's my hope that by studying these earlier expressions of automotive innovation, you will gain a greater appreciation for the history of the automobile. Not only will you enjoy yourself, but you'll emerge having broadened your horizons. Perhaps you'll even pick up some inspiration for a vehicle of your own. If you do, know that you are following in the footsteps—and honoring the legacies—of the creative minds who have come before you.

From the beginning, every automobile needed only a few basic components: an engine for power, wheels, some means of transmitting power between the engine and wheels, a chassis to locate all these components, and a driver and perhaps some passengers. Providing shelter or comfort to said humans was a secondary consideration.

Not surprisingly, two of the cars in this book that stray the least from this fundamental collection of parts are in this section and are the earliest cars in the book. The 1911 Mercer Raceabout and the 1916 Stutz Bearcat were among the first cars that one could consider sports cars, eschewing roofs and doors, among other things, in order to simplify and enhance the driving experience. The other two cars in this section, while newer, do away with a roof altogether for different considerations—outright high-speed racing in the case of the *Mormon Meteor I*, and style with the Edsel Ford's Model 40 Speedster.

It's one thing to drive a car that is open to the elements, but it's another thing altogether to drive one that doesn't provide even the most rudimentary top. It requires a different level of commitment from both its drivers and its passengers. Ultimately, though, we treasure such cars because they discard all that can be frivolous and superfluous and give us instead something real, something raw.

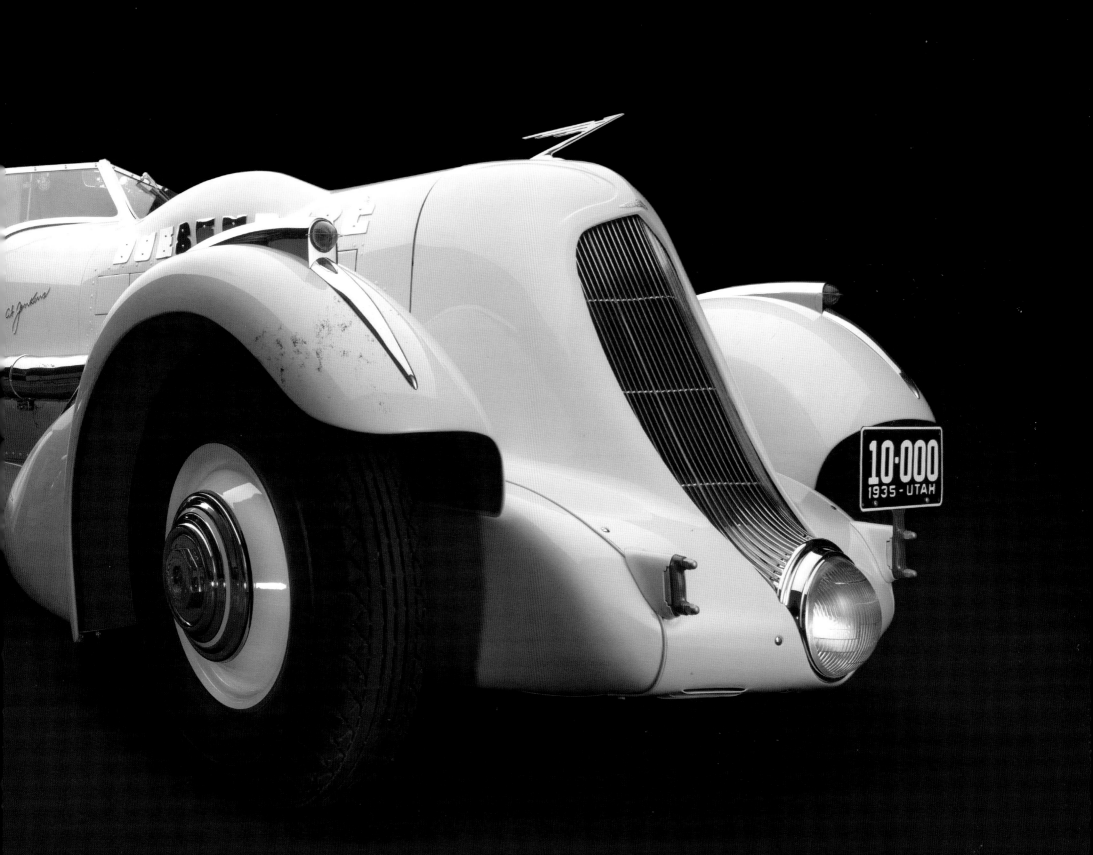

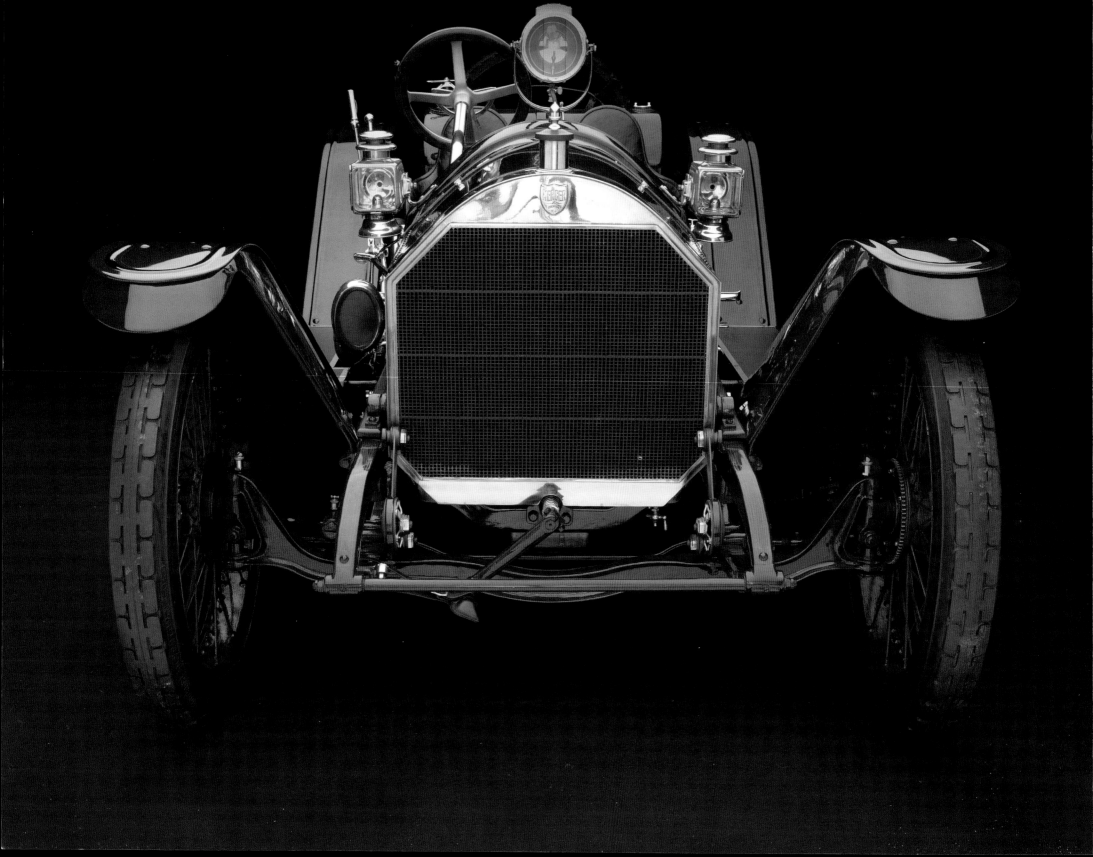

1911
Mercer 35R Raceabout

More than 100 years have passed since this car was built—nearly the entire history of the automobile. Yet here, in the Mercer Raceabout, we see the first glimpse of a philosophy of design that has always created and nurtured the essential passion for driving in those who experience it.

The Mercer sketched the blueprint: light weight, a competent chassis, minimal creature comforts or useless gadgets, two seats, and with a willing engine driving the rear wheels. A host of cars followed the Mercer's lead over the decades after its creation, including the Jaguar XK120, roadsters from the likes of MG and Alfa Romeo, the Datsun 240Z, Mazda's RX-7 and Miata, and today's Toyota GT-86/Scion FR-S/ Subaru BRZ triplets.

Like many of the aforementioned sports cars, owners of the Mercer Raceabout could take their autobobiles directly to the

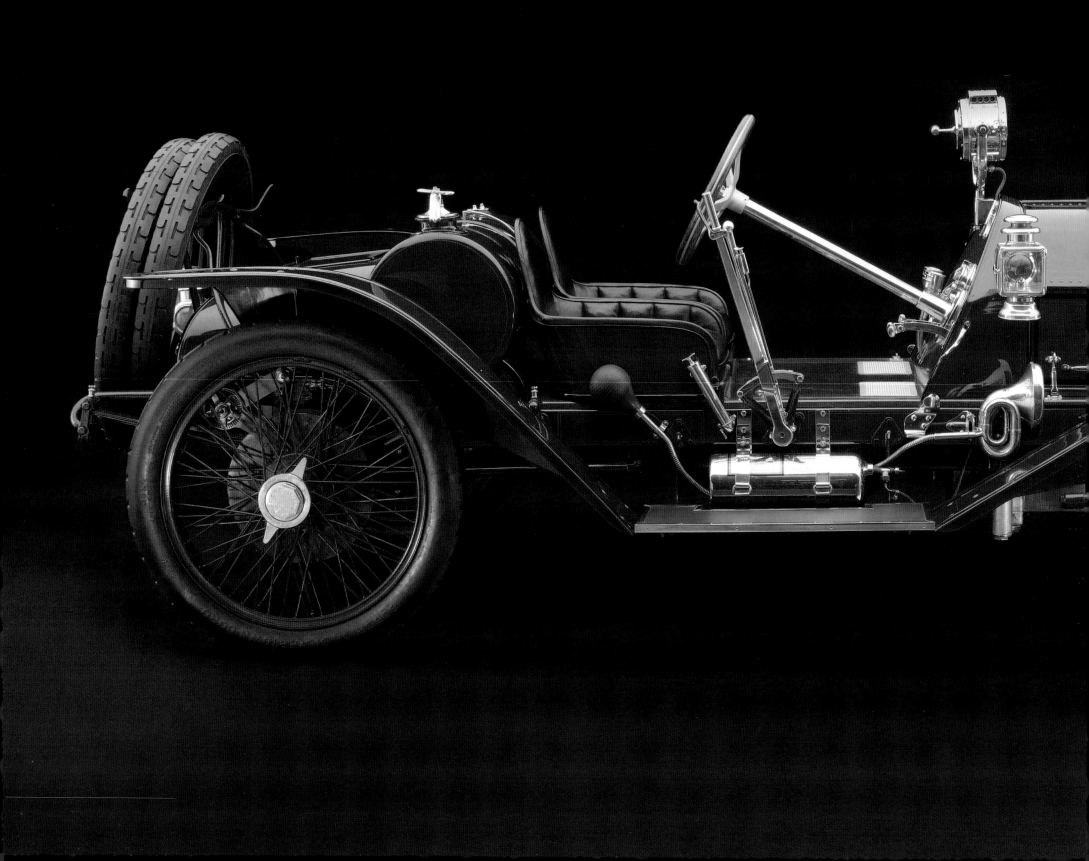

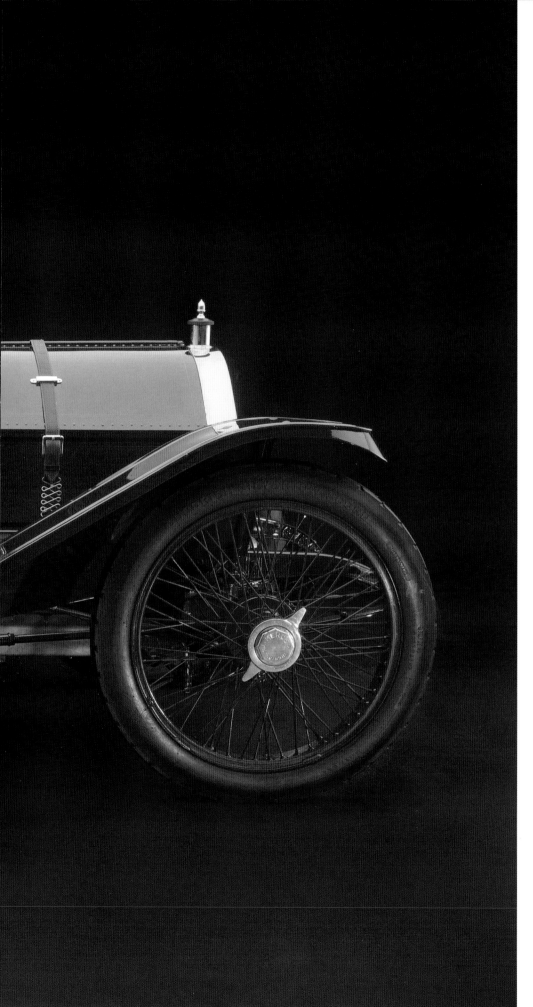

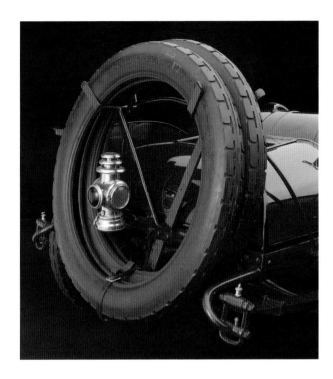

racetrack. After finishing 15th in the 1911 Indianapolis 500, the Mercer team reinstalled their car's headlights and fenders and drove it back to the company's headquarters in Mercer County, New Jersey.

Mercer made do with a smaller engine in a lightweight car. That was not a prescription for victory at a track like Indianapolis, but on smaller circuits and in hillclimbing competition, which rewarded handling over horsepower, the Mercer was a force. Spencer Wishart, one of the top drivers of the era, once drove a Mercer straight from an Ohio dealership to a dirt-track event and won a 200-mile race.

The Raceabout was designed from the ground up to perform. Designers achieved a low center of gravity by placing the engine deep in the chassis, and by giving the driver and passenger low seating positions. The car had no top, no body, and only minimal fenders. The driver sat behind a steeply raked steering column and no windshield to speak of. The external shift column used an H-pattern arrangement to select each gear, another feature that later became typical.

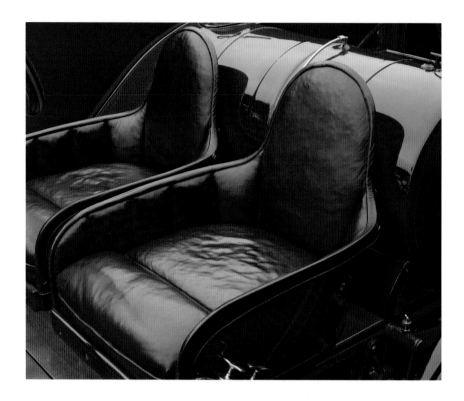

The foot brake was marginal at best, so a hand lever controlled rear drum brakes to add much-needed stopping power. Mercers utilized shaft drive between the engine and rear wheels, whereas most competitors of the day used chain drive.

Modern-day writers repeatedly comment that the car feels remarkably modern and nimble to drive, save for its inadequate brakes. As Ken Purdy wrote in *The Kings of the Road*, "Most antique automobiles are not fast, and this one is."

Mercer guaranteed its customers that the car would top 70 miles per hour, a bold claim in the pre–World War I era. Its inline four-cylinder, 4.9-liter engine produced 56 horsepower at 1,900 rpm, but the torquey T-head engine had less than 2,300 pounds of curb weight to carry around. With a little tuning, 100 mph could be reached.

Today the Mercer Raceabout is the most desirable pre–World War II car built in America. They typically change hands at more than $1 million. They have never been inexpensive, like the everyman sports cars that came after it. When new, a Raceabout cost $2,250, comparable to the price of a home.

That said, it's impossible to overstate the importance of the Mercer's influence. Every time an automaker decides to go back to the roots of what truly makes a car fun to drive, they build another link in the chain stretching back to the Mercer Raceabout.

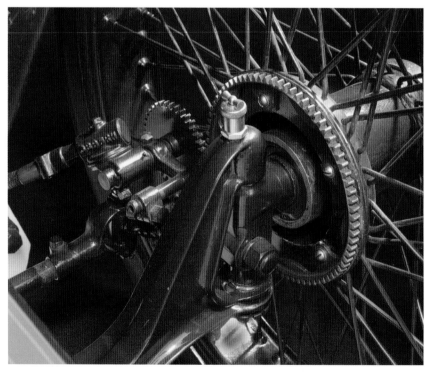

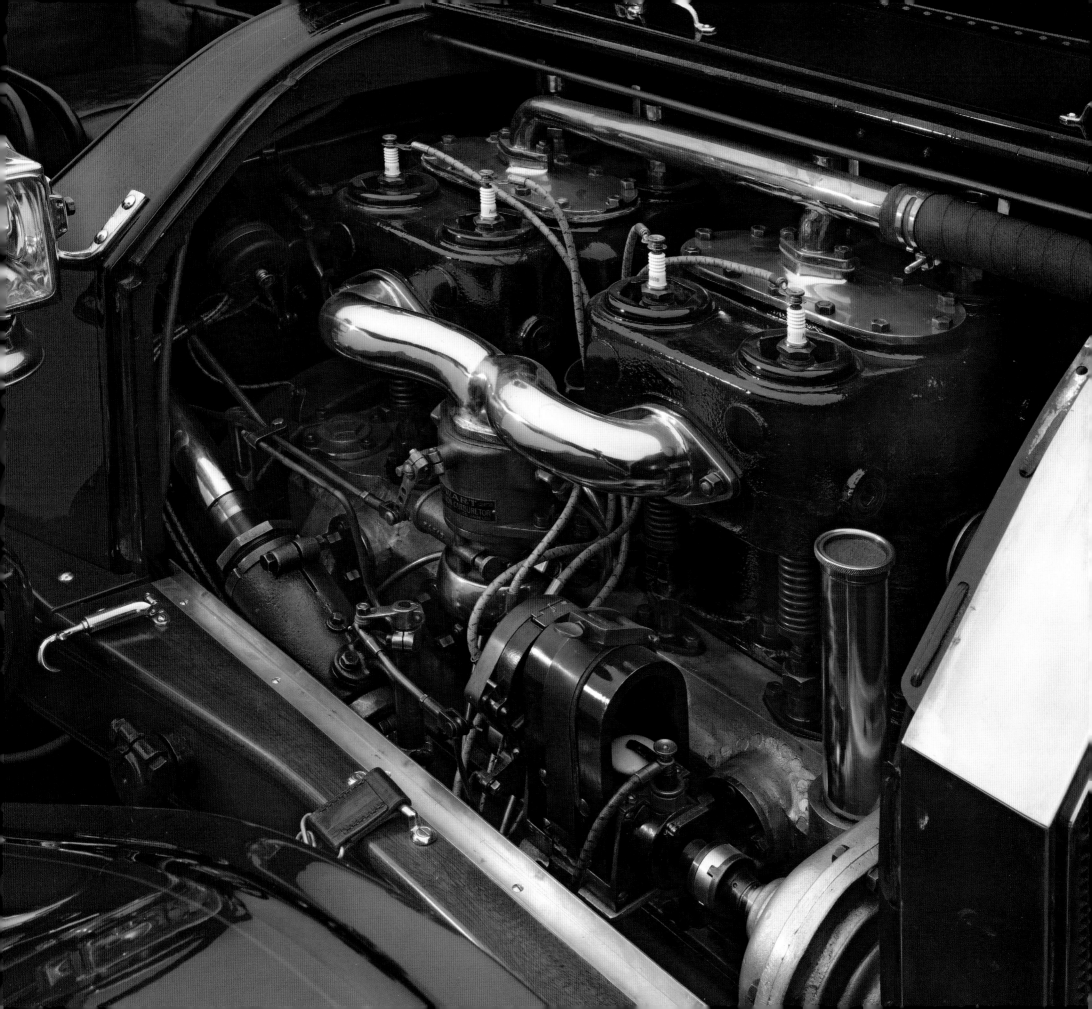

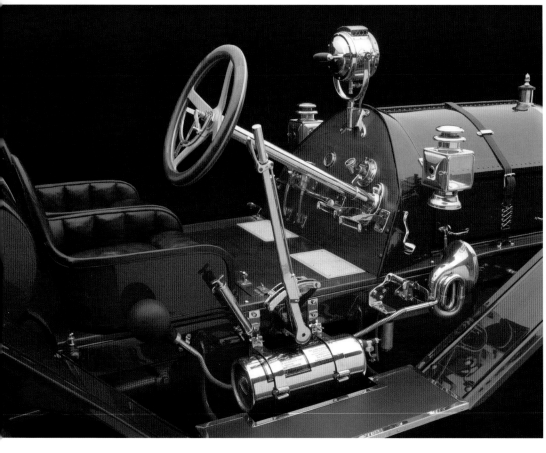

SPECIFICATIONS
OF INTEREST

NUMBER REMAINING
30 to 35

CLUTCH
Steel-steel, oil immersed

TRANSMISSION
Three-speed manual

CARBURETION
Fletcher or Stewart updraft

IGNITION
Dual, magneto

WEIGHT
2,240 lbs/1,015 kg

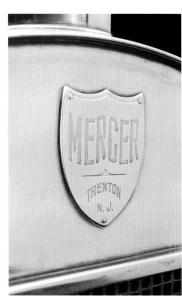

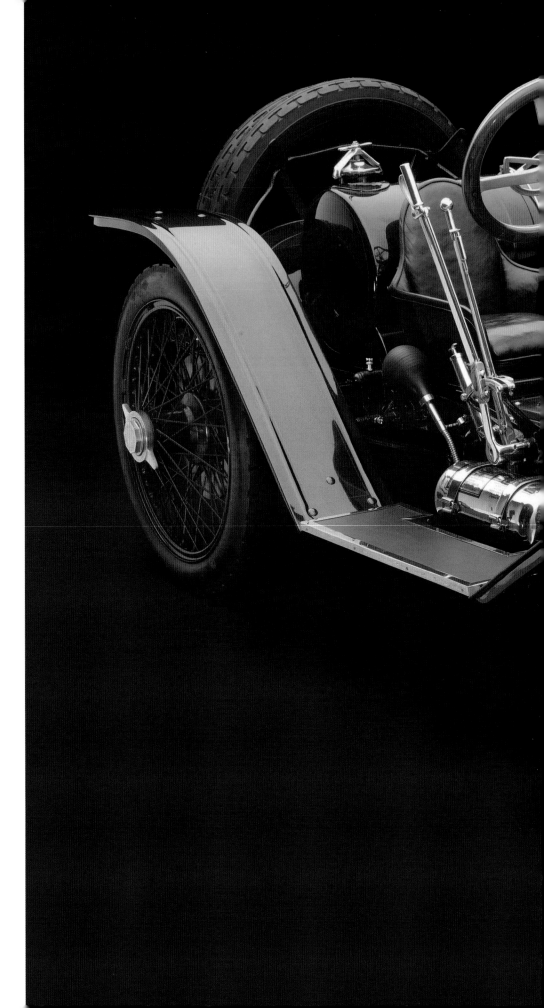

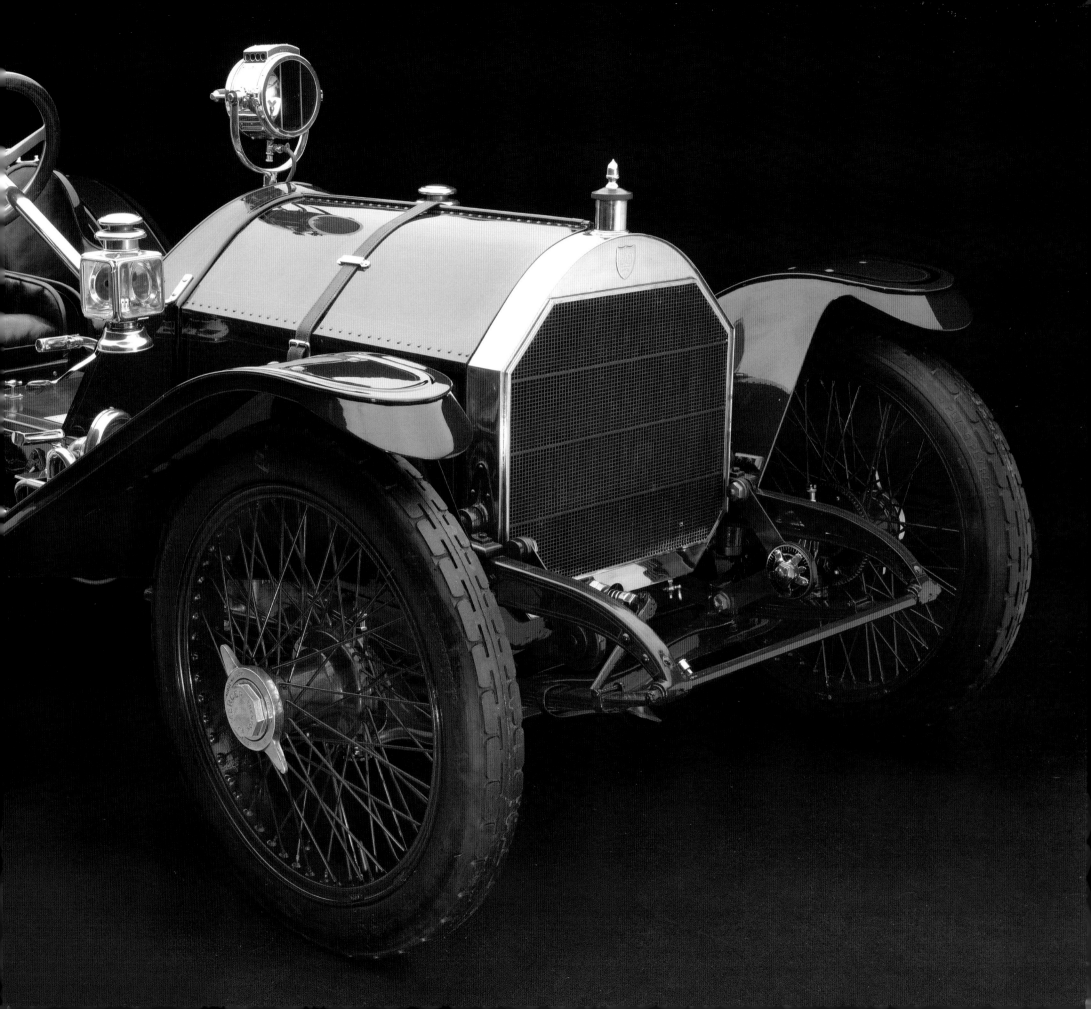

1916
Stutz Bearcat

◆

Owing to its reputation as a favorite of raccoon coat–wearing swells of the Roaring Twenties, and numerous pop-culture references through the decades, the Stutz Bearcat maintains an uncommon level of cultural relevance today, even among those who have no idea what the car actually is.

Stutz Bearcat—the name rolls so easily off the tongue. It serves as a kind of shorthand, as an emblem of a bygone era. That probably accounts for the Bearcat popping up in everything from an episode of *The Simpsons* to a Velvet Underground song.

Unprecedented and widespread success as a performance machine gave the Bearcat its fame originally. After entering his first production car—reportedly built in only five weeks—in the 1911 Indianapolis 500 and finishing in 11th place, Harry C. Stutz adopted "The Car that Made Good in a Day" as his company's slogan. Stutz gained additional notoriety when

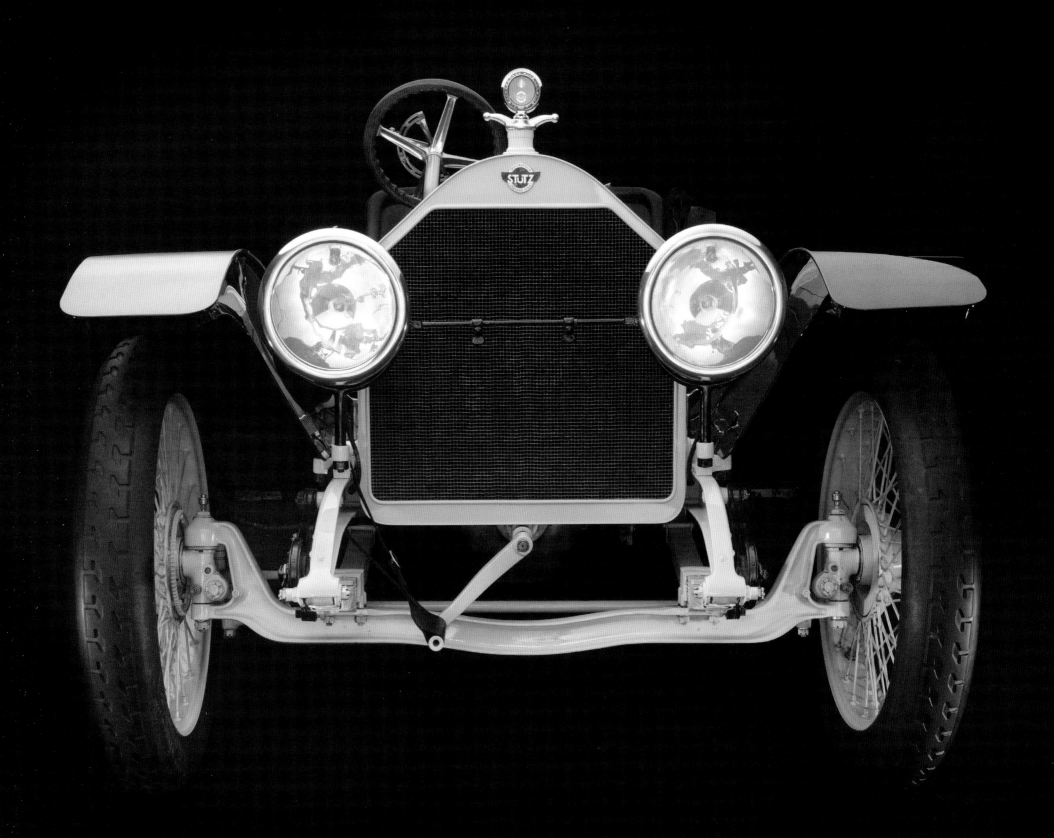

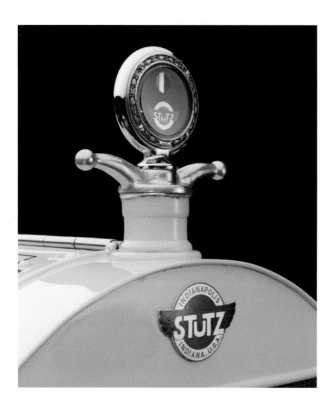

Erwin George "Cannonball" Baker drove an early Bearcat from San Diego to New York in 11 days, 7 hours, and 15 minutes, breaking the previous coast-to-coast record.

The Bearcat delivered a new kind of sporting driving experience to the public, and also had a spirited rivalry with the Mercer Raceabout (see page 10). These two sports cars faced each other often, particularly on American racetracks, and battled for the loyalty of enthusiast drivers.

The Mercer had a significant weight advantage of some 2,000 pounds. The Bearcat had the Mercer beat, if less emphatically, in the horsepower stakes.

This Bearcat, a Series C model, has a four-cylinder engine with 390 cubic inches of displacement—a six-cylinder engine was also available. The cylinders were cast in pairs, and the T-head design featured twin spark plugs for each cylinder. Early Bearcat engines ranged from 60 to 80 horsepower.

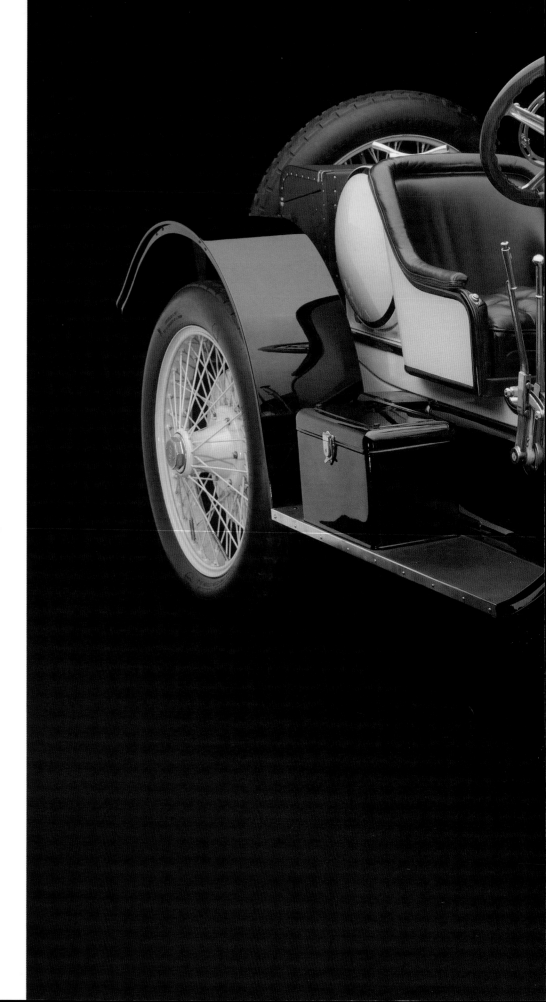

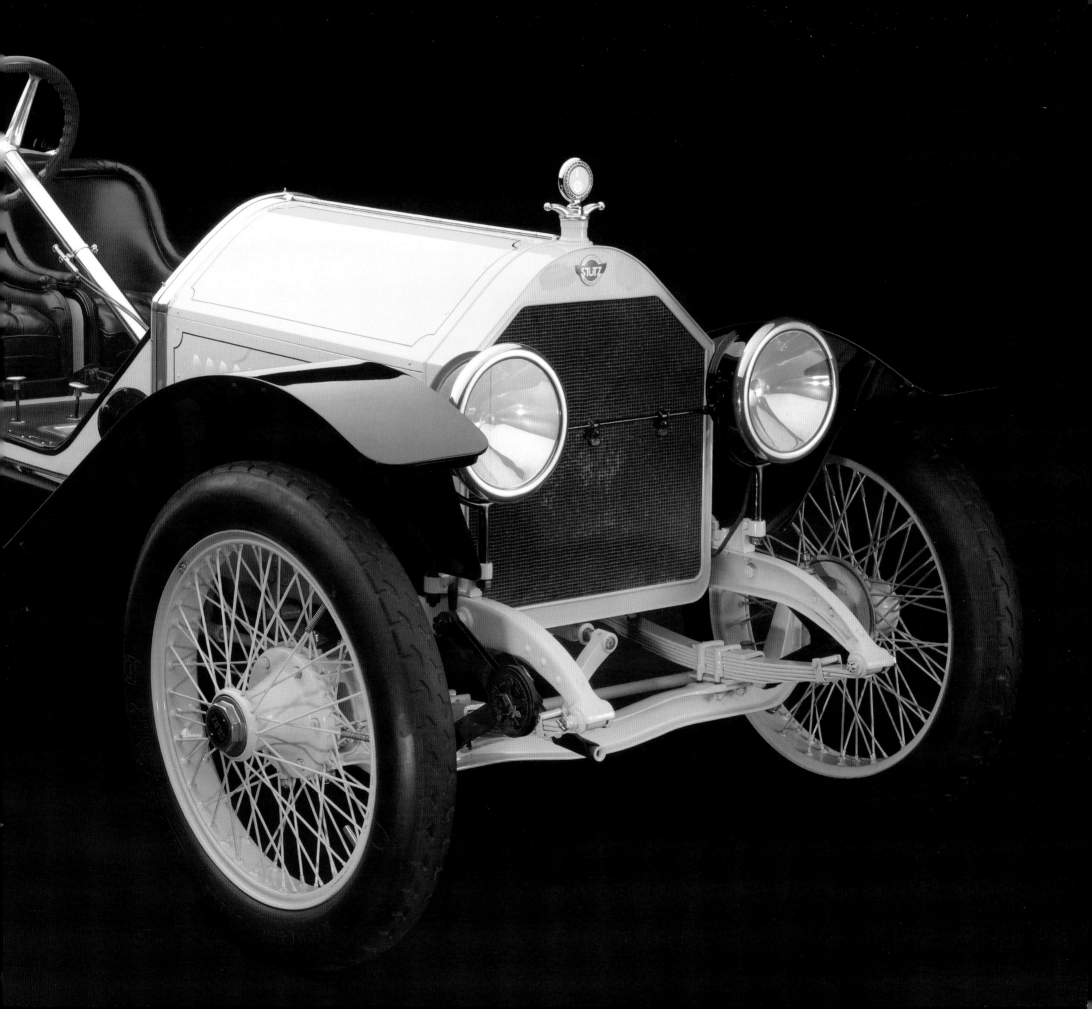

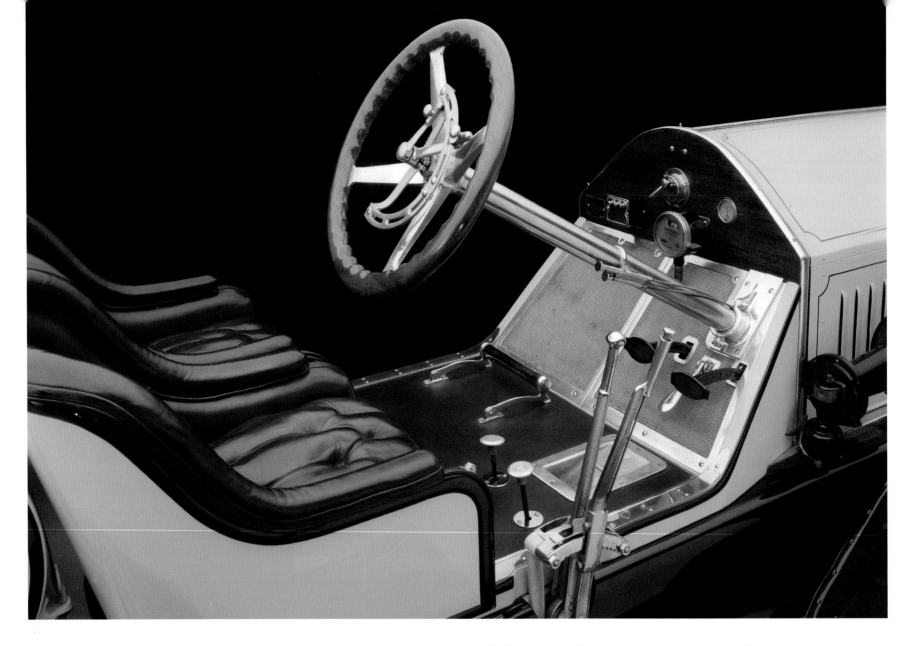

The Bearcat's minimal bodywork, including a simple hood and trim fenders, kept its weight relatively low. It had no doors, no windshield (a monocle windscreen could be fitted to the steering wheel column), no cowl, and no top. A stiff clutch and an intimidating hand-crank starter helped give the Bearcat a reputation as a "real man's" car.

As with later marques like Ferrari and Porsche, racing success led to increased status among a certain type of car buyer. The Stutz became the "it" car among wealthy buyers who could afford to spend a bit more on a vehicle that made up in performance what it lacked in practicality. By the 1920s, though, the company catered to customers a bit more, adding creature comforts to its roadster such as doors, a windshield, and a top.

Stutz's relative success as a company boosts the Bearcat when evaluating the overall scorecard of its battles with the lithe and nimble Mercer. Long after Mercer was gone, and even after model production ended in 1924, Bearcats continued racking up racing victories and could still be found in competition through the rest of the 1920s. Despite this, by 1934 Stutz had quit making cars. Today, it is estimated that fewer than a dozen original Bearcats exist.

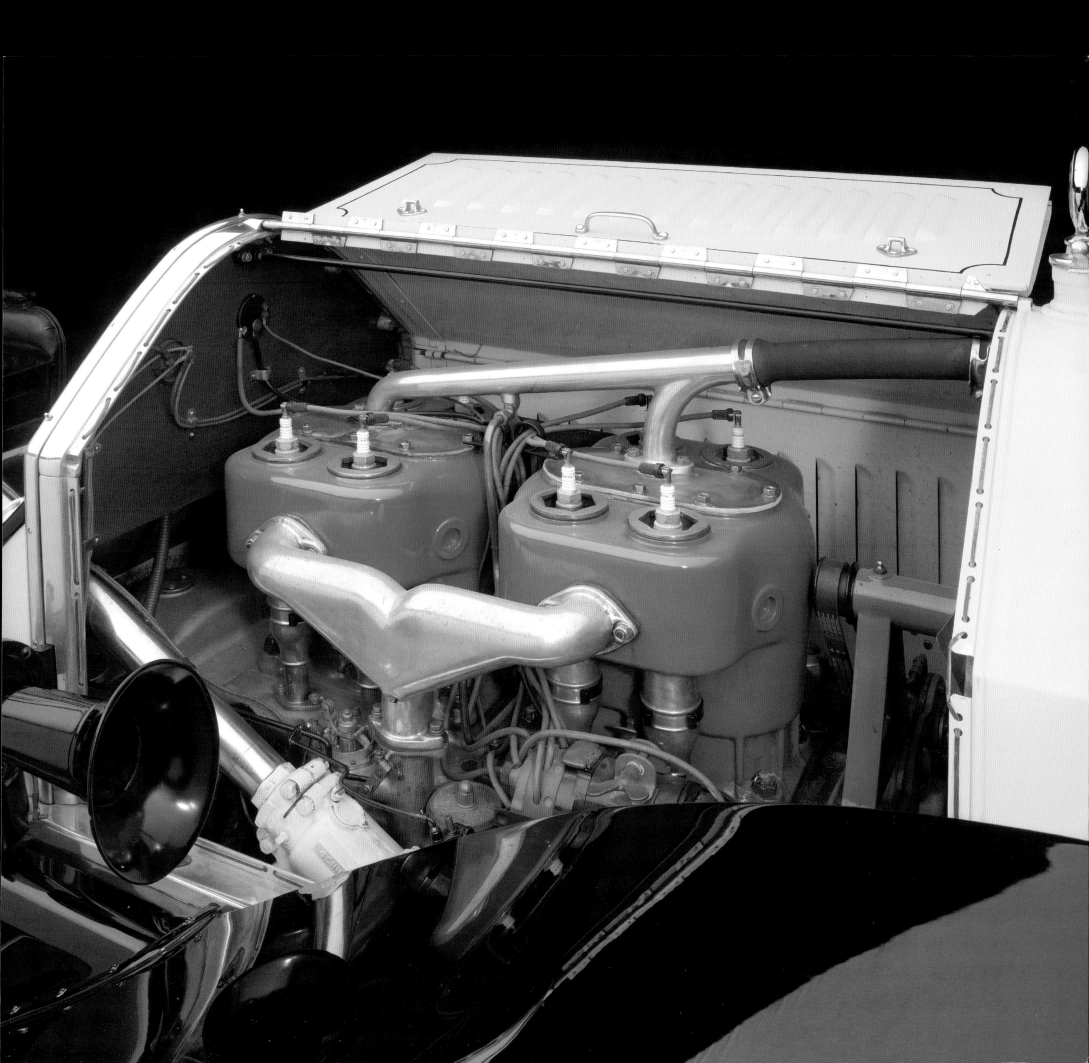

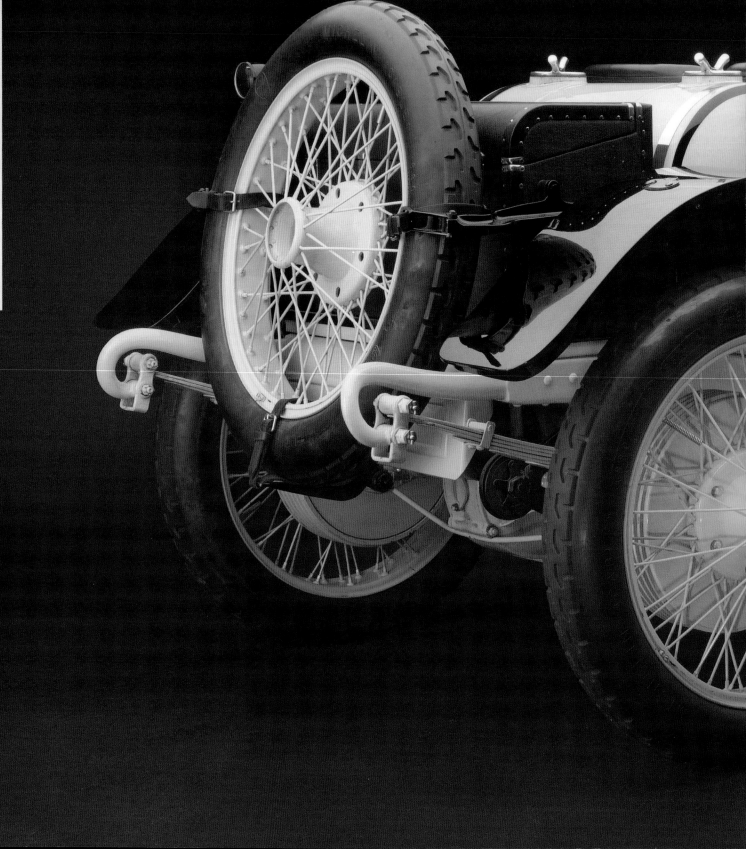

SPECIFICATIONS OF INTEREST

BRAKES
Rear drums only; no front brakes

WHEELS
Houk center-lock, wire spokes

SUSPENSION
Rigid axles with Hardford shocks, semielliptic springs

TRANSMISSION
Three-speed manual, external shift lever

WHEELBASE
120 inches/305cm

CARBURETION
Single updraft Schleber

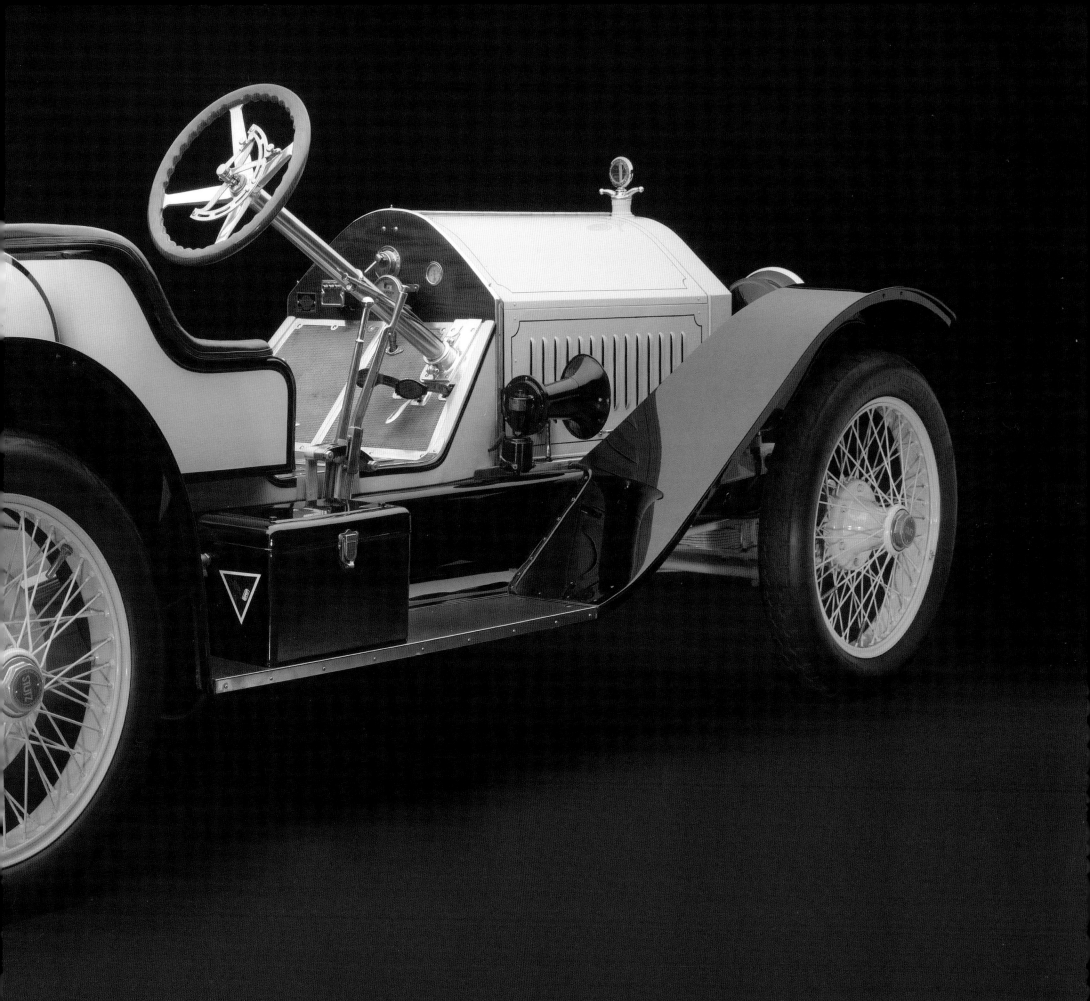

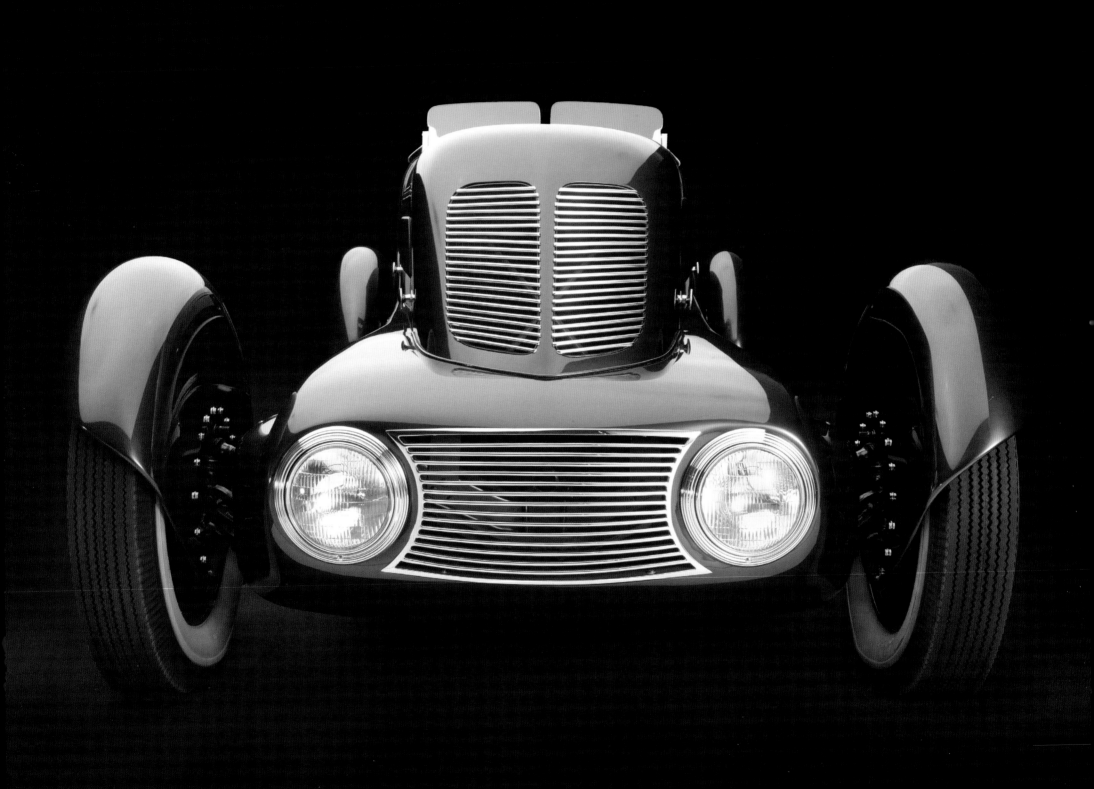

1934
Edsel Ford Model 40 Special Speedster

◆

Beauty in simplicity—if ever there was a vehicle that embodies the meaning of that phrase, it is this one-off Model 40 Speedster built under the direction of Ford Motor Company president Edsel Ford. Inspired by sports cars he saw in Europe during a visit in the early 1930s, Edsel asked E. T. "Bob" Gregorie, Ford's chief designer at the time, to design a low and racy car. The resulting car was based on a modified 1934 Ford (Model 40) frame and was powered by a stock flathead V-8 (later replaced by a more powerful Mercury motor).

The body itself is like the top half of a butter dish with wheels, but in all details and proportions it delivers the impression of a low, sleek, fast, and fun car. The split front grille is laid back at just the right angle, while underneath another, wider

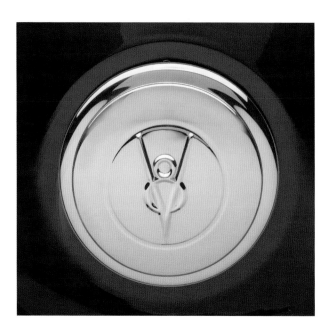

grille is flanked by two round headlights. This lower portion of the car recedes like a wedge from the very front of the car back to the rear wheels; this taper keeps the bluff front and horizontal hood from looking too blocky. Cut-down openings aside the passenger compartment add a racy element and further break up the car's flat sides. A low-profile split windshield just in front of the cockpit gives a sporting driver the barest protection from the wind.

Edsel died in 1943, and the Speedster disappeared a few times over the ensuing decades. It resurfaced in 1999 and eventually made its way back to the Edsel & Eleanor Ford House in Michigan, which is now operated as a historic site. Ford House had the car restored to its 1940 configuration.

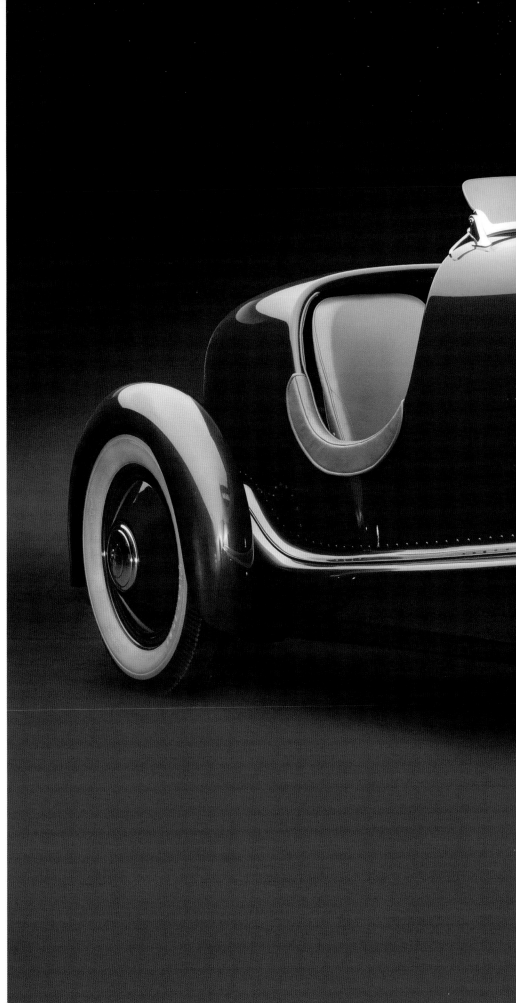

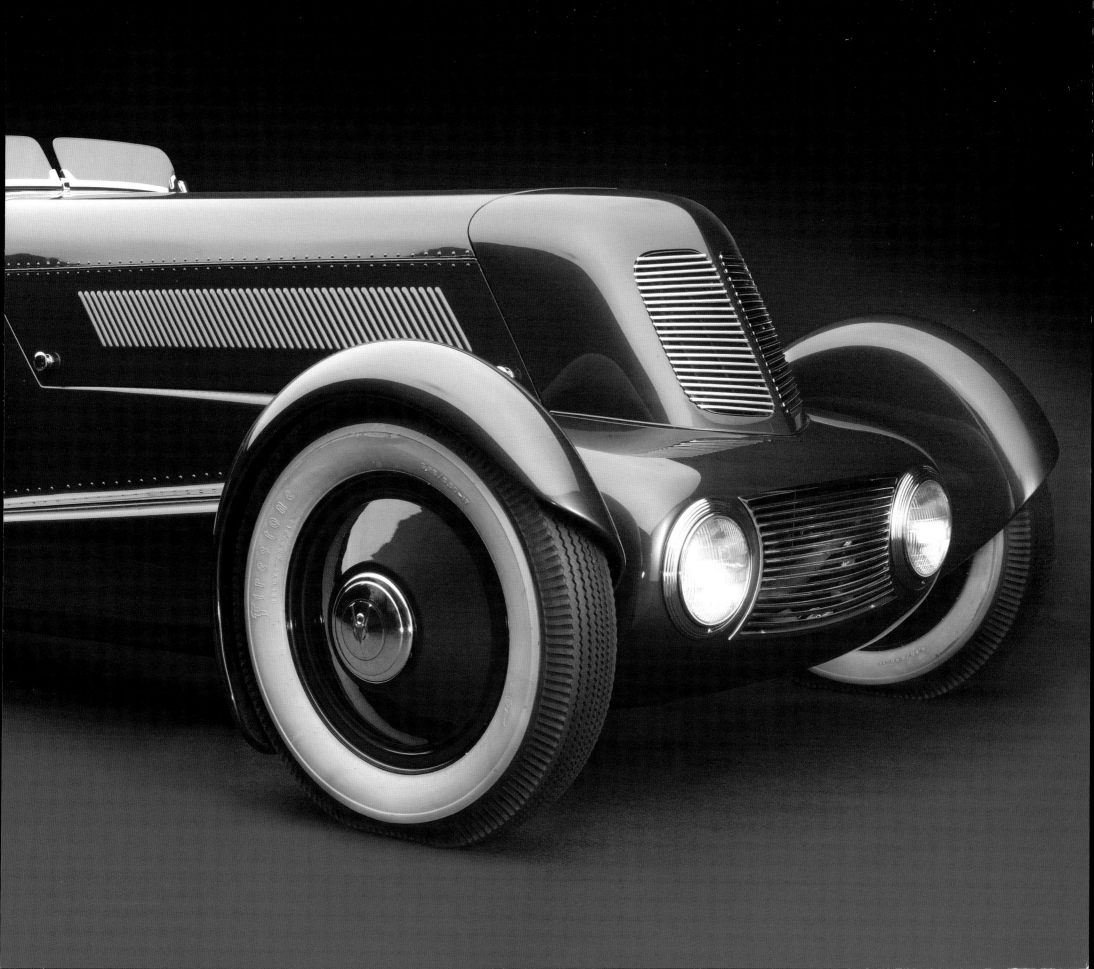

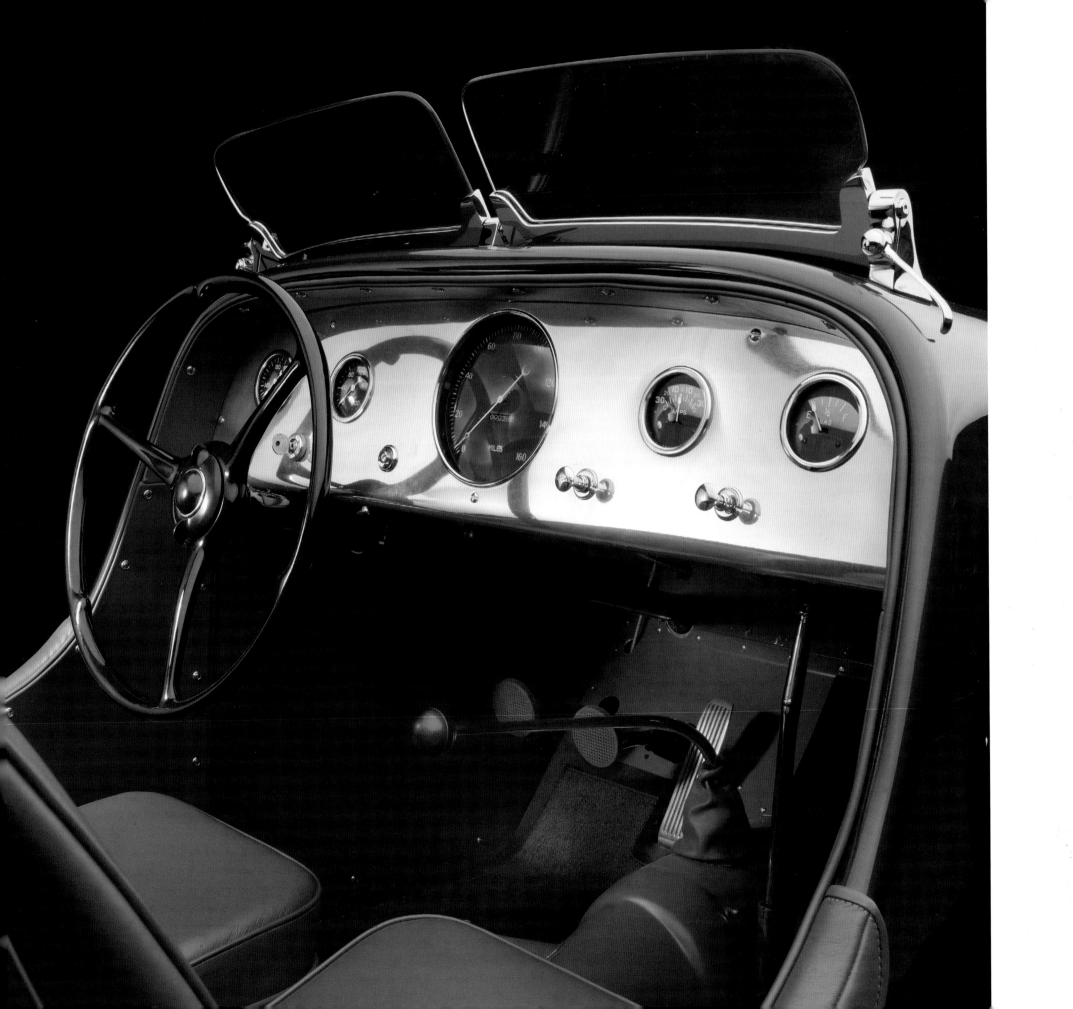

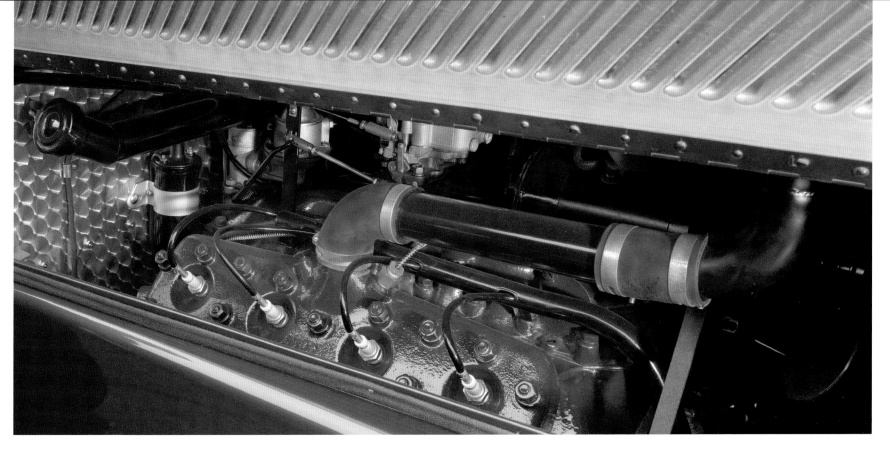

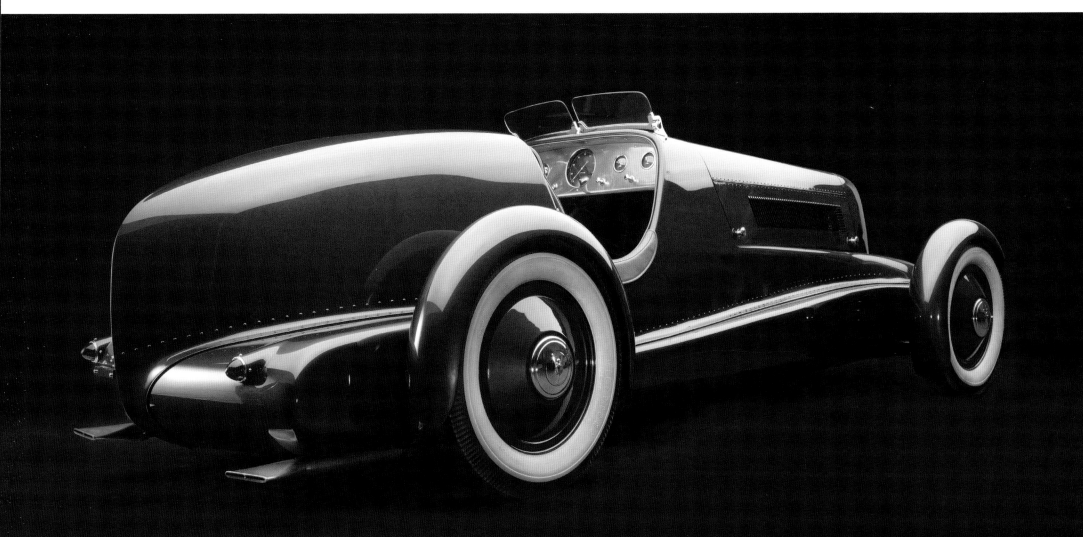

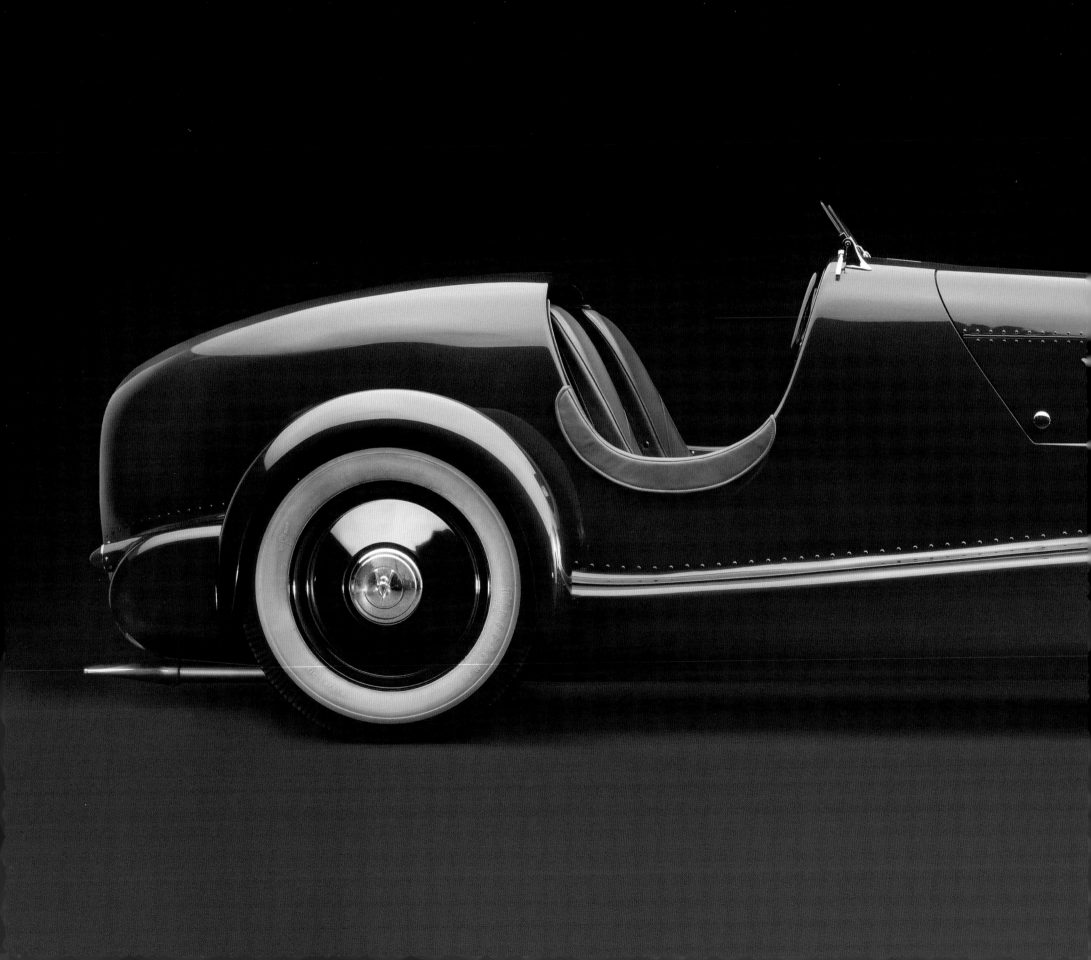

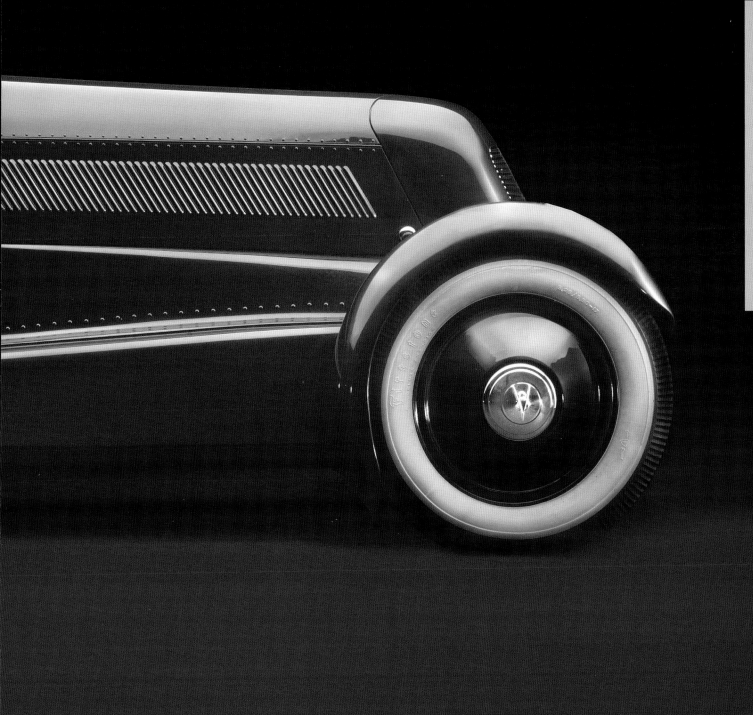

SPECIFICATIONS OF INTEREST

ENGINE
Mercury V-8, 239 ci/3.9 liters

POWER
100 bhp

BODY
Sheet aluminum over aluminum structural framework

EXHAUST
Straight dual exhaust, enclosed in bodywork

WEIGHT
2,100 lbs/952 kg

WHEELBASE
113 inches/287cm

1935
Duesenberg SJ
Mormon Meteor I

◆

The *Mormon Meteor I* is the one true racing car in this book. Fittingly it is a Duesenberg, from the remarkable American company that made quite a name for itself in the early 20th century with both elegant street cars and successful competition cars. In fact, this car was first called the *Duesenberg Special*, and was constructed specifically for Ab Jenkins. Jenkins had set various speed records at his home state's Bonneville Salt Flats, many of them endurance records set while circling an enormous oval laid out on the Utah salt.

Jenkins looked to Duesenberg to produce this massive, fast roadster that could travel at high speeds for hours, or even days. It was built on a 142-inch Model J chassis. J. Herbert Newport designed the car's narrow aluminum body, with its raked grille and windshield and dramatic fairings, for its occupants as well

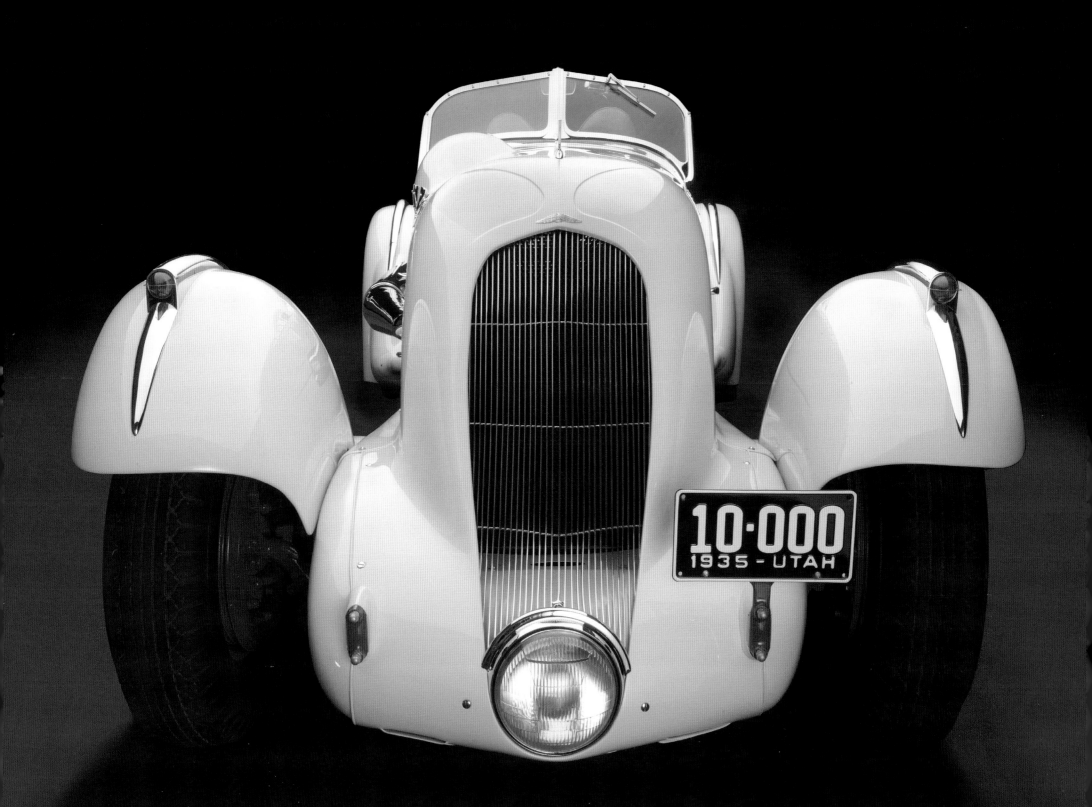

as for the four wheels. A flat belly pan and a tapered tail further streamlined the car.

The car's 6.9-liter straight-eight Duesenberg engine had dual overhead cams, and two Stromberg carbs fed an intake that was boosted using a centrifugal supercharger. A standard Duesey SJ engine made 320 bhp; with the help of cam-grinding legend Ed Winfield, the Jenkins car's mill pumped out 400 bhp.

Jenkins, co-driving with Tony Gulotta, managed an average of 135.580 mph for 24 hours to set a new record, but that record was soon surpassed. Jenkins knew he needed more power, so he installed a Curtiss Conquerer V-12 aircraft engine more than twice the size of the Duesenberg engine, subsequently dubbed the car *Mormon Meteor II*, and eventually set a 157.27 mph 24-hour mark, among other records.

Jenkins felt this was probably the limit of the chassis though, so he soon constructed the *Mormon Meteor III*, which carried on with a Curtiss engine. He retired the old car's chassis, installed a Duesenberg engine, and drove it on the road for more than 20,000 miles. It is now restored to its 1935 configuration.

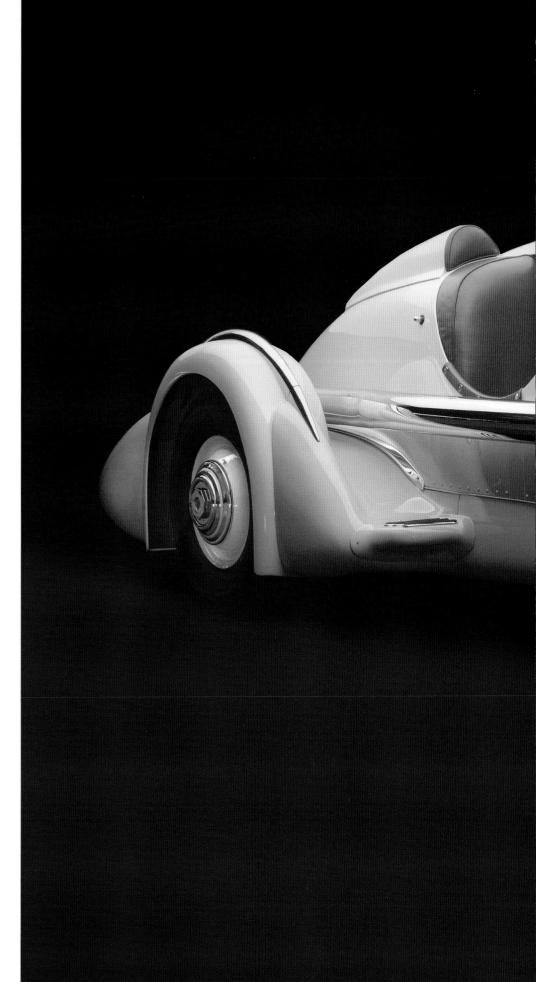

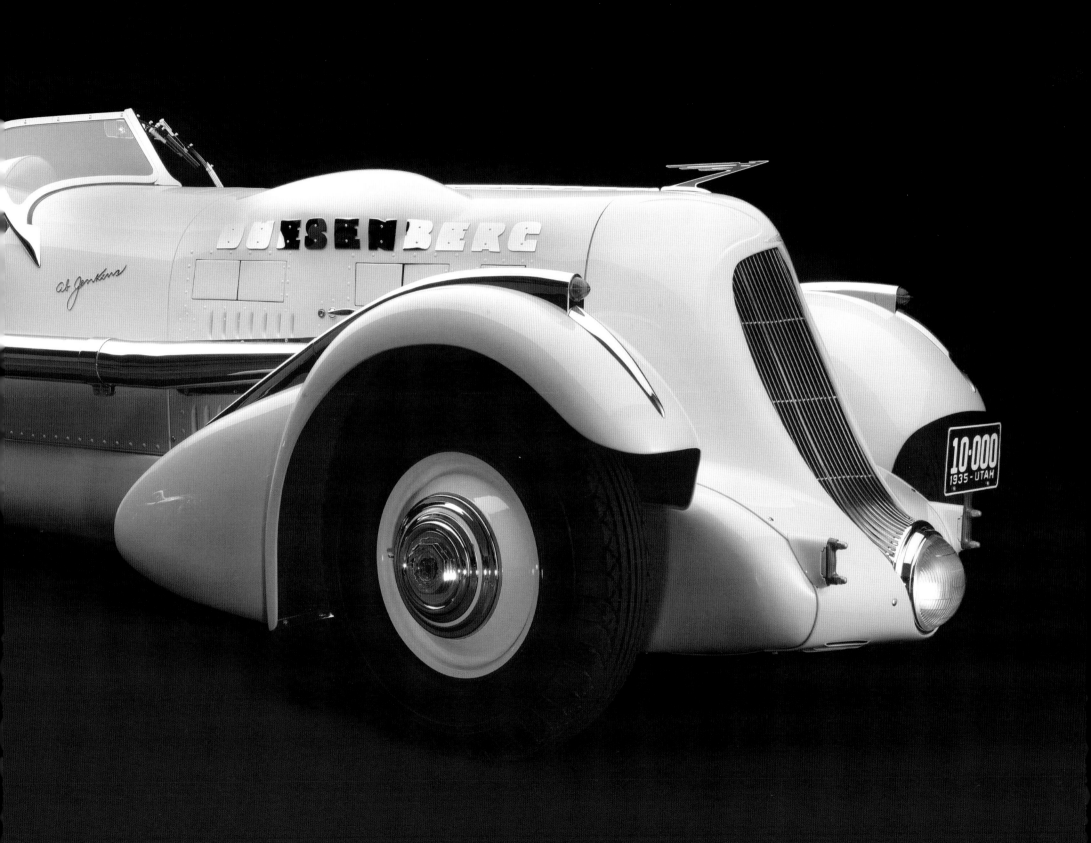

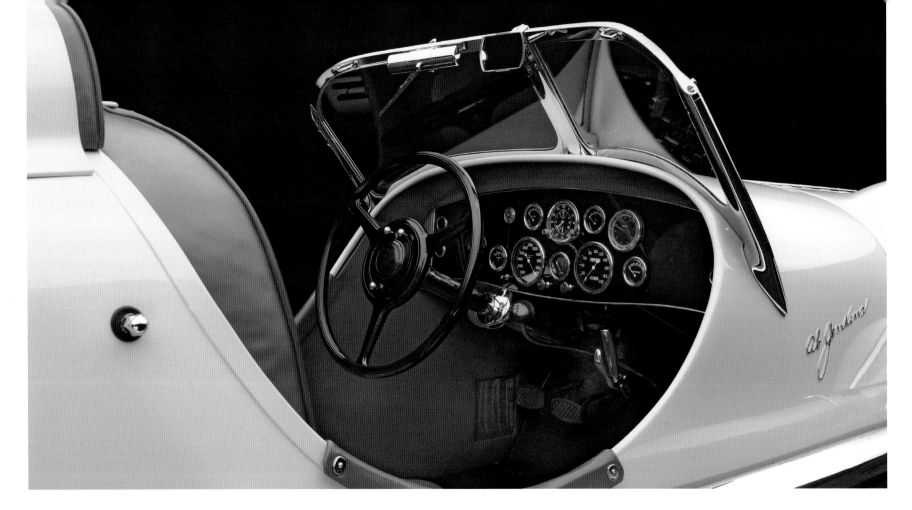

SPECIFICATIONS
OF INTEREST

ENGINE
Straight eight, 4 valves per
cylinder, 419.6 ci/6.9 liters

SUPERCHARGER
Centrifugal, gear-driven

COMPRESSION
5.2:1

TIRES
Firestone 18-inch/46cm

WEIGHT
4,800 lbs/2,177 kg

TRANSMISSION
Warner Hy-Flew three-speed
manual

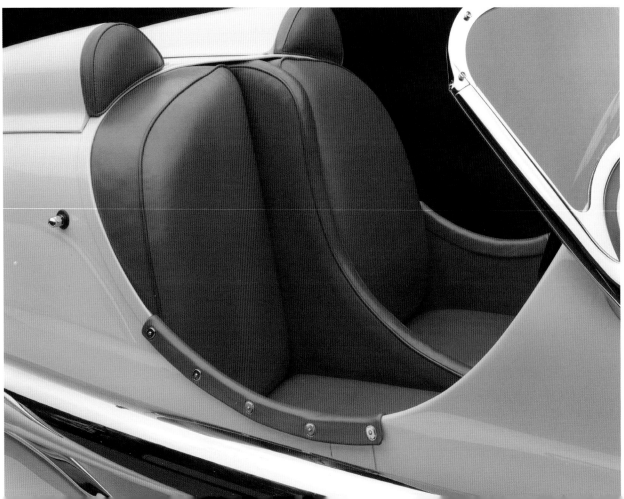

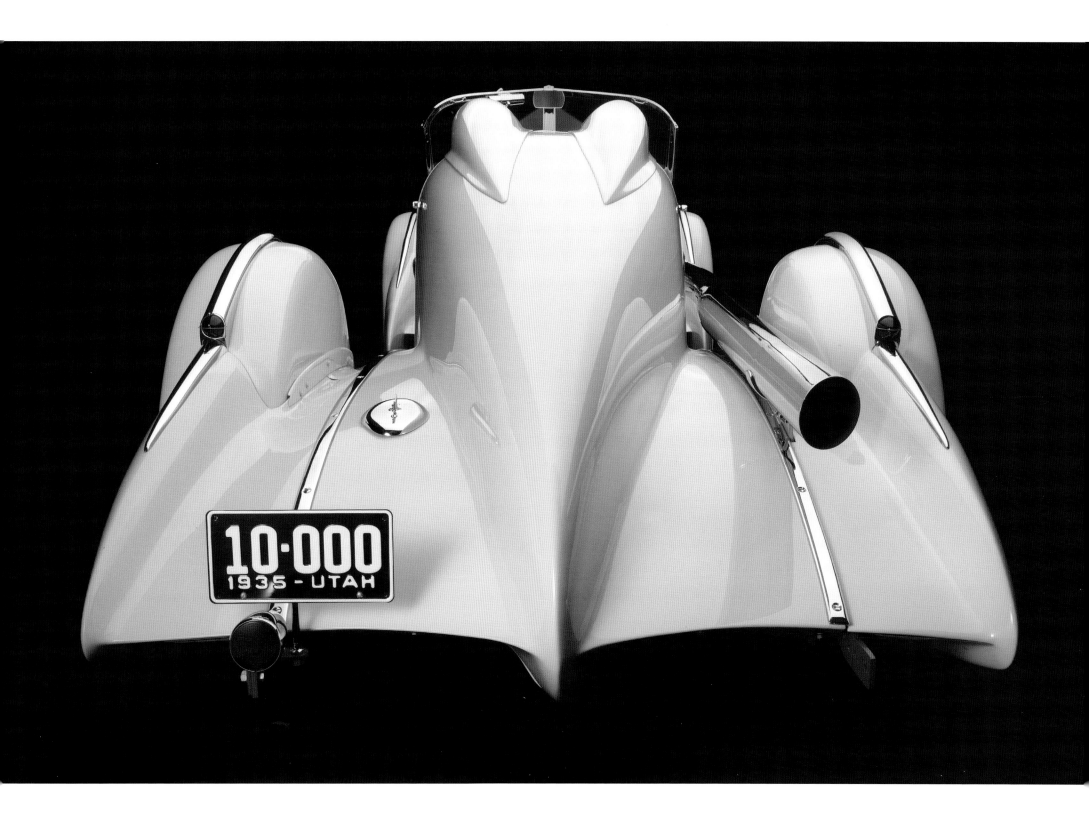

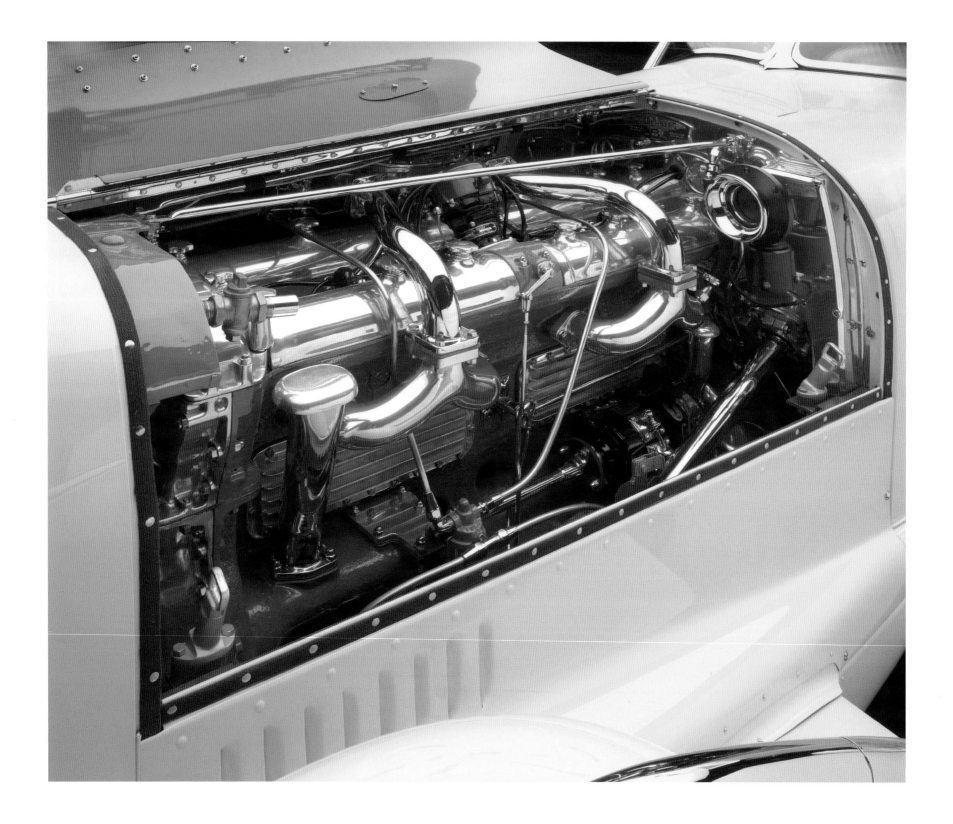

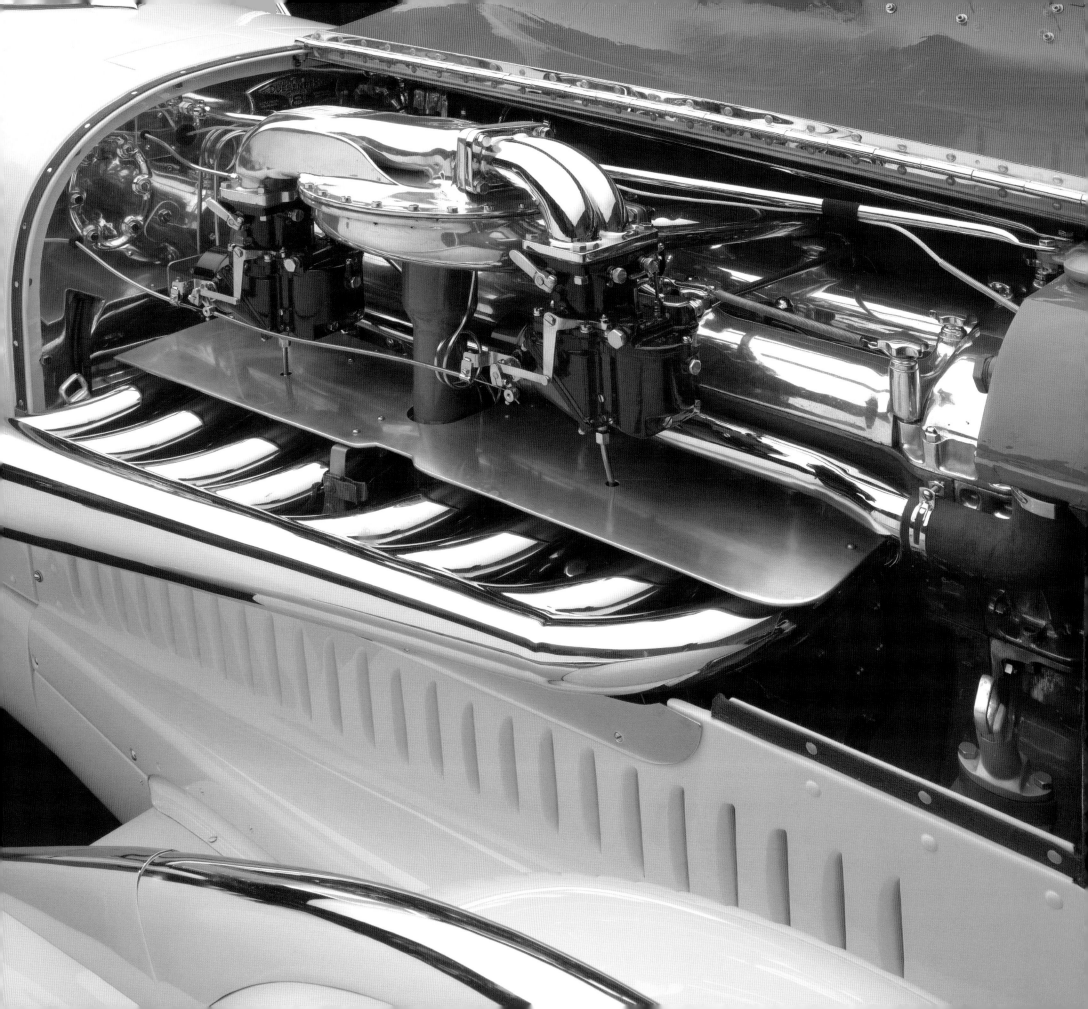

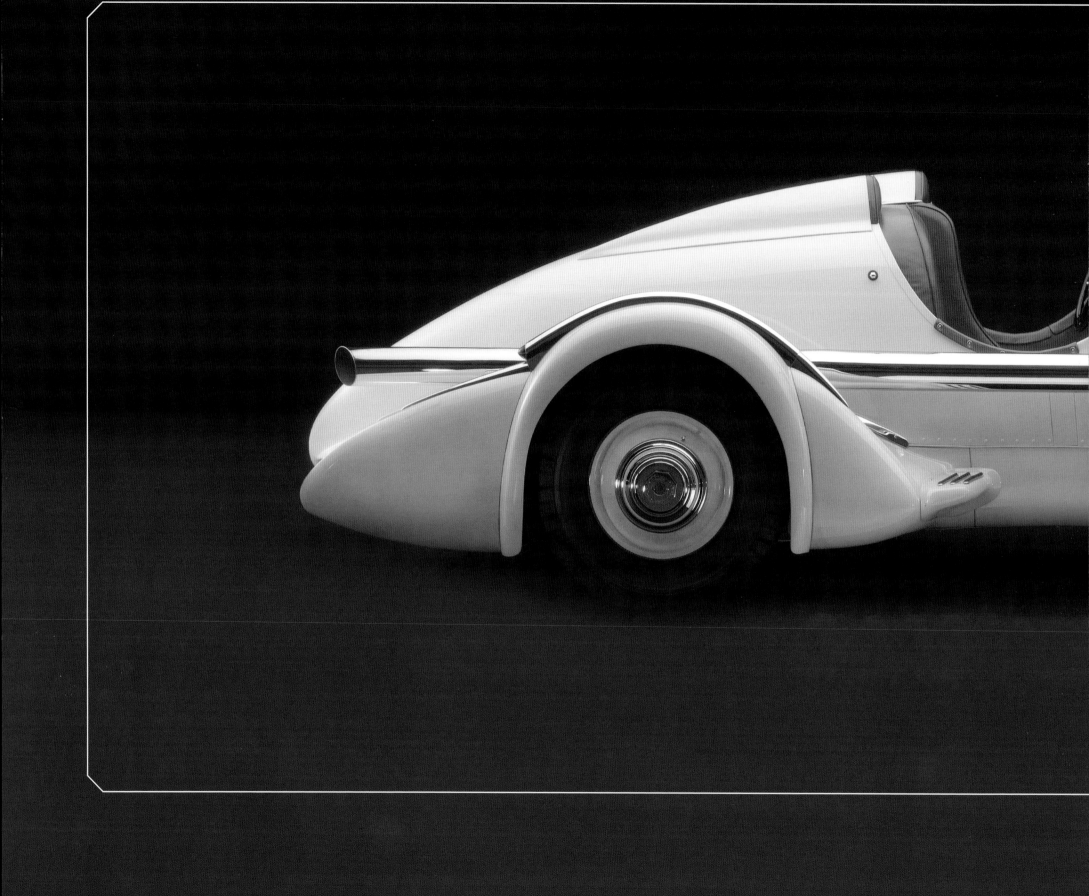

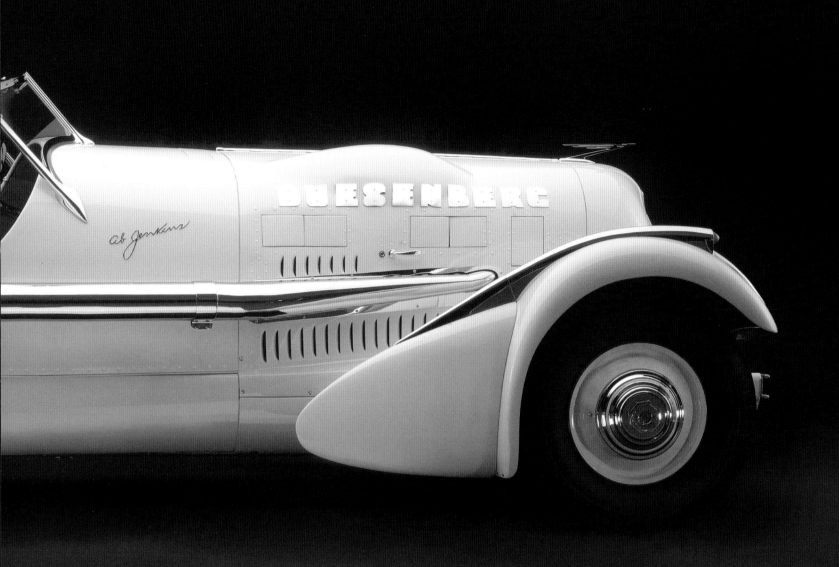

nyone who has ever possessed a convertible (and if you haven't, I recommend you make a point to do so), knows that driving a car with the top down completely changes the experience of driving a car. Anyone who has spent their automotive life caged within glass and steel can have no comprehension of this—it's something that must be felt firsthand.

It's not all wind-in-the-hair fun, though. You are no longer immune to bird droppings, insect attacks, sunburn, windburn, or the occasional rock thrown up from the road. There's nowhere to hide from your fellow motorists or from nearby pedestrians—you can see them better, but they can see you better too. You'll find that open communication with your fellow man and a timely smile go a long way.

It's all part of the charm. With a convertible you can smell the countryside as you drive by. You can feel each microclimate as you wind through a shaded forest road. You can hear the river running alongside you, or the thunder in the distance. And, needless to say, if you should find yourself behind the wheel of any of the classic convertibles featured in this section, your top-down drive will only be enhanced as you are conveyed by one of the most elegant vehicles ever built. When you arrive at your destination and climb out of one of these attention-grabbing rides, take my advice and don't forget to smile!

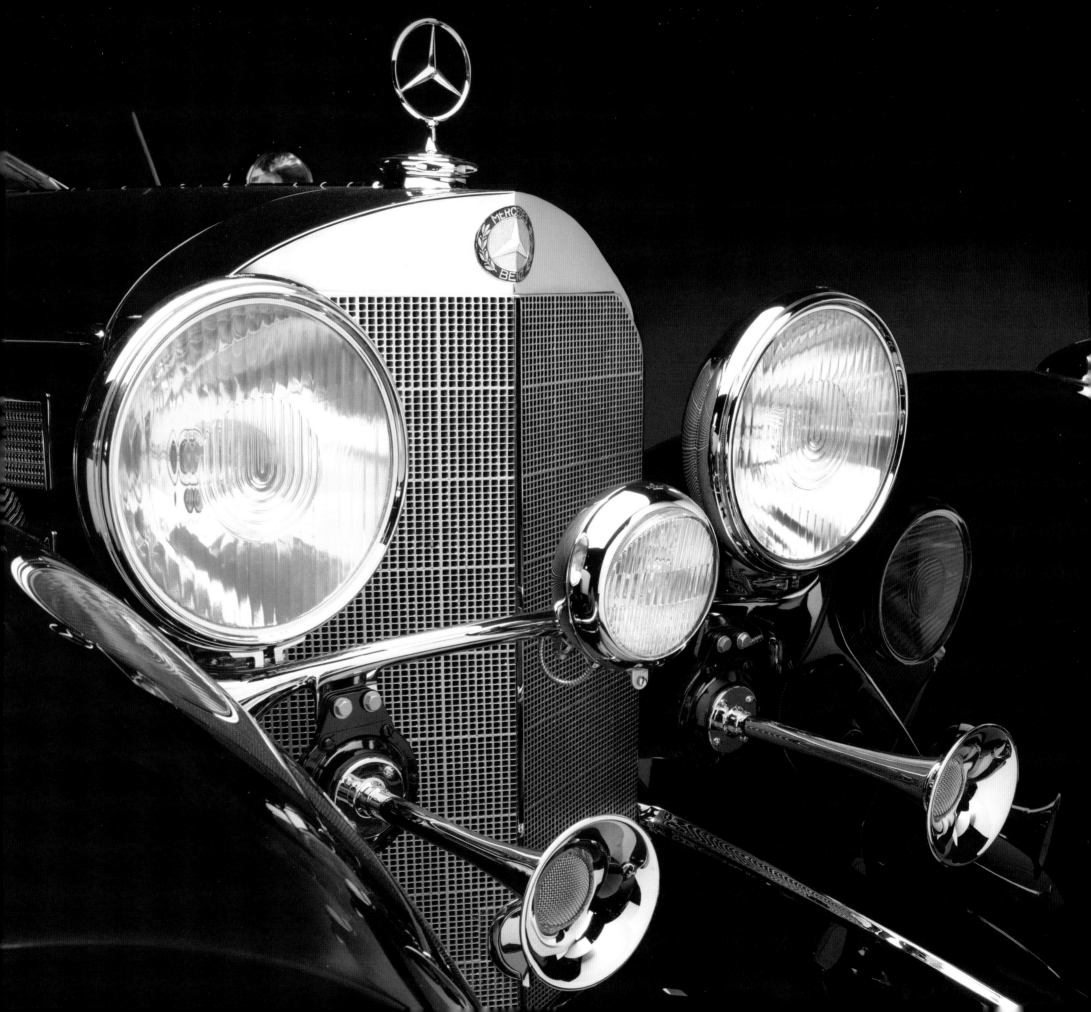

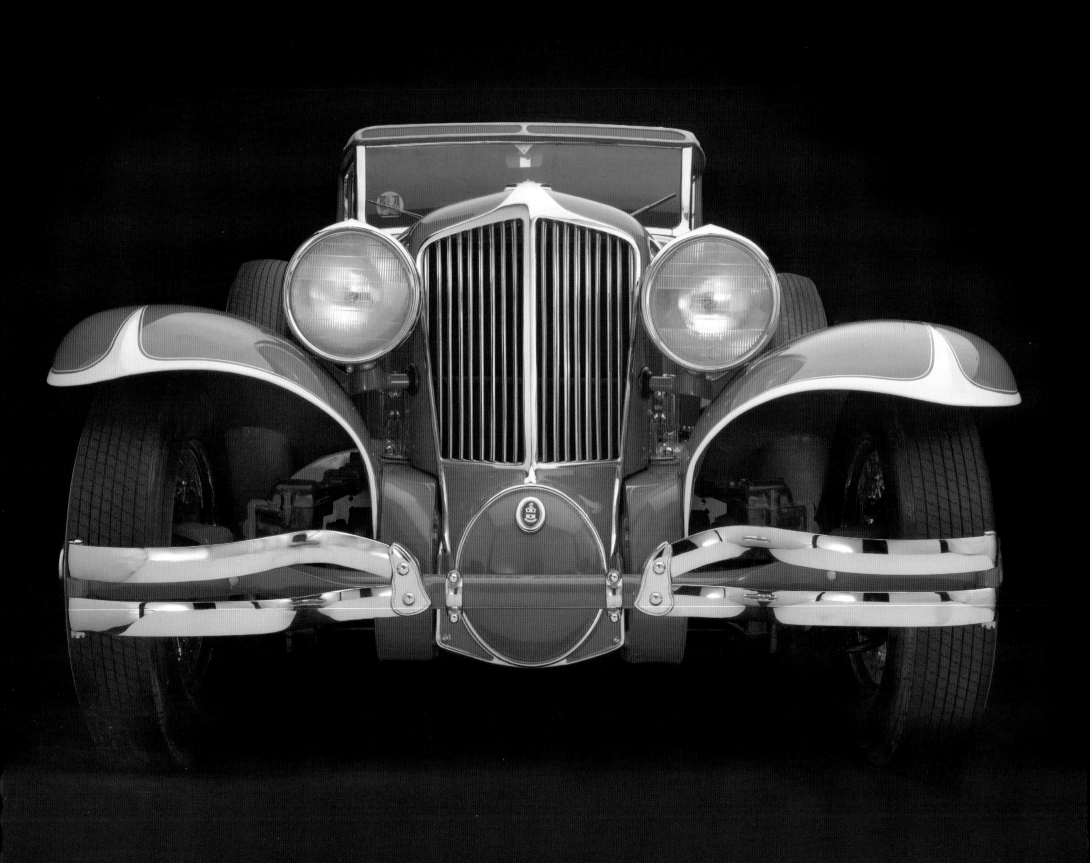

1929
Cord L–29 Cabriolet

A t first glance, the Cord L-29 may not appear to be a remarkable car, at least for its era. Upon closer examination, however, this L-29 could be called revolutionary—no less a visionary than Frank Lloyd Wright, who once owned this car, declared it so.

The L-29 was the first front-wheel-drive car to be manufactured in any significant quantity. Among others, Cord selected Harry Miller to engineer the car. Miller had set the racing world on its ear with his superb front-wheel-drive racecar designs that succeeded at Indianapolis.

For Miller, front-wheel-drive had two primary advantages. First, it eliminated the need for a driveshaft to be placed underneath the car. This allowed the chassis and body to sit much lower, which enhanced both handling, through a lower center of gravity, and aerodynamics, by presenting a smaller body to the air rushing by. Second, with the drive wheels at

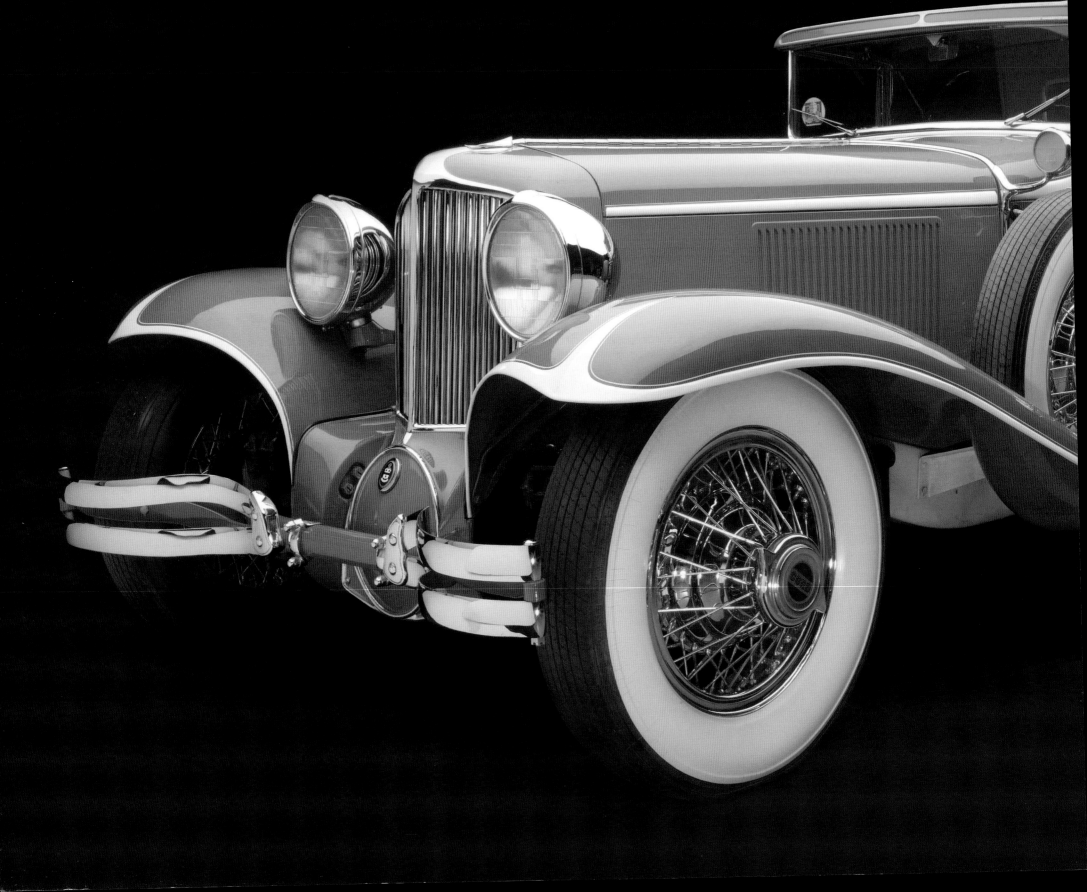

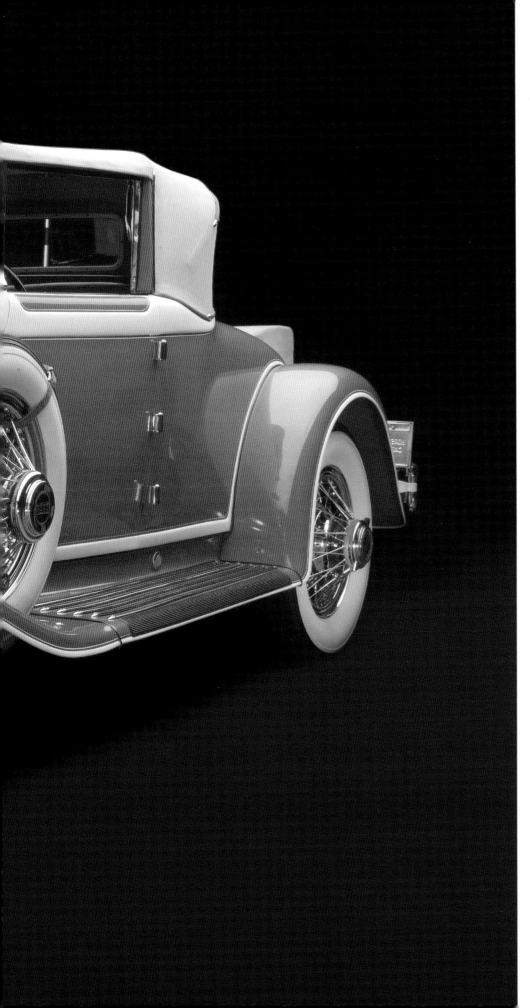

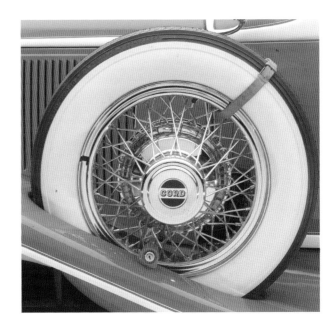

the heavy end of the vehicle, the traction of those tires was enhanced and power could be translated into forward momentum that much more effectively.

Transferred to the L-29, these front-wheel-drive advantages were apparent to Wright. In his autobiography, Wright predicted that the principles of front-wheel-drive were logical and scientific, and that all cars would eventually be set up that way. By the 1980s, the auto industry's widespread adoption of front-wheel-drive had largely followed Wright's prediction.

The L-29's transaxle was placed in front of its long, straight-eight engine. This in turn necessitated a long hood. Cord's Al Leamy only emphasized the car's low, long nature in his body design. A color-coordinated radiator surround, a low roofline, and raised accents running the length of the car helped stretch out the vehicle's visual impression.

The L-29's impact on the larger automobile industry was blunted by the stock market crash that immediately followed its introduction. Cord was forced to lower prices and only moved a few thousand cars before production ended in 1932.

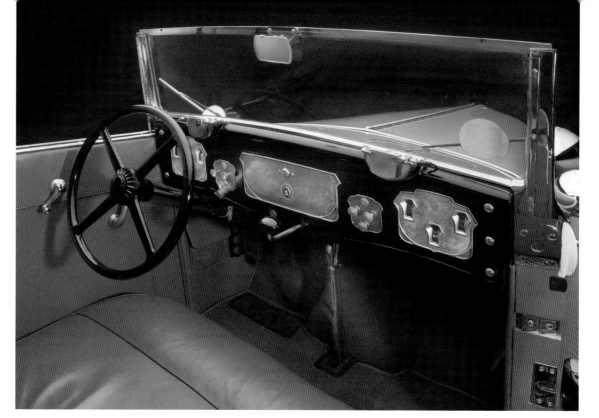

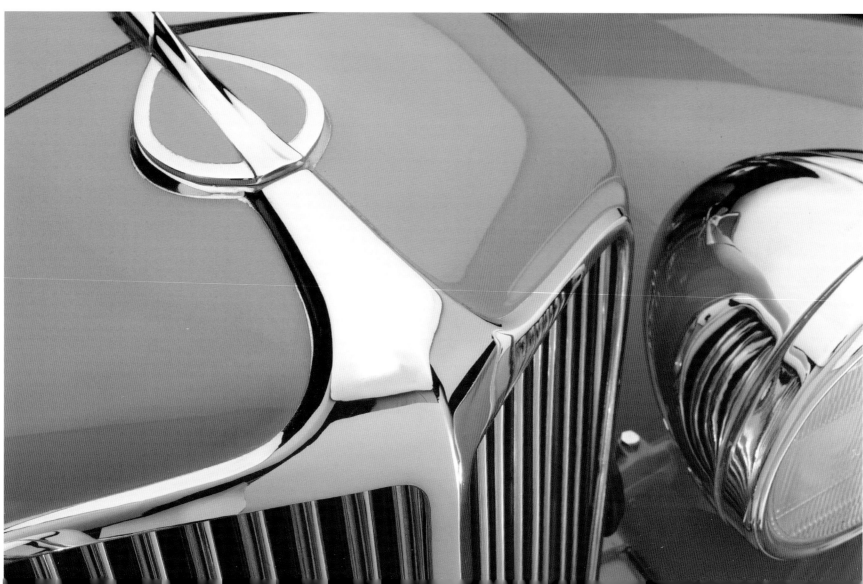

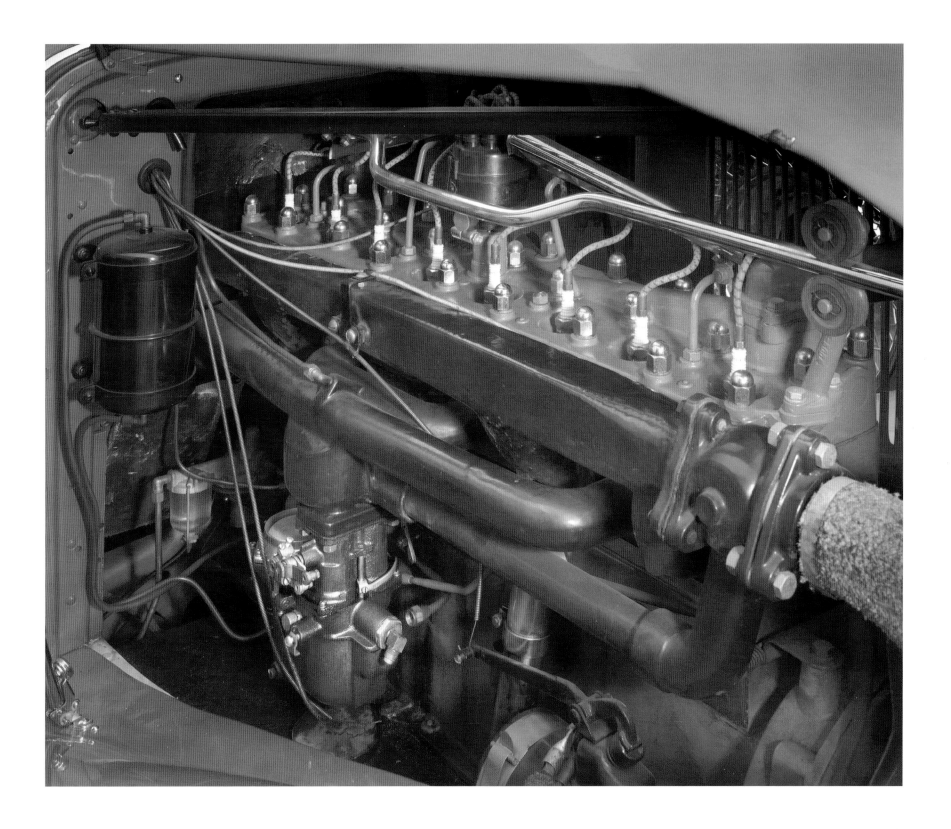

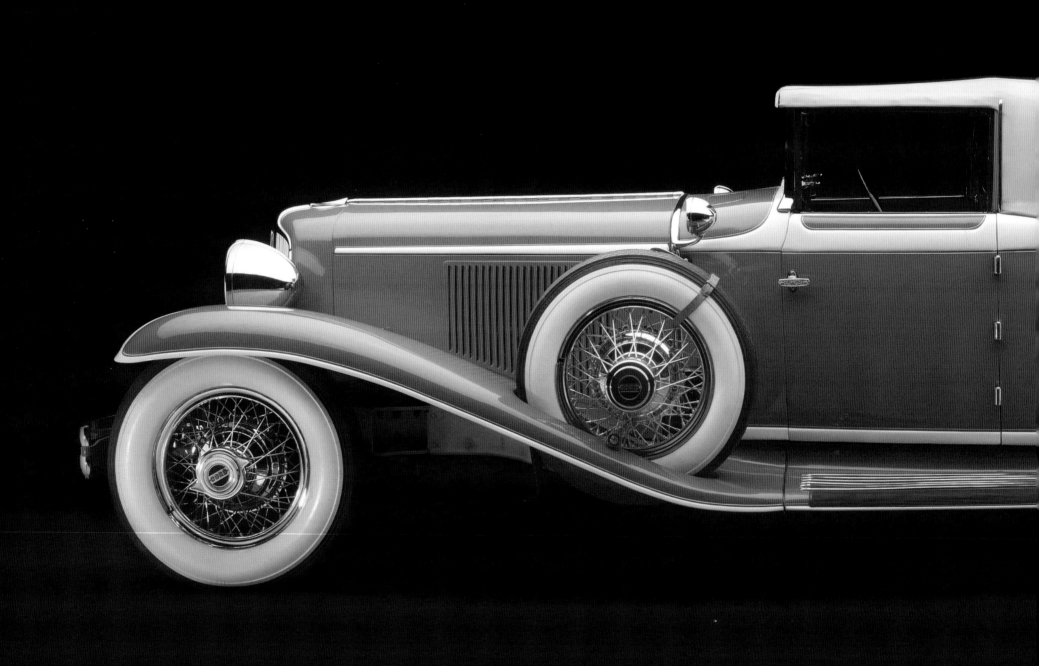

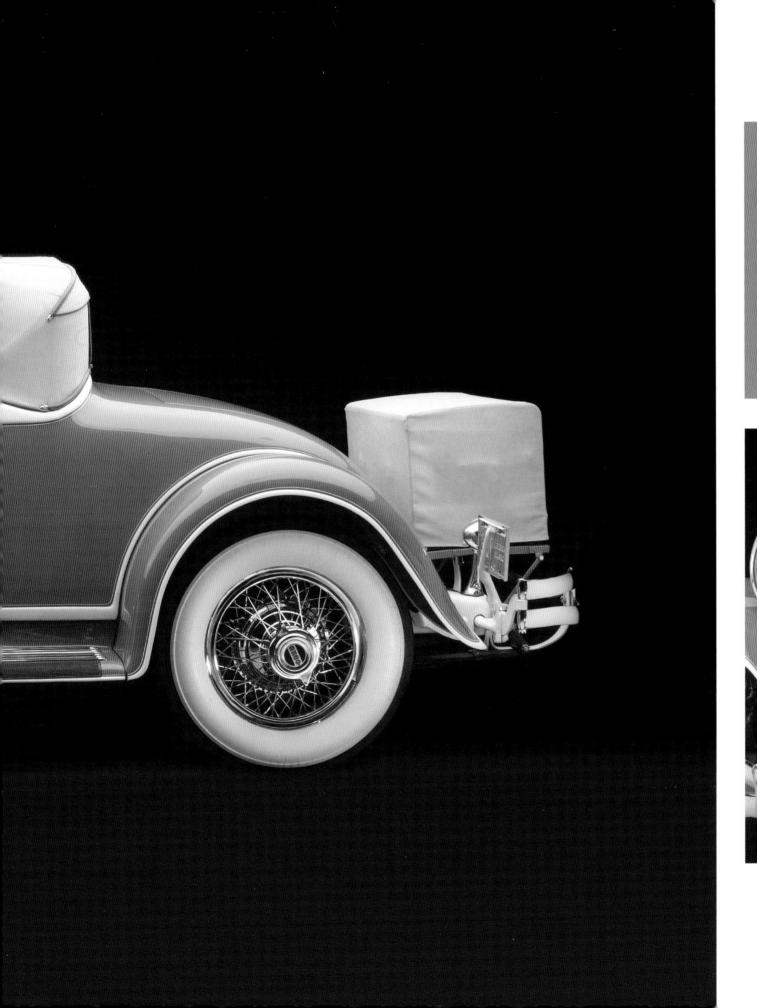

SPECIFICATIONS OF INTEREST

ENGINE
125 bhp straight eight, 299 ci/
4.9 liters

BASE PRICE
$3,000

FRONT SUSPENSION
de Dion solid axle, quarter elliptic
leaf springs

WEIGHT
4,600 lbs/2,086 kg

TOP SPEED
77 mph/123 kph

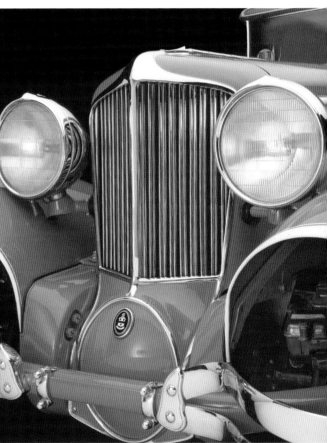

1930
Jordan Model Z Speedway Ace Roadster

◆

One of the last Jordan model cars ever built is also the only one of its kind known to exist—the Model Z Speedway Ace Roadster, of which only 14 were made. Like many companies, automotive and otherwise, Jordan failed to make it out of the Great Depression, but not before making some cars of remarkable quality and uniquely American style.

The Cleveland, Ohio-based Jordan Automobile Company, was founded in 1916. During the 1920s, Jordan made its mark on automotive culture and advertising through a popular ad campaign for its Playboy roadster and Blueboy sedan; their tagline was, "Somewhere West of Laramie." At one point Jordan had 85 dealers in the United States, and during its history more than 43,000 Jordan cars were built.

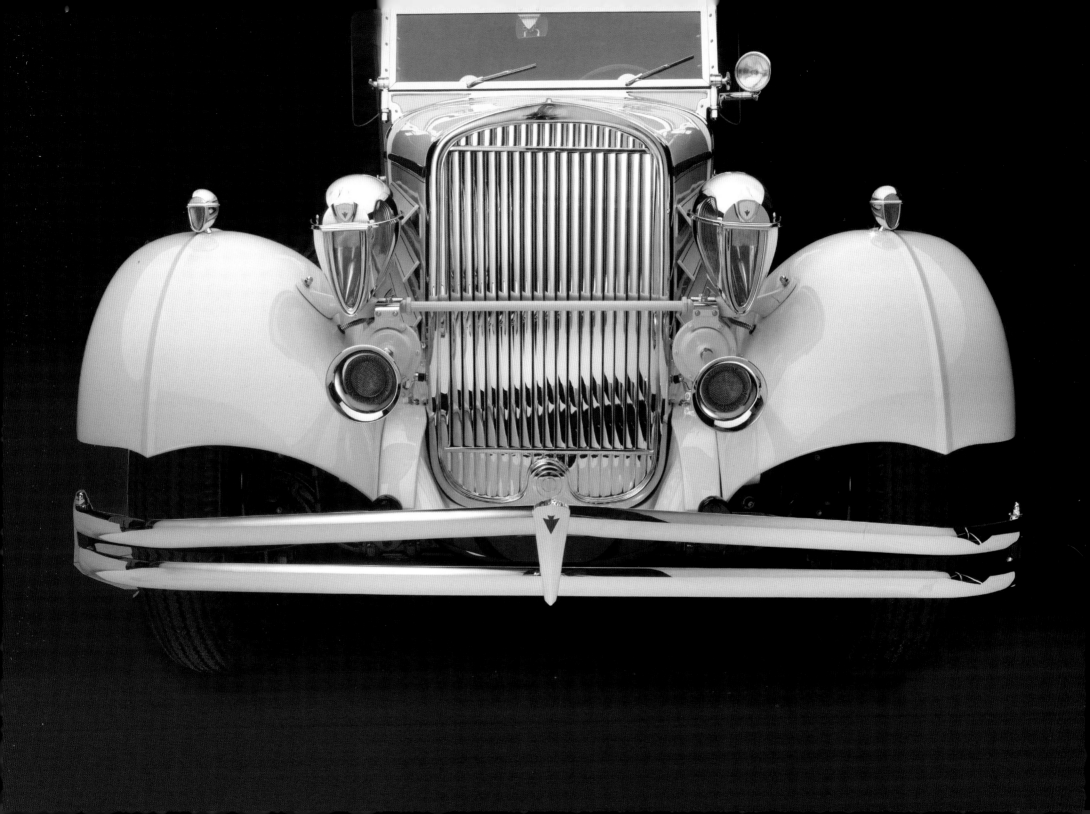

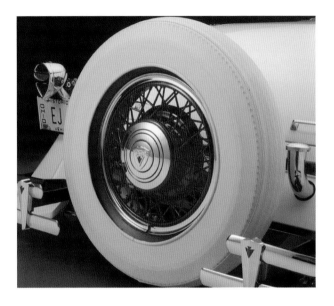

The Model Z Ace was introduced in 1930. It had a low-mounted body on a long 145-inch wheelbase frame. Its body was built by another Cleveland firm, the Facto Auto Body Company. It had a large 5.3-liter, straight-eight engine (mated to a four-speed gearbox) that made 114 bhp at 3,300 rpm. Jordan sought to capture some of the interest in aircraft during this period by using toggle switches for various accessories and even incorporating an altimeter into its dashboard. Jordan wasn't completely dependent on gimmicks, however—it used high-quality components and even included filters for its oil and fuel, an automatic windshield washer, thermostatically controlled radiator shutters, and other unique and advanced features. Its engine's crankshaft ran smoothly on five main bearings, and the car stopped with the aid of fully hydraulic brakes.

Unfortunately, the Ace Roadster's price and market timing doomed it from the outset. Priced at over $5,000, it arrived just one year after the stock market crashed and eliminated the ability of many potential customers to afford such a car.

Found in 1998, this lone surviving Jordan Model Z Speedway Ace Roadster was restored, and received a class award at the 2008 Pebble Beach Concours d'Elegance.

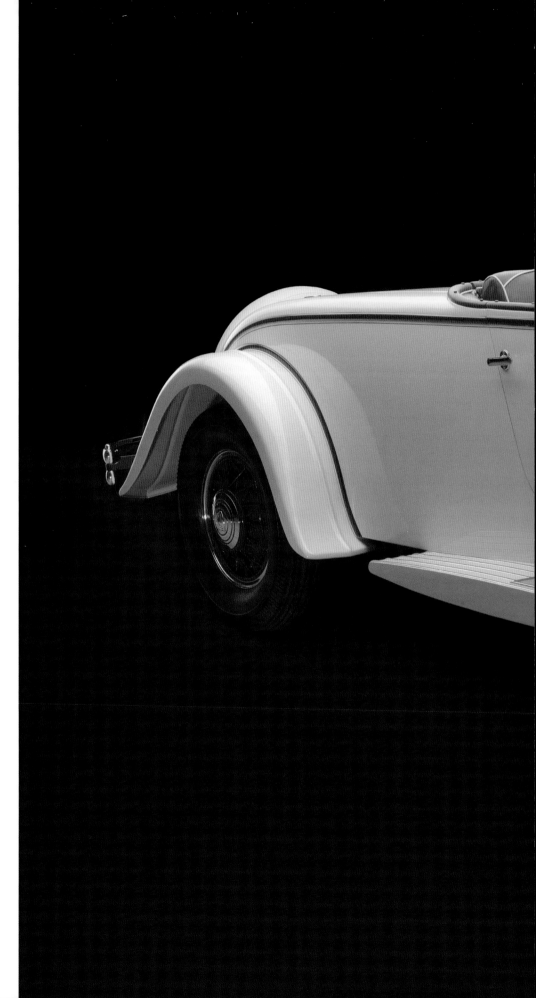

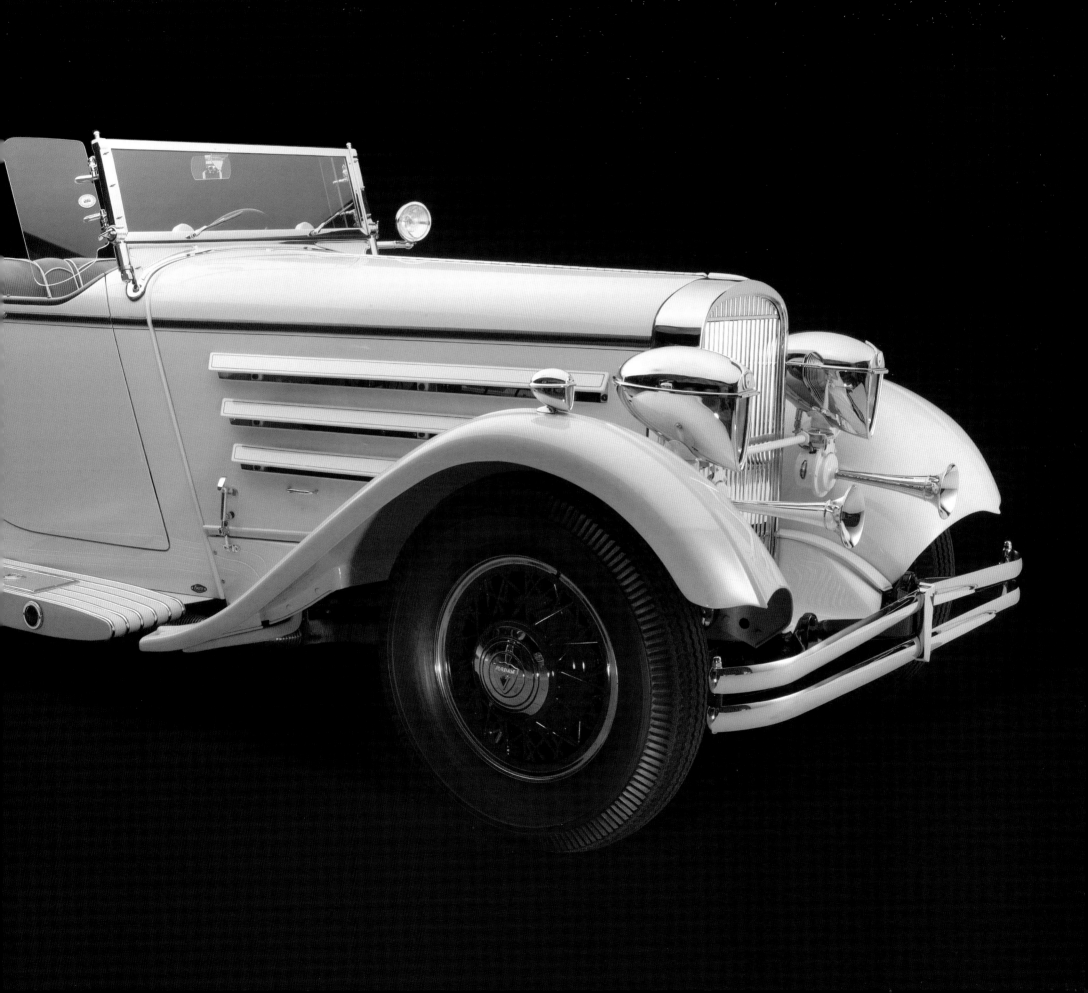

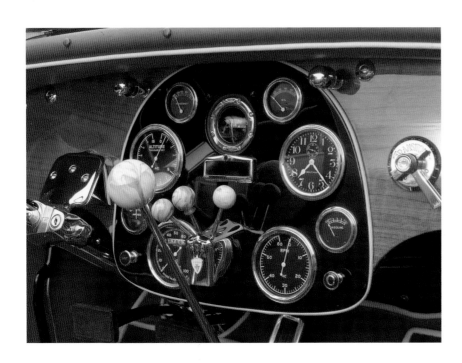
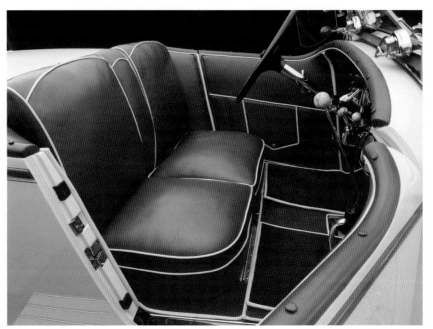
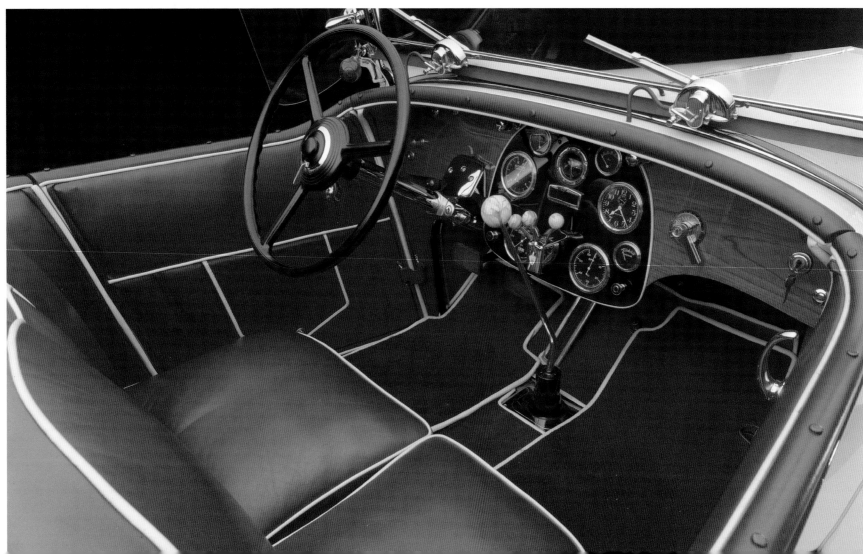

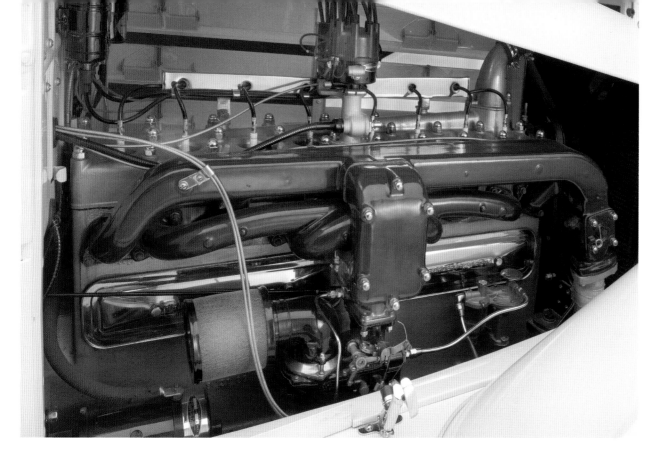

SPECIFICATIONS OF INTEREST

CHASSIS
Double-dropped, pressed-steel, seven crossmembers

ENGINE
Straight eight, aluminum pistons, 422 ci/6.9 liters

IGNITION
Dual points and coils

CARBURETOR
Twin choke

TOP SPEED
100+ mph/160+ kmh

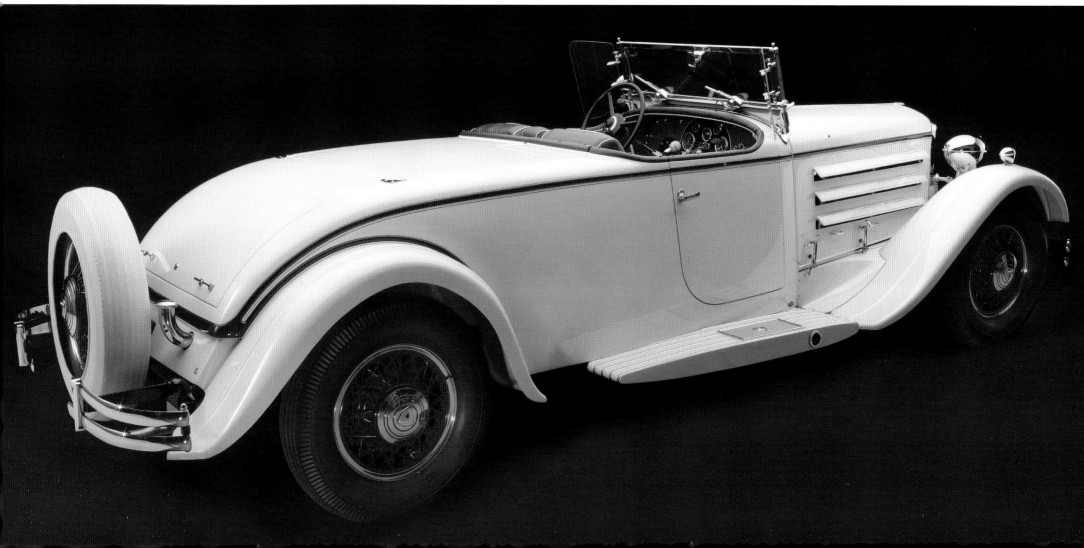

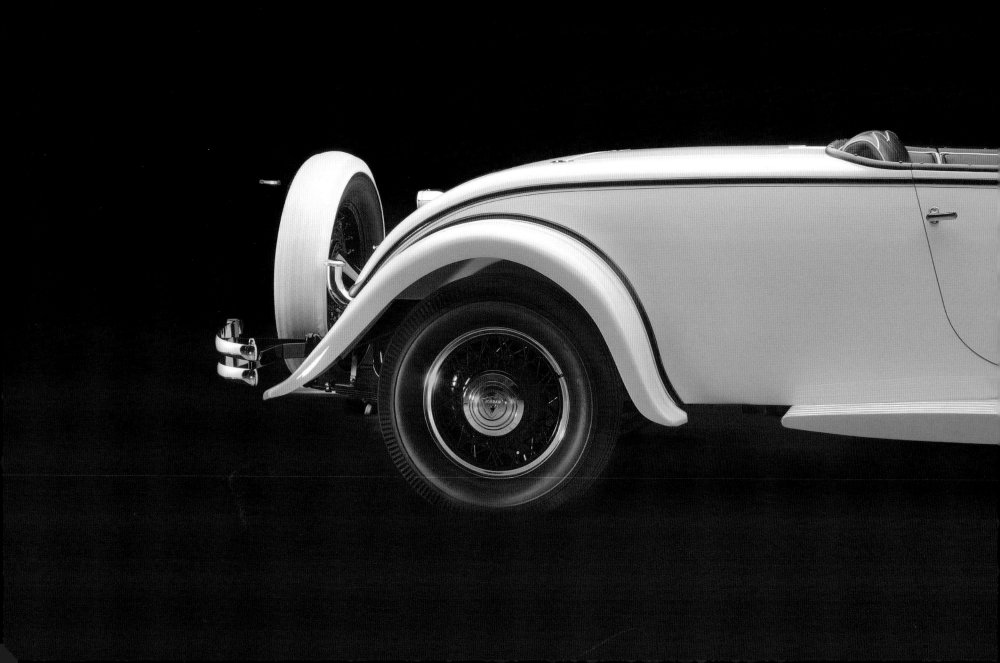

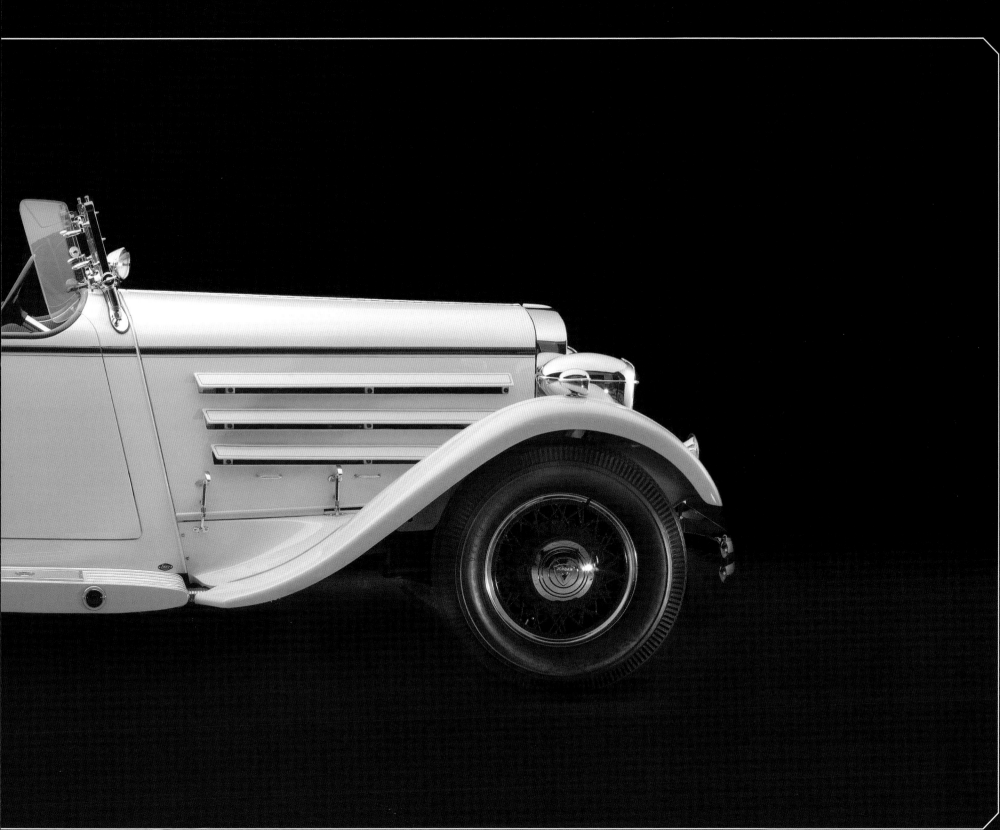

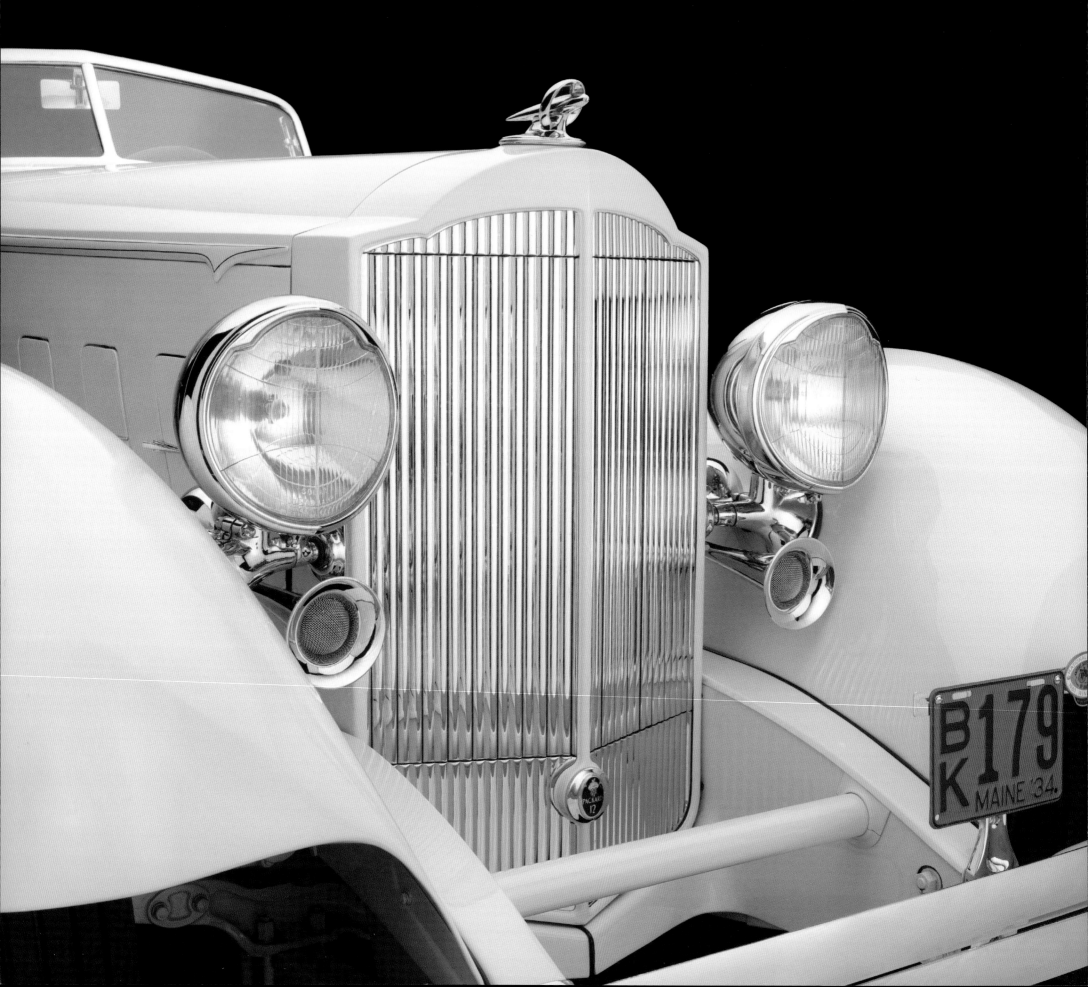

1934
Packard Twelve
Runabout Speedster

◆

This car is a kin to the Packard Sport Coupe found elsewhere in this volume. It therefore follows that it shares many characteristics with that car, down to its rarity; while 10 Sport Coupes were made, only 4 Runabout Speedsters were built. Setting this particular Runabout Speedster apart from the others (all of which still exist) is that this car was ordered by actress Carole Lombard for her husband and fellow Hollywood leading light, Clark Gable. These two stars enjoyed romantic drives in the Duesenberg JN Roadster detailed in the next chapter. A lowered windshield, a rear-mounted spare tire, and spun disc wheel covers were among the distinctive custom features of Gable's Packard.

Like the Sport Coupe, the body of the Runabout Speedster was built by LeBaron at the direction of Edward Macauley,

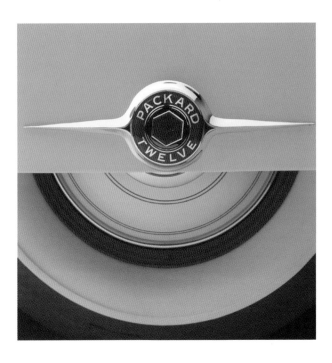

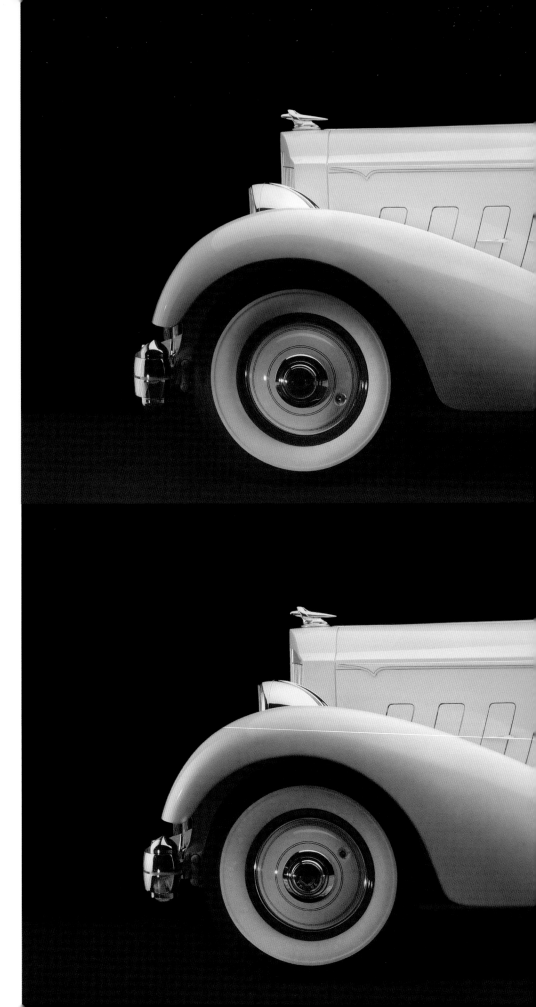

director of design and the son of Packard president Alvan Macauley, and possibly with some input from Dietrich, another coachbuilding firm with which Packard worked. Following lessons learned since introducing its first 12-cylinder engine in 1916, Packard installed a 445 ci V-12 engine to provide ample and smooth power.

Surrounding this impressive engine was a long hood, the appearance of which was extended by an unbroken beltline that reaches from the color-keyed grille surround all the way back to the rear of the car. Six identically sized vents are spaced evenly on the hood side, each graced with a horizontal chrome spear. A seventh, identical vent in the cowl scuttle, combined with a suicide-door cutline that mirrors the edge of the hood side, provides additional design continuity to the side of the car. The skirted rear fenders taper to the rear and down to a point, as does the rear deck behind the intimate cockpit.

The Packard Model 1106 was designed to show off the high level of quality and style the automaker could produce. The fact that these cars remain so highly prized is proof this goal was reached.

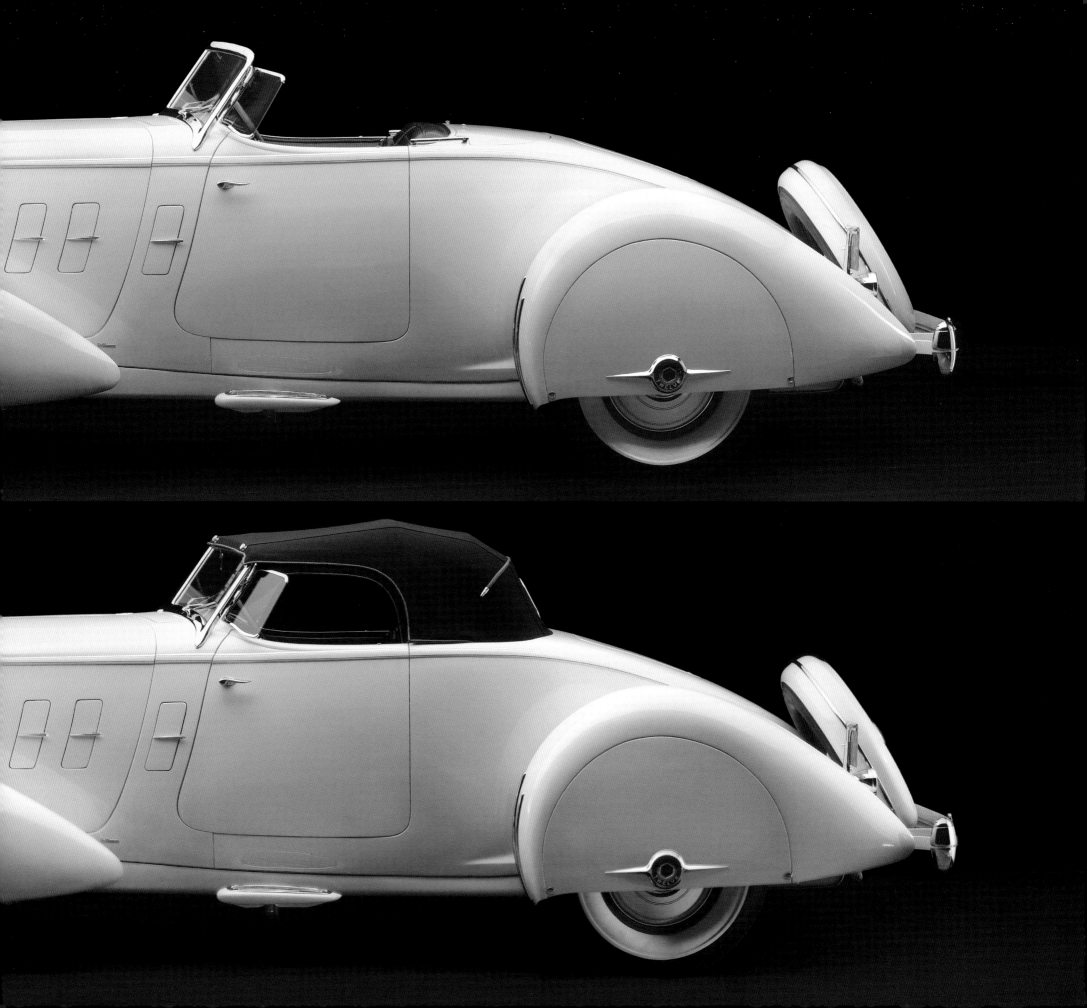

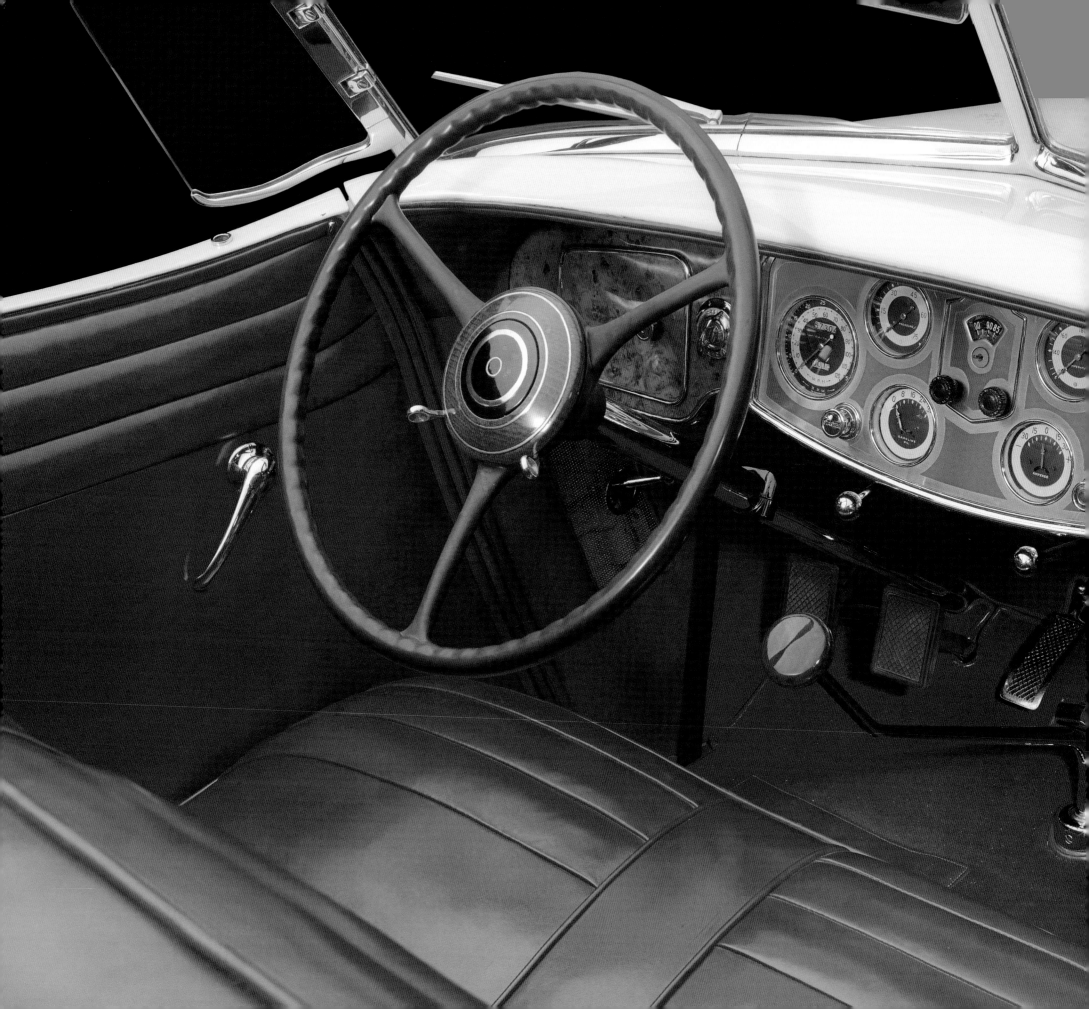

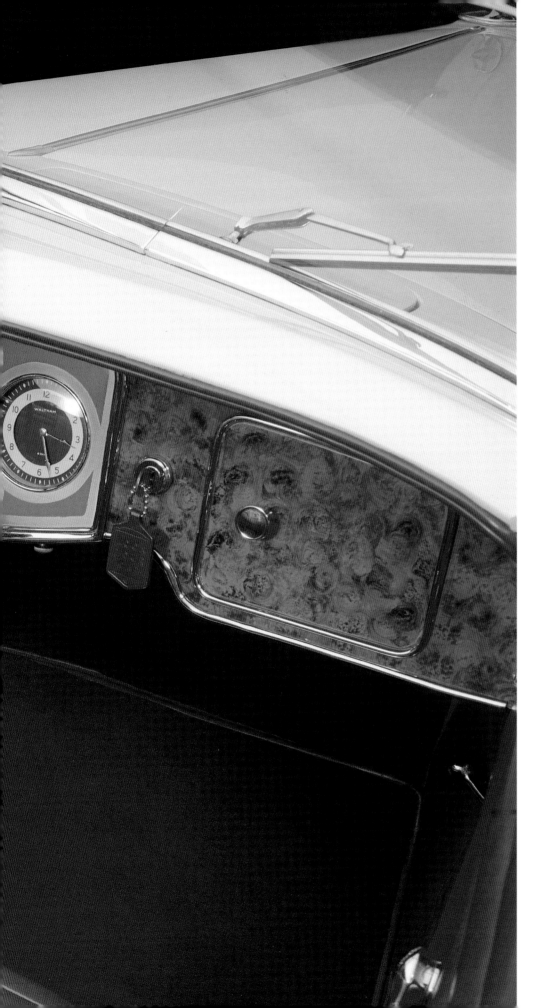

SPECIFICATIONS
OF INTEREST

ENGINE
67-degree V-12, modified L-head,
445 ci/7.5 liters

HORSEPOWER
160 bhp at 3,200 rpm

TORQUE
322 lbs-ft at 1,400 rpm

BRAKES
Cable-operated drums with
vacuum assist

TRANSMISSION
Three-speed synchromesh

WHEELBASE
134⅞ inches/342cm

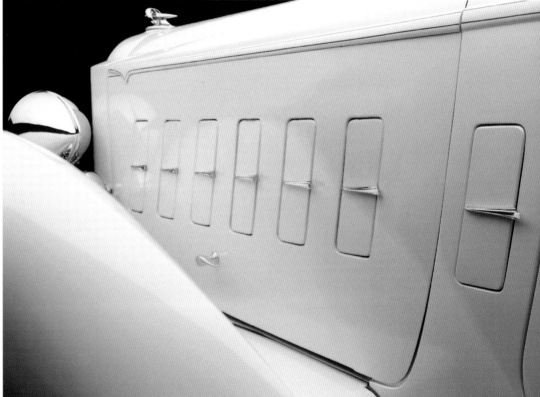

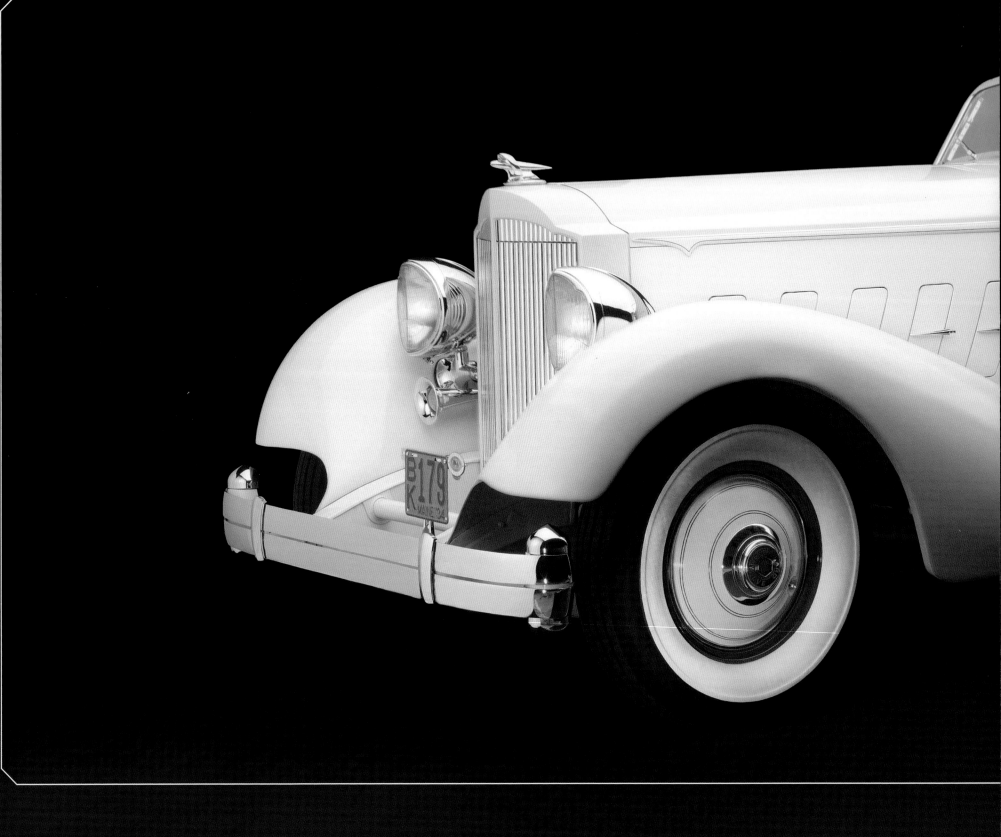

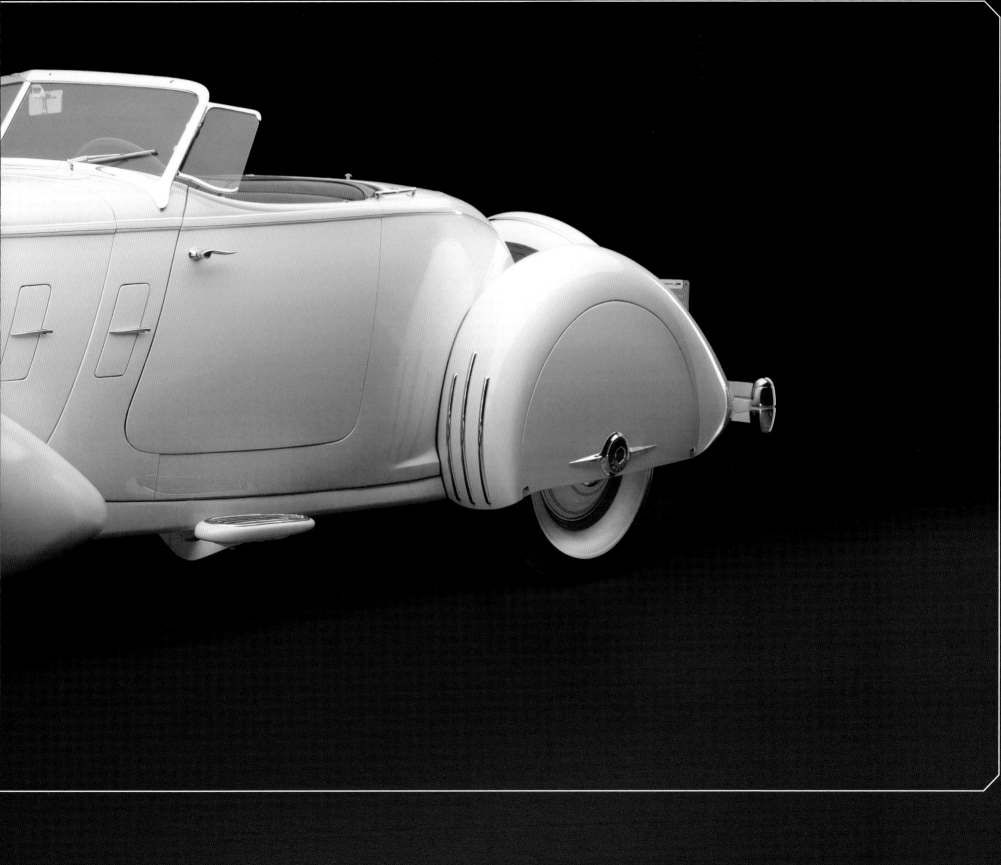

1935
Duesenberg JN Roadster

It's easy for the average person to complain about the rich and famous. But automotive enthusiasts must sometimes put such feelings aside when the resources of the wealthy create the automobiles that inhabit one's dreams.

The Duesenberg JN Roadster of actor Clark Gable is such a car. It was one of only 10 JNs built, of which only 4 had convertible coupe bodies. And what a body that was—a raked-back windshield gave a sense of speed to the otherwise upright center portion of the body, which was surrounded by gorgeously shaped fenders and coated in a creamy paint color that oozed smooth style, apropos for a top star like Gable.

It's not hard to picture Gable cruising the countryside with wife Carole Lombard in this car, and that is in fact what they often did. They undoubtedly enjoyed the car's cozy Cognac leather interior, which contrasted beautifully with its exterior color. Bohman & Schwartz modified the Rollston body at

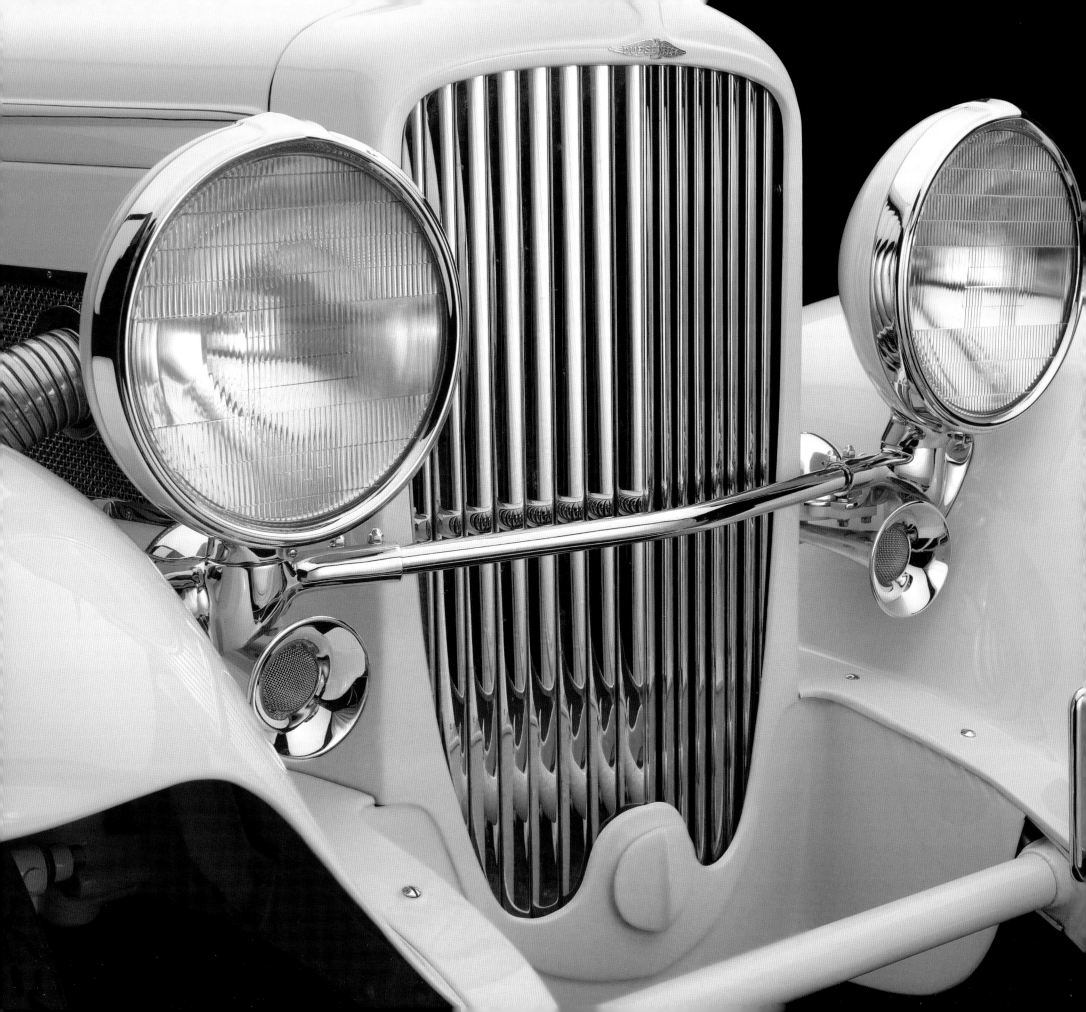

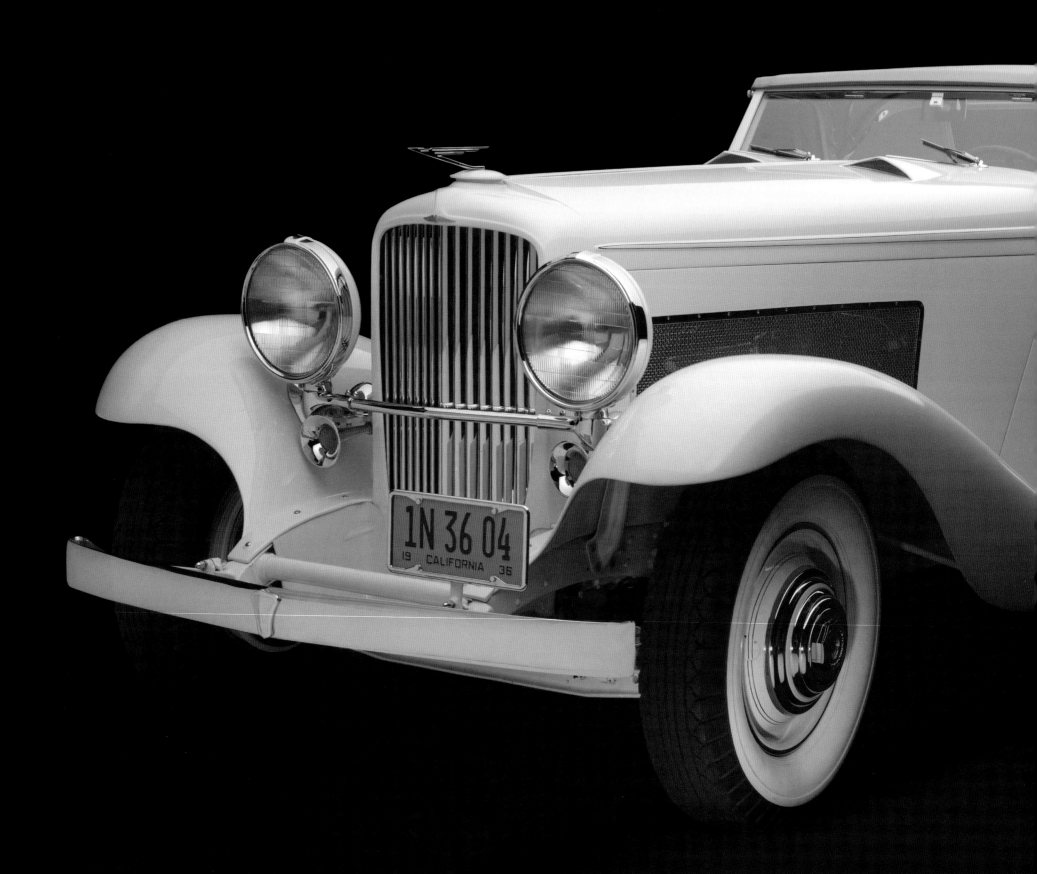

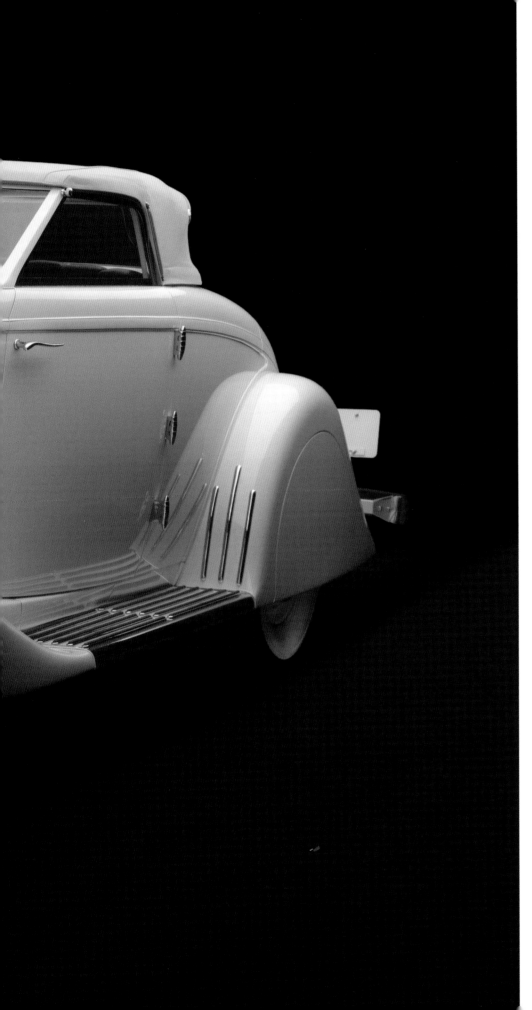

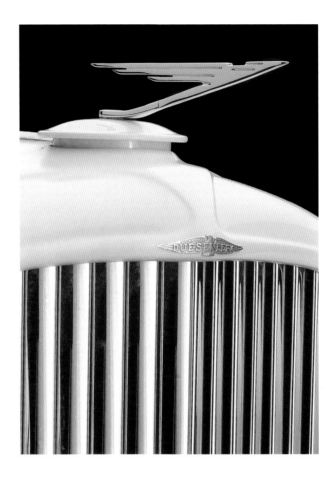

Gable's direction. These upgrades included rear fender spats and the dual rear-mounted spares—perhaps a questionable addition, at least in terms of style.

The JN was an offshoot of the Model J, introduced in 1935 as an update to a somewhat aging design. Along with a few other styling changes, the body was set on frame rails for a lower appearance. Duesenbergs always had powerful engines, and with the light Roadster body this JN, despite lacking the supercharger found on other Duesys, was a fast car.

The car was a Special Award Winner at the 2007 Pebble Beach Concours d'Elegance and also won Best of Show at Meadow Brook and Amelia Island. It was one of the top draws of the 2012 Gooding & Co. Pebble Beach auction, but it was not sold on the block.

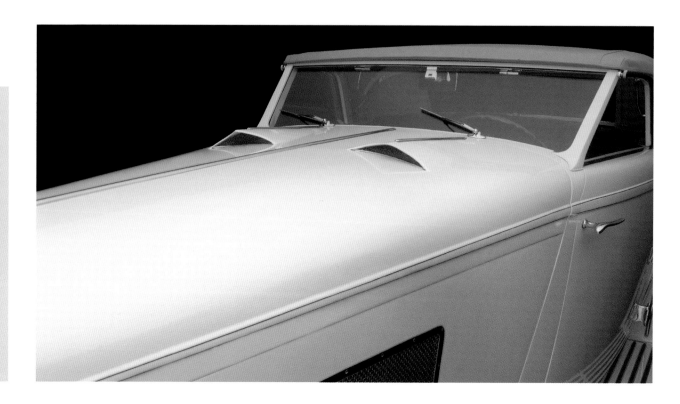

SPECIFICATIONS OF INTEREST

ENGINE
Straight eight, Lycoming manufacture

POWER
265 bhp

VALVETRAIN
DOHC, four valves per cylinder

WHEELS
17-inch/63cm diameter

TOP SPEED
Approximately 119 mph/190 kph

PRICE
$20,000

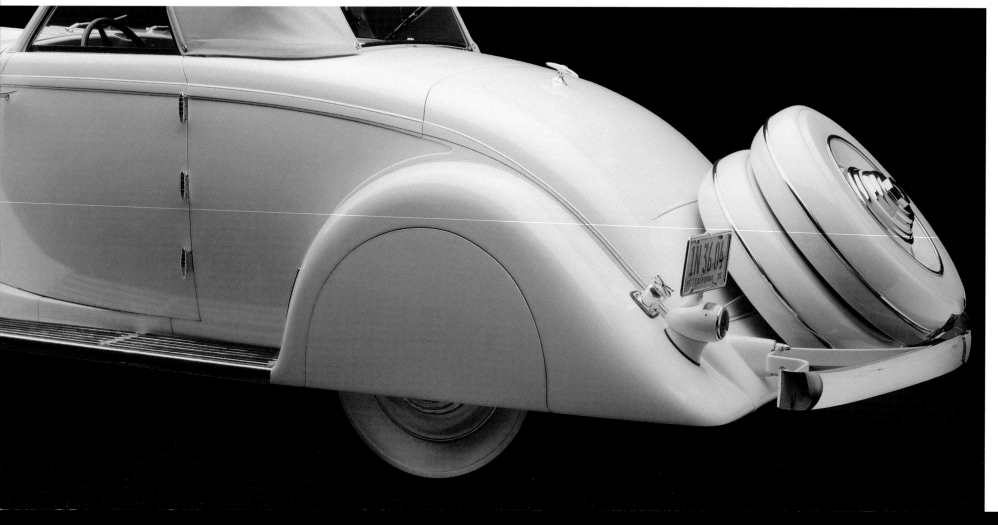

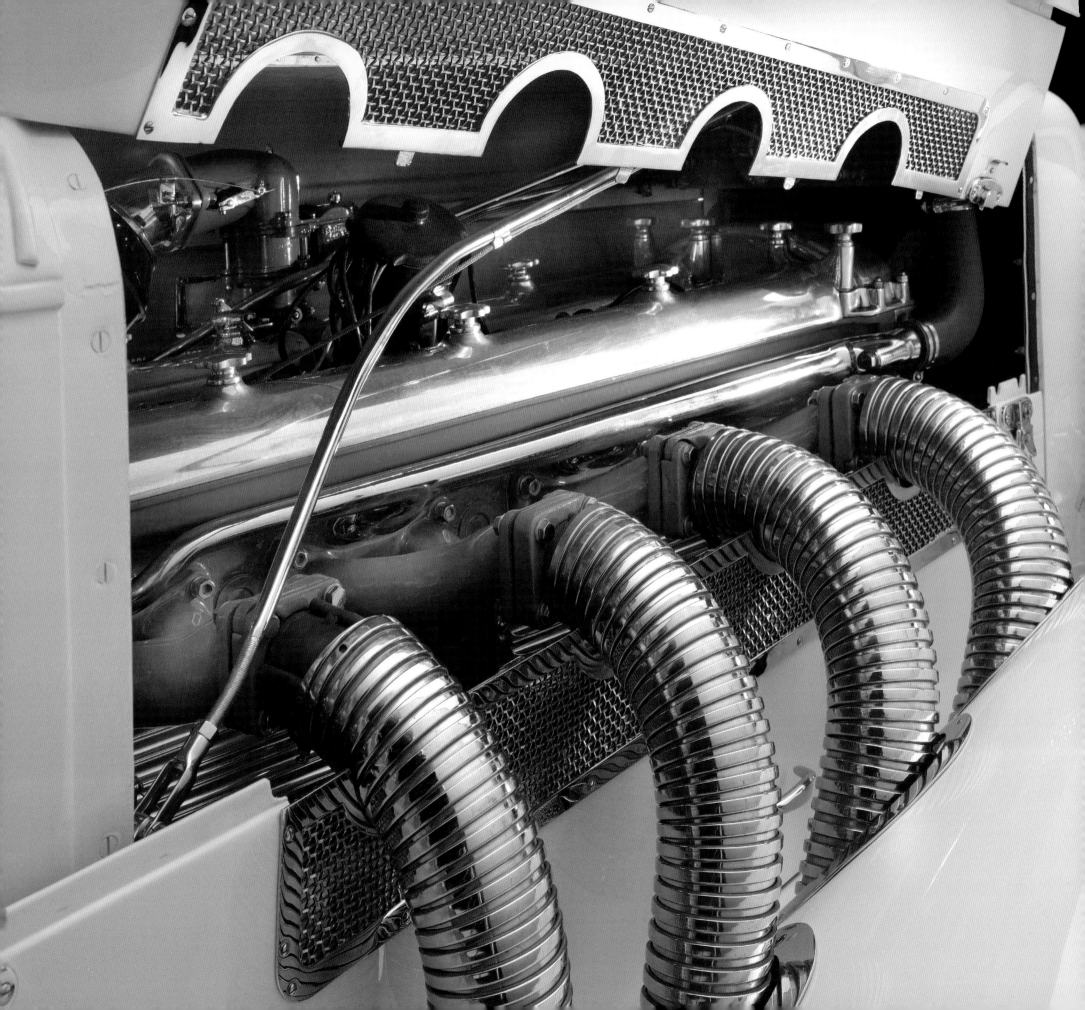

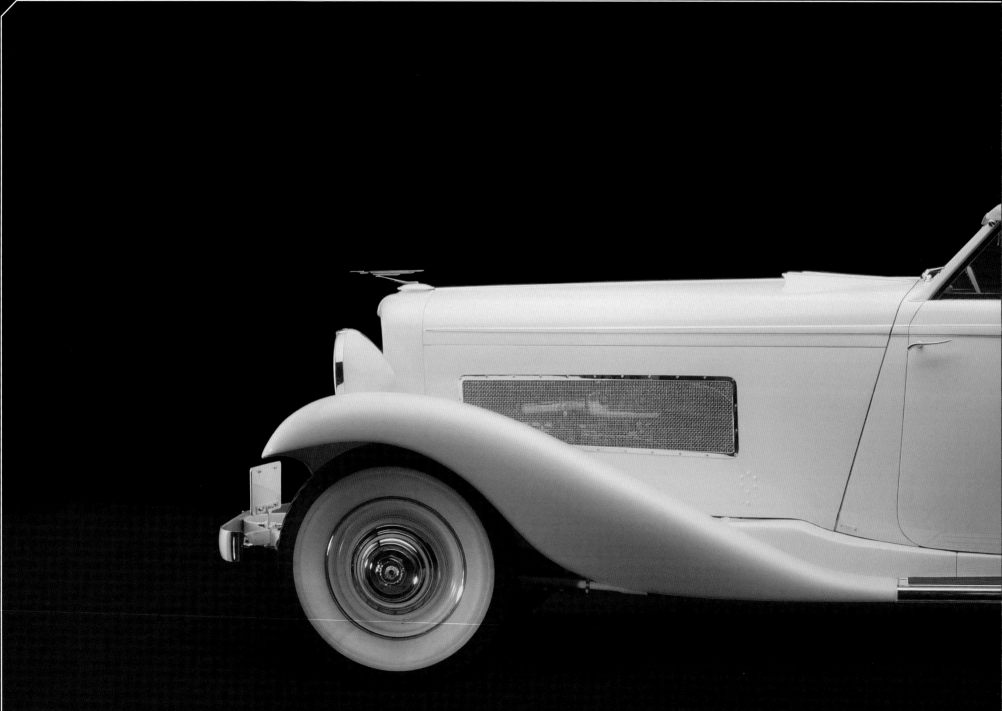

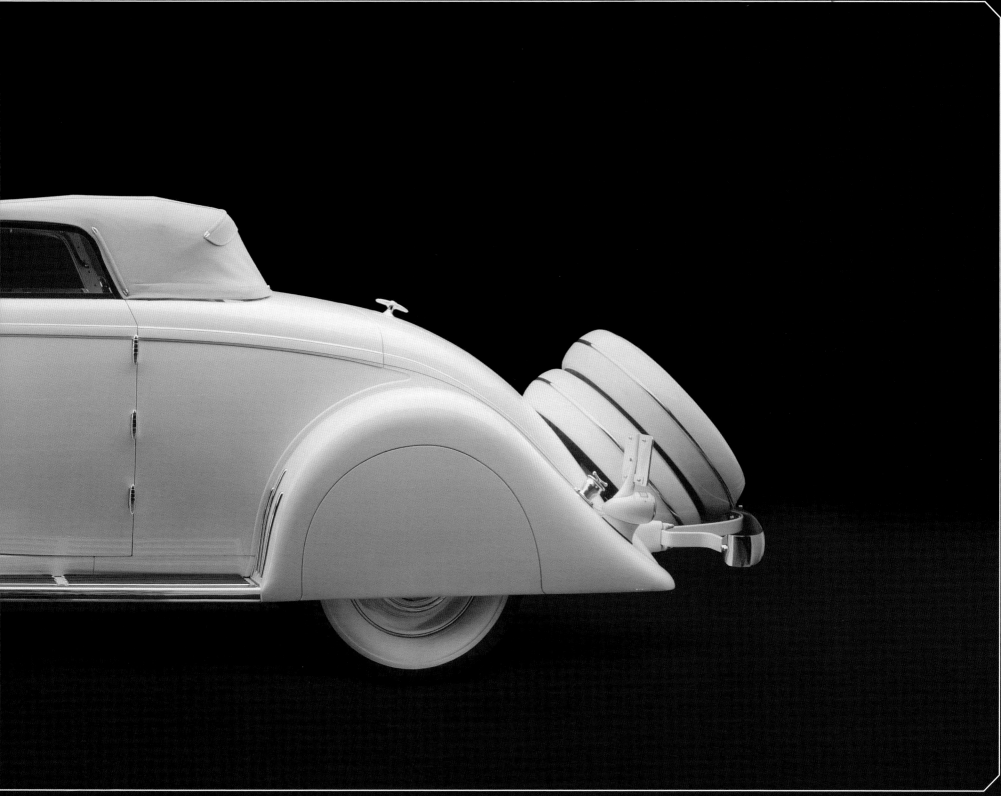

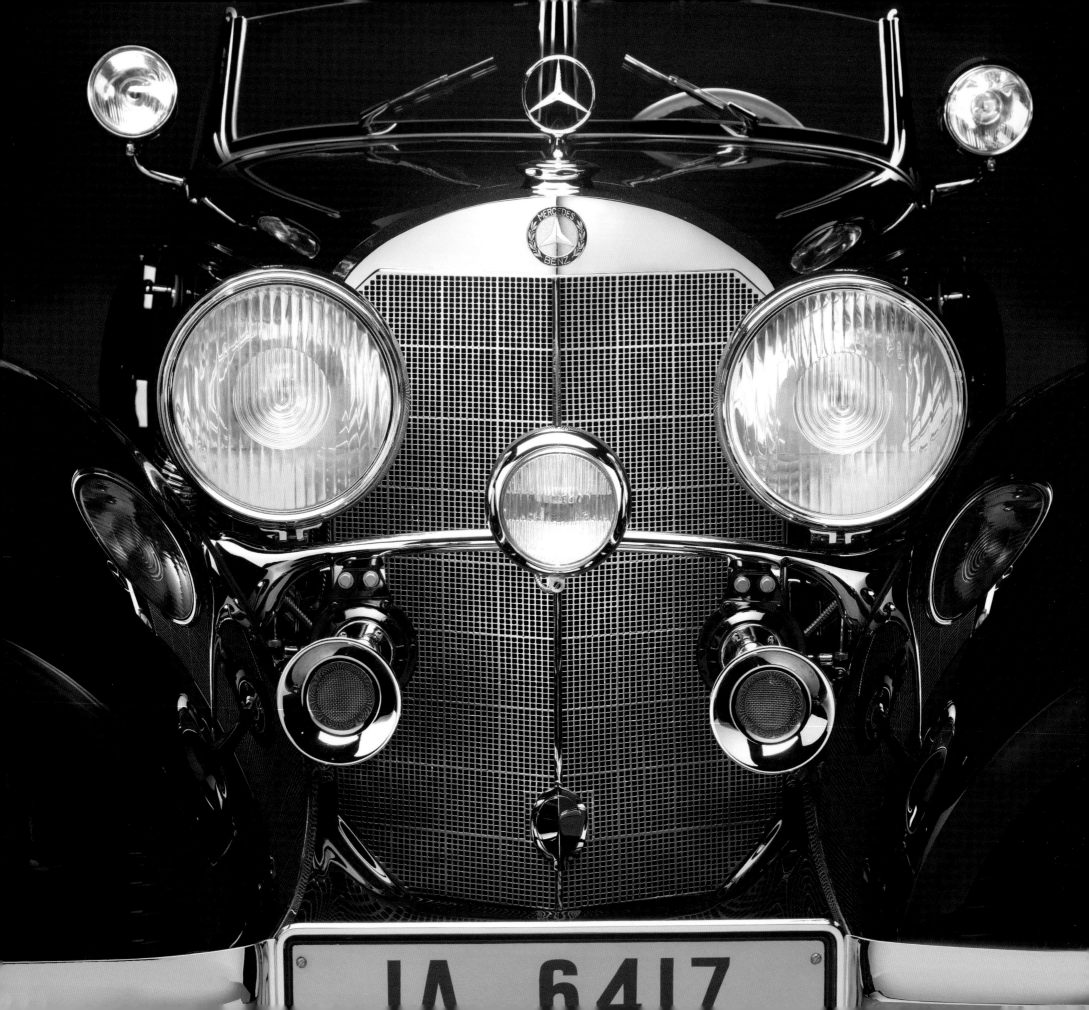

1936
Mercedes-Benz 540K
Special Roadster

◆

They say beauty is in the eye of the beholder, but is there a beholder unable to see the undeniable beauty of this elegant automobile? The Mercedes-Benz 540K chassis was the ultimate evolution of the company's prewar designs, and some people have even said it is Mercedes-Benz's masterwork.

The 540K evolved from the 380K (denoting a 3.8-liter displacement) introduced in 1932. The engine grew in size but retained the overhead-valve straight-eight configuration. The *K* stands for "kompressor," indicating a supercharged engine. The Roots-type supercharger only engages under full throttle, allowing sophisticated motorists to call on the extra power (and the supercharger's accompanying whine) only when necessary.

The 540K incorporates independent suspension at all four corners, using a coil-sprung swing axle at the rear. Large, hydraulically assisted drum brakes are another advanced feature for the period. At more than 5,000 pounds, it is not a sports car, but with its sophisticated suspension and powerful engine, it is a comfortable, capable car.

What sets this car apart is its body. The 540K chassis was fitted with a variety of bodies, from limousines to cabriolets to coupes. The Special Roadster body was designed by Hermann-Ahrens, and the body was built by Mercedes-Benz's in-house coachbuilder, Karosserie Sindelfingen.

This 17-foot-long two-seater (leaving aside a rumble seat hidden in the back) is incredibly well proportioned. The upright, triangular grille announces a long, straight hood, leading to a split and laid-back windshield. Behind the cockpit, the car slopes away at just the right degree, joining the rear fenders as they complete their sweep up from behind the doors.

Only 26 Special Roadsters were built, and only by special order. One such order was placed by the Prussian von Krieger family, an aristocratic clan whose crest adorns the driver's door of the car to this day. Henning von Kreiger was the first owner, followed by his

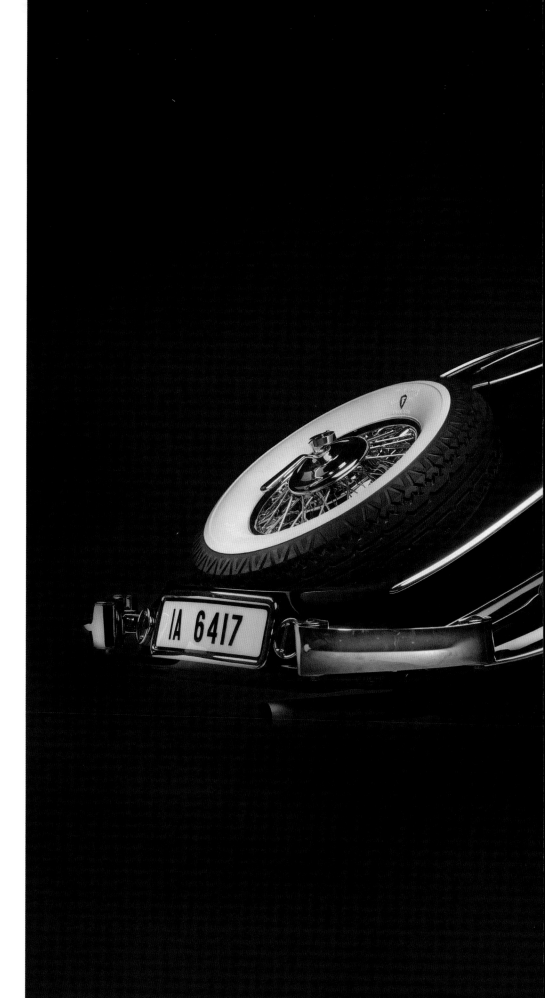

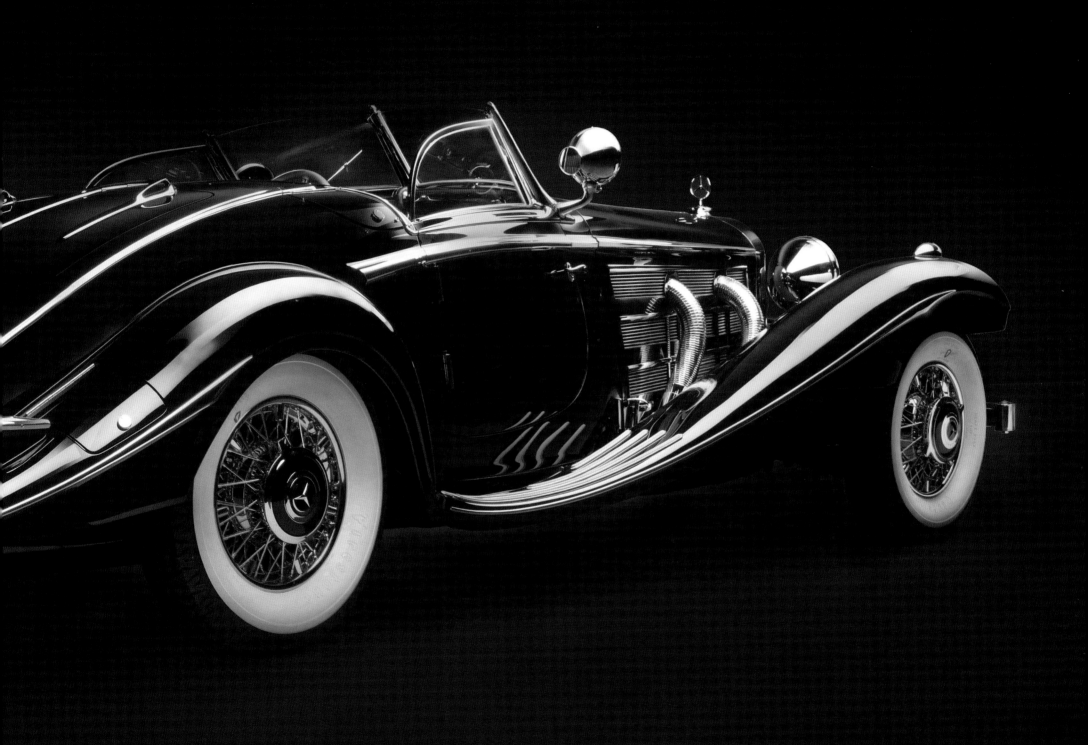

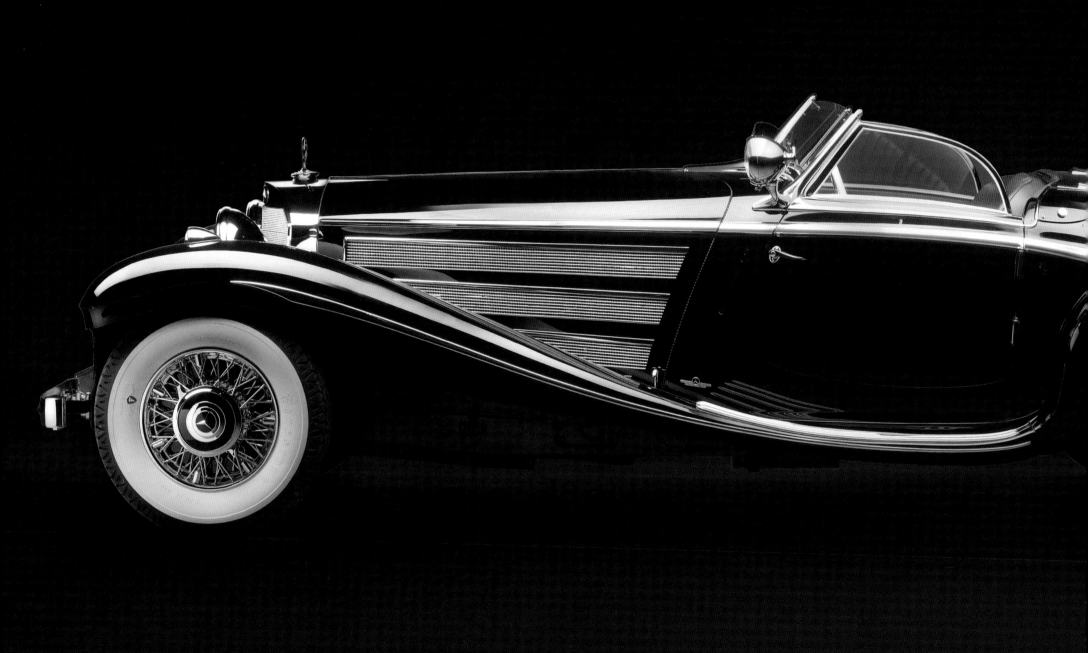

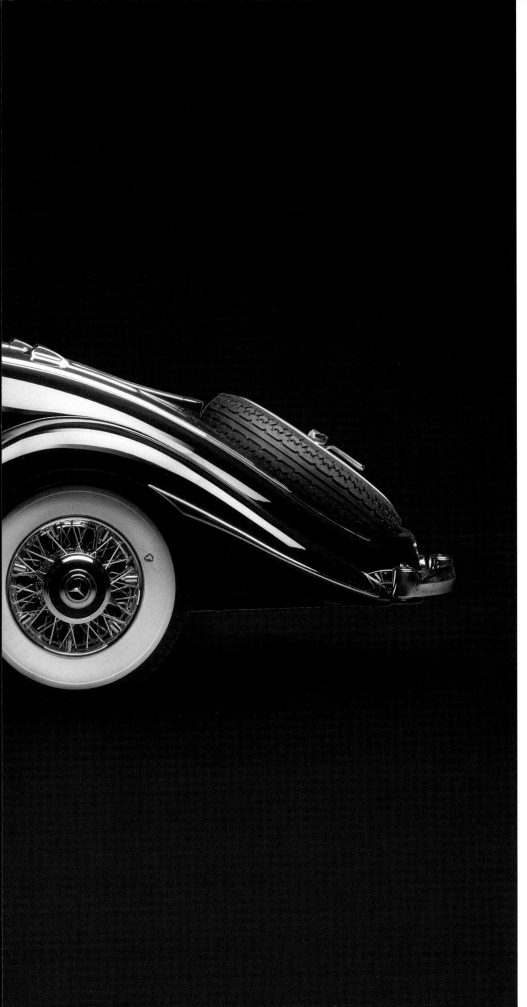

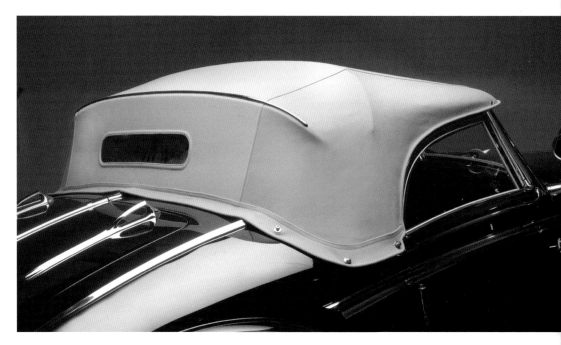

sister, Gisela. Baroness von Krieger was a leading light in European high society during the prewar years and lived a life of privilege, embodied in the sweeping lines and hand-built finishing of her 540K Special Roadster.

The von Kreiger family fled the Nazis during the war, but they didn't leave this special car behind. The 540K was shipped to Switzerland in 1942 for safekeeping, and when the Baroness emigrated to the United States after the war, the car was shipped over by boat and kept in Greenwich, Connecticut. Von Kreiger returned to Europe in later years, but the car remained in storage and eventually passed to her heirs. When the car finally emerged, the ashtray still held cigarette butts with Gisela's lipstick on them and her silk glove was found under the seat.

The restored car won the prewar Mercedes-Benz class at the 2004 Pebble Beach Concours d'Elegance. In 2012, after being repainted in as-delivered black, it was auctioned by Gooding & Co. for $11.77 million including buyer's premium at its Pebble Beach event.

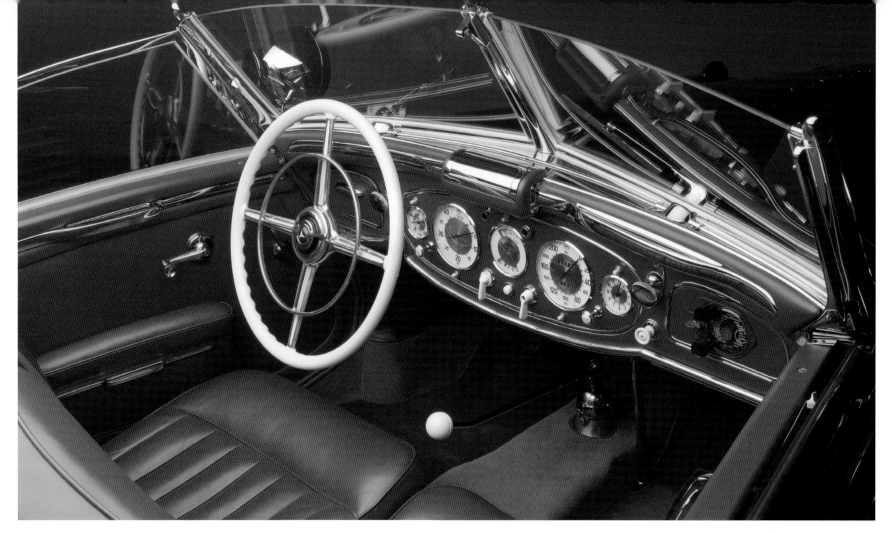

SPECIFICATIONS OF INTEREST

ENGINE CONSTRUCTION
Cast-iron monobloc (head and block one piece)

POWER
180 bhp

TRANSMISSION
Four-speed, automatic top two gears

LENGTH
202.8 inches/515cm

WHEELBASE
129.5 inches/329cm

TOP SPEED
115 mph/184 kph

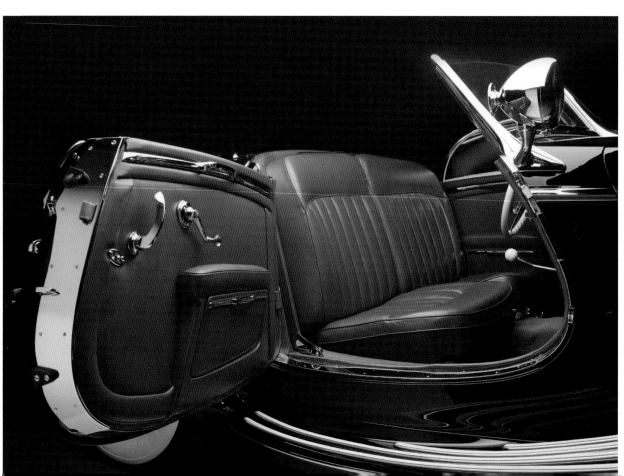

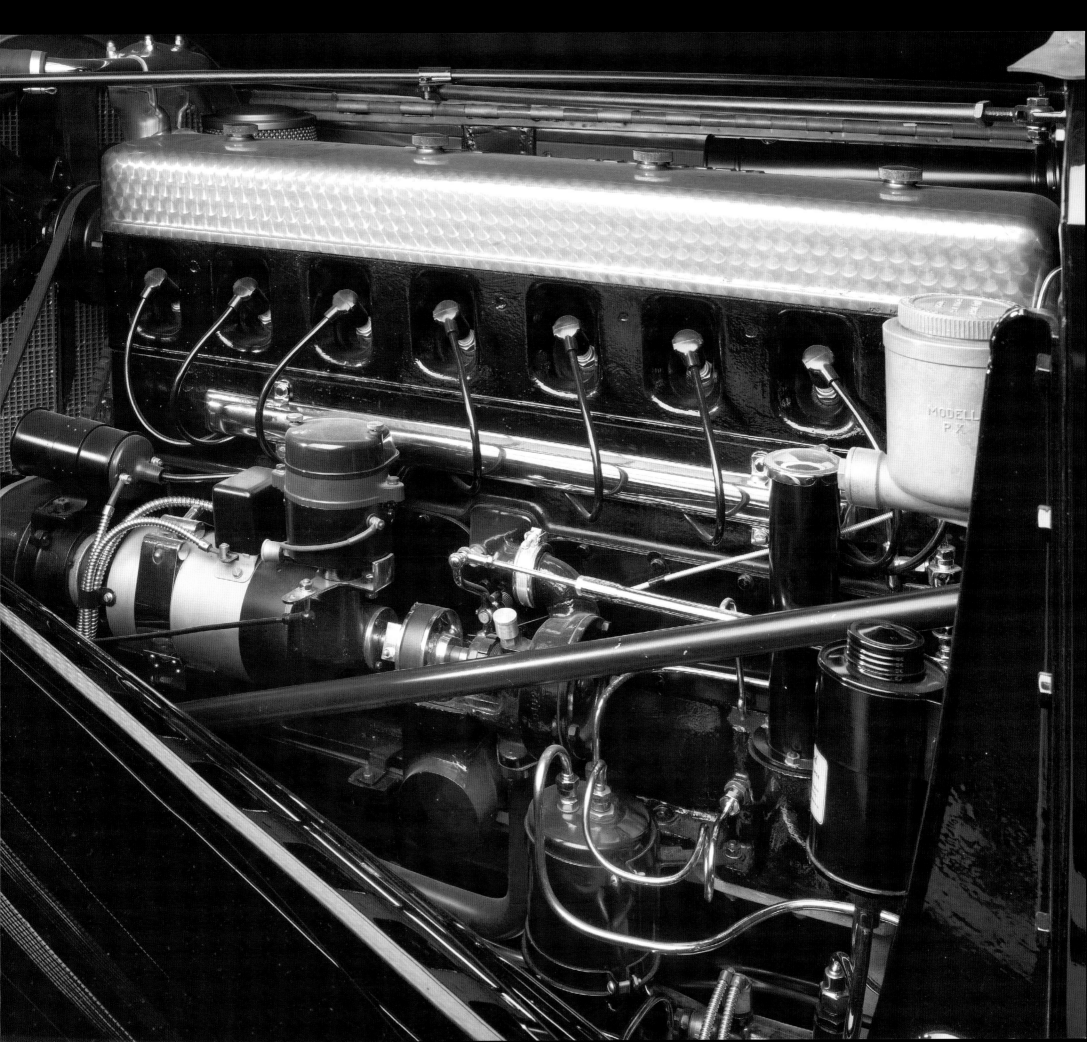

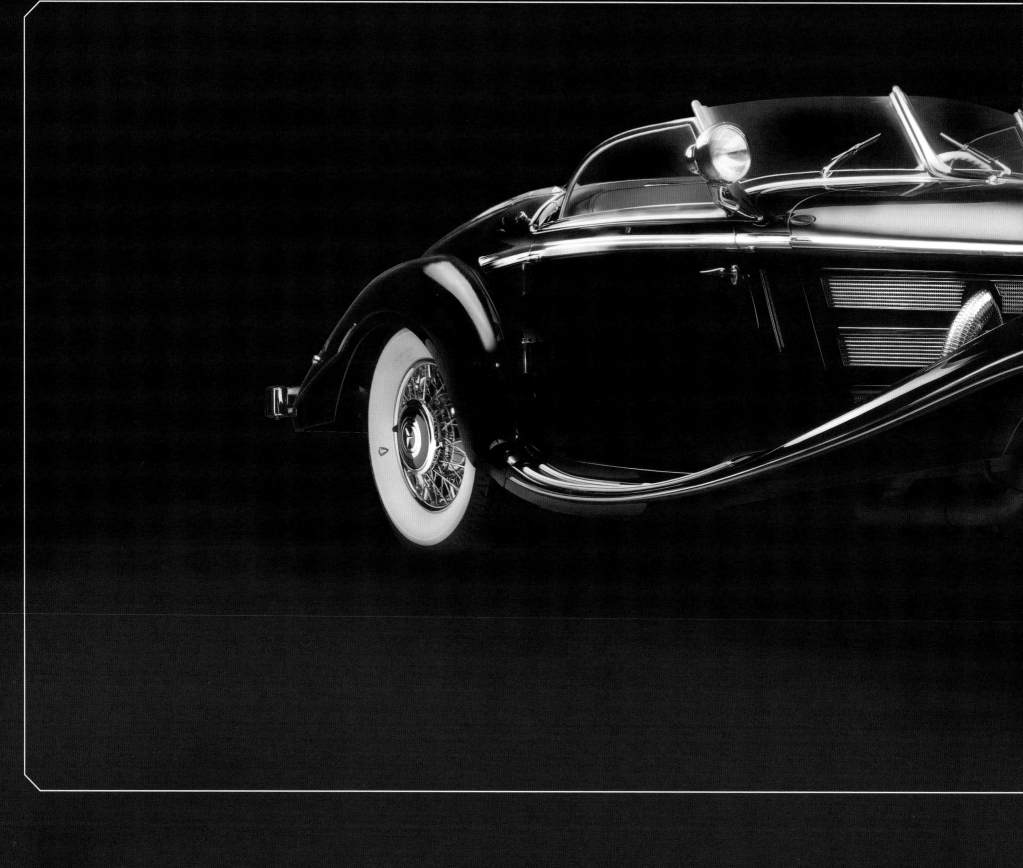

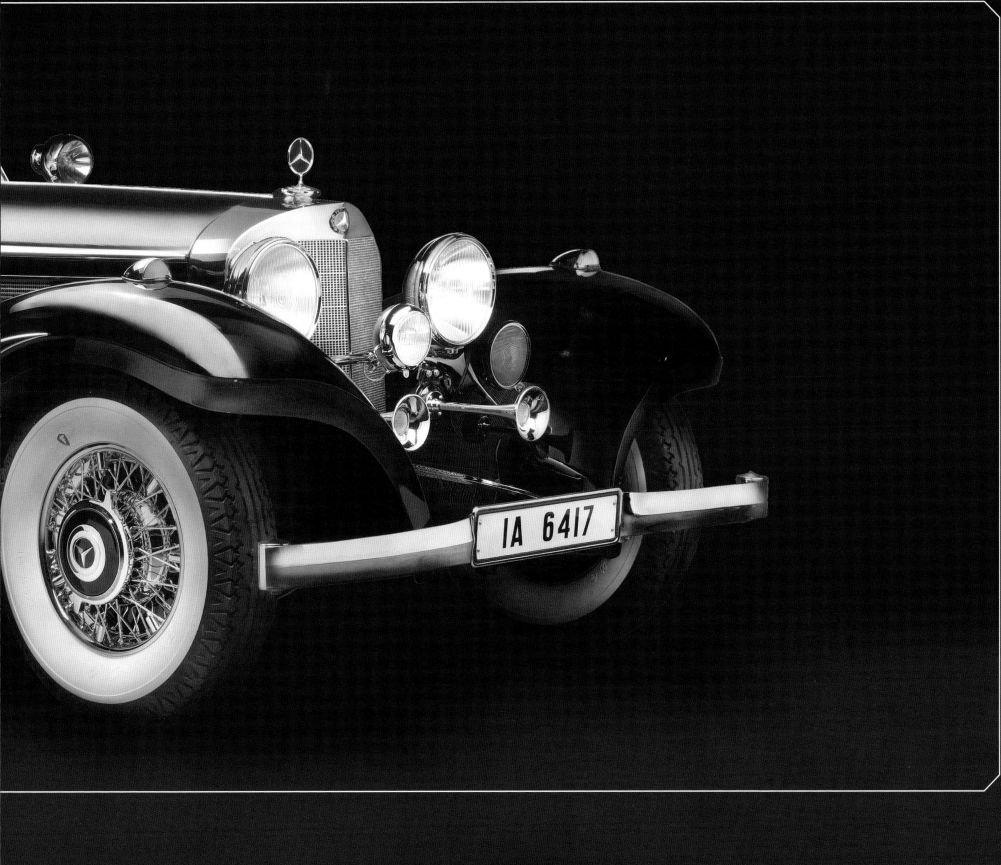

Delahaye 135MS
Roadster

◆

At first glance this car might seem to be merely a topless version of the Delahaye coupe (chassis number 46756) found elsewhere in this book. And, in some respects it is, in that it is built on a "competition" Delahaye chassis, and was styled and bodied by Figoni & Falaschi. It repeated many of the chrome styling accents that had worked so well on the coupe.

This roadster was built for the 1937 Paris Auto Salon (the coupe debuted there in 1936) and featured several new features that Figoni and Falaschi subsequently patented. These included the front fender design; the crank-down windshield and folding convertible top, which disappeared into the body; and seats with a light, tubular construction that were suitable for competition. Other significant highlights included a centrally

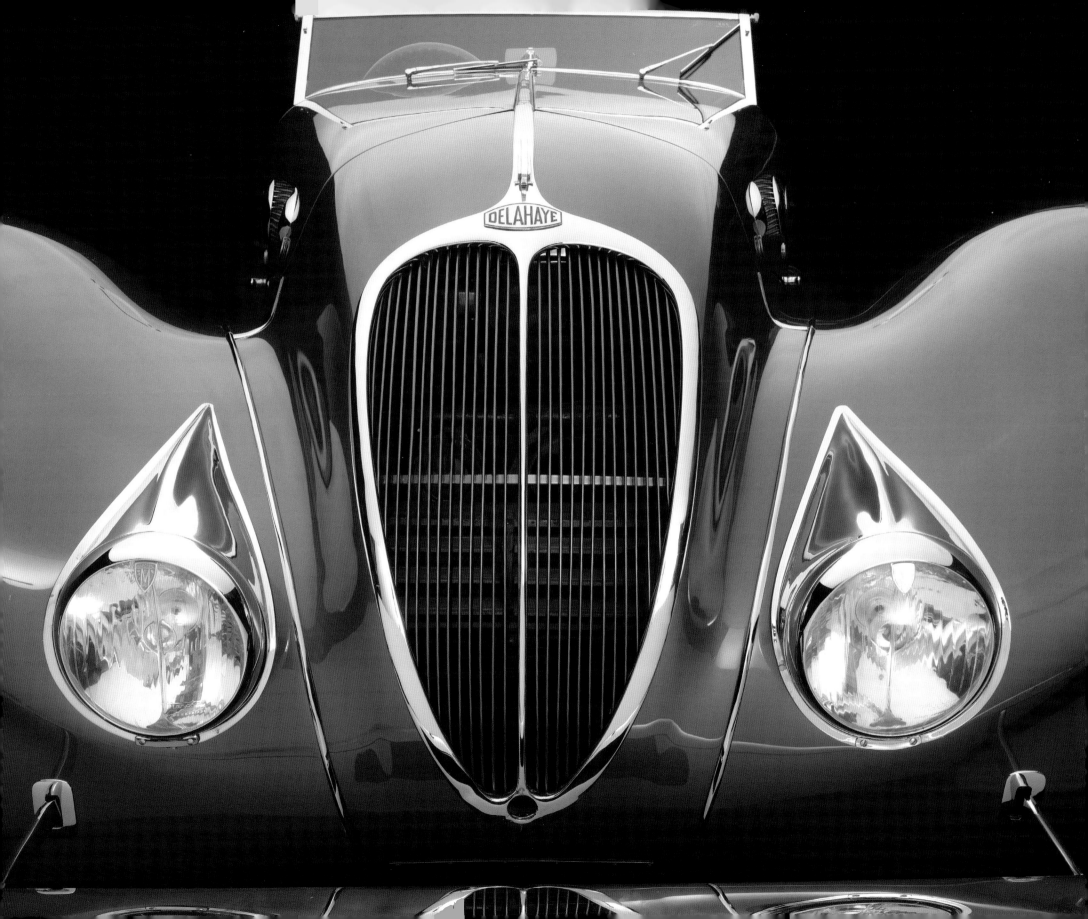

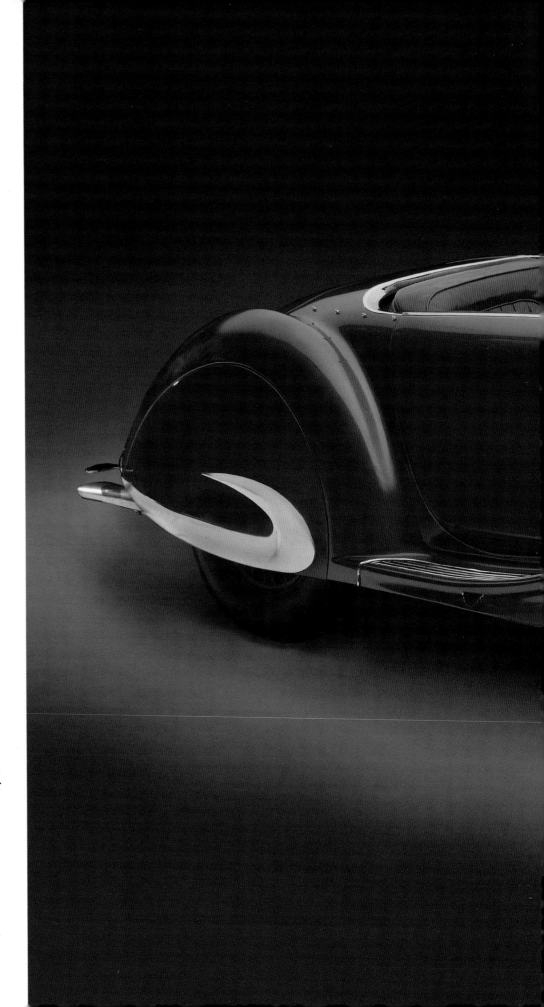

mounted front headlight and red leather interior appointments and matching carpets provided by Hermès, the French luxury goods purveyor.

Like chassis number 46756, this roadster has quite a history to tell. First, it was purchased by the Brazilian ambassador to France, who returned the car to F&F to have the central headlight removed and to add bumpers. After World War II began, the car was sold to a Frenchman, who attempted to hide it. He was unsuccessful, but fortunately that was not the end for this beautiful roadster. An Italian officer spirited the car away to Italy, where it turned up again in 1947. The car was returned to Figoni's workshop, where it was restored.

The car passed through two more owners in France, and was painted blue, before it was sold to current owner Miles Collier of Naples, Florida, in 2001. At that point it had been driven less than 5,000 miles, but its age dictated a mechanical refresh and a repaint. It remains in the Collier Collection today.

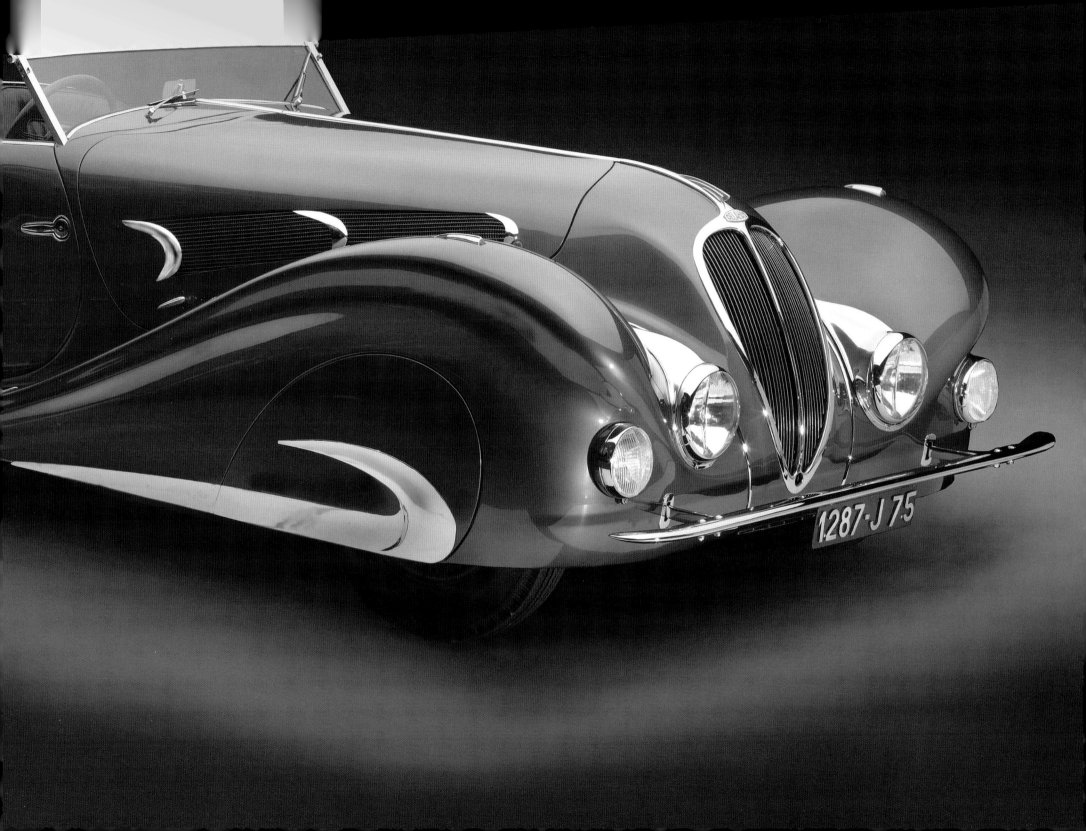

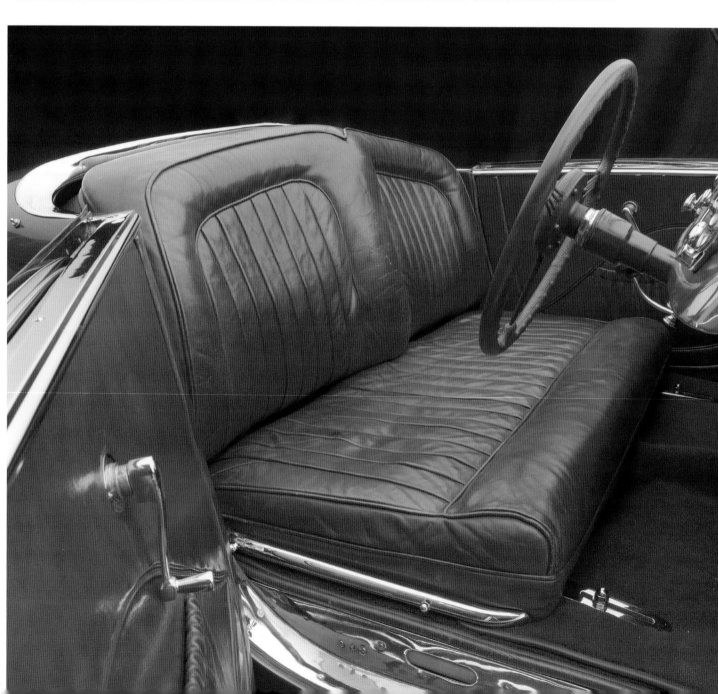

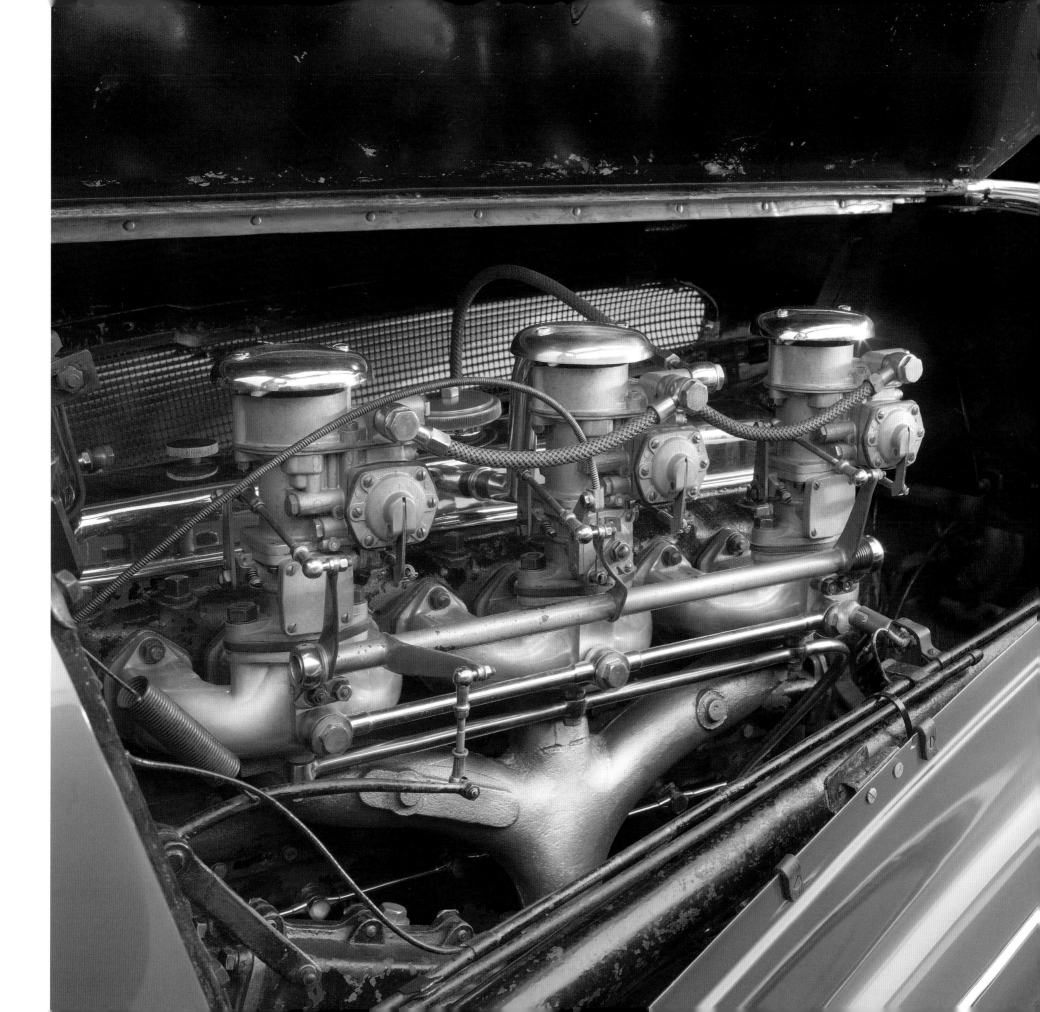

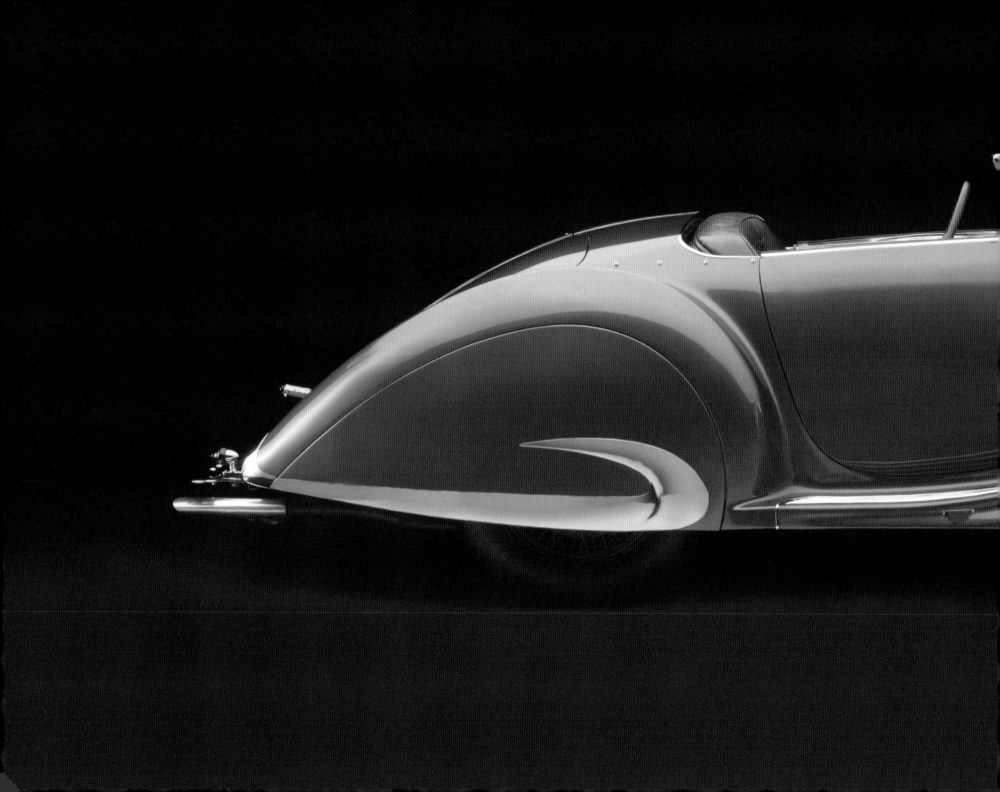

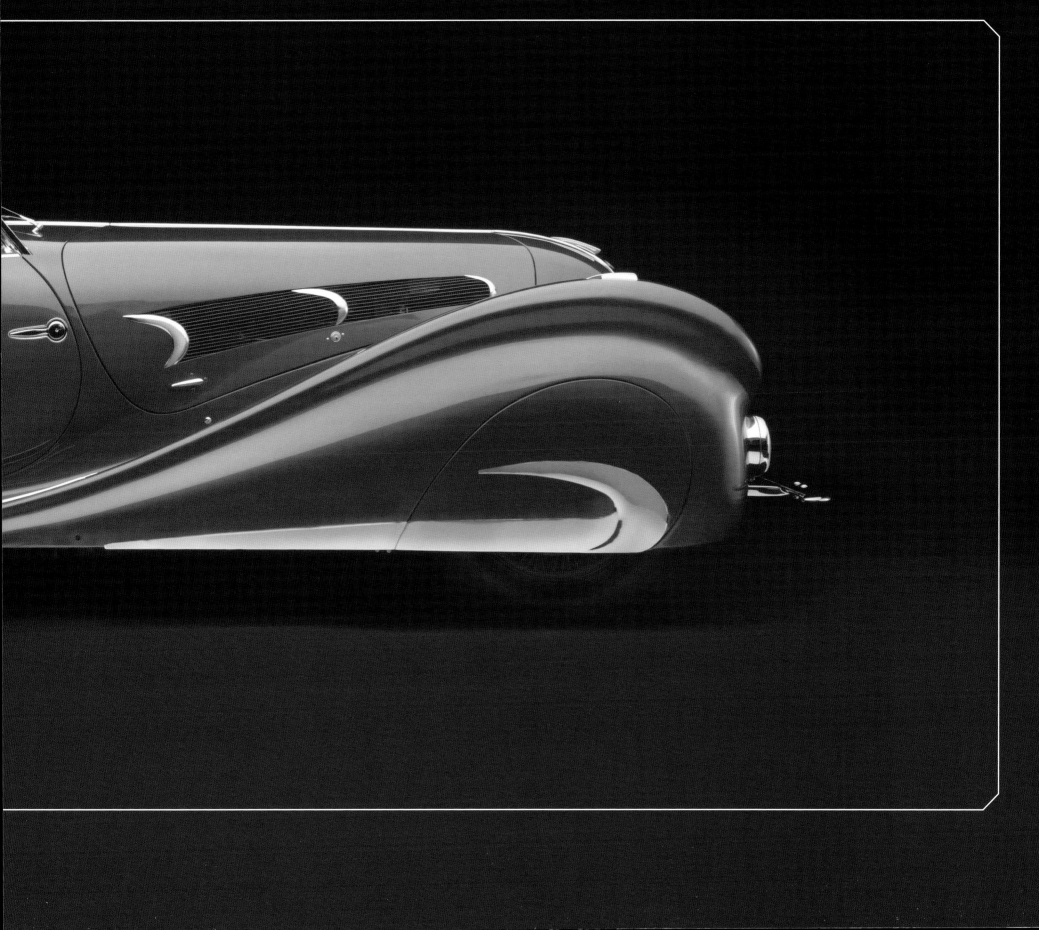

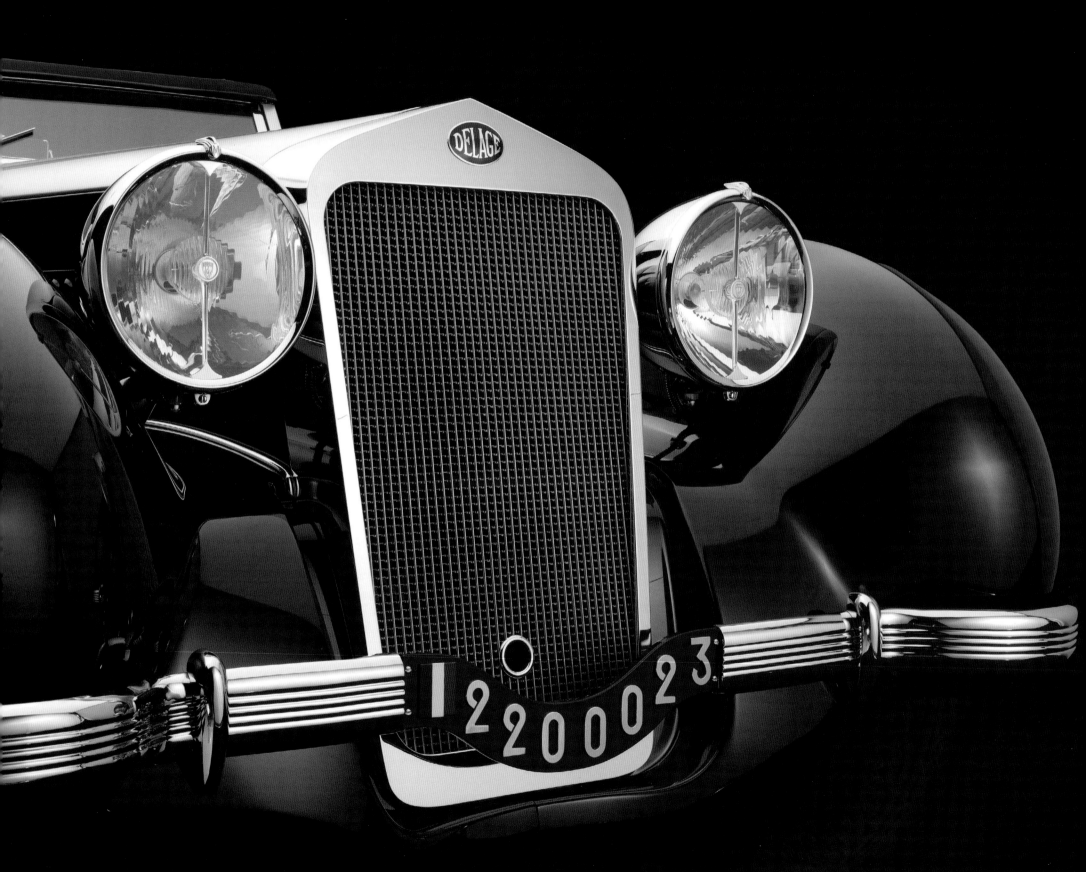

1939
Delage D8-120S
Cabriolet

◆

When a car's doors open in an unusual way, it can cause a level of fascination among onlookers. In some cases this appeal is completely out of proportion with that of the vehicle itself (Bricklin SV-1, I'm looking at you). That is not the case with this stunning Delage Cabriolet and its unique—and patented—doors. This D8-120S was one of only a few of the Saoutchik-bodied Delages to receive these special doors, which used a pantograph mechanism to extend the door panels away from the body. As doors opened, they moved parallel to the body side and slightly to the rear, leaving the entrance to the front seat completely unobstructed. Aside from the doors, according to French car expert Richard Adatto, this car was much more subdued than the typically flamboyant Saoutchik bodywork.

This particular car was one of the last examples of about 56 Delage D8-120S cars built, the S denoting an updated, lower, and more sporting chassis than the 120 chassis introduced in 1936. This car was commissioned by the French government to be displayed at the 1939 Paris Auto Salon. The timing wasn't very good—the show was canceled ahead of the fighting with Germany that began in September. The car was hidden before the German invasion but reemerged after the war, again in government service to be driven in parades and for other official duties.

The car was then sold in 1949 to a manufacturer of travel trailers, who added a hitch and photographed the car all over Europe with his trailers. Later the car was restored to its original configuration and eventually sold to John W. Rich for his Pennsylvania museum in 2011. At the 2012 Pebble Beach Concours d'Elegance it won the Elegance in Motion Trophy and the Most Elegant Convertible award.

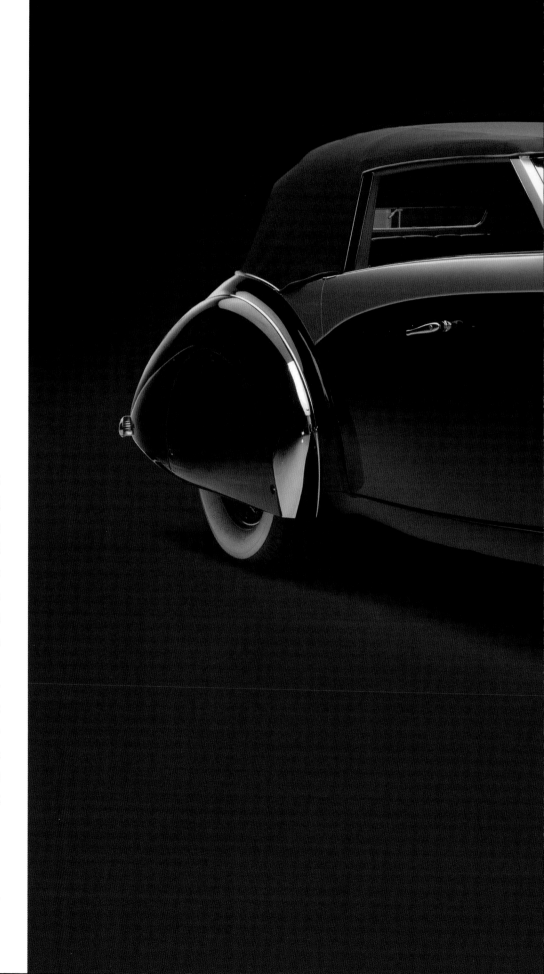

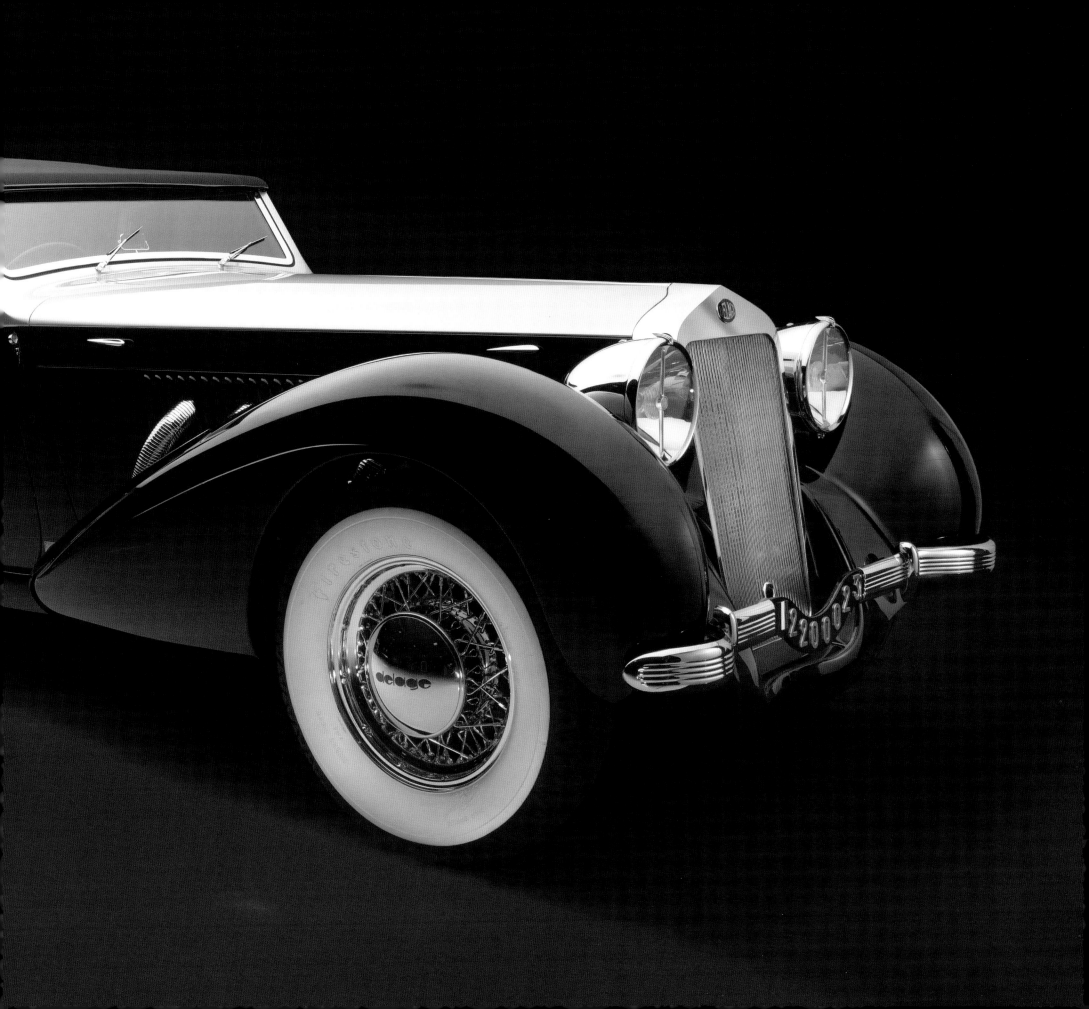

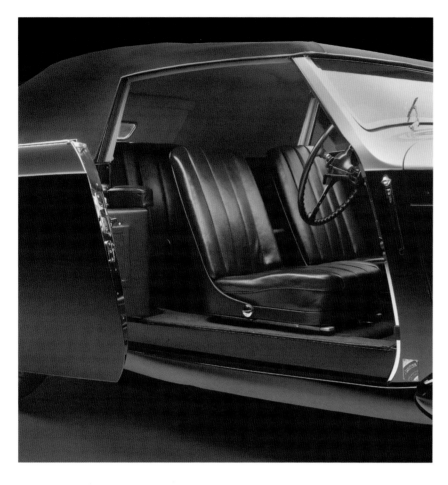

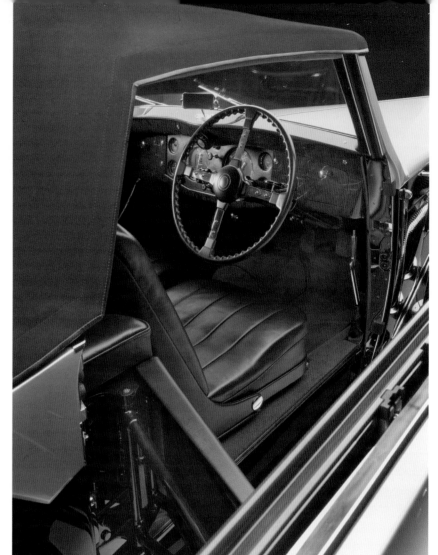

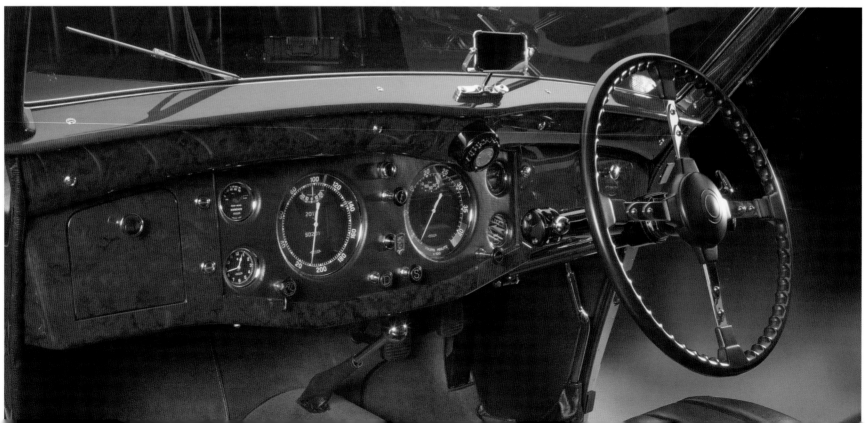

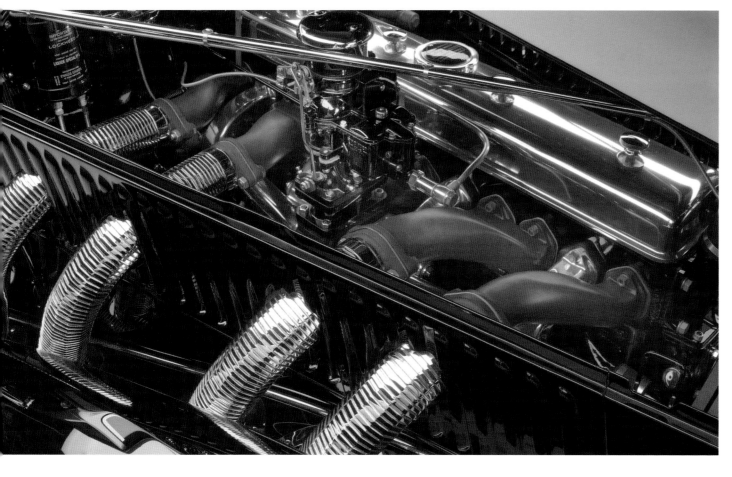

SPECIFICATIONS OF INTEREST

CHASSIS NUMBER
51976

ENGINE
Straight eight, 287ci/4.7 liters

POWER
120 bhp at 4,200 rpm

TORQUE
181 lbs-ft at 2,000 rpm

TRANSMISSION
Cotal preselector four-speed manual

WHEELBASE
130 inches/330cm

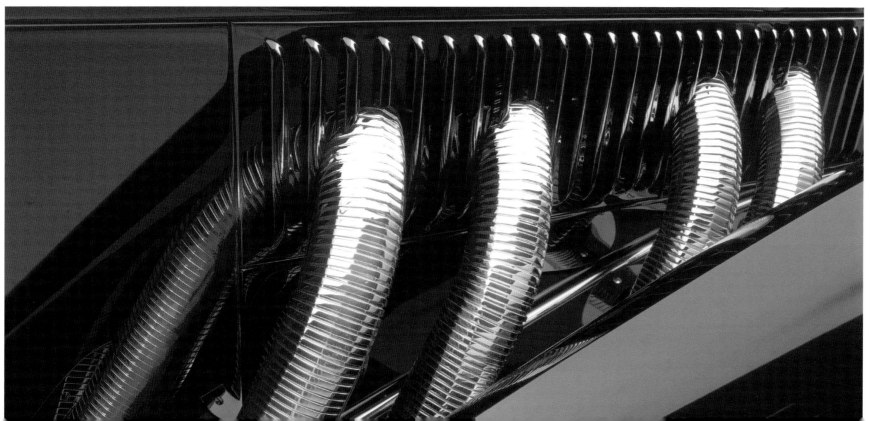

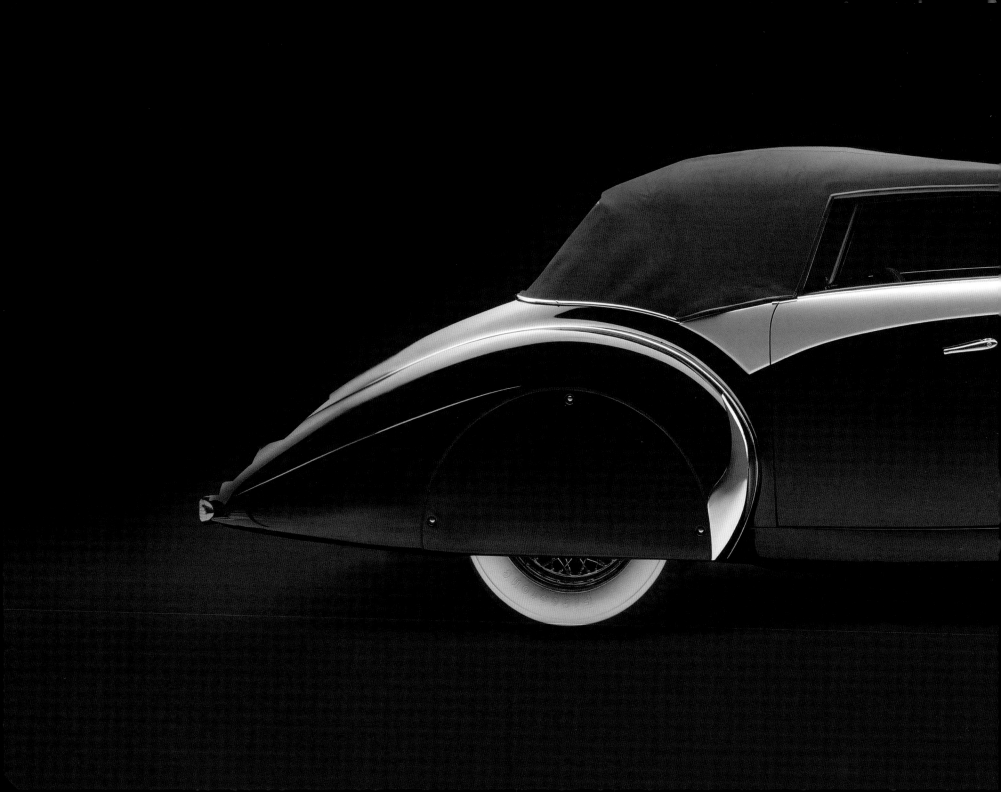

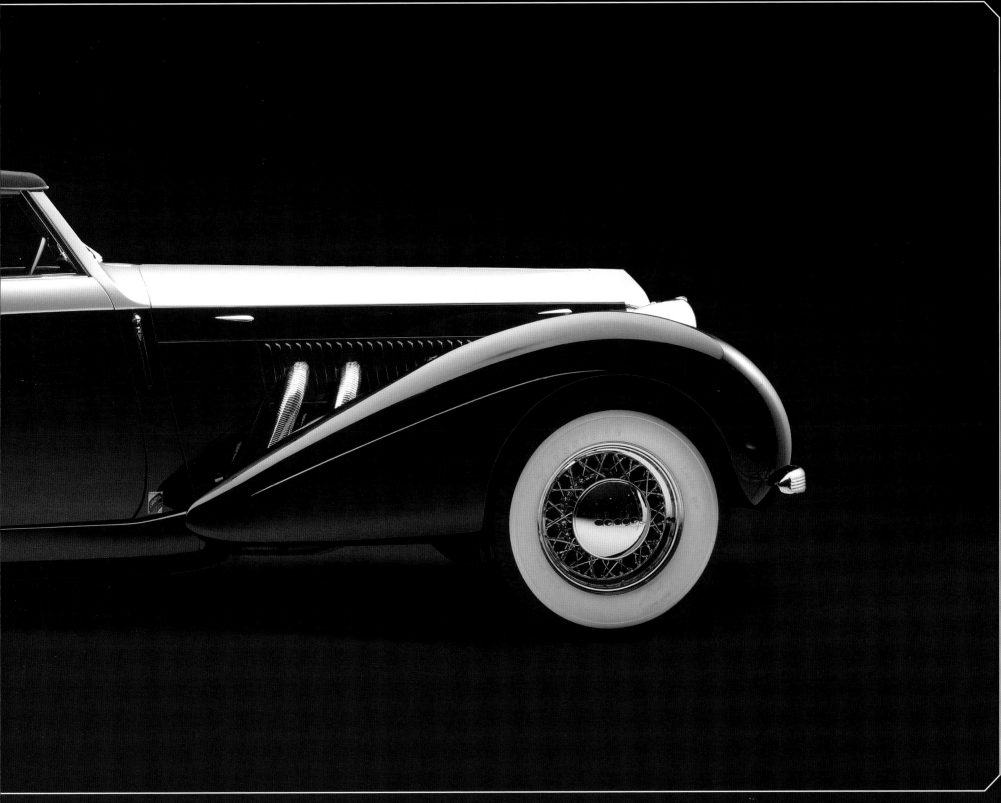

Coupes

———◆———

I'll just come out and say it: two-door cars rarely make sense. Unless a vehicle is so short that it will only accommodate one door on each side, a car is almost always more practical, more useful—in short, better at being a car— with four doors.

Truth number two is that two-door cars are usually better-looking than four-door cars, and this is the reason two-door cars have always been built. A two-door is just a much better way to make a statement of style, elegance, and power with an automobile. Look at the 1936 Delahaye 135M and try to imagine making such a stunning car as a four-door; it just can't be done. Take the massive 1933 Cadillac Aerodynamic

Coupe—such an audaciously large car with only two doors simply screams that its driver is well beyond having to worry about practical matters when selecting his automobile.

The two-door cars in this section showcase the practice of coachbuilding prevalent in the early 20th century, when a customer would choose a manufacturer's chassis, then have it equipped to his or her exact specifications, sometimes by that company or by another outside firm. Cars built by a carrosserie, or coachbuilder, are among the most spectacular and unique automobiles ever built, and we're lucky to be able to show you some of these cars in gorgeous detail in the pages to follow.

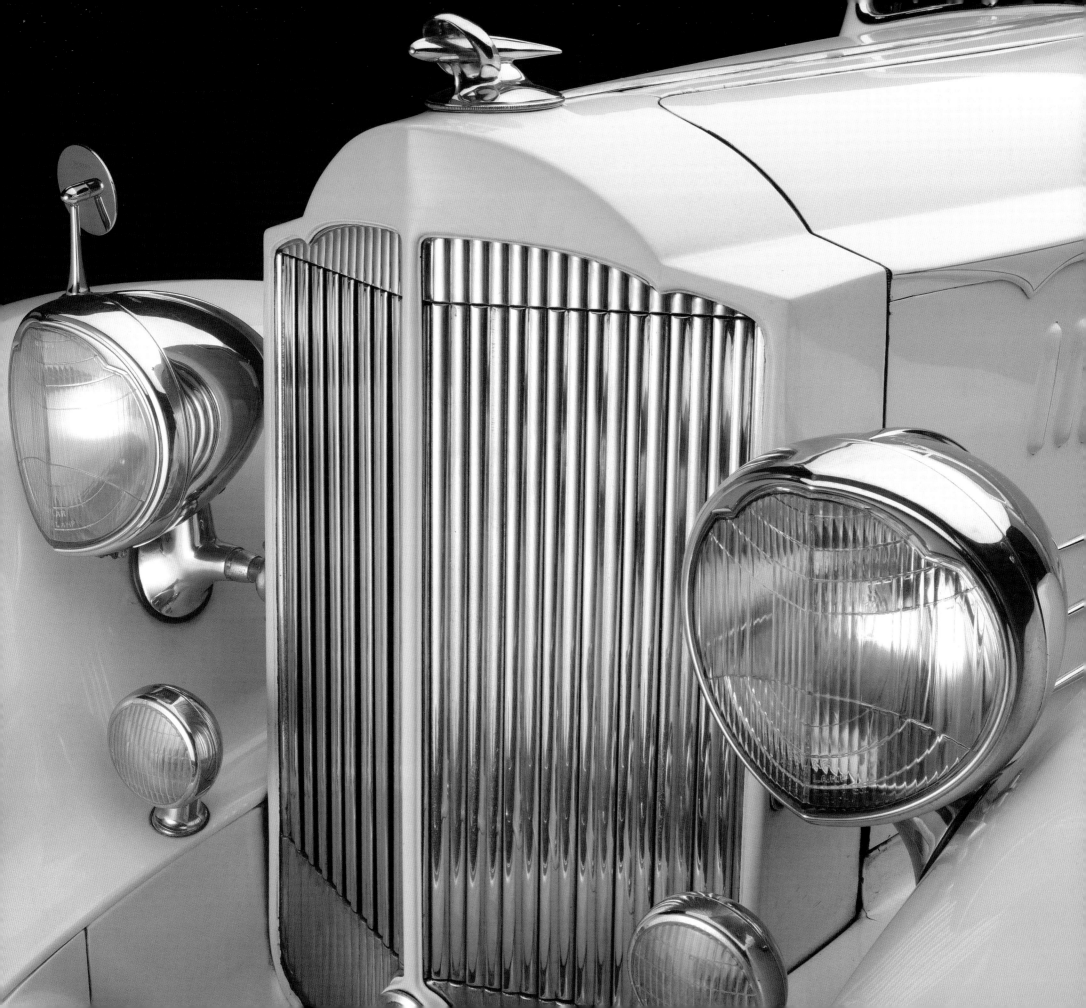

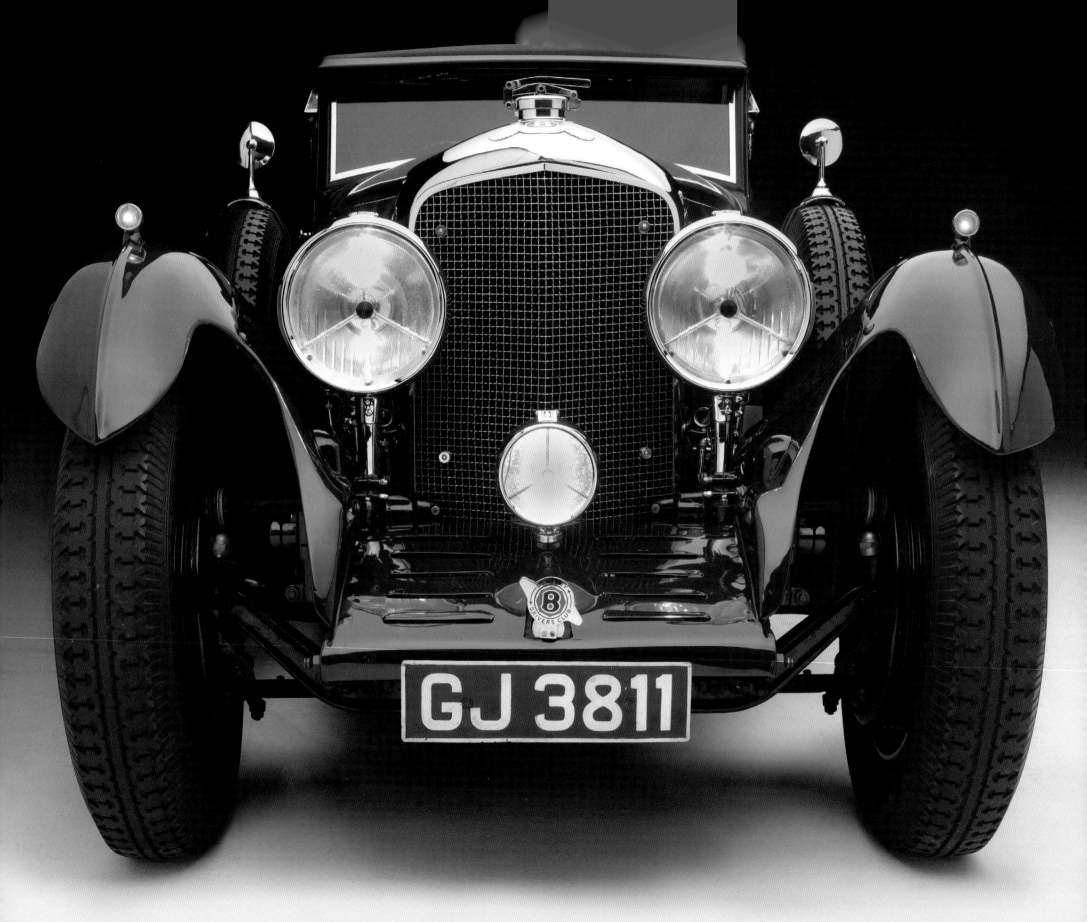

1930
Bentley Speed Six
Blue Train Special

◆

Bentley enjoyed a brief, brilliant tenure as a manufacturer of topflight performance automobiles, but it is this period of time that continues to anchor the allure of the Bentley brand today. This period of glory lasted just over a decade, from when the first Bentley automobiles were produced in 1919 until the firm entered receivership in 1931 and Rolls Royce purchased its assets. During that time, Bentley's brawny and reliable machines managed to win the 24 Hours of Le Mans five times.

Besides its founders Walter Owen and Henry Bentley, the South African mining millionaire Joel Woolf Barnato brought much-needed cash to the fledgling car company, and became one of Bentley's most important figureheads. Barnato also

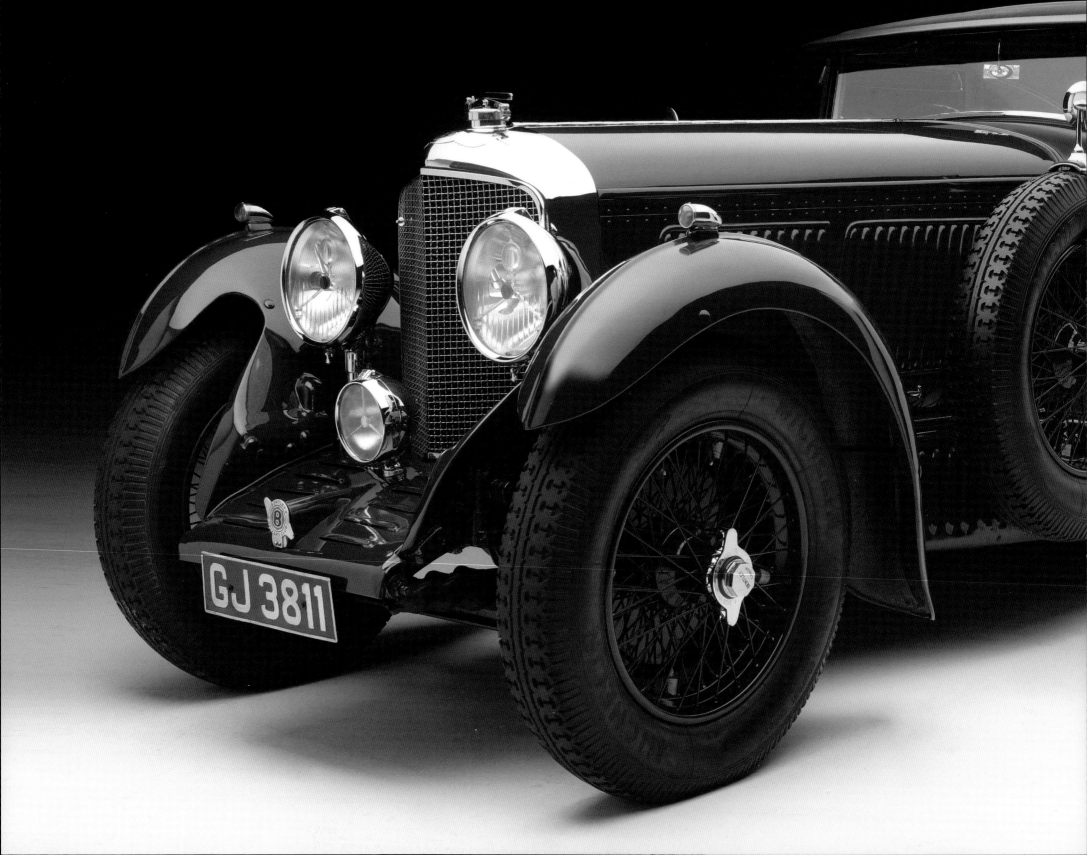

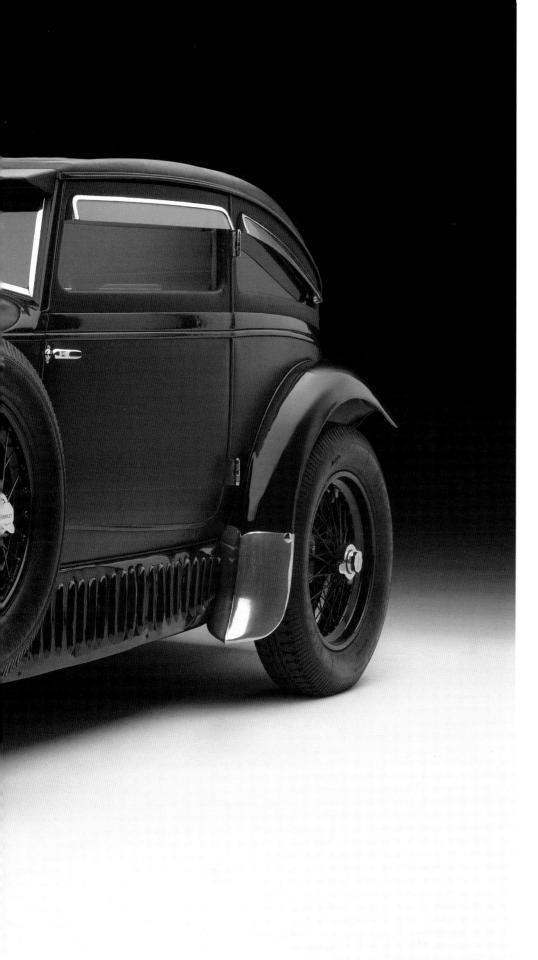

showed his prowess behind the wheel, winning three of those Le Mans victories from 1928 through 1930.

Understandably, Barnato had a great deal of confidence in himself and his Bentleys. In March 1930, at a party in Cannes, France, Barnato bragged that his Speed Six could get him to his club in London faster than the famed Blue Train express could travel between Cannes and Calais. One hundred pounds sterling was put on the line and Barnato took the challenge.

The next afternoon, Barnato and his friend, Dale Bourne, left Cannes just as the Blue Train left Cannes station. Despite a rainstorm, a blown tire, dark and unfamiliar French roads, and the necessity of a cross-Channel ferry ride, Barnato and Bourne arrived at the Conservative Club in London by 3:30 p.m. the next day. The Blue Train arrived in Calais exactly four minutes later.

The car seen here is not generally believed to be the car that beat the Blue Train. Rather, most believe it was delivered to Barnato two months after the race, whereupon he dubbed it "the Blue Train Special" to commemorate his recent cross-country victory (Barnato's daughter, for one, claimed that this car was in fact the one driven in the race).

In any case, this custom-bodied Speed Six Bentley is worthy of any and all the recognition it receives. Its body was built by

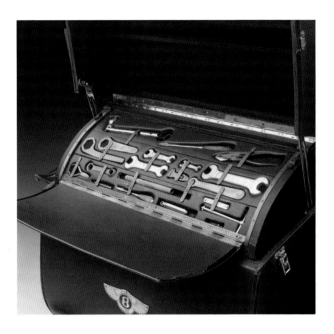

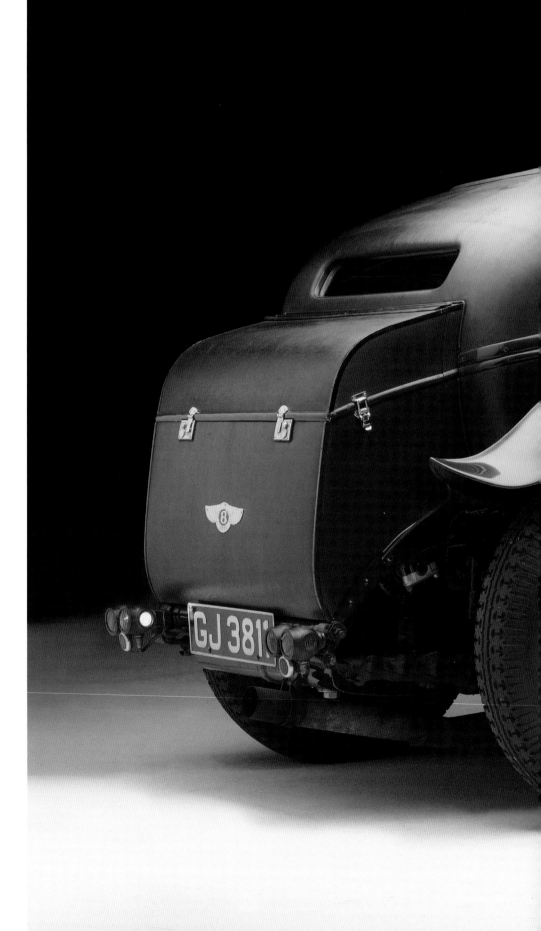

J. Gurney-Nutting and Co., and it is stunning. The gunslit-height windows (additionally concealed by individually fitted shades), along with the sloping fastback roofline, tall, black wire wheels, and dark-green paint create an air of menace that isn't often associated with cars of the period, except perhaps for those that ferried gangsters like Capone and Dillinger.

The aggressive theme continues with the car's long hood, which houses a 6.5-liter straight six producing upwards of 180 horsepower. Numerous louvers accent the hood sides and low frame covers that run along each side, below the body and between the peaked and flared fenders. A bustle-back look, which extends the car and carries the sloping roofline rearward when viewed in profile, is created by a tool chest and luggage compartment behind the passenger cabin. Inside are three leather-appointed bucket seats, one of which resides sideways behind the two front seats, with a cocktail cabinet nearby.

Today the car rarely makes public appearances. When it does, it is often accompanied by the Mulliner-bodied Bentley that probably actually raced the Blue Train, as both cars are owned by Bruce and Jolene McCaw of Seattle, Washington.

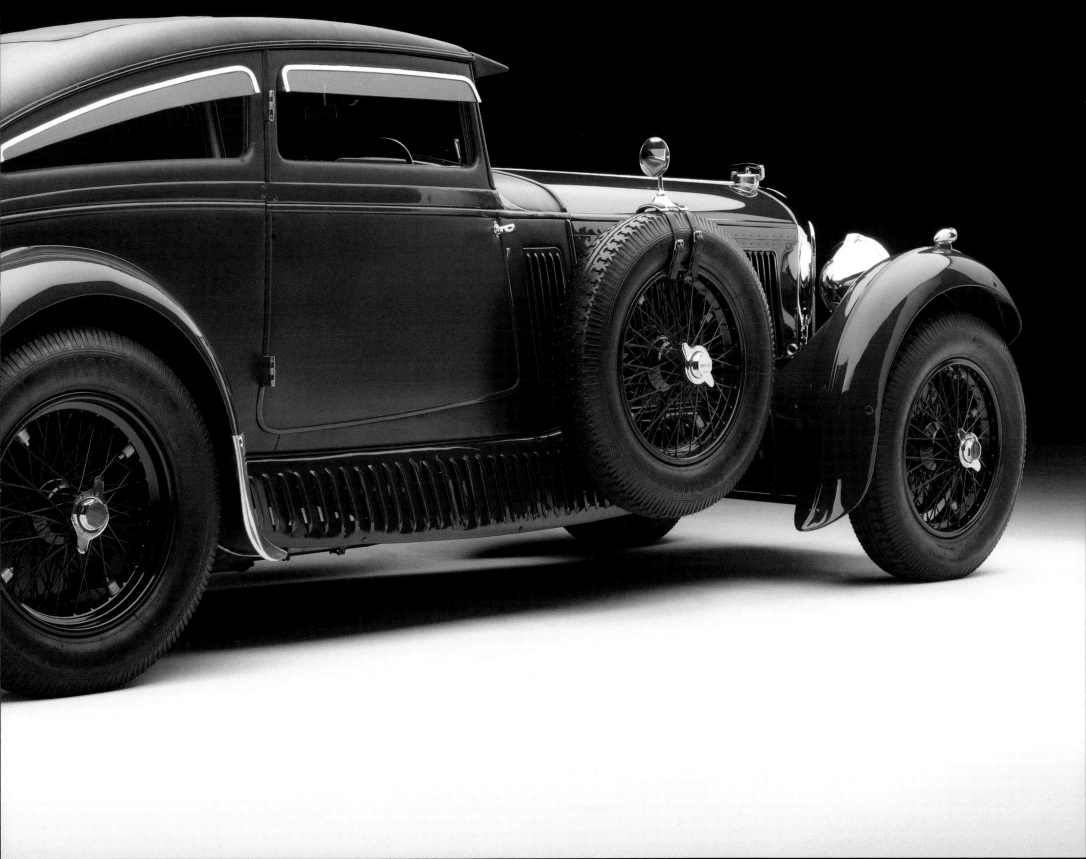

SPECIFICATIONS
OF INTEREST

VALVETRAIN
Four valves/cylinder, SOHC

CARBURETION
Two SU HVG5

COMPRESSION RATIO
5.3:1

GEARBOX
Four-speed manual

WEIGH
4,840 lbs/2,195 kg

WHEELBASE
140.5 inches/357cm

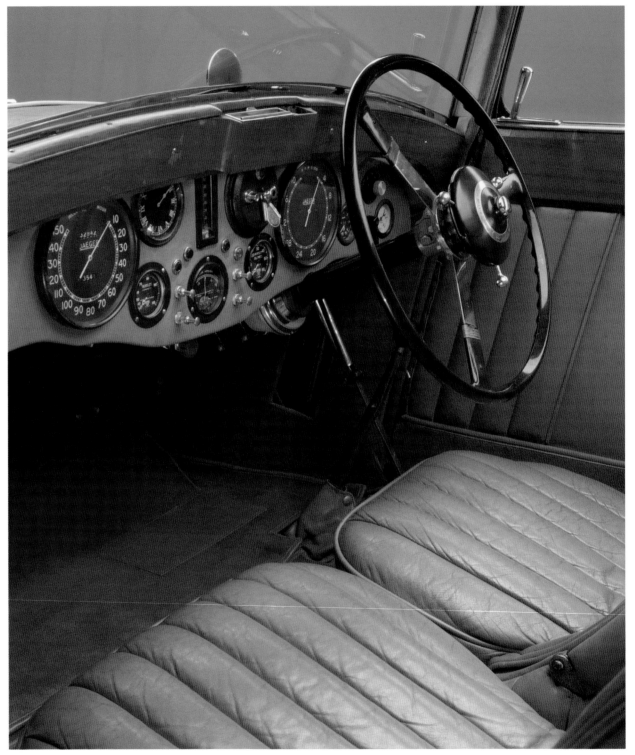

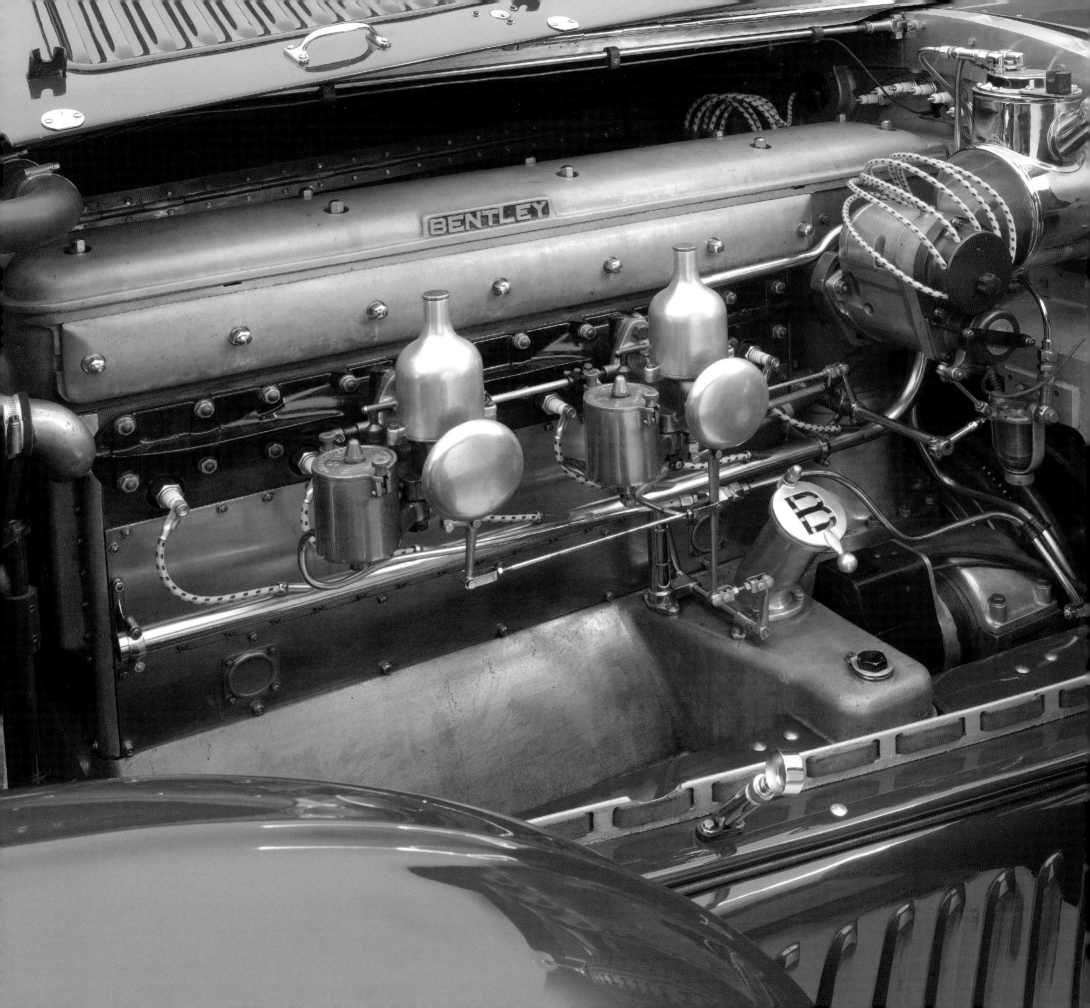

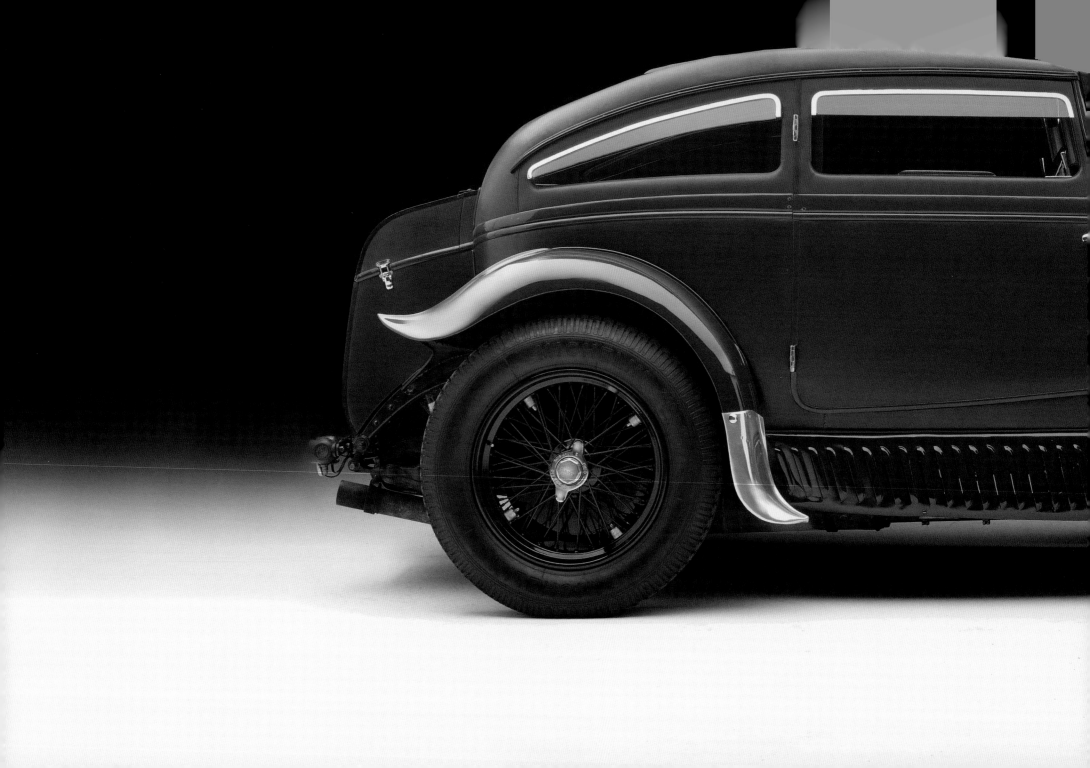

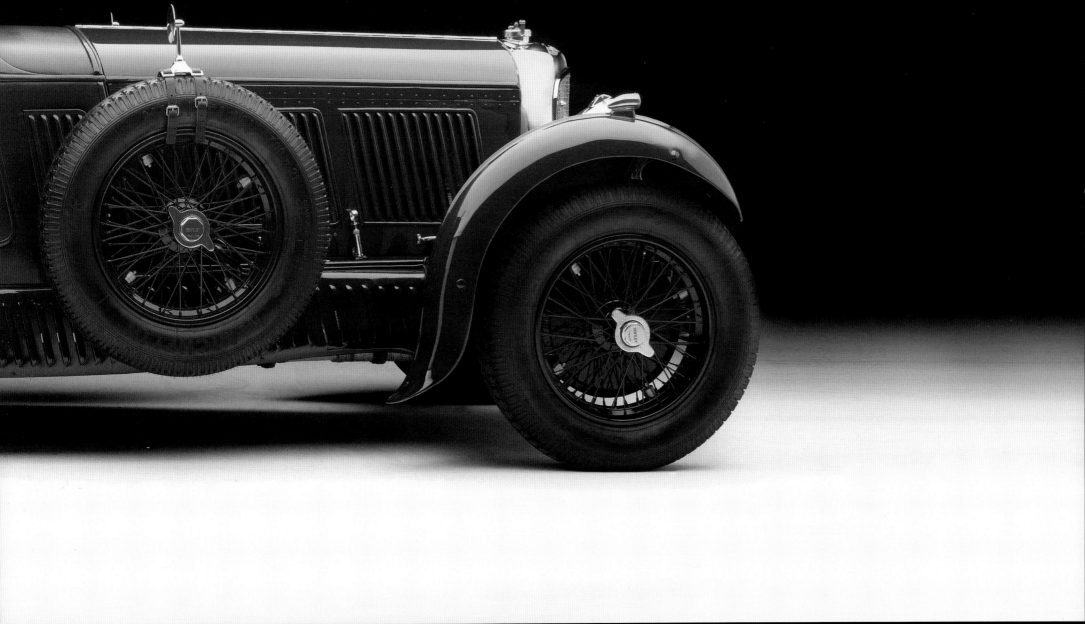

1933
Cadillac Fleetwood V–16 Aero-Dynamic Coupe

Sixteen cylinders! The thought of such an engine is audacious even today, and was just as much so in 1930 when Cadillac introduced its V-16 to the world. It seems odd that the existence of the massive 7.4-liter engine, produced from 1930 through 1940, coincided with the Great Depression, but such was the strength of the Cadillac brand back when it dubbed itself "the Standard of the World." The Cadillac V-16 was the first such engine offered for passenger car use. This engine featured overhead valves with hydraulic lash adjusters and twin carburetors. It delivered 160 horsepower and even more torque.

The Cadillac Fleetwood V-16 Aero-Dynamic Coupe (back then Fleetwood was a coachbuilder for Cadillac, not simply

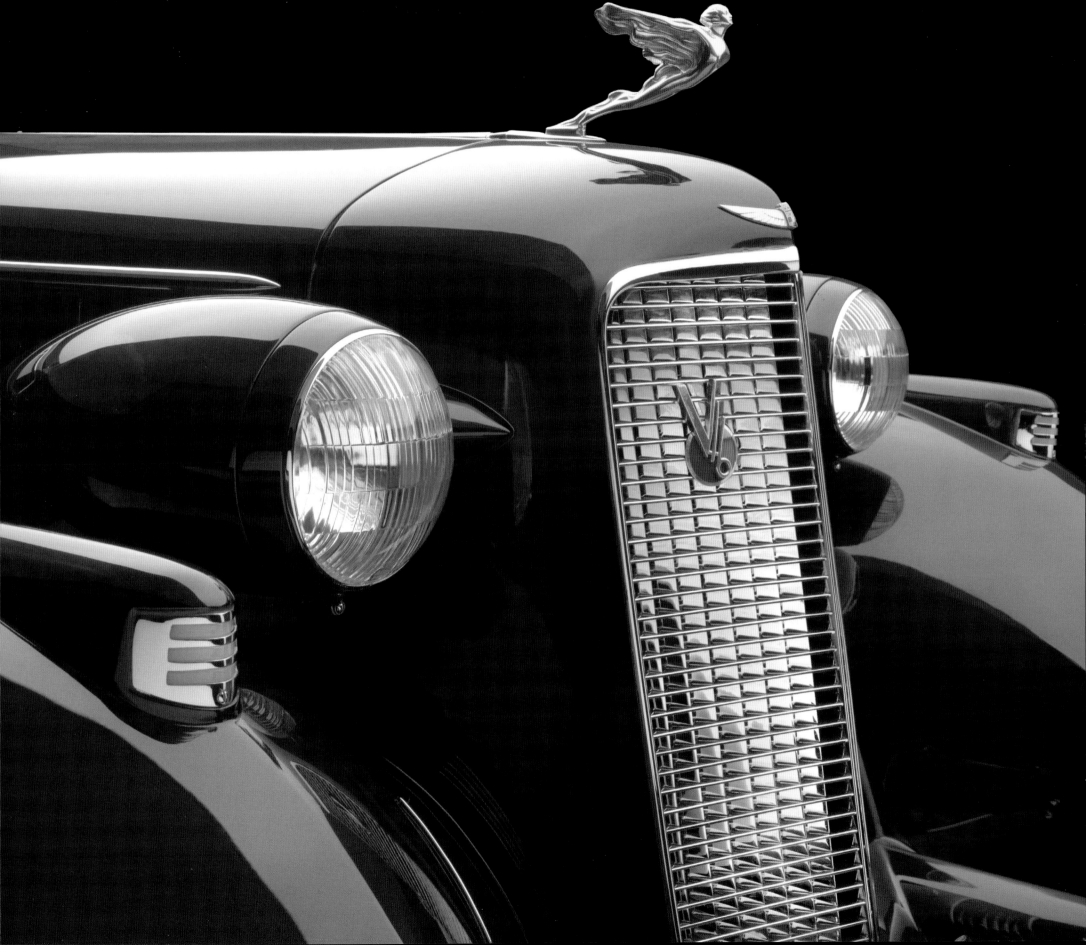

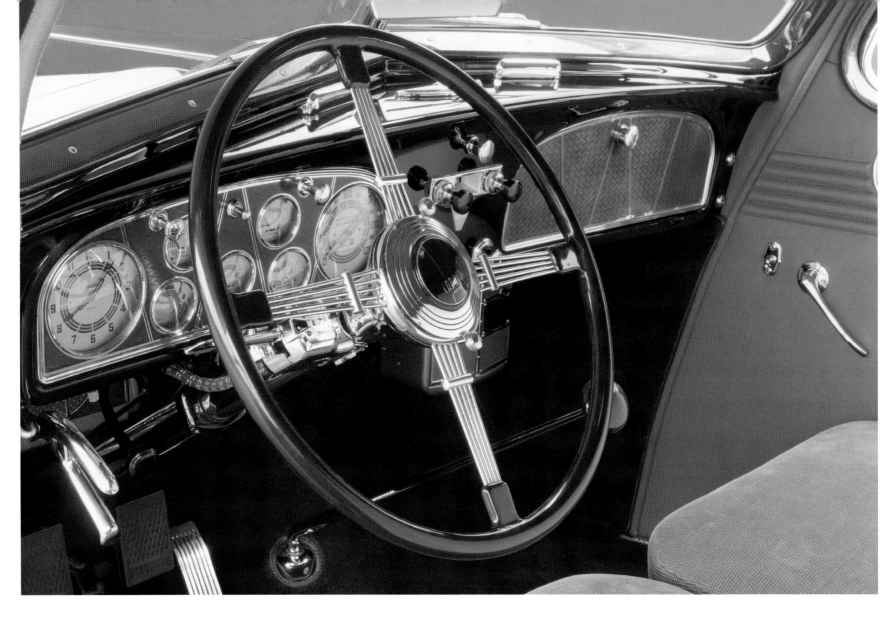

a model name) was the first Cadillac show car. It was created under the direction of GM design legend Harley Earl for the 1933 Chicago Century of Progress Exposition, where it graced the General Motors exhibit. The car's 154-inch wheelbase, the longest ever used on a Cadillac production car, made it quite big, especially for a coupe. While it certainly doesn't look particularly slippery by today's standards, the Aero-Dynamic did introduce the fastback styling that would become commonplace in the 1940s. The coupe's designers also relocated the spare tire inside the trunk—unusual in an era when spare tires were typically mounted outside vehicle bodies. Other unique aesthetic touches are the twin fishtail-style

exhaust outlets located below the rear bumper, which were shaped to enhance the V-16's exhaust sound.

The V-16 engine itself was made to be visually appealing, with hidden wires and plated fuel lines dressing up the massive lump; a firewall concealed wiring and plumbing. Writers of the time indicated that the car could idle along at 2 mph while in top gear and then, with a tip of the throttle, quietly thrust away to high speeds because of the flexibility of this remarkable engine.

After the World's Fair the Aero-Dynamic was offered for sale. Of 20 bodies built only 8 were known to have been equipped with the V-16 through 1937, making this car very rare indeed.

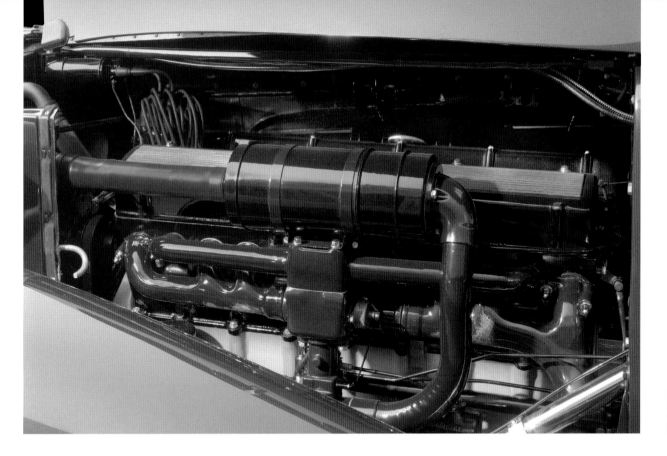

SPECIFICATIONS OF INTEREST

ENGINE
45-degree V-16

TRANSMISSION
Three-speed manual selective
synchromesh

ENGINE WEIGHT
900 lbs/408 kg

WEIGHT
6,000 lbs/2,721 kg

INTERIOR
Five-passenger

PRICE
$8,100

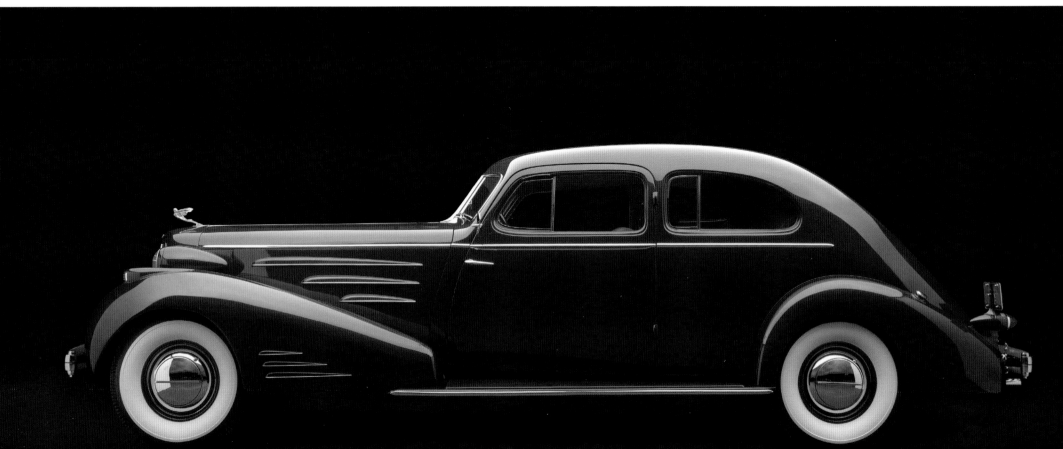

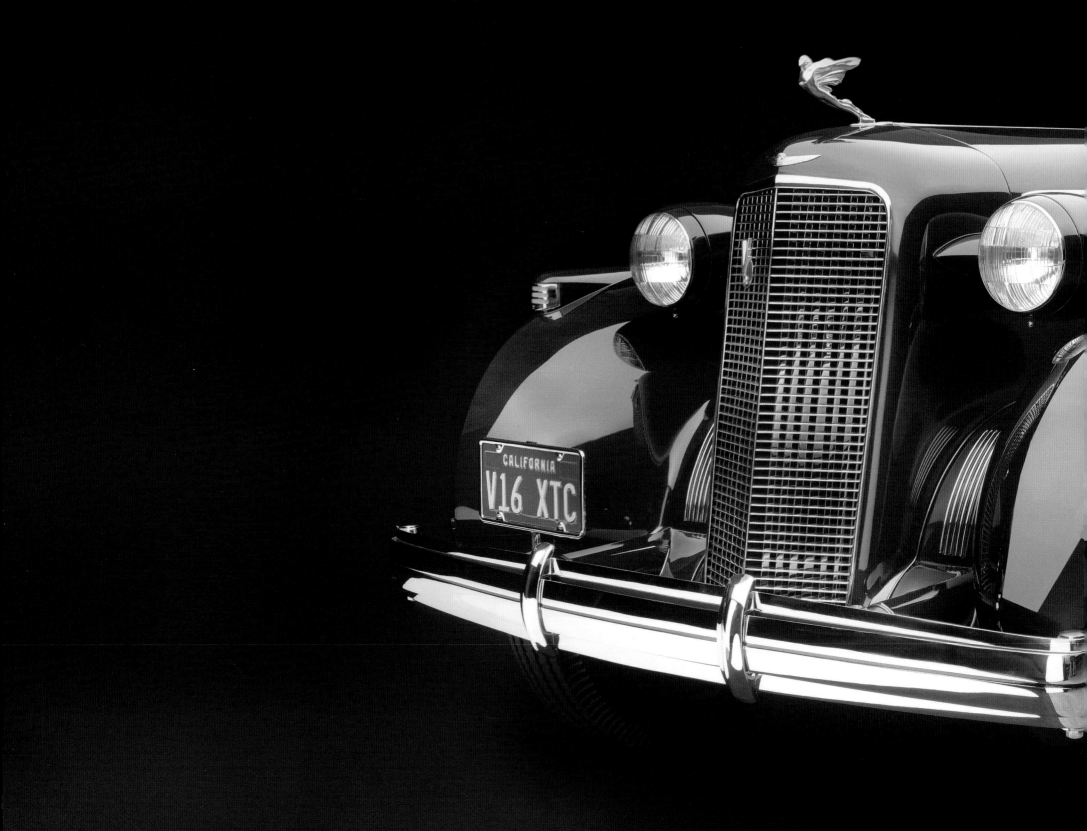

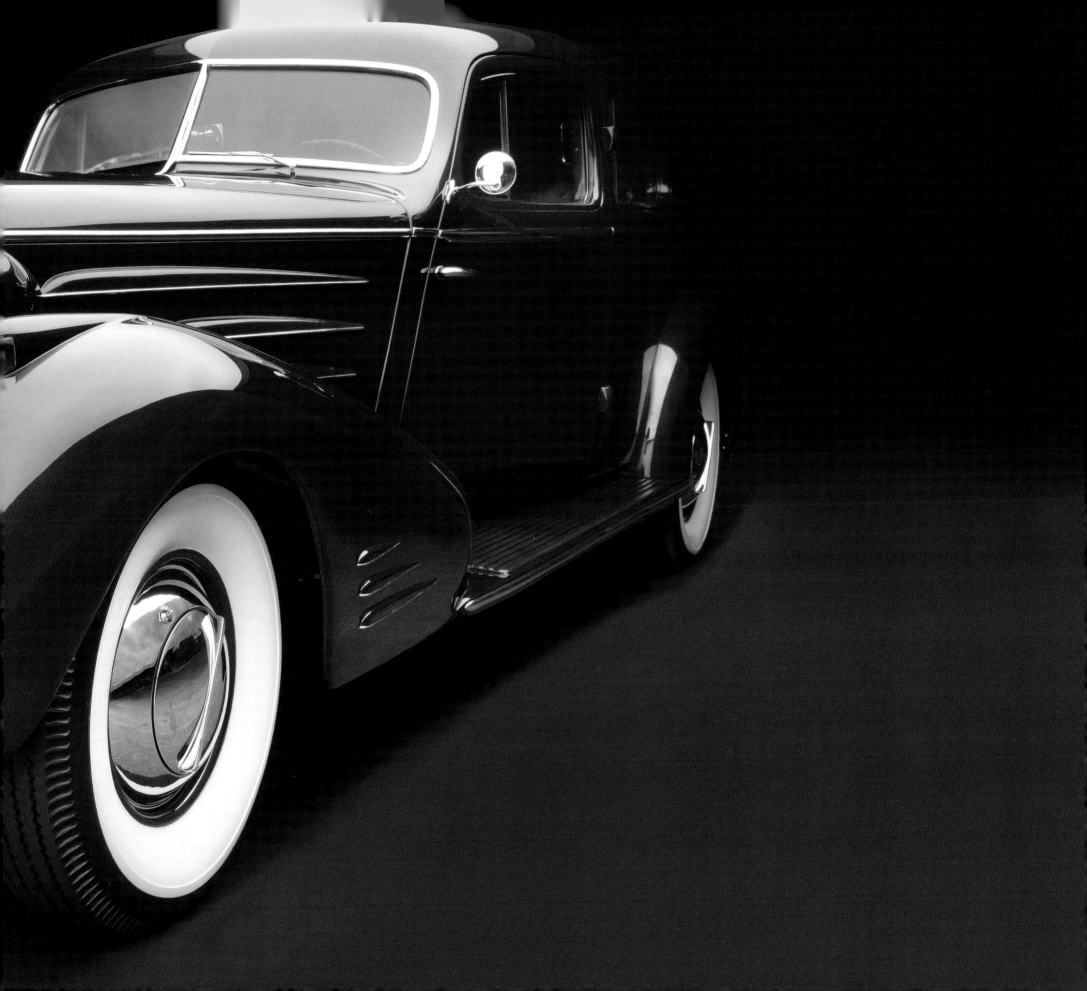

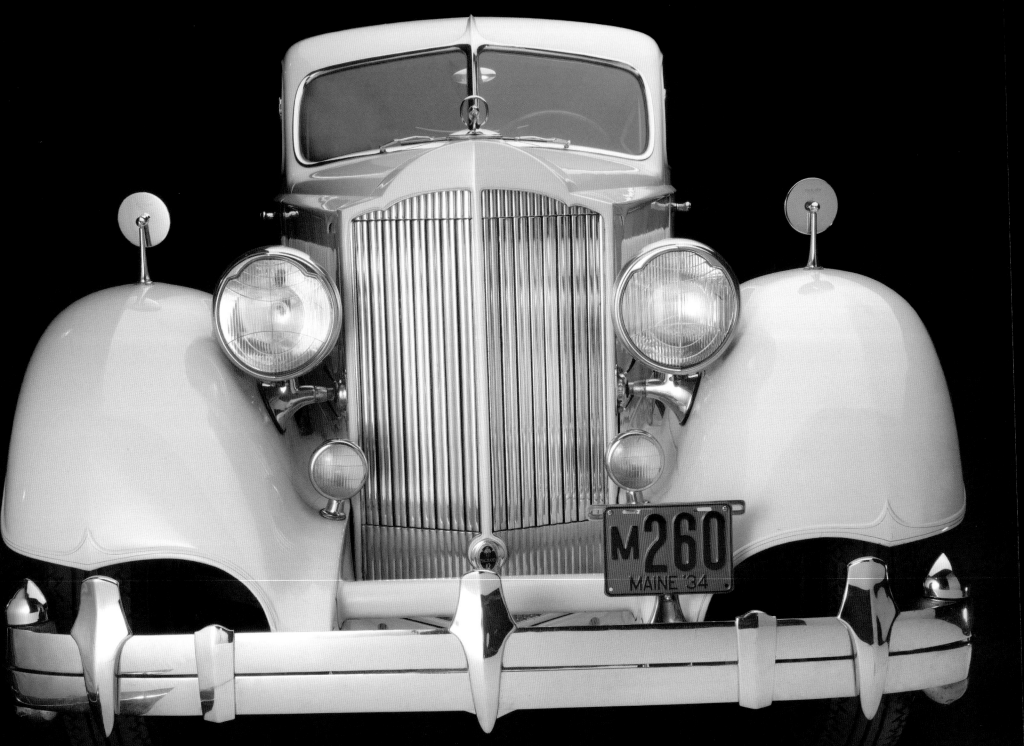

1934
Packard Model 1106 V-12 Sport Coupe

◆

While the cars built on Packard's Model 1106 chassis are considered among the best and most beautiful Packards ever made, they are somewhat at odds with the rest of Packard's output as a car manufacturer. Packards were high-quality, solidly built cars, without a doubt, but high style and advanced aesthetics were not typically part of the company's recipe. That changed with the Model 1106, which carried the Sport Coupe body seen here, as well as the LeBaron-built Runabout Speedster body seen elsewhere in this book. Packard built them to prove the company could build cars the equal of anything else in the world, including from a stylistic standpoint.

Several styling features made the Sport Coupe distinctive, and even highly influential on European manufacturers and

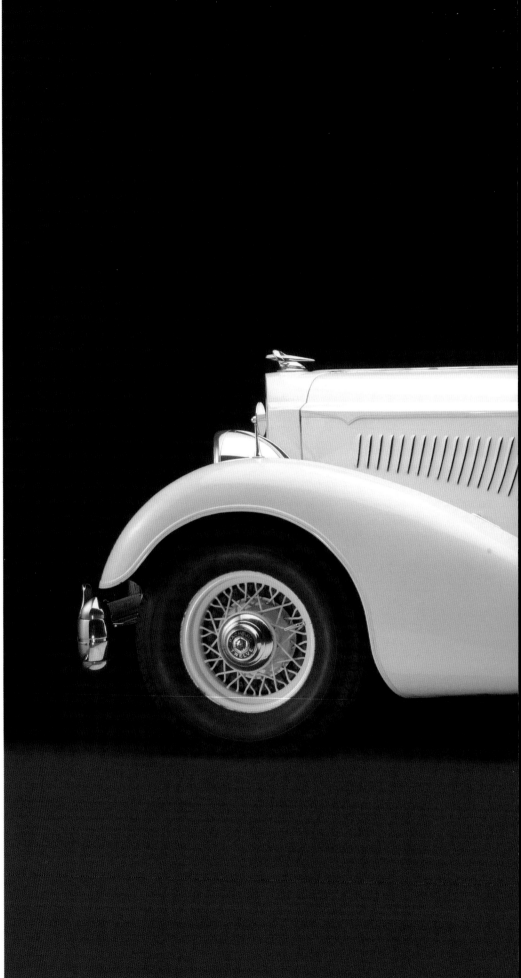

designers. The hood and cowl incorporated several visual tricks, which one of the car's designers, Alexis de Sakhnoffsky, described as a "false hood," to extend the length of the car's front, leading back to a split windshield that echoed an earlier Packard show car. The rear quarter windows taper to a point as the body wraps around to the rear, where a split rear window repeats the triangular taper.

Peaked, torpedo-shaped fenders were another hallmark of the car that helps give a long and elegant appearance despite its relatively short, sport-minded wheelbase of 134⅞ inches. With its gently sloping roofline and sleek fully skirted rear fenders, the Sport Coupe successfully incorporated elements of streamlining that had become popular during the 1930s. With a powerful V-12 under the hood, the Packard Sport coupe pulled like a train as well. The V-12 offered a shorter overall length than the popular straight-eight designs of the period, yet could make more power. At more than 7 liters of displacement, it ensured that the driver of the Sport Coupe would travel not only with style, but with speed.

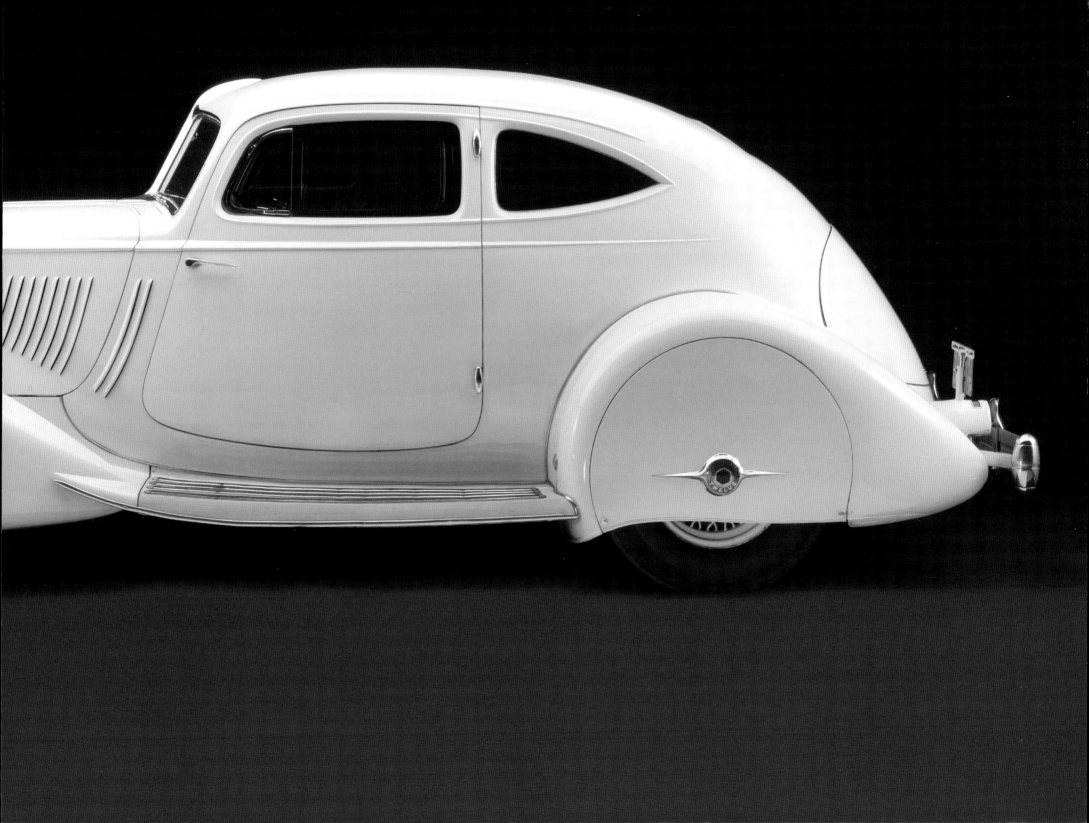

SPECIFICATIONS OF INTEREST

ENGINE
67-degree V-12, modified L-head, 445 ci/7.3 liters

HORSEPOWER
160 bhp at 3,200 rpm

TORQUE
322 lbs-ft at 1,400 rpm

BRAKES
Cable-operated drums with vacuum assist

TRANSMISSION
Three-speed synchromesh

WEIGHT
5,500 lbs/2,494 kg

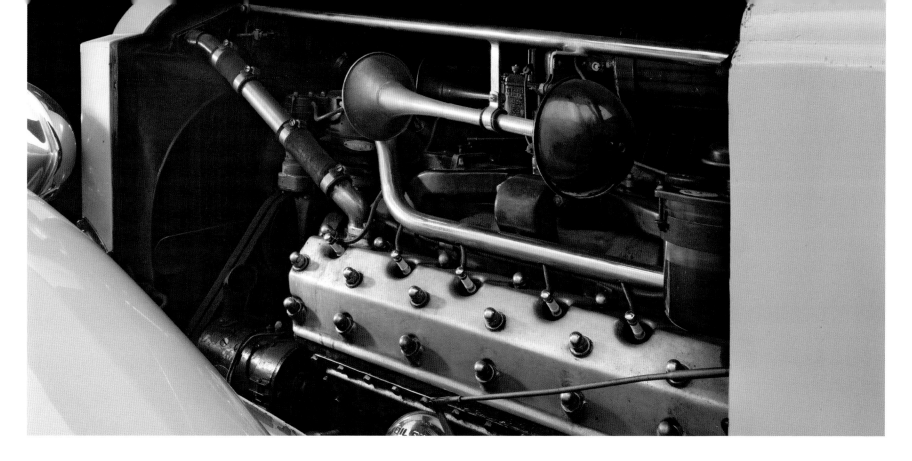

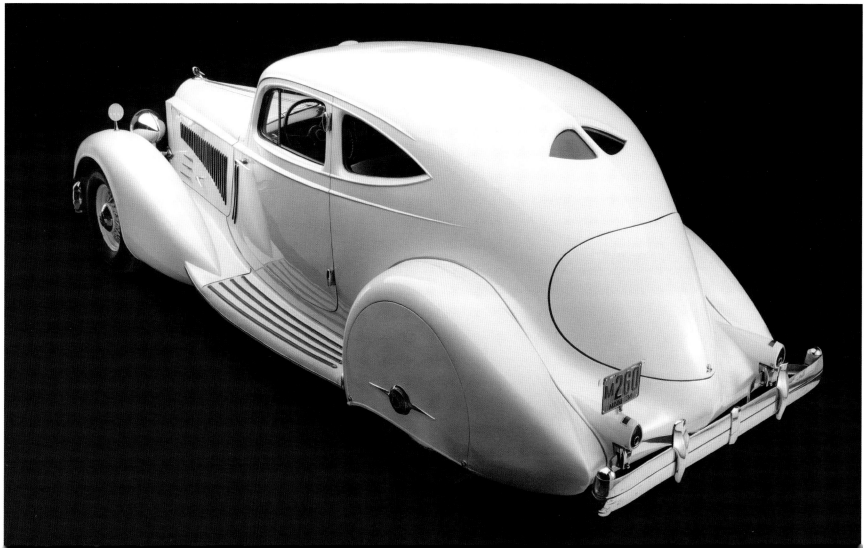

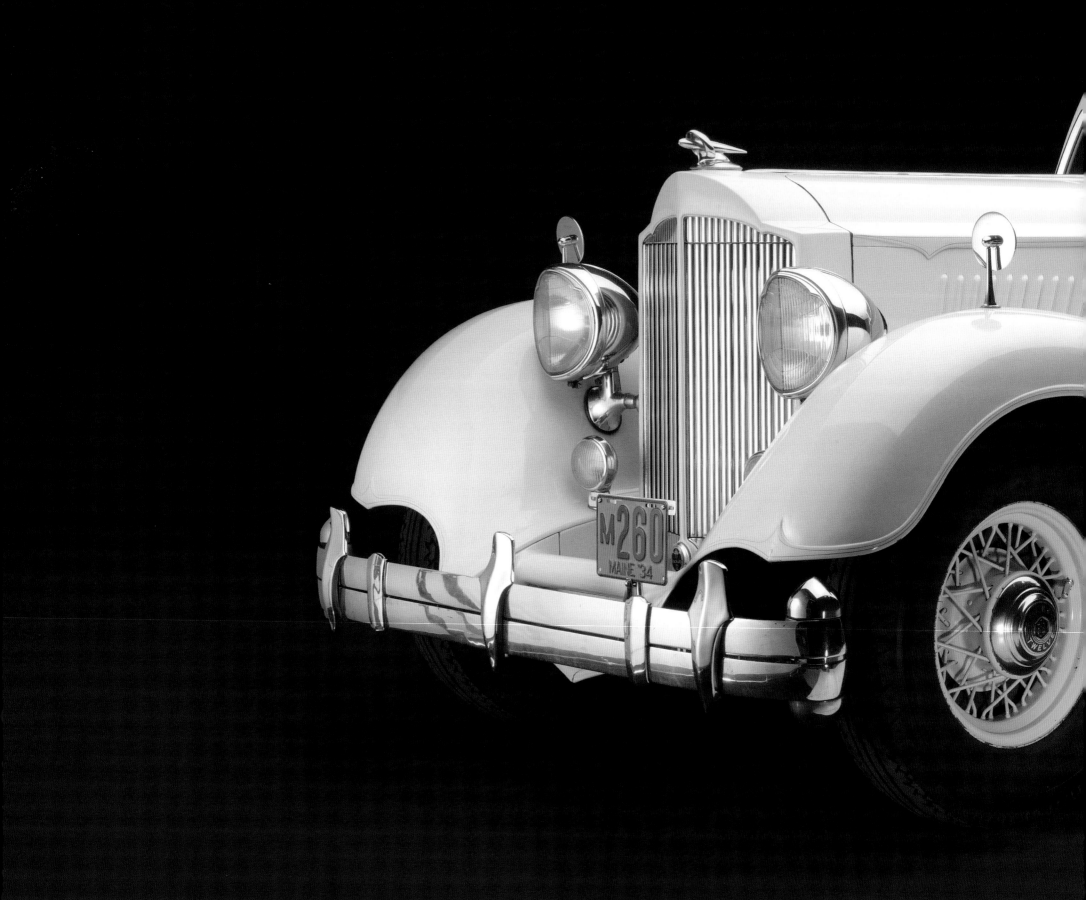

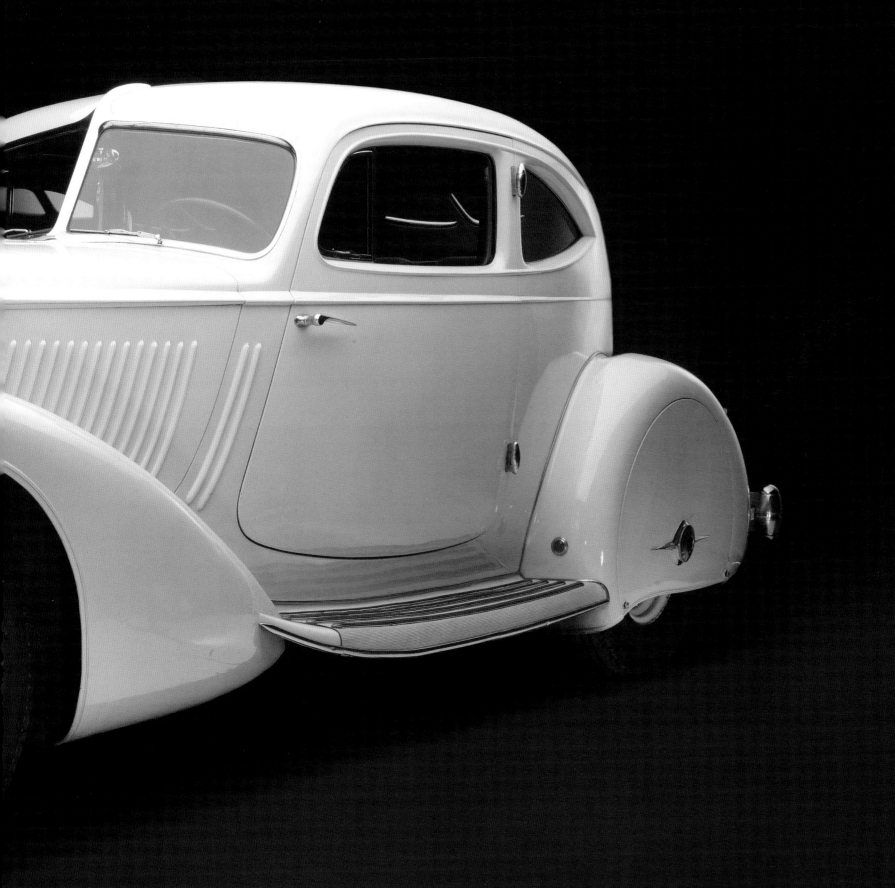

1935
Chrysler Imperial Model C2
Airflow Coupe

◆

The Chrysler Airflow is one of the clearest examples of a consumer product that failed because it was ahead of its time. Indeed, when a car company sets out to create a new model today, they address aerodynamic and safety concerns while building a unitized body that also serves as the car's chassis.

The Airflow did all of these things well before other carmakers did, and because of that it can be considered a genesis point for the modern automobile. However, the Airflow's abject marketplace failure can be seen as a cautionary tale about why carmakers shouldn't let their engineers run roughshod over sales and marketing concerns.

Chrysler was an engineering-driven company at the time of the car's introduction. The Airflow was billed as the first

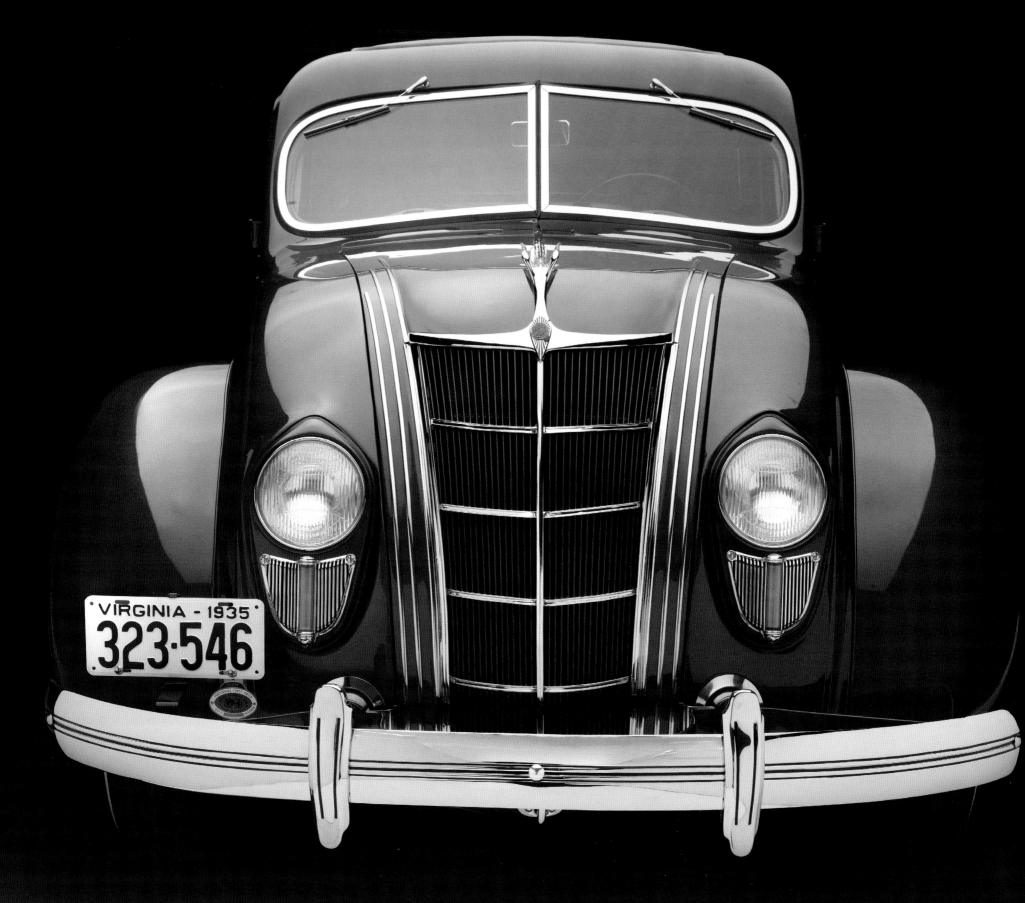

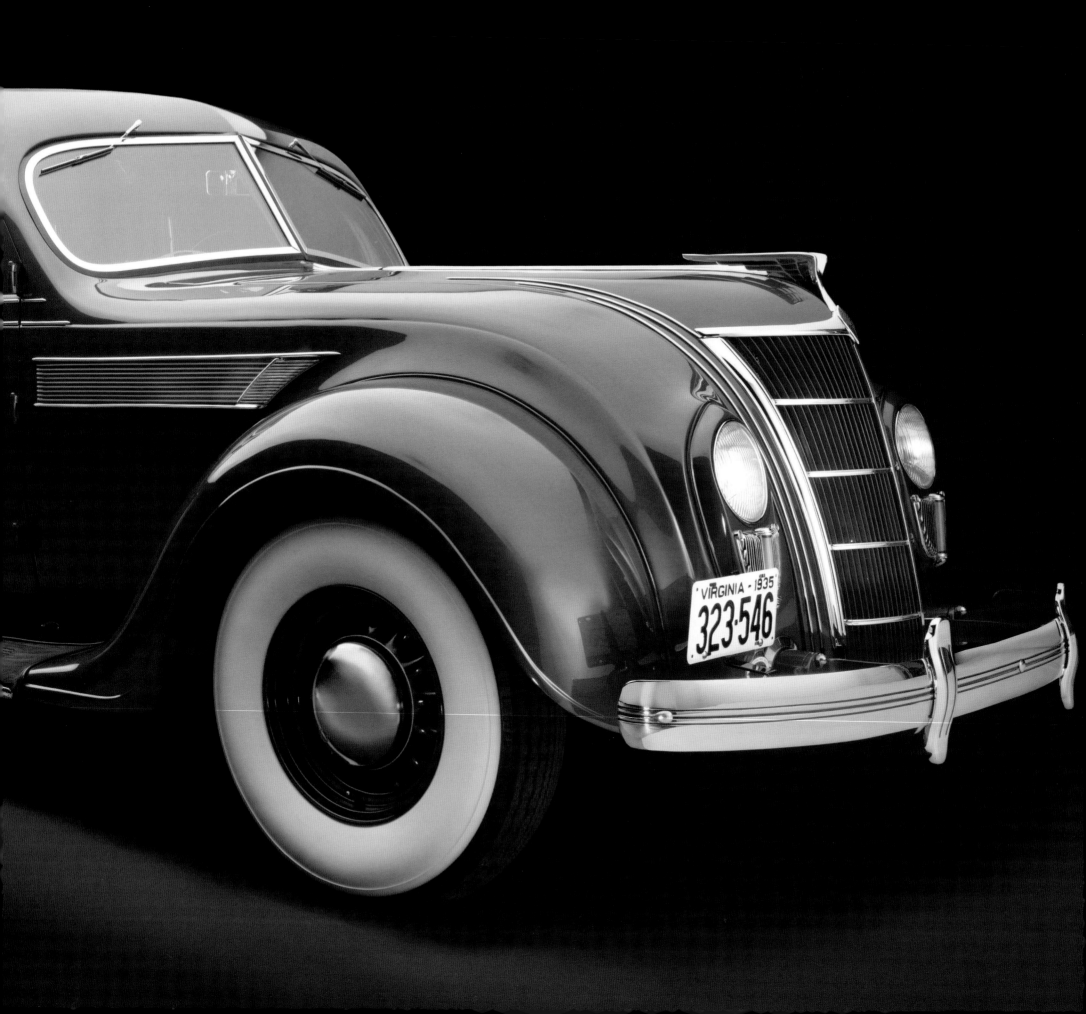

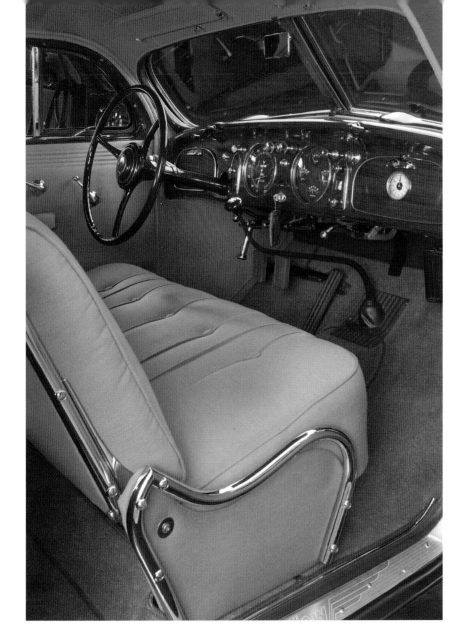

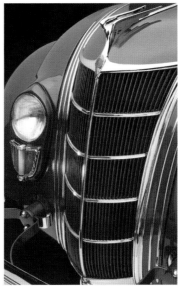

"ride-inside" motorcar, because passengers were centered between the axles and did not ride atop a ladder-style chassis. This subjected passengers to less vibration.

The car's unitized construction meant that the body was much more rigid than a conventional car's. Somewhat counterintuitively, this also assisted ride and handling, as bumps in the road were left to the car's suspension to deal with, rather than transmitted through the body to the passengers.

Unfortunately, because of the car's failure in showrooms, its engineering innovations (such as placing the wheels at the corners of the vehicle with minimal overhang and aerodynamically efficient styling) were not adopted industry-wide for some time.

Introduced in 1934, only about 25,000 examples were sold between Chrysler and DeSoto models that first year, despite many more preorders. The car's waterfall grille, short hood, and lack of conventional fenders signaled that this was no ordinary automobile, and for buyers it proved to be a step too far into the future. In 1935, consulting designer Norman Bel Geddes added a more conventional-looking grille to the Airflow; owners of 1934 models could have their cars upgraded to the new look.

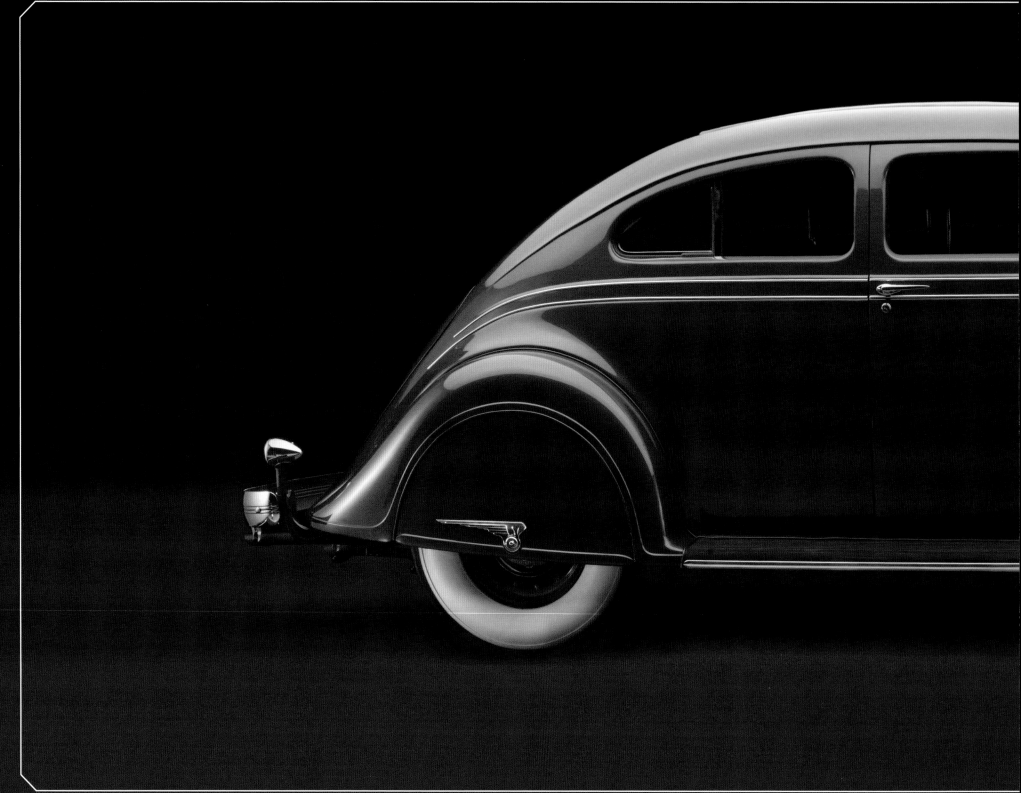

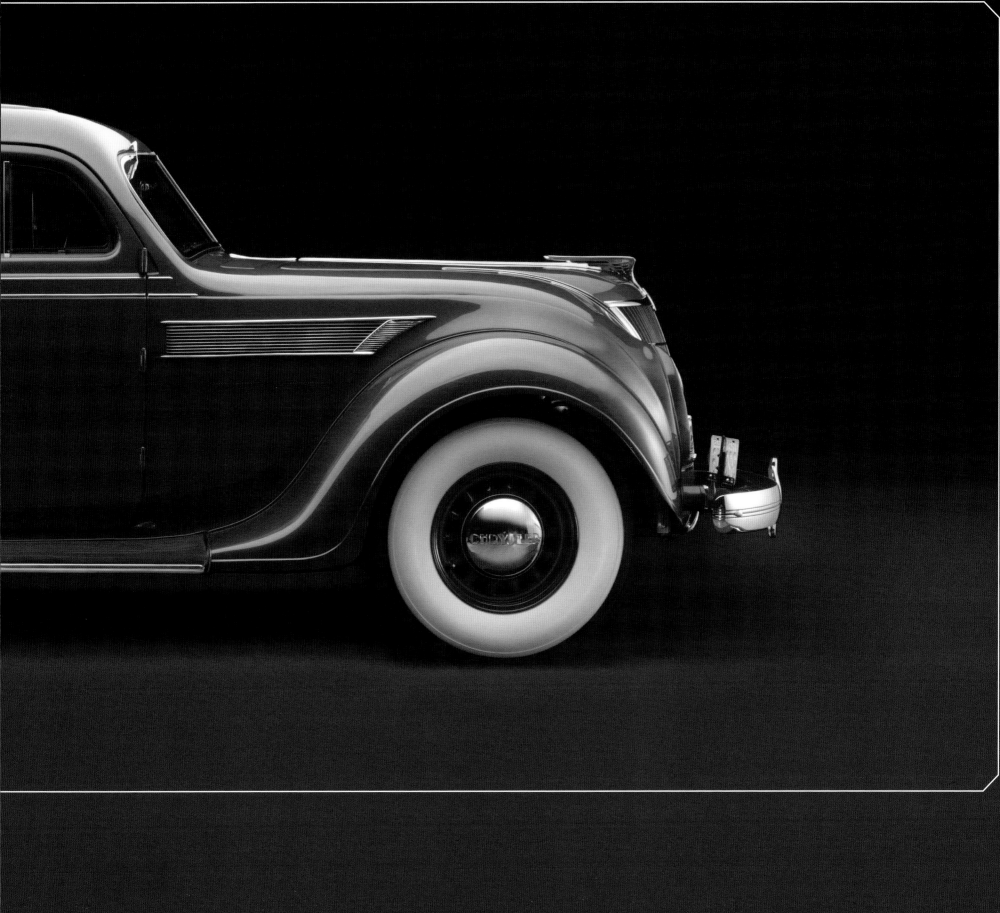

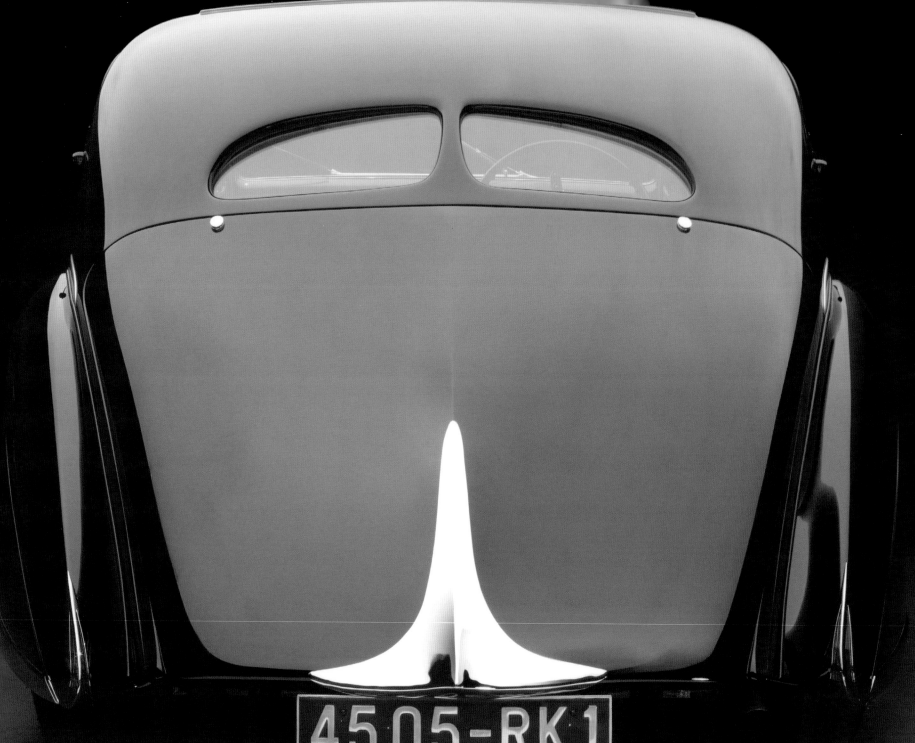

1936
Delahaye Model 135M Coupe

◆

This car provided inspiration for the designs of many high-end coachbuilders after its introduction in 1936. While it is a Delahaye, the name Joseph Figoni is equally important to its history. Figoni designed the enveloping, streamlined body-work for his Figoni and Falaschi coachbuilding firm, and it is considered to be one of Figoni's first coupe designs. The car wears its black aluminum body like a finely tailored dress, with dramatic, reflective swooshes and scallops accentuating its sensual curves.

Both front and rear wheels are enclosed; the headlights are also hidden from view by fine-barred, flush-mounted grilles. These grilles complement the central radiator grille's vertical bars and the hood-side vents, which have similarly spaced bars that sweep downward and are accented by three chrome

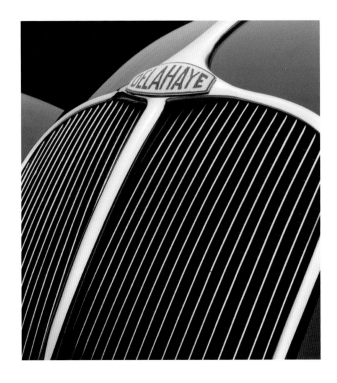

boomerang-shaped curves. The radiator grille is divided by a strip of chrome that runs back to the hood, where it splits into three strips—the two side strips continue along the length of the body, sweeping down the doors and rising dramatically over the rear fenders; the central strip runs straight back along the hood top to the triangular cowl.

Above the car's beltline, flush-mounted door handles add another splash of chrome. A large sunroof takes up most of the panel above the passengers; the roof then slopes downward to incorporate the split rear window.

We lack the space to detail all of the car's fascinating history, but highlights include: hiding from the Nazis, ownership by Mexican actress Dolores del Rio, an ill-advised trip through an eastern snowstorm, an exchange for paintings that turned out to be fake, a restoration in two-tone blue, a class win at the 1981 Pebble Beach Concours d'Elegance, and a 2004 restoration that reunited the car with its original engine and brought back its black paint.

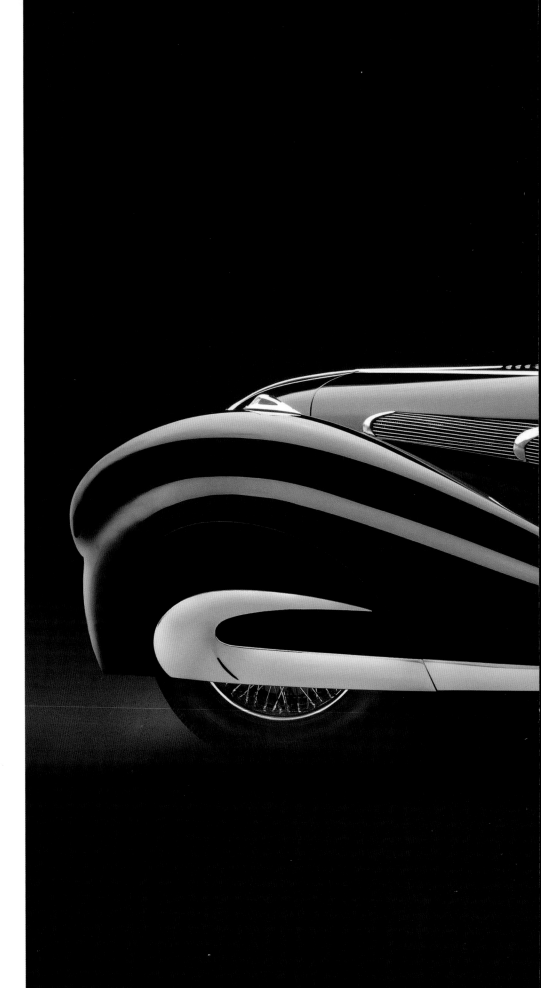

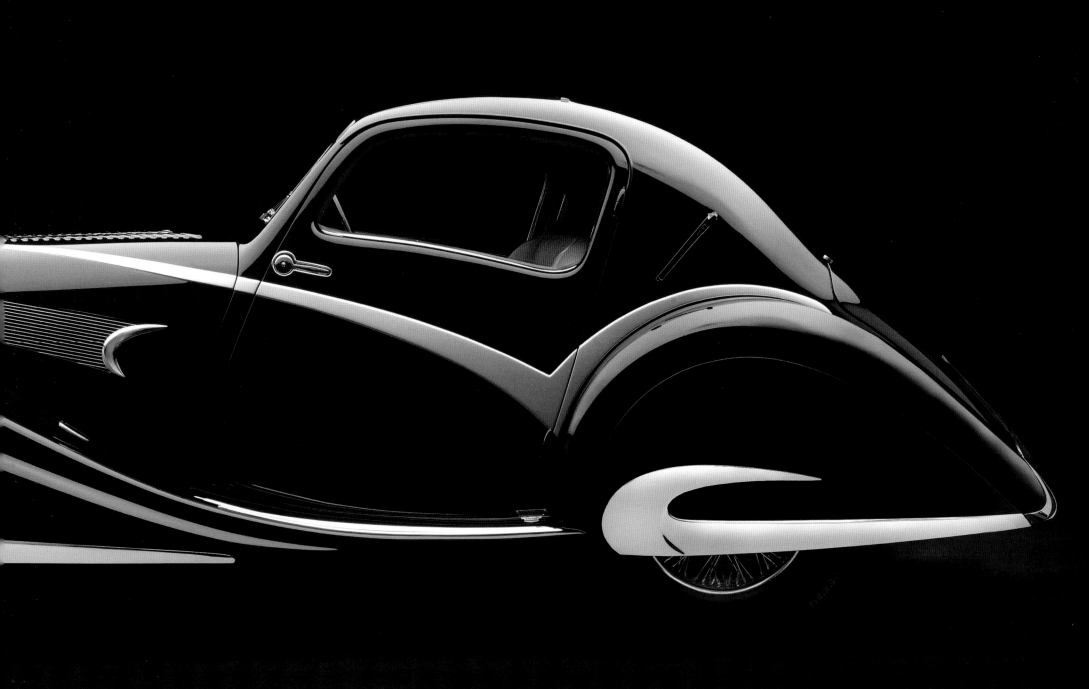

SPECIFICATIONS OF INTEREST

CHASSIS NUMBER
46576

ENGINE
Two OHV per cylinder, cast-iron straight six, 220ci/3.6 liters

POWER
120 bhp at 4,200 rpm

CARBURETORS
Three Solex 40s

TRANSMISSION
Four-speed manual

WHEELBASE
106.3 inches/270cm

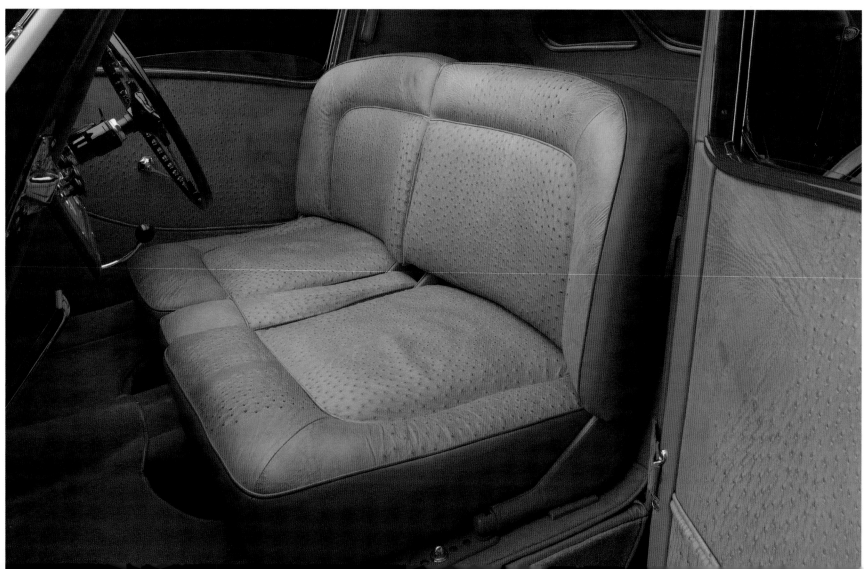

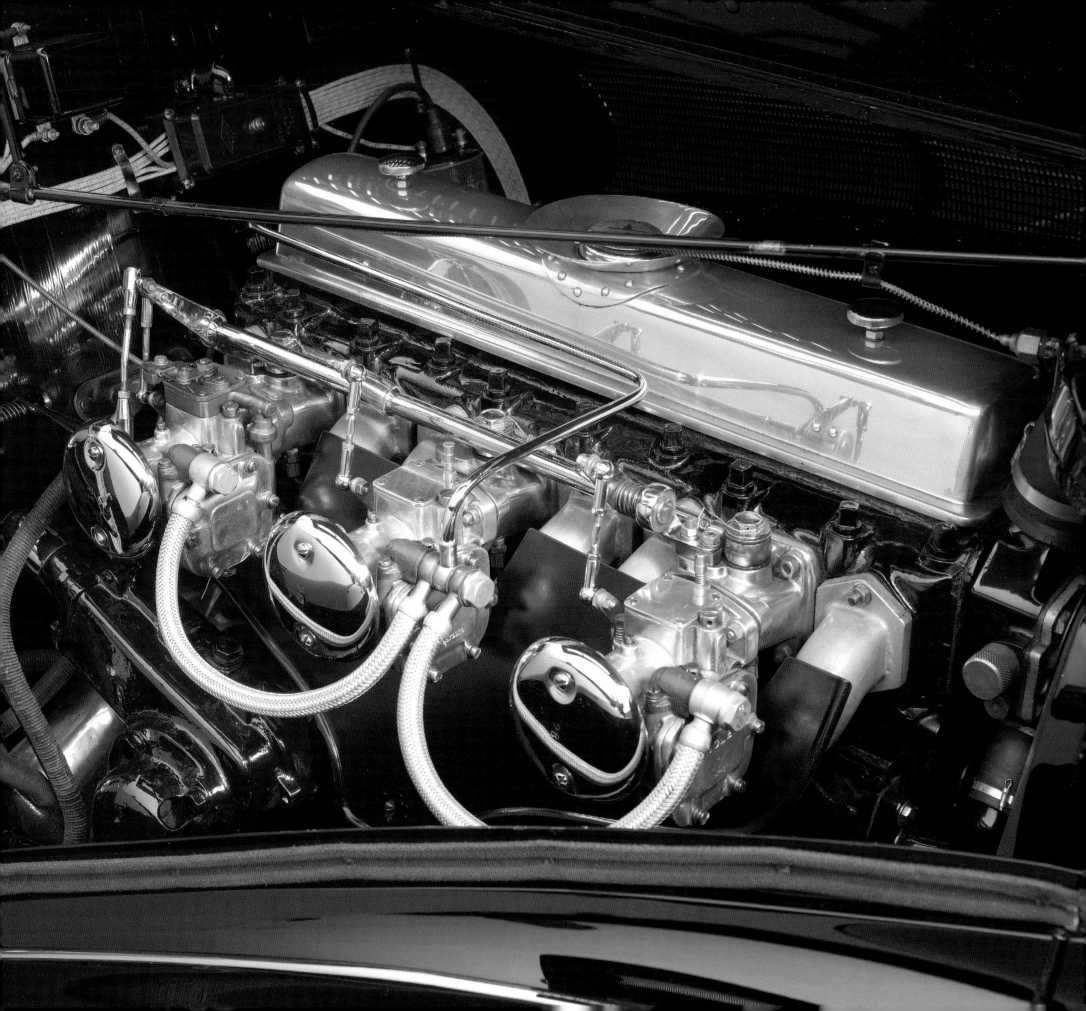

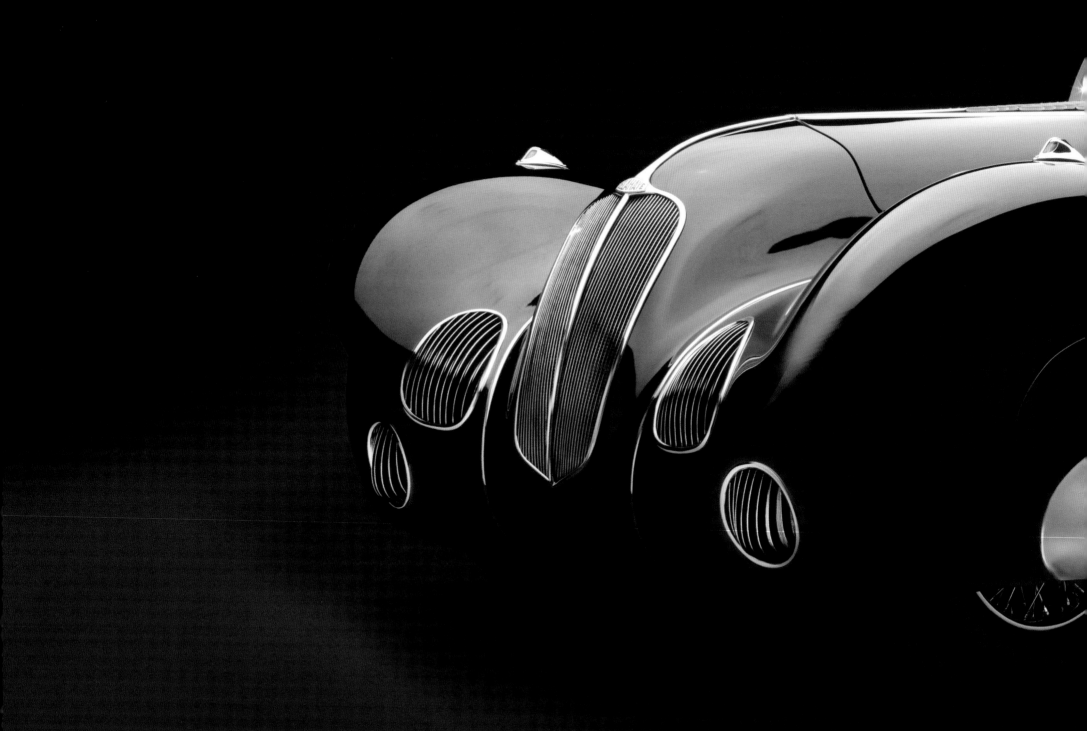

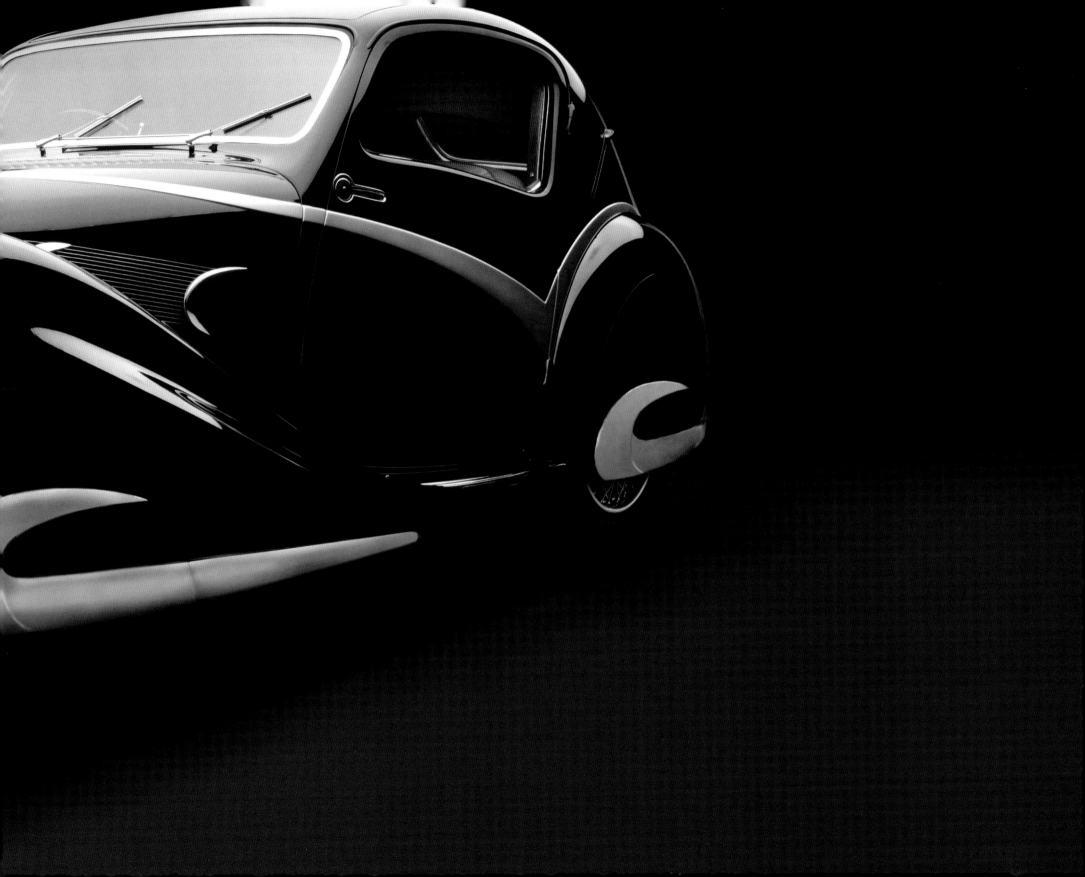

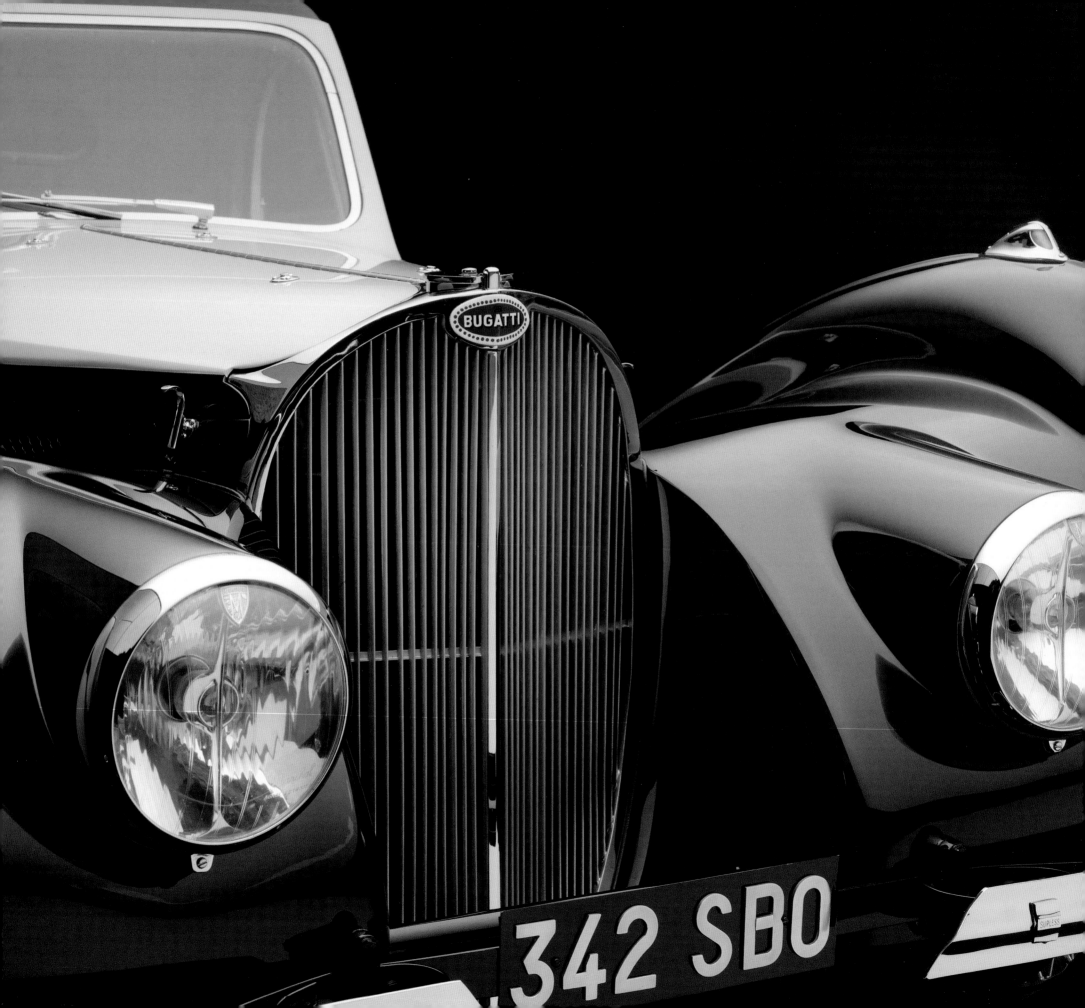

342 SBO

1937
Bugatti Type 57S
Atalante

◆

The cars of Ettore Bugatti were unmatched in their ability to combine elegance and speed with little compromise. Bugatti himself, an Italian-born engineer living in France, created Grand Prix–winning racers and grand road cars, and all were both fast and beautiful.

The Type 57 came about in the early 1930s as the company strove to create a chassis that could be used for a variety of body styles. Among those, the 57S Atalante was the most sporting and low-slung (aside from racing versions), with its axles mounted above the chassis centerline and a short wheelbase. It was also the most exclusive body style.

Of the Atalantes that were built, no two are exactly the same. Some have roll-back tops, others have independently mounted headlights, and some have lengthened rear fenders.

Many of them use contrasting colors to show off their bodylines, as chassis number 57562's yellow French curve accents the deep black bodywork and encircles the car's bubble-shaped roof. A split rear window, teardrop-shaped side windows, and skirted rear wheels add more allure to the distinctive shape of this Bugatti. Front and center, of course, is Bugatti's signature upright horseshoe grille.

The Type 57S chassis was victorious at the 1937 24 Hours of Le Mans, and that performance pedigree carries over to the Atalante. Its high-compression straight-eight engine produces 175 horsepower in a car weighing around 3,400 pounds. Bugatti also produced a Type 57SC, which added a supercharger to produce 210 horsepower and a top speed of 130 mph.

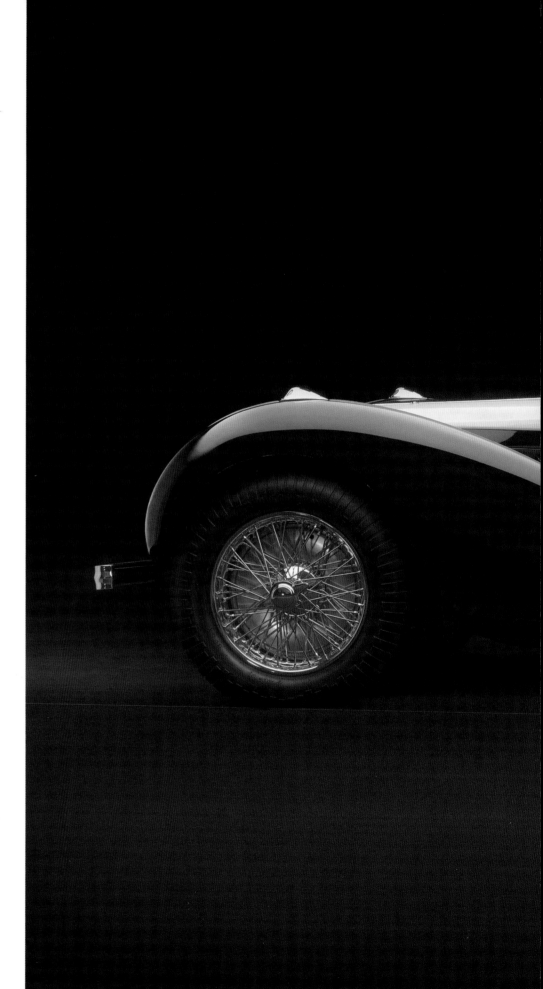

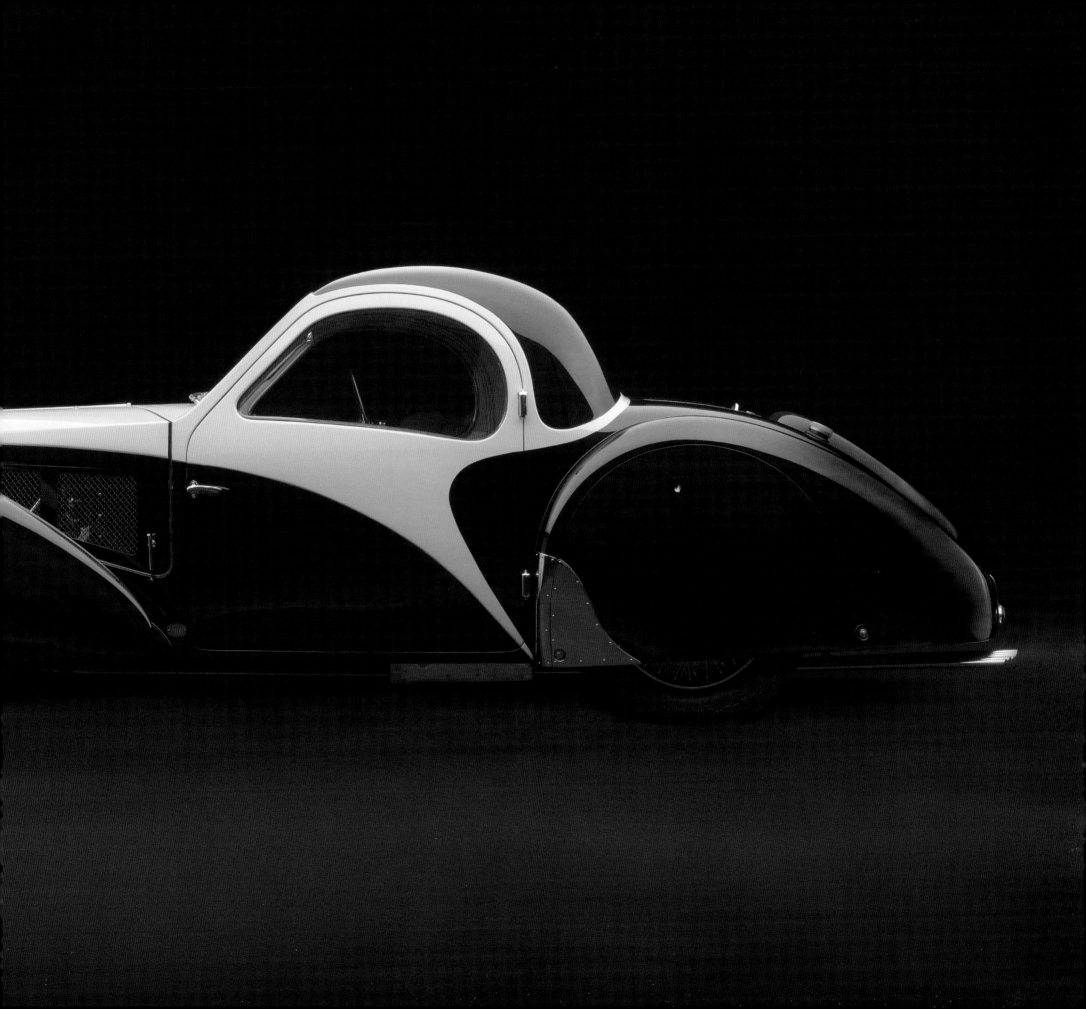

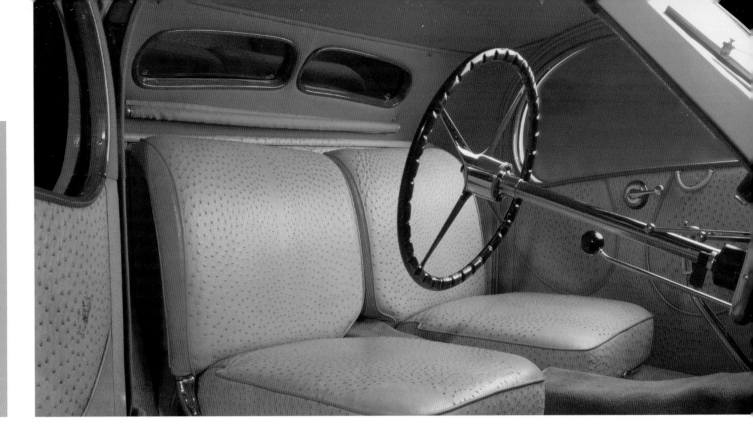

SPECIFICATIONS OF INTEREST

BODY/FRAME
Steel over steel

WHEELBASE
101 inches/257cm

LENGTH
117 inches/298cm

HEIGHT
54 inches/138cm

ENGINE
DOHC, two valves per cylinder,
198ci/3.3 liters

TRANSMISSION
Four-speed manual

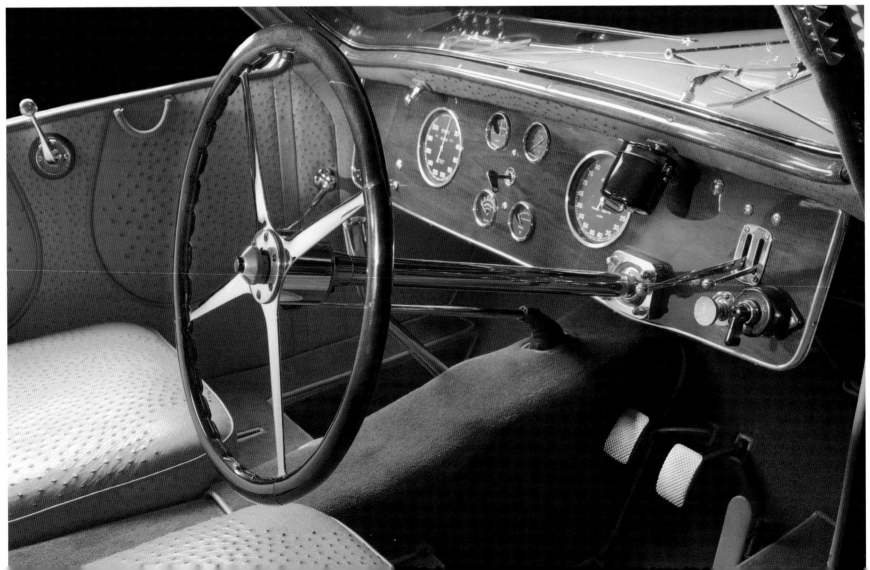

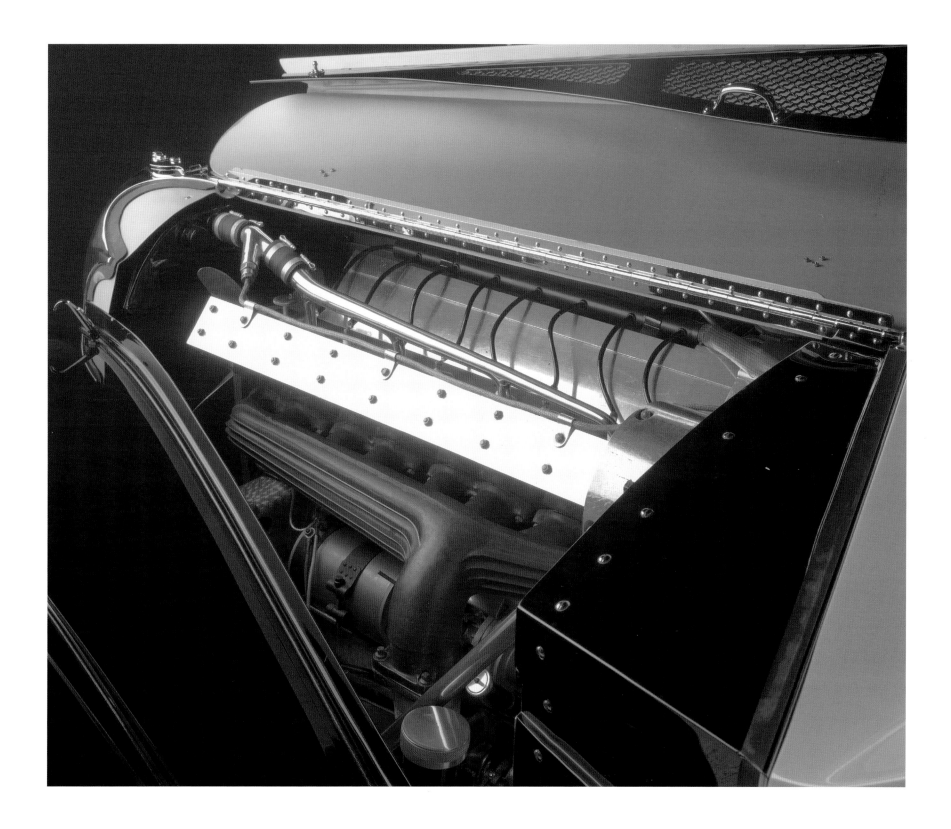

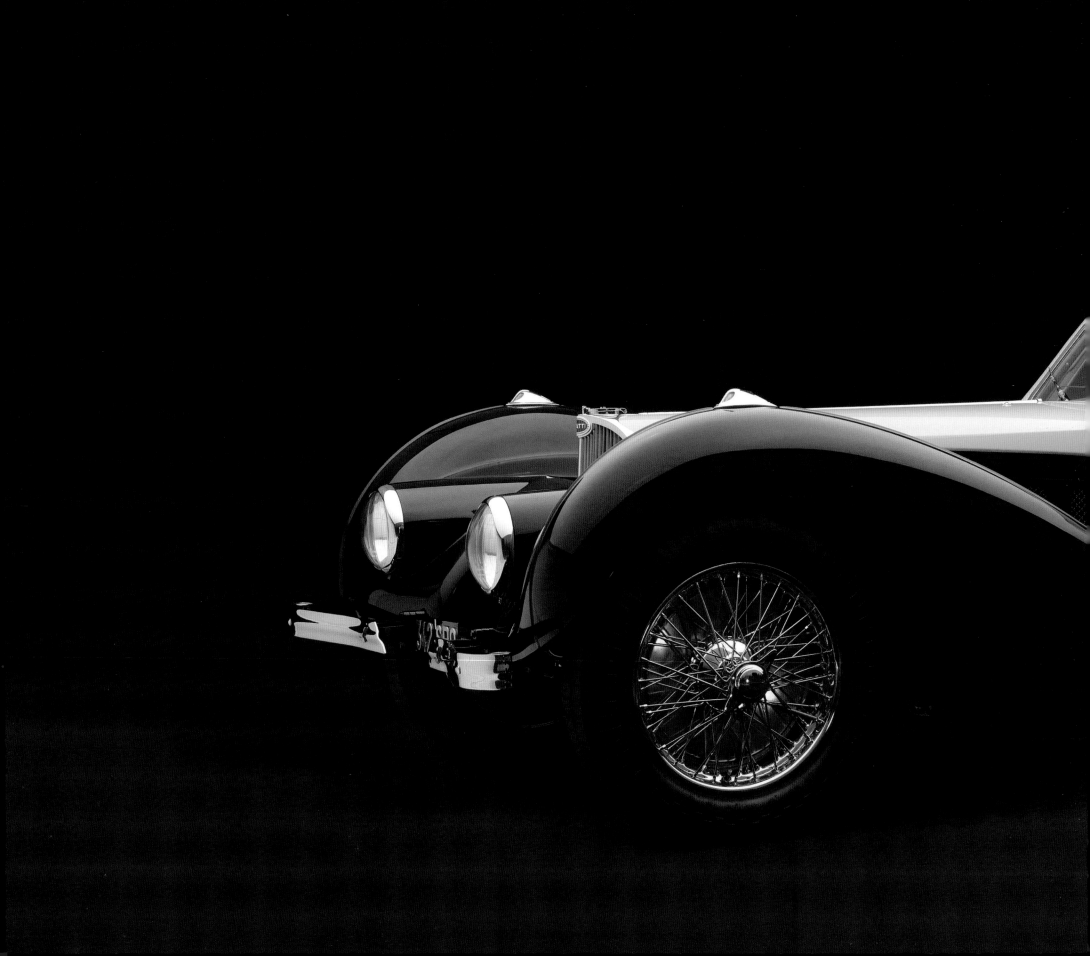

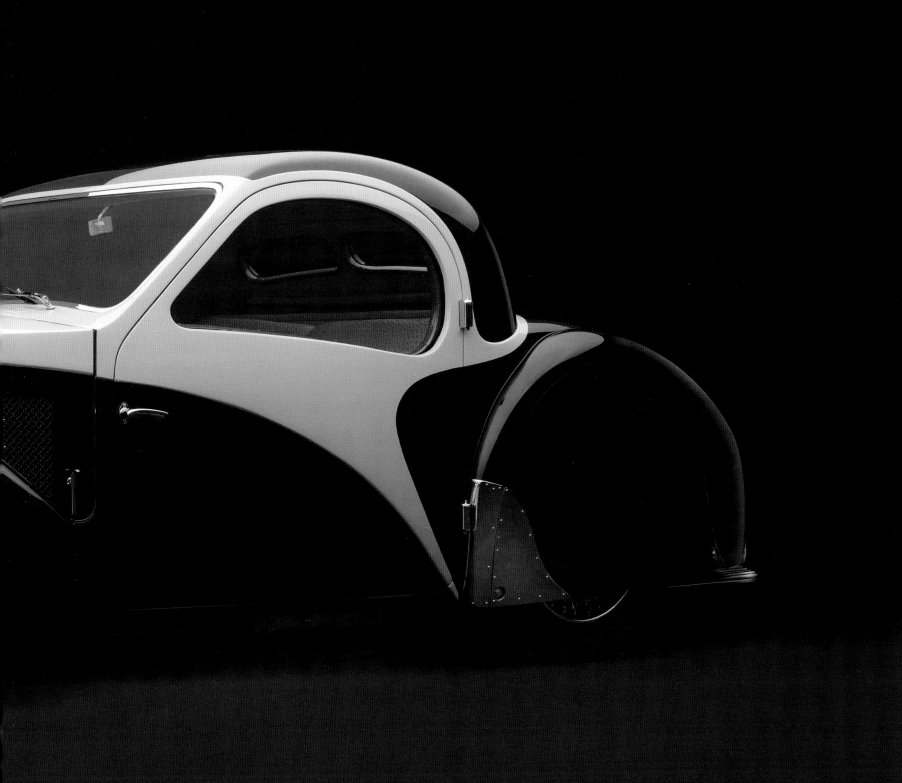

1937
Delage D8–120S
Aérodynamic Coupe

◆

To win but one Best in Show award at the Pebble Beach Concours d'Elegance is a remarkable achievement. To win four times is something else altogether. Sam and Emily Mann won their fourth Best in Show in 2005 with this very car, a 1937 Delage D8-120S with a Pourtout coachbuilt body.

During the year 2005, the Pebble Beach concours honored the Delage marque with a centennial celebration of the automaker's genesis in 1905. Eight cars represented Delage, a company that was eventually absorbed by Delahaye in 1935. Delahaye then introduced a new eight-cylinder engine in 1936 in its D8-100 and D8-120 chassis, which were the basis for a number of cars that were built by the top coachbuilders of the day. This particular car, however, is built on a prototype

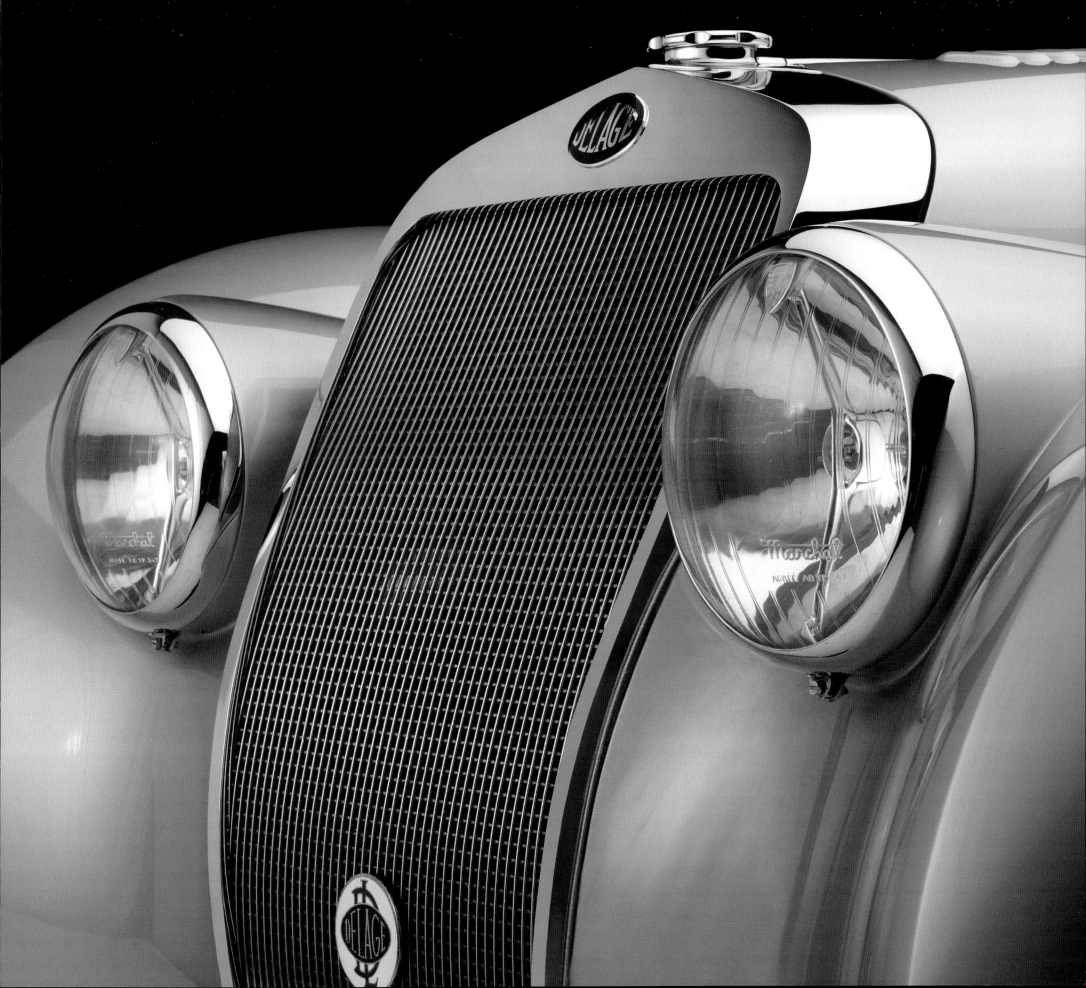

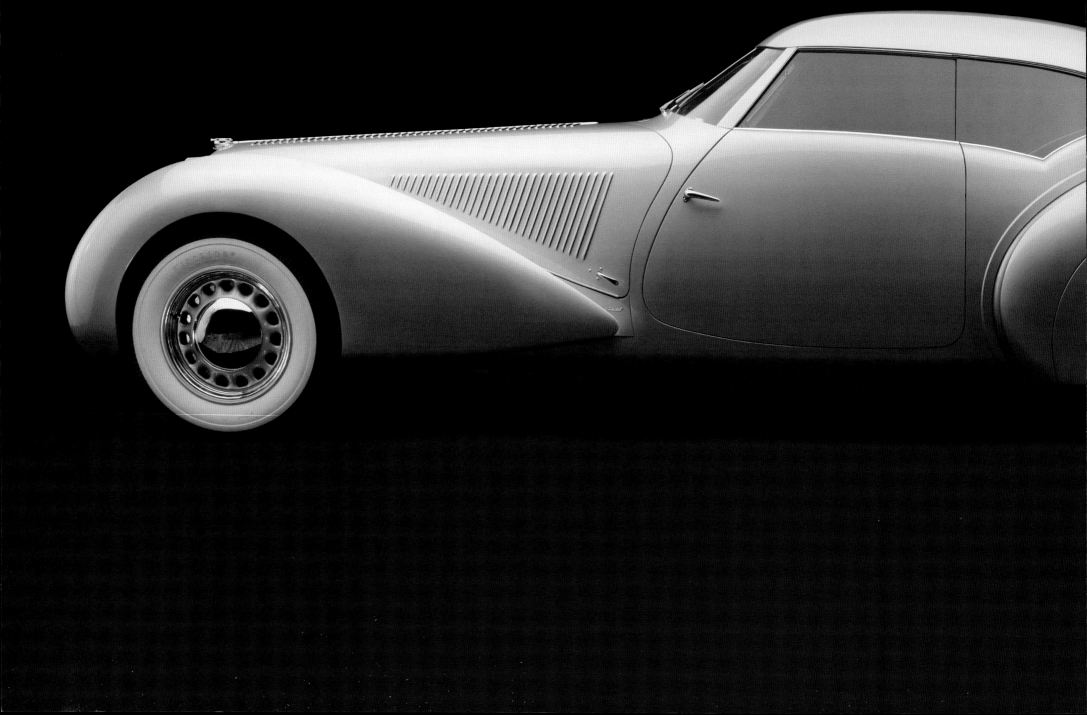

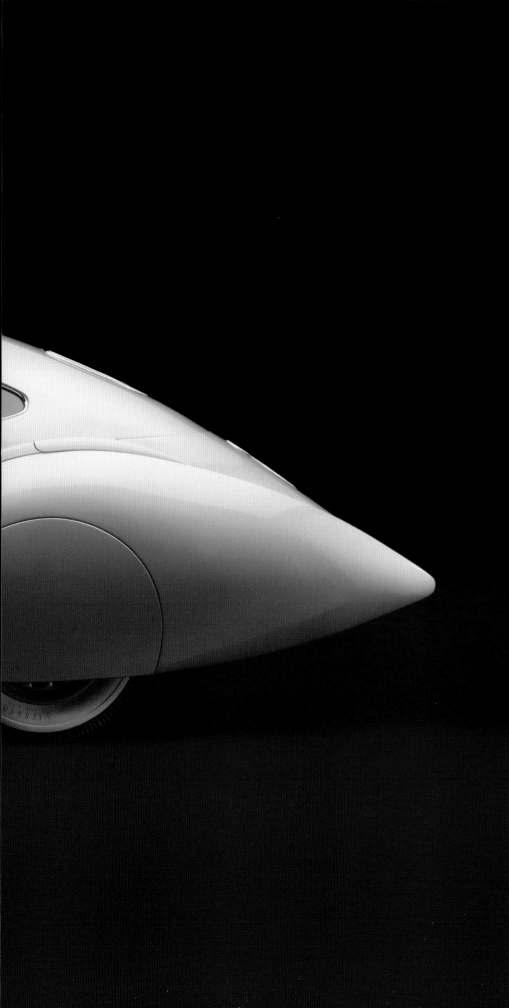

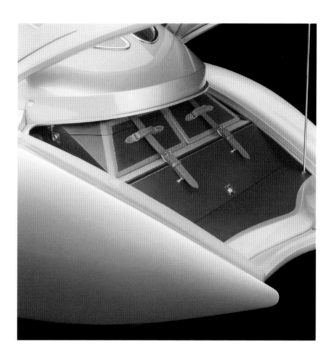

chassis that featured a lowered suspension, a narrow track, and a larger engine.

One look is all you need to know that this is an incredible automobile. The car's laid-back but sharp-framed radiator grille contrasts nicely with the sweeping lines that carry the front fenders back to the cowl scuttle, and the fully skirted rear fenders and sloping roofline back to the car's pointed tail. The side glass is particularly elegant, with no weatherstripping—however practical—wedged between the front and rear windows. There is almost no chrome trim either, nor parking lights or bumpers. An immaculately turned-out engine bay and a set of fitted luggage round out the stunning appearance of this unique automobile.

After Marcel Pourtout completed the car, it debuted at the 1937 Paris Auto Salon. Louis Delage was listed as the car's owner until 1940. It came to the United States in the mid-1950s and went through a series of owners before Mann became aware of the car and was able to purchase it. After more than two years of restoration and body repair, it emerged to the delight of the Pebble Beach audience.

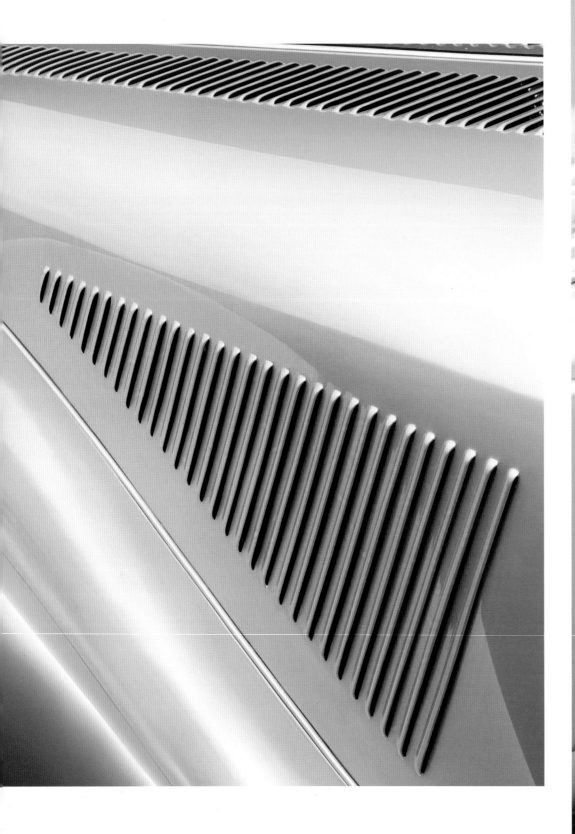

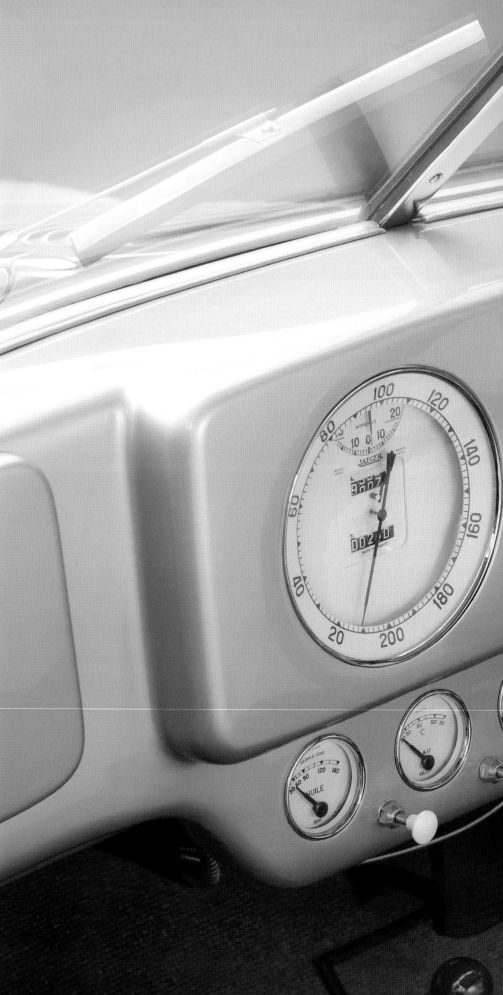

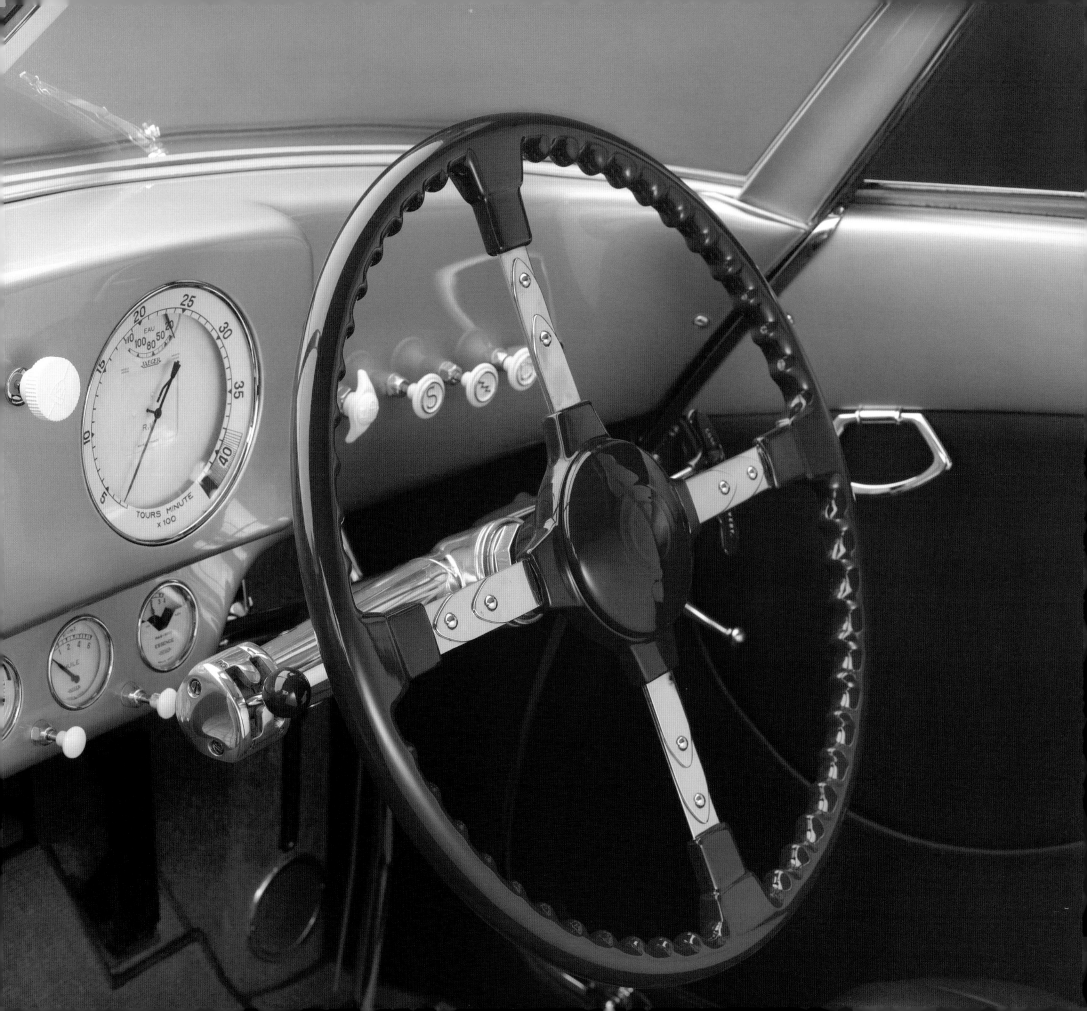

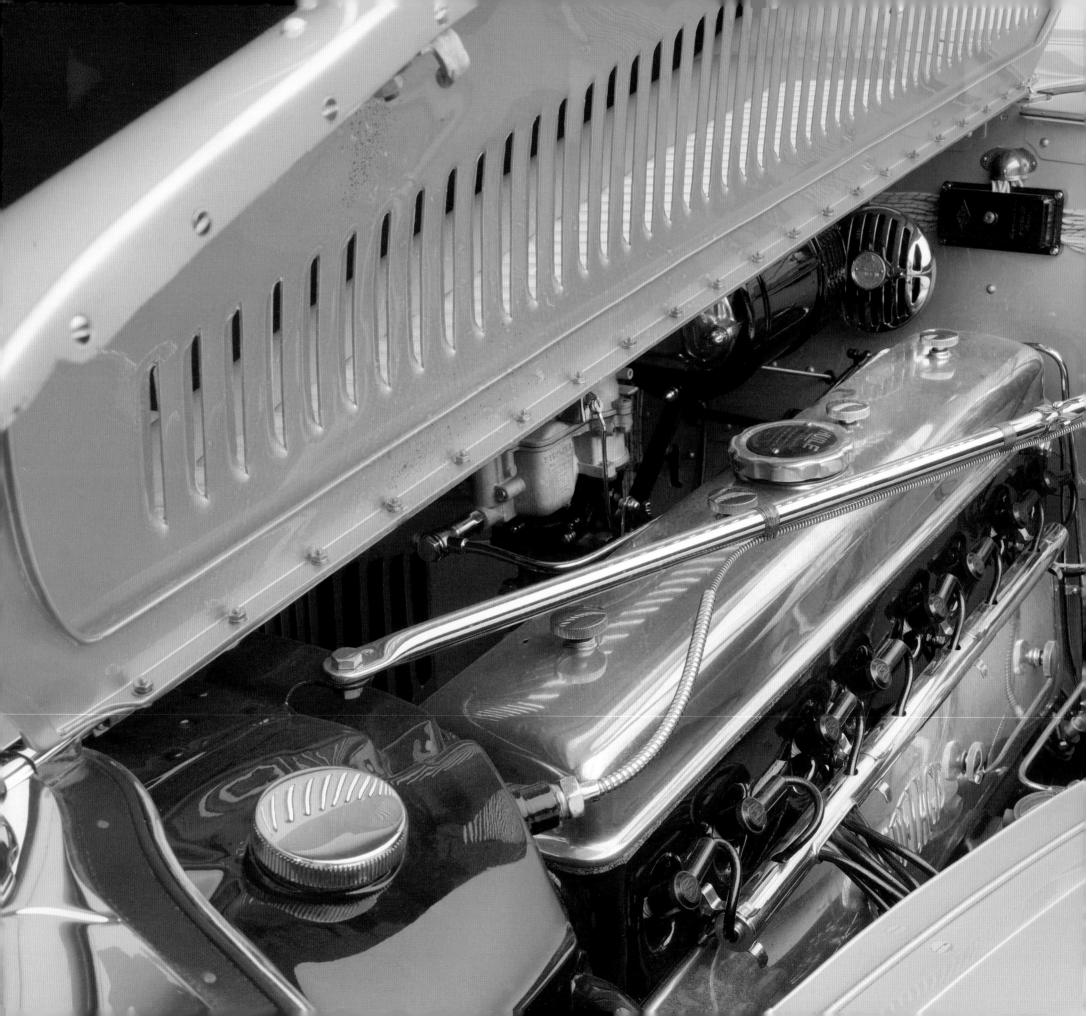

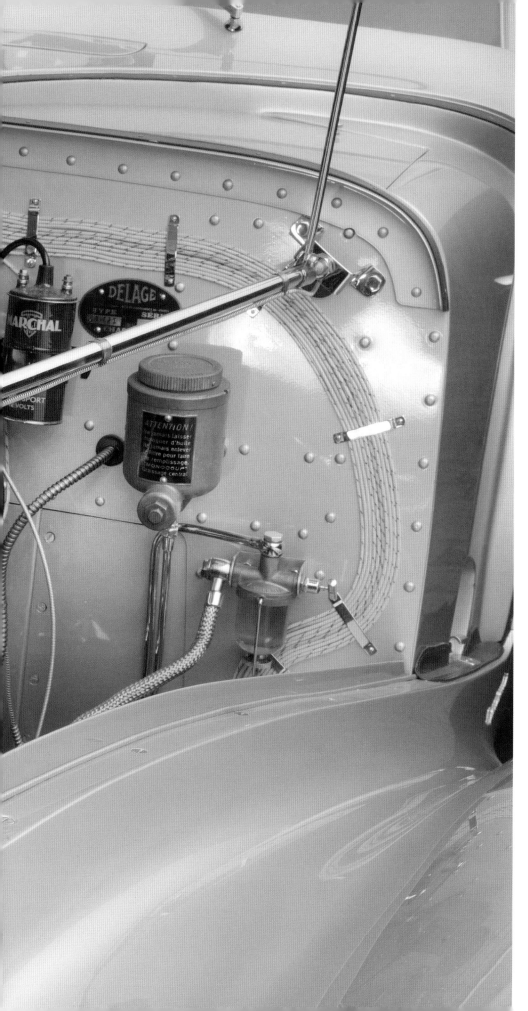

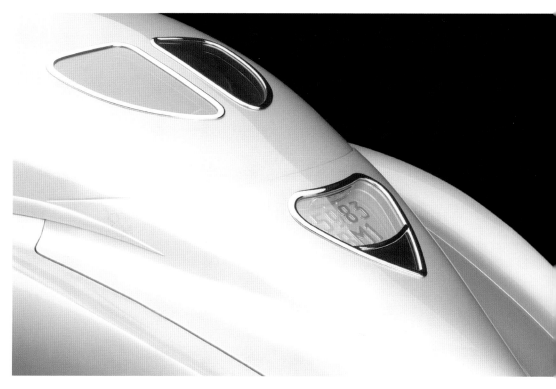

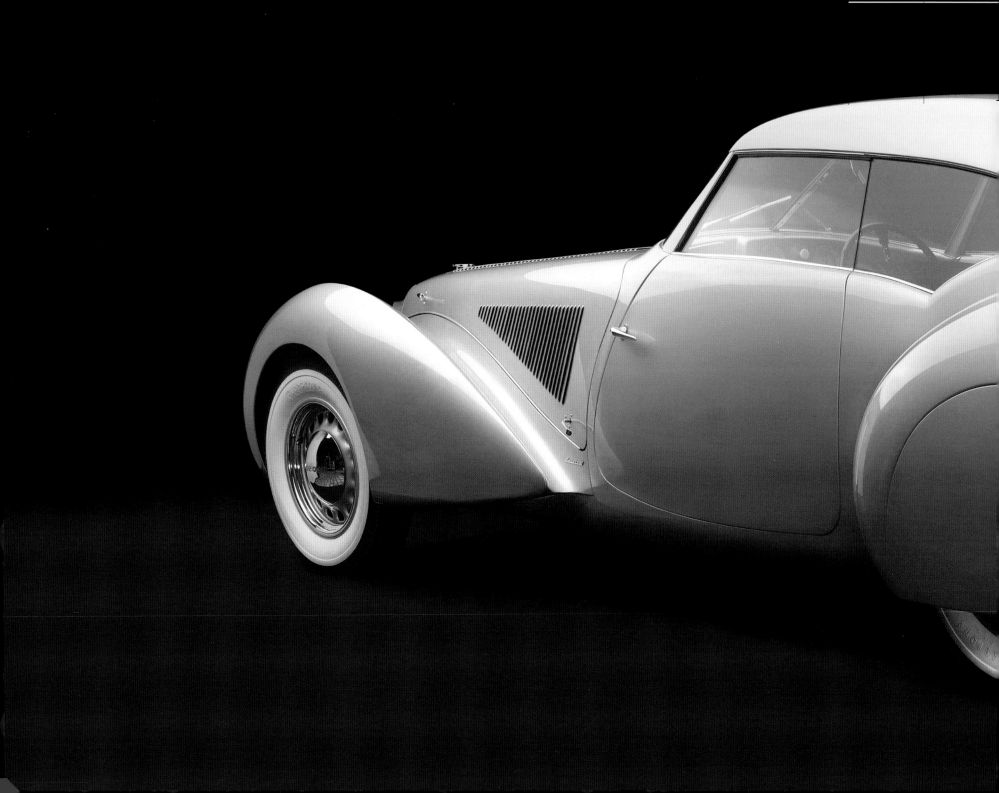

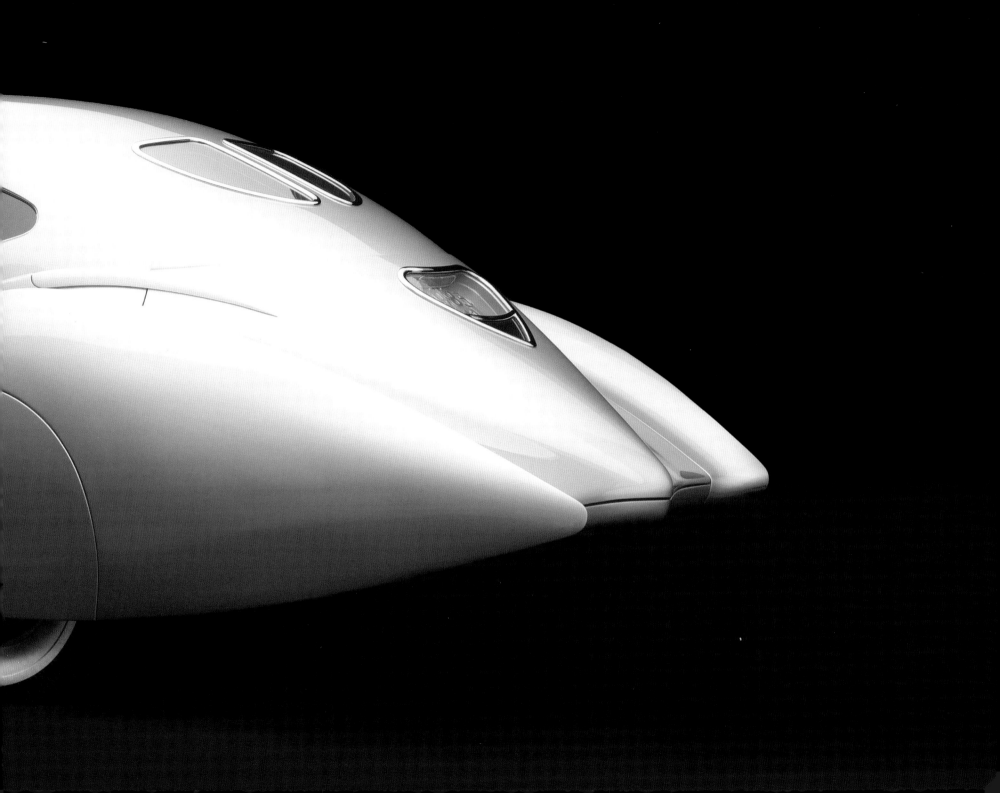

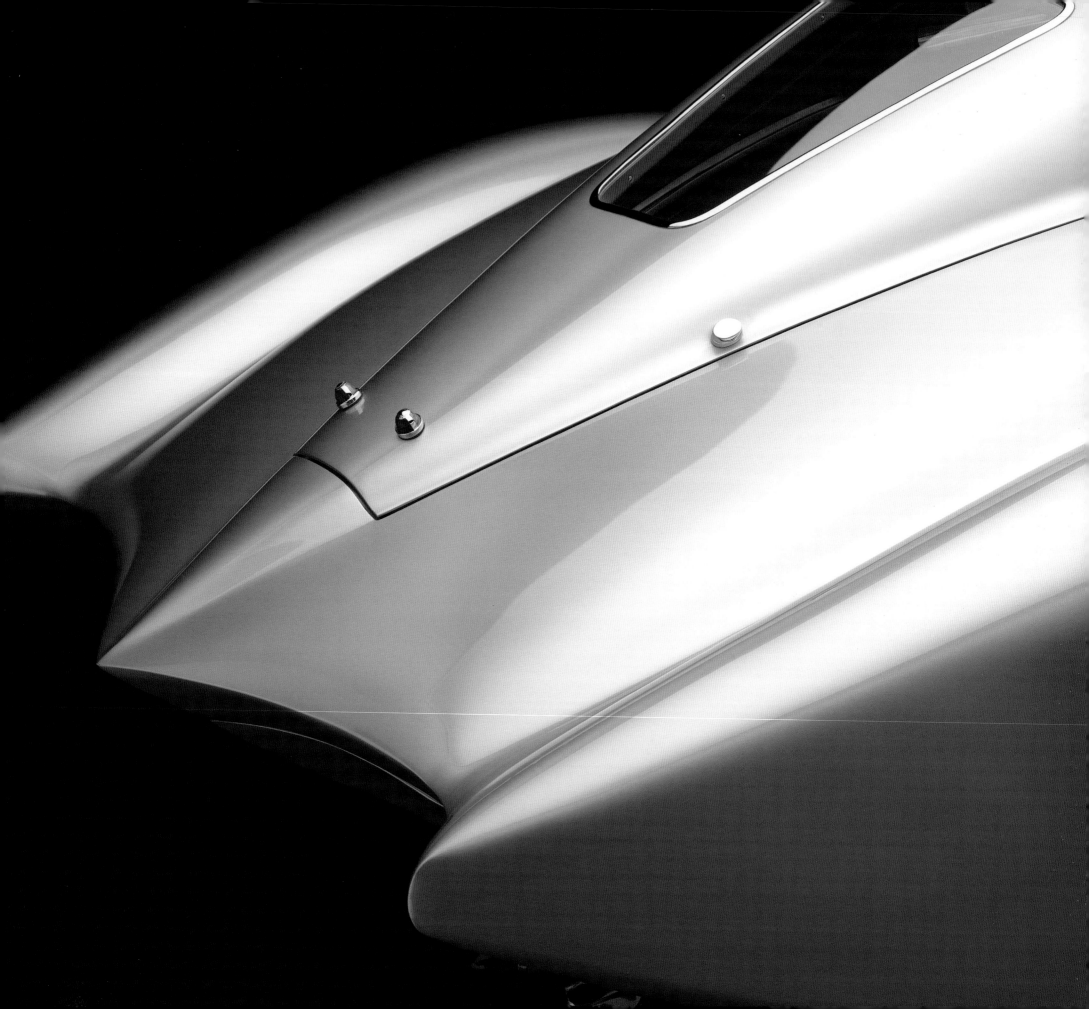

1937
Dubonnet Hispano-Suiza H–6C "Xenia" Coupe

◆

The name "Xenia" evokes the exotic, the unique, and the feminine. This incomparable work of automotive art lives up to that expectation in full. The Xenia is in fact named after the late wife of its initial owner and creator, Andre Dubonnet. The Frenchman, who made a fortune making fortified wines, was also an inventor and racing driver.

Dubonnet loved Hispano-Suiza automobiles and had many custom vehicles built on their chassis. Dubonnet designed a unique independent suspension system, which was fitted to the Xenia. The coupe's bodywork, built by Saoutchik, was designed by Jean Andreau, whose experience in creating streamlined aircraft is obvious.

The car's panoramic windshield was well ahead of its time. No production car would have one until GM brought them out

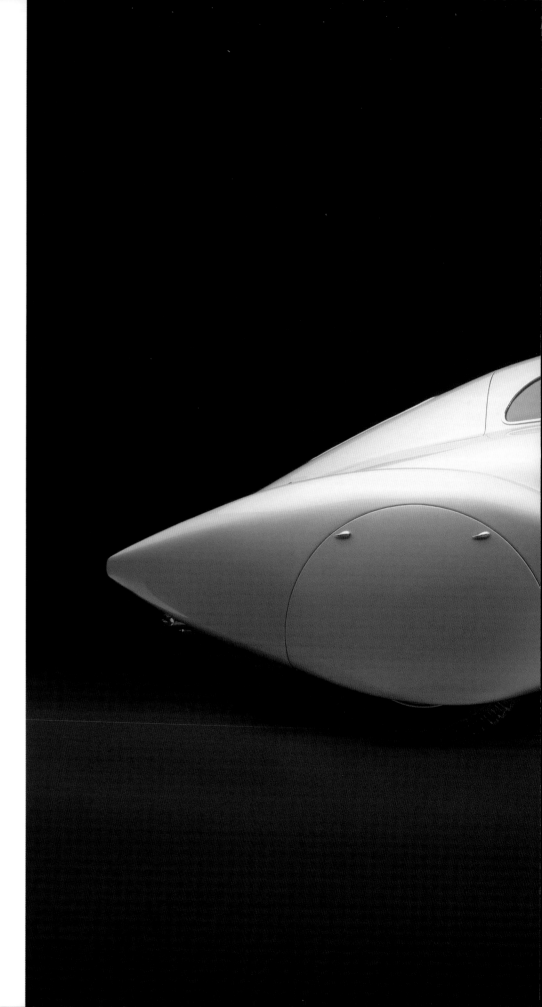

in the 1950s. More curved glass pieces were used to complete the rest of the canopy-like greenhouse, which tops off a fuselage-shaped body. The car's two doors open with a trapezoidal mechanism, while the side windows lift up like a bird's wings.

The front fenders look at least somewhat conventional, but the rear fenders are shaped somewhat like the fairings one would find on the wheels of a streamlined propeller plane, and they taper into a wide, flat tail. The tail's three points, with scallops between, would look at home on the Batmobile.

Under the car's hood is the Hispano-Suiza H6B engine. An inline-six of nearly 8 liters, it has overhead valves and produces 144 bhp (although some believe this car's engine may be upgraded to produce 200 bhp).

The car was hidden away during World War II; after surviving the scourge of war, it reappeared in 1946. After passing through the hands of the president of the French Hispano-Suiza club and others, it was fully restored and shown at the 2000 Pebble Beach Concours d'Elegance. It won Best of Show at the 2009 Goodwood Festival of Speed.

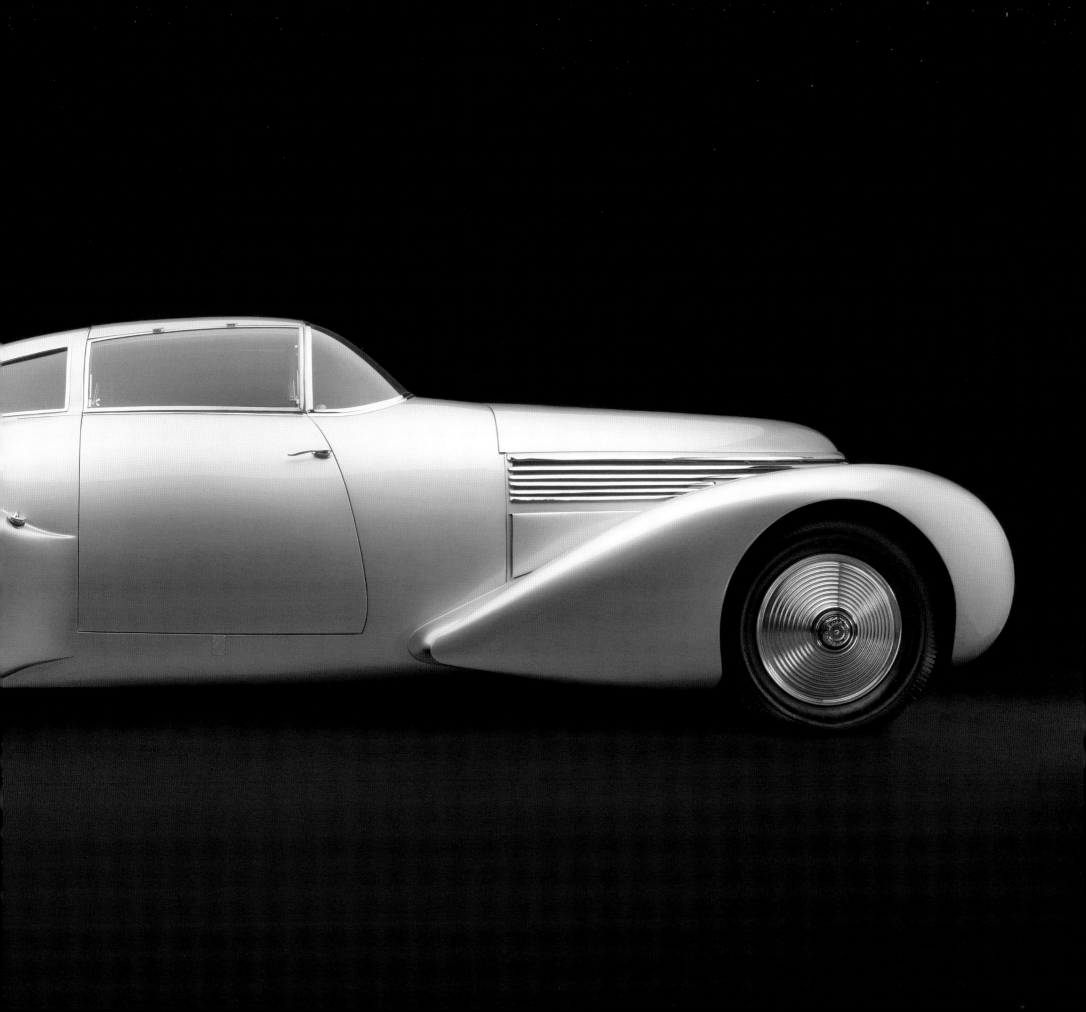

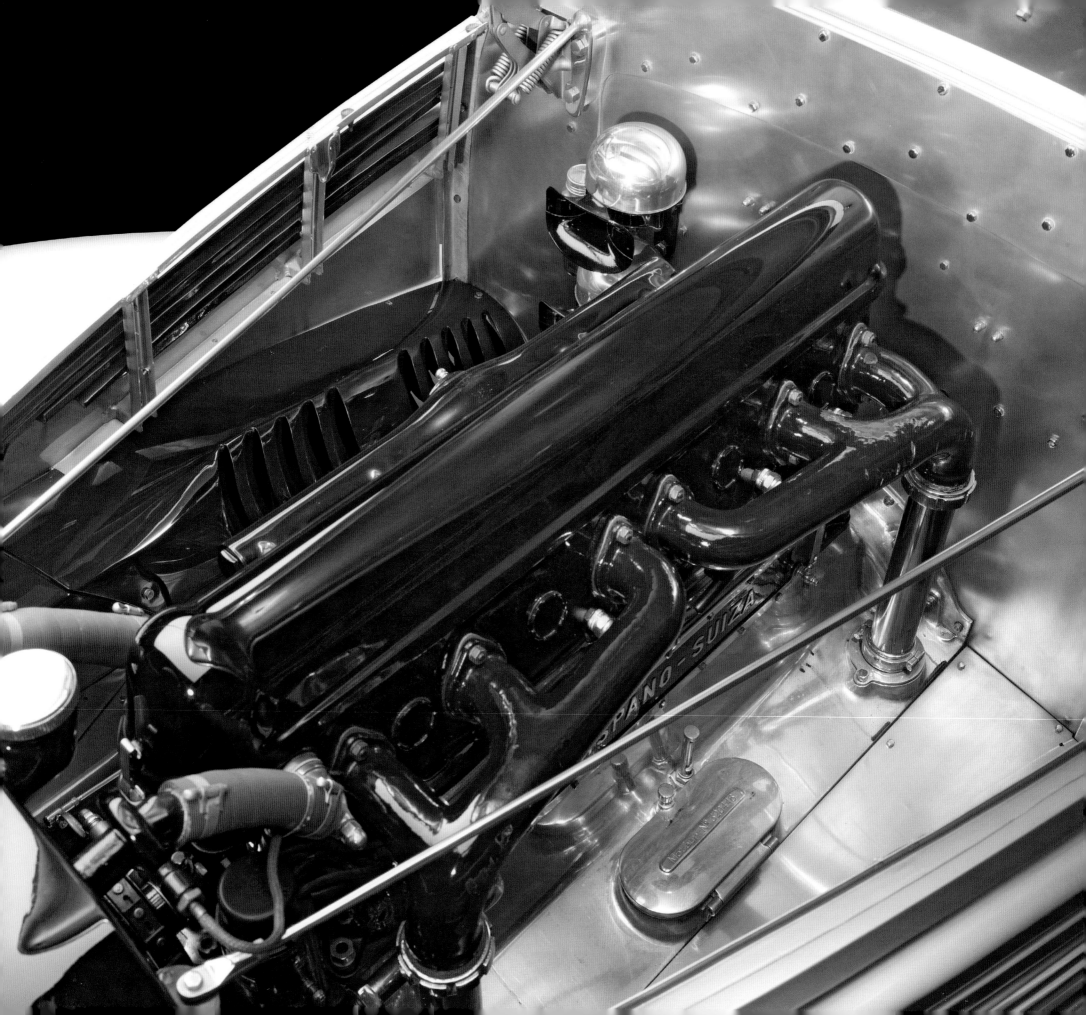

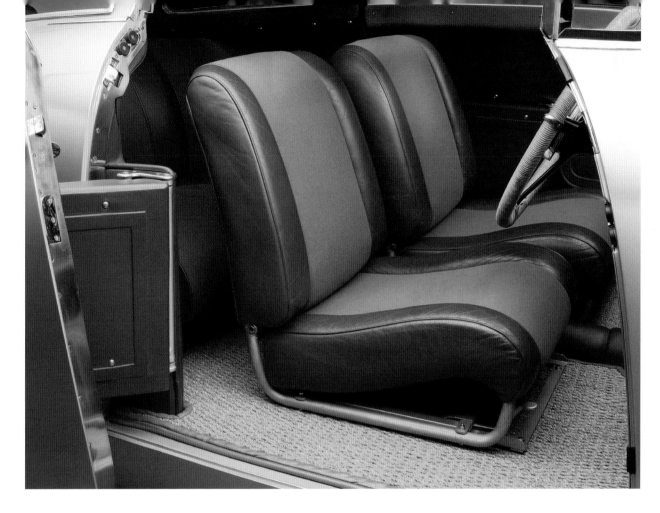

SPECIFICATIONS OF INTEREST

CHASSIS
1932 Hispano-Suiza H6-C

CHASSIS NUMBER
103

ENGINE
OHC, aluminum inline six

TRANSMISSION
Four-speed manual

SUSPENSION
Four-wheel independent "Hyperflex" coil spring suspension

BRAKES
Drums, servo-assisted

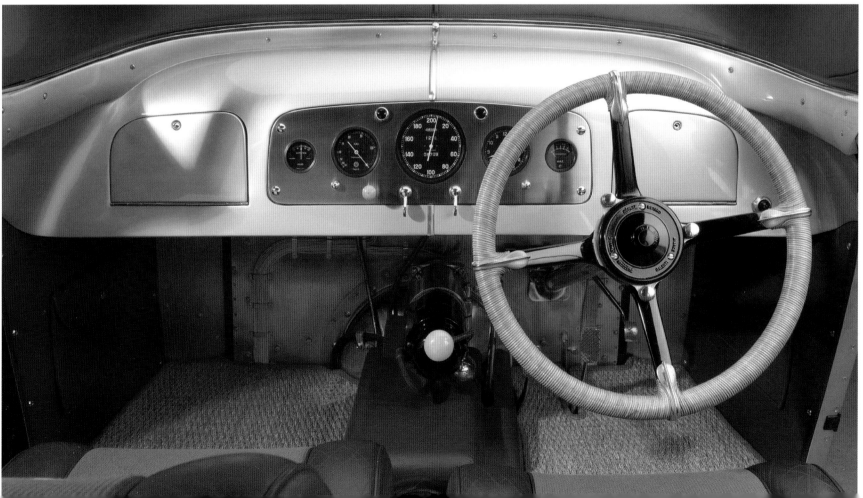

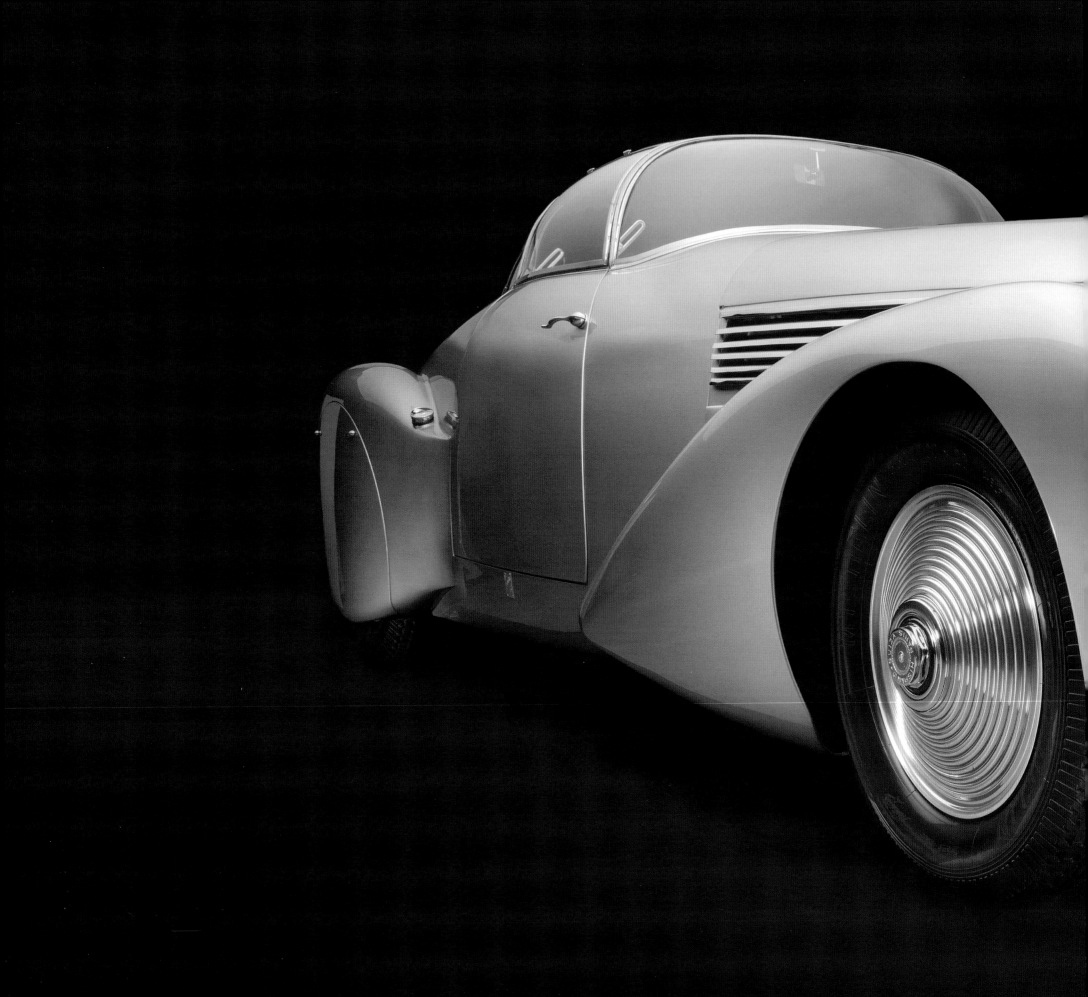

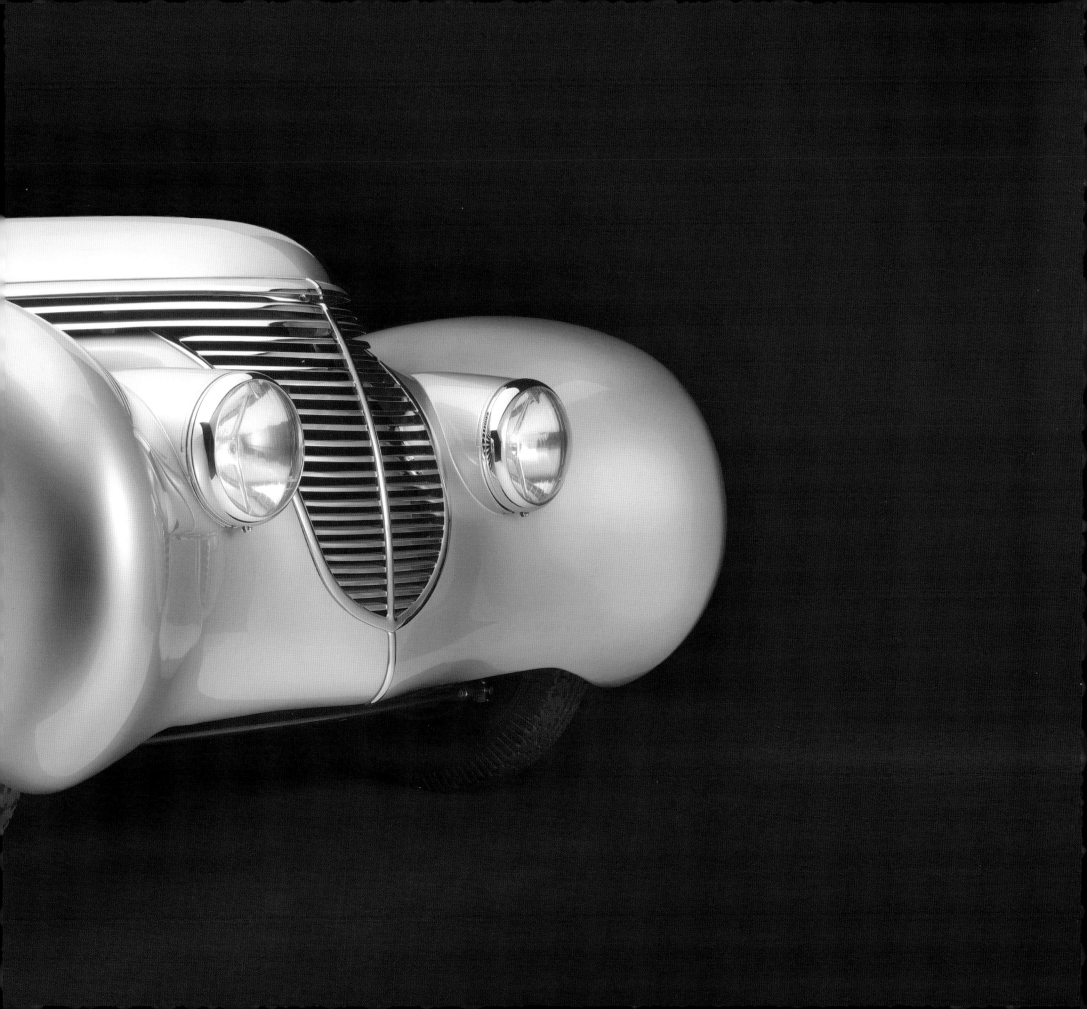

1938
Alfa Romeo 8C2900B

A lthough it could easily be considered one of the more beautiful cars selected for this volume, in fact this Alfa Romeo's looks do not reside at the top of the list of this car's most remarkable attributes.

Instead, it is the innovative construction that makes this elegant coupe stand apart. While the word *superleggera* has been adopted by Lamborghini most recently to describe "super light" versions of its road cars, in fact this term was first used to describe a construction technique that was used to great effect in the 8C2900B. Rather than the conventional body-on-frame arrangement, superleggera construction used triangulated, small-diameter tubing welded together to create a very light, very stiff chassis, upon which a body would be formed and shaped. Maserati's later "Birdcage" racecar, which incorporated superleggera-style construction,

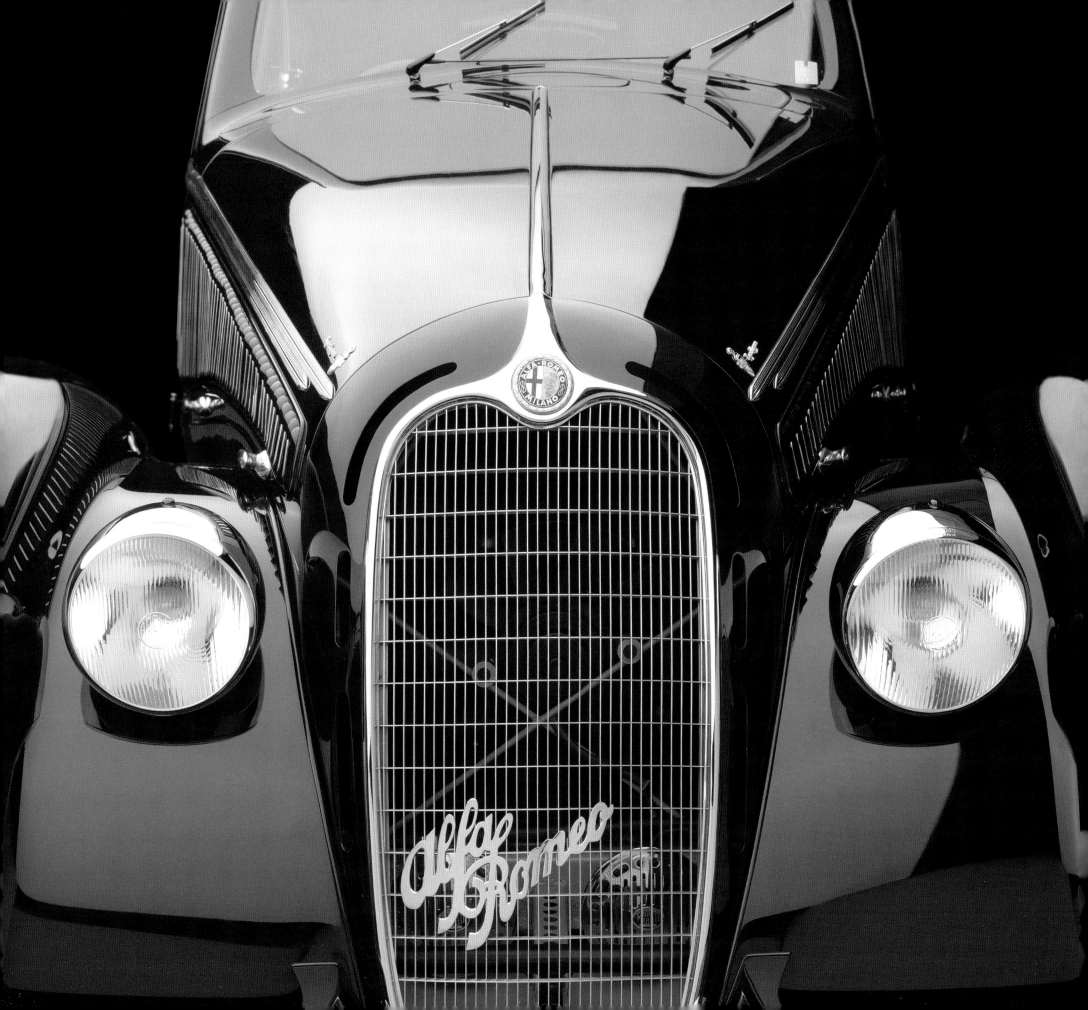

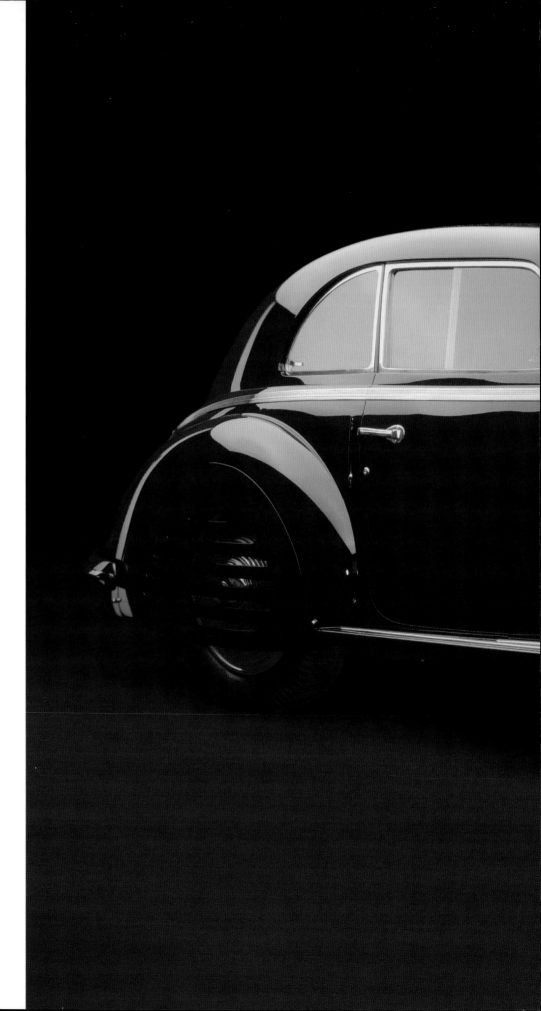

was so named because part of its network of chassis frames was exposed and looked much like a birdcage.

The result was a car that weighed 2,900 pounds when equipped with its hand-formed, aluminum body—at the time, cars of a similar style and size might weigh more than 4,000 pounds. This certainly helped the car perform, so much so that this particular car, chassis number 412035, was the winner of the inaugural Watkins Glen Grand Prix in 1948.

Underneath the car's Corrozzeria Touring body, the car has a twin-supercharged straight eight under the hood that produces 180 bhp. It also has independent front and rear suspension and hydraulic drum brakes. Each of the 40 or so examples of this car that were built is different; this one can be identified by its slotted rear fender skirts and the side-hood louvers that extend into the cowl scutttle.

Upon its restoration this Alfa Romeo was shown at the 2008 Pebble Beach Concours d'Elegance, where it won best of show. It repeated that performance at the 2009 Villa d'Este Concorso in Lake Como, Italy.

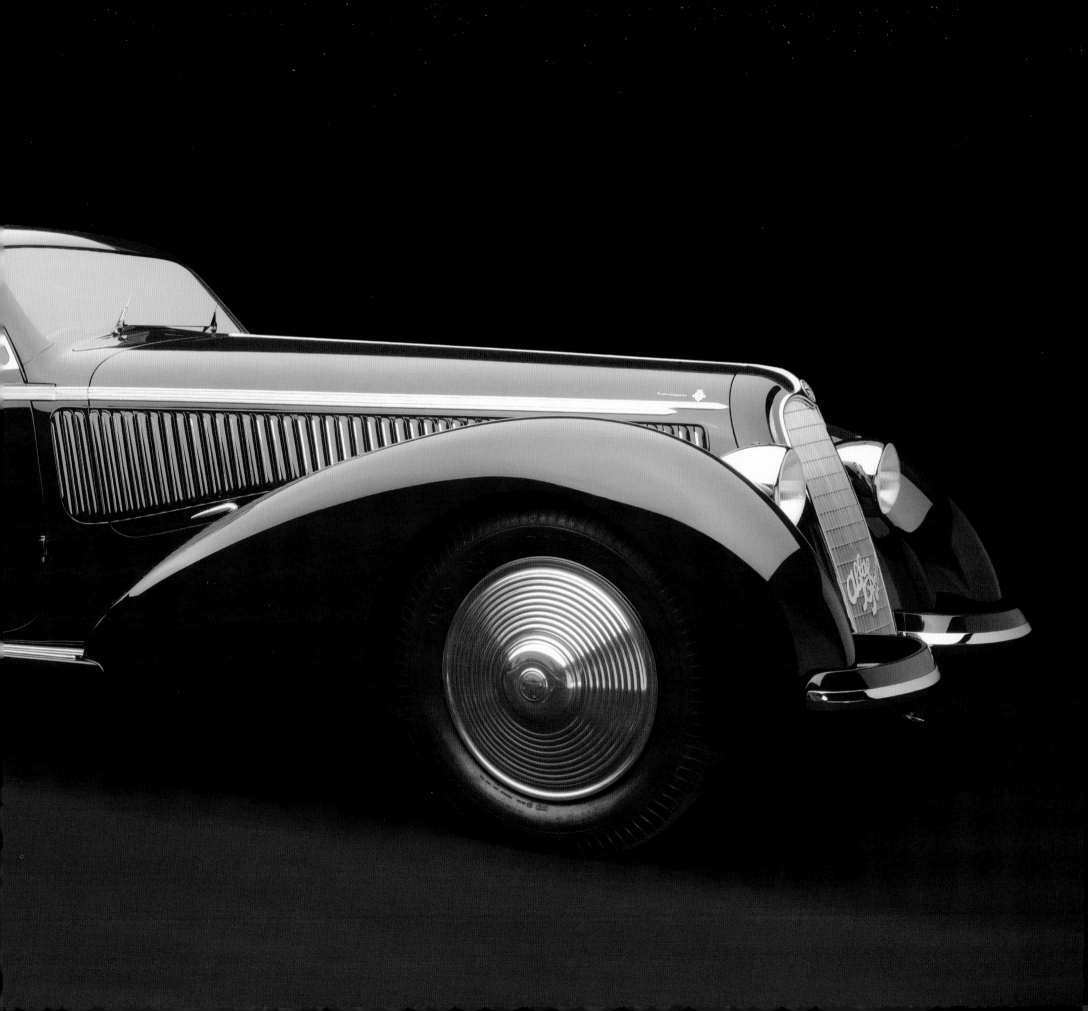

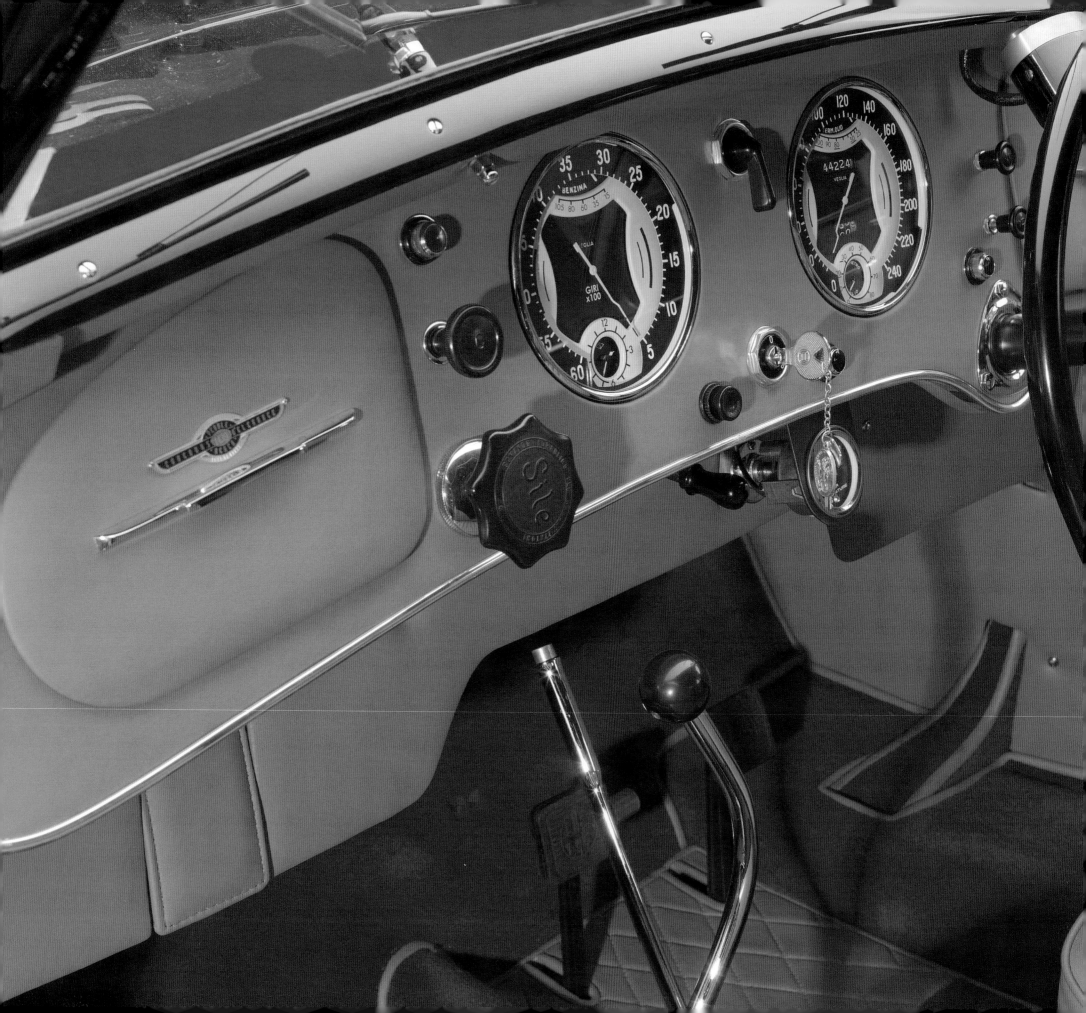

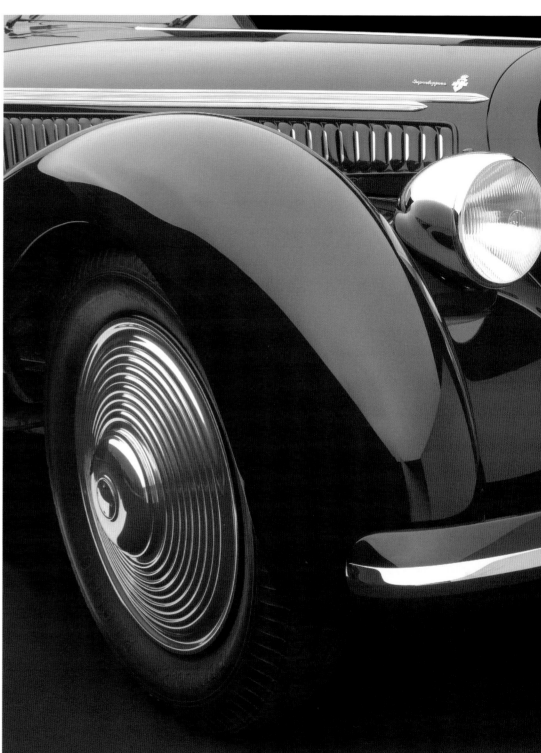

SPECIFICATIONS OF INTEREST

BODY STYLIST
Felice Bianchi Anderloni

ENGINE
DOHC, two valves per cylinder, all-alloy straight eight, 183ci/ 3.0 liters

SUPERCHARGERS
Twin Roots-style

WHEELBASE
118.1 inches/ 300cm

FRONT SUSPENSION
Double trailing arms, coil springs, hydraulic dampers

REAR SUSPENSION
Swing axles with radius arms, transverse elliptic leaf spring, hydraulic and friction dampers

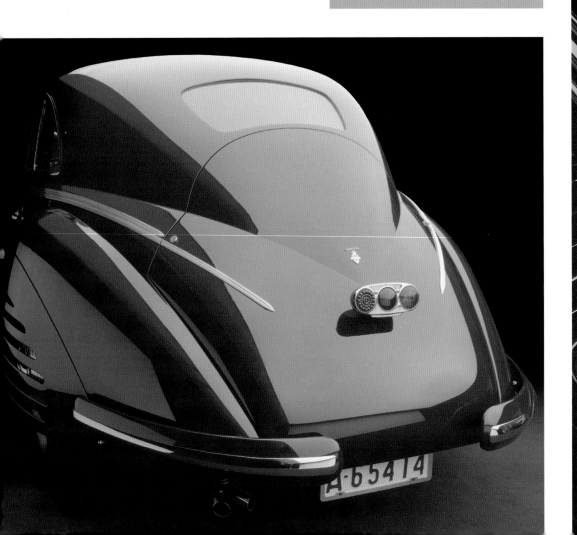

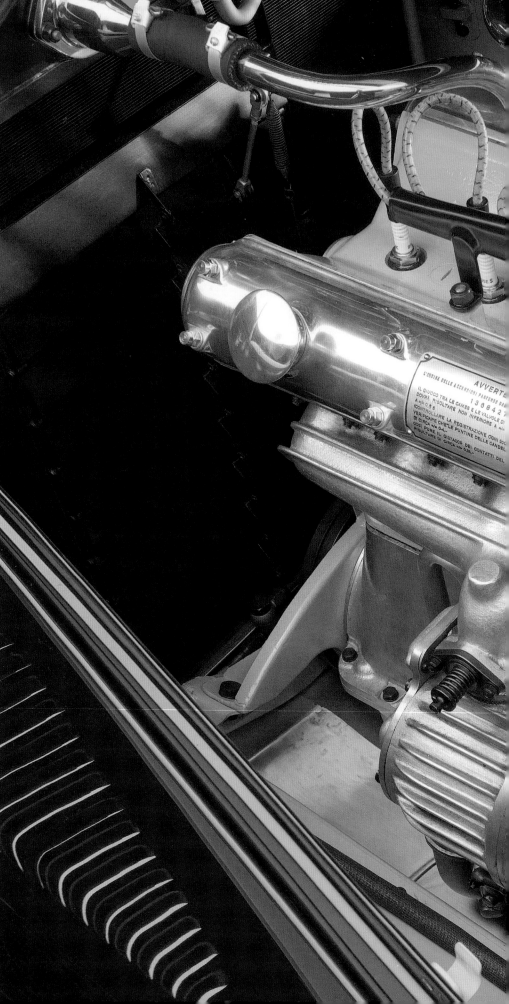

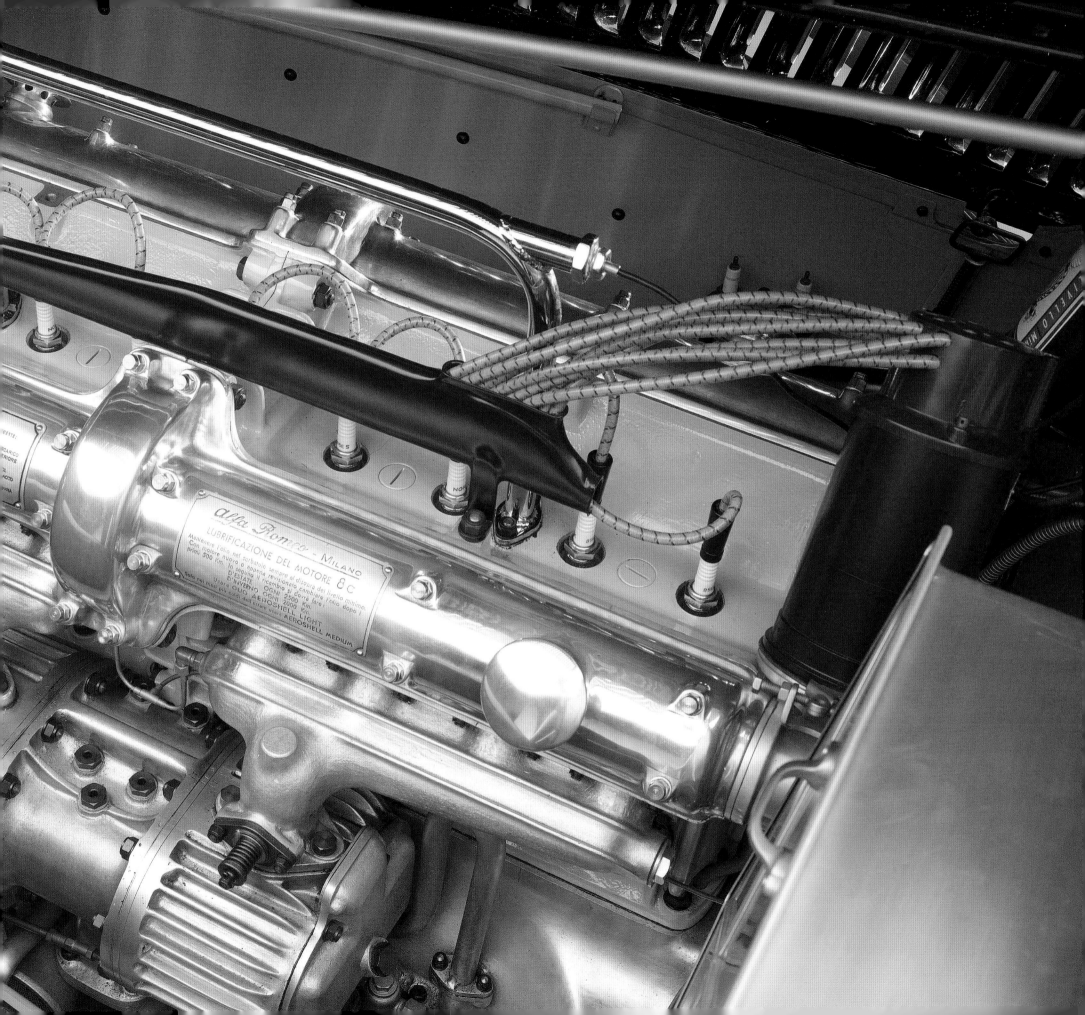

numbers today, let alone 80 years ago. Underneath its long hood is the Duesy's speed secret: a centrifugal supercharger, an uncommon feature in a production car, to say the least.

The 1934 Silver Arrow was built by Pierce-Arrow as an exclusive luxury car to top all that The Town & Country, despite being the newest car in this book, reaches backward to incorporate wood in its construction to a degree matched by few cars before or since. All of these sedans, for different reasons, exemplify the art of design and engineering that make any car a work of art.

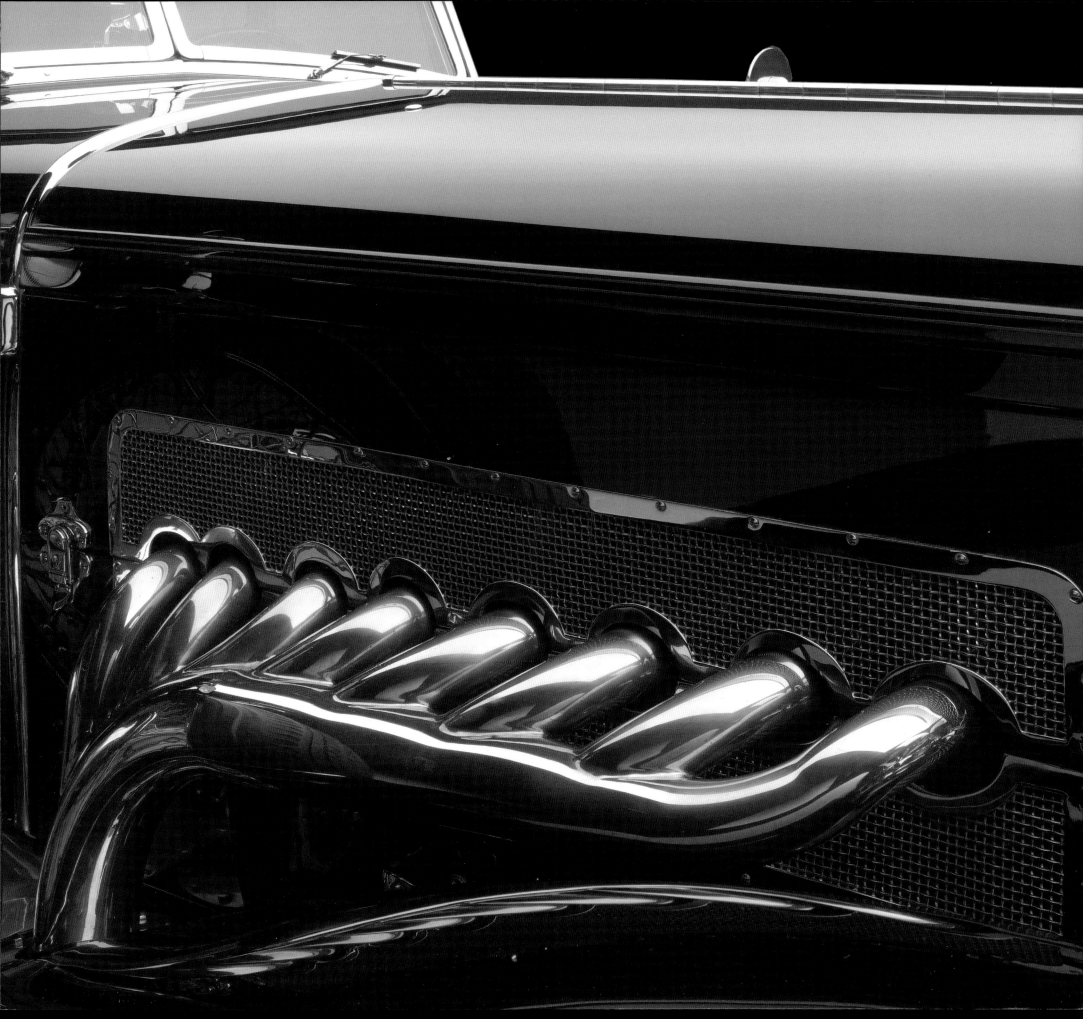

1931
Duesenberg SJ Convertible Sedan

◆

The Duesenberg marque is truly one of the most out-standing in American automotive history, particularly in terms of the excellence of the cars it produced. As part of the Auburn-Cord-Duesenberg company, headquartered in Indiana, the brand got its name from the Duesenberg brothers, August and Fred, who had built Indianapolis 500–winning race cars. Some 481 Series J Duesenbergs were built following the model's introduction at the 1928 New York Automobile Salon.

Like many of the automakers of the era, the Duesenberg company focused on building chassis and engines, letting outside coachbuilders create bodywork suited to the demands of the end customer. This Duesenberg SJ Convertible Sedan was, according to historian Randy Ema, unusual in that the

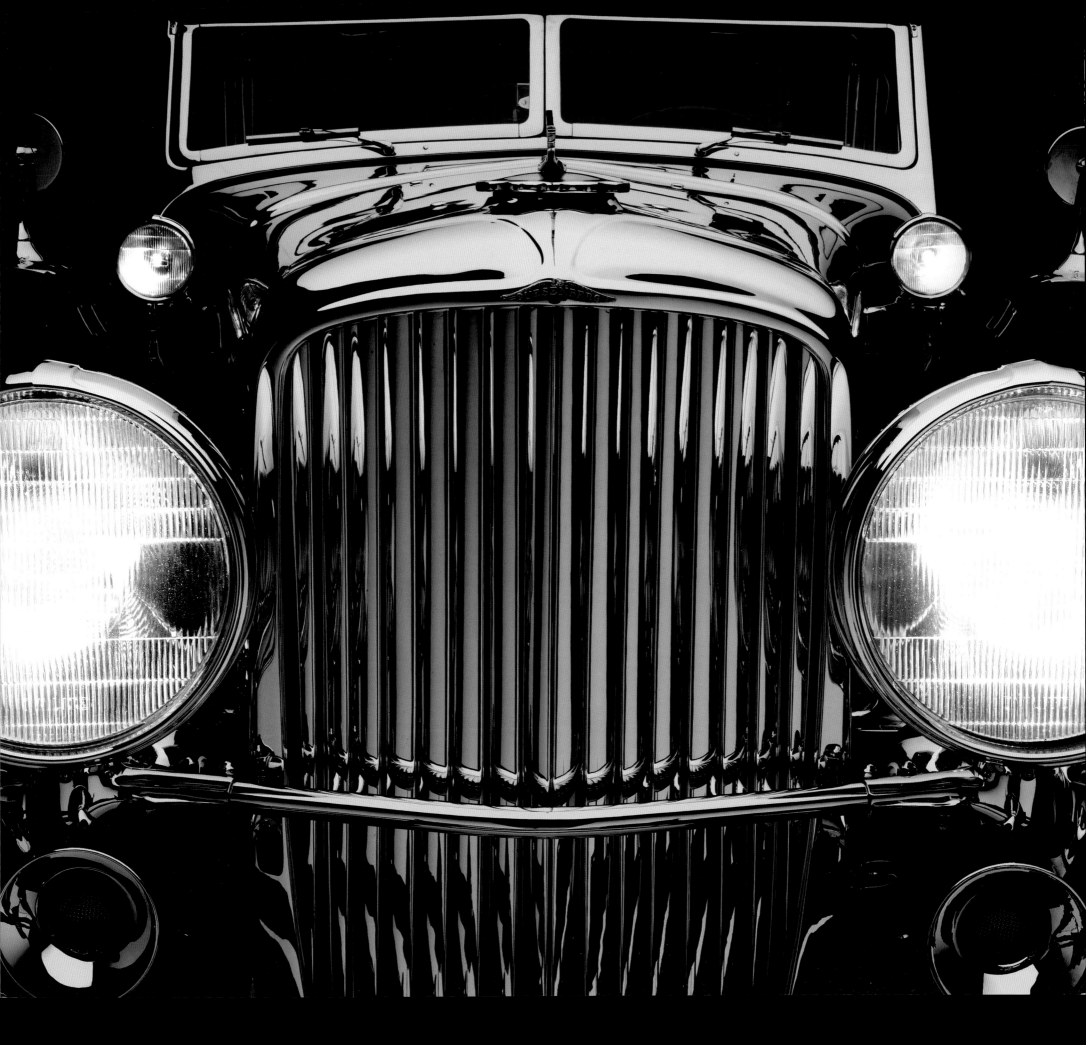

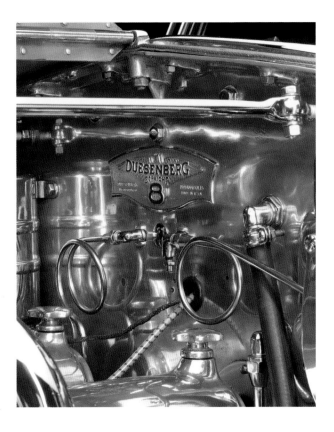

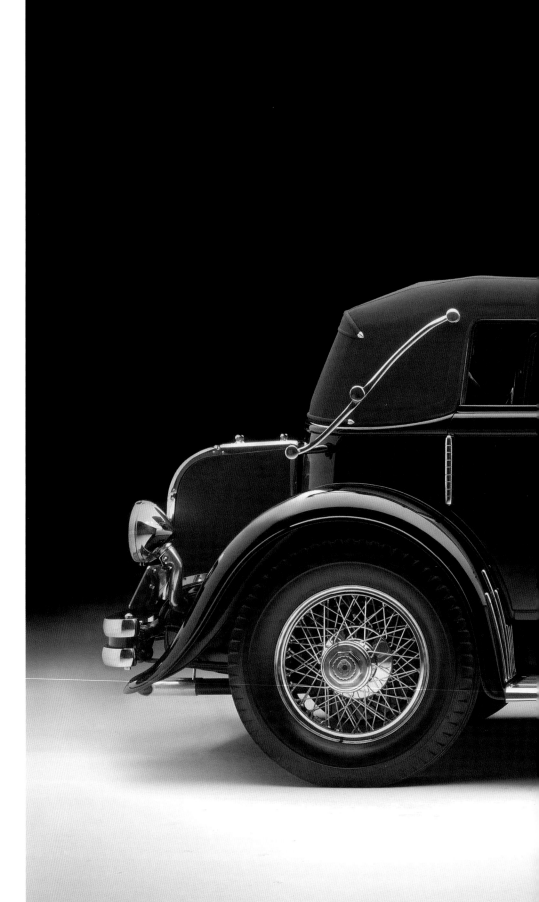

body was ordered by the Duesenberg company, not a customer. This gave Duesenberg a car to have on hand which could be shown to prospective customers.

The car is built on Duesenberg's 142.5-inch, short-wheelbase chassis. Duesenberg's Gordan Buehrig designed the body, which was built by the Derham Custom Body Company.

Like many Duesenbergs this car is quite massive; in typical Duesy fashion, however, its 420 cid Model J engine is up to its job. The engine is a four-valve, double overhead-cam straight eight. As denoted by the car's SJ designation, it is equipped with a supercharger to build even more power. Unlike many Duesenbergs, this engine has a beautiful 8-into-1 exhaust manifold that emerges from the side of the hood, rather than the characteristic four flex pipes. The engine could propel this 6,000-pound-plus behemoth to more than 130 mph—a notable speed for a passenger car of the time.

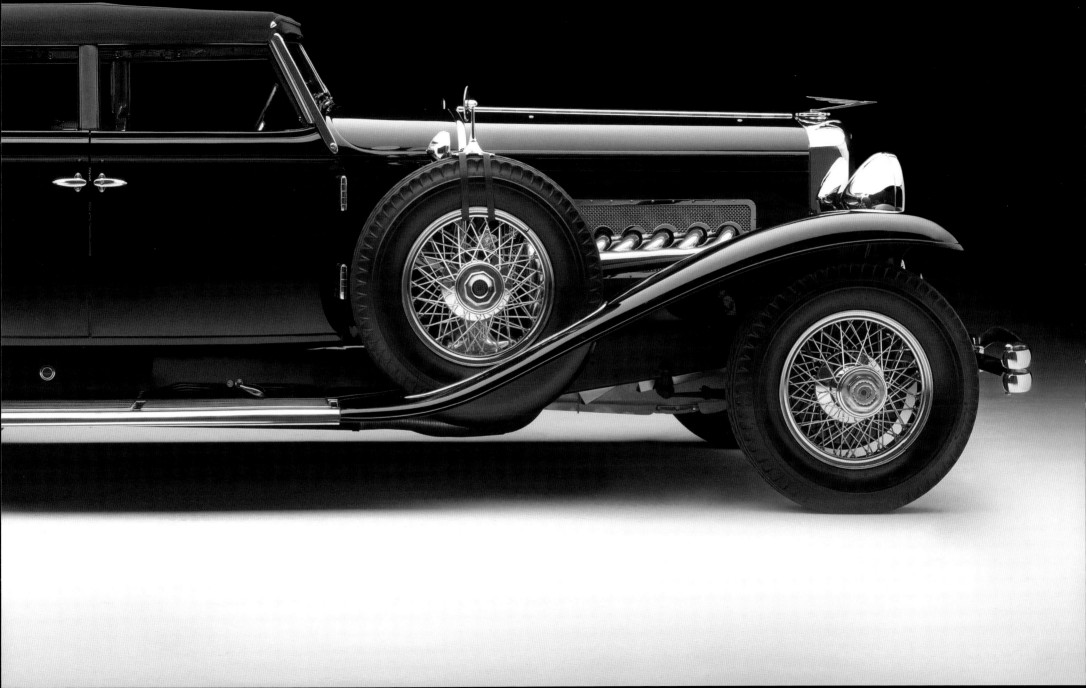

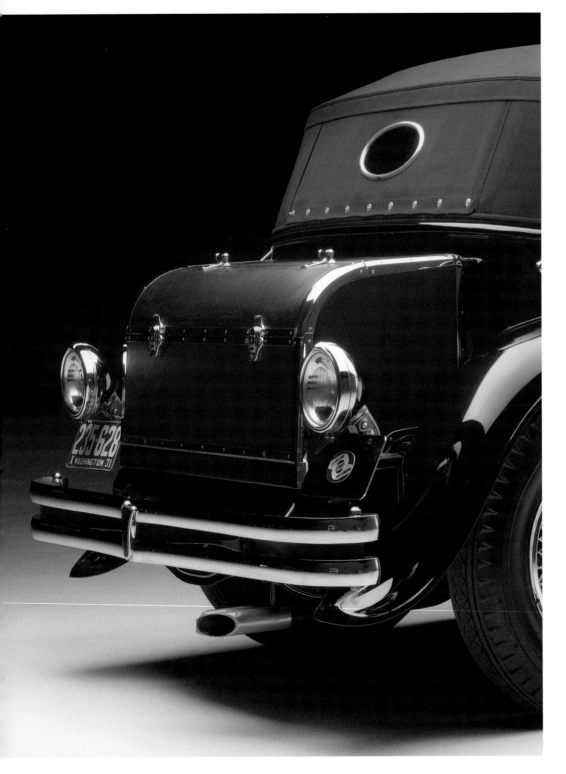

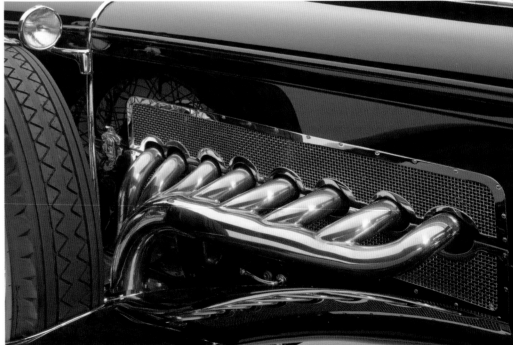

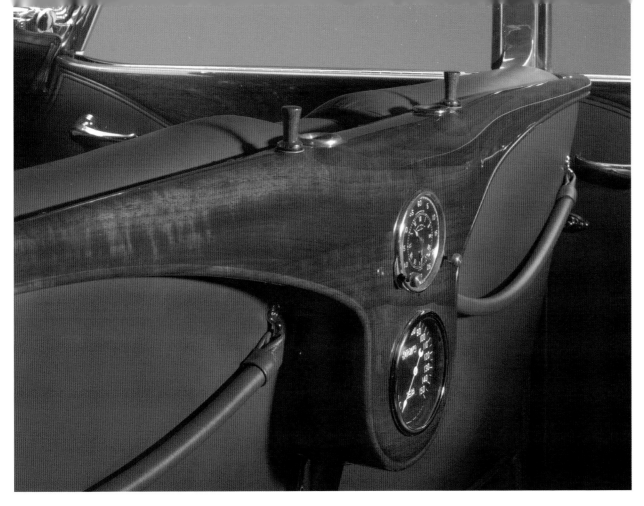

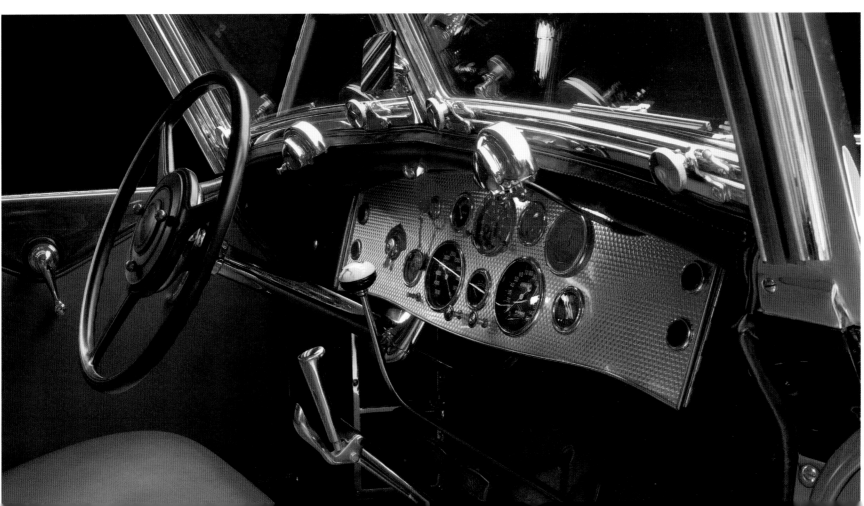

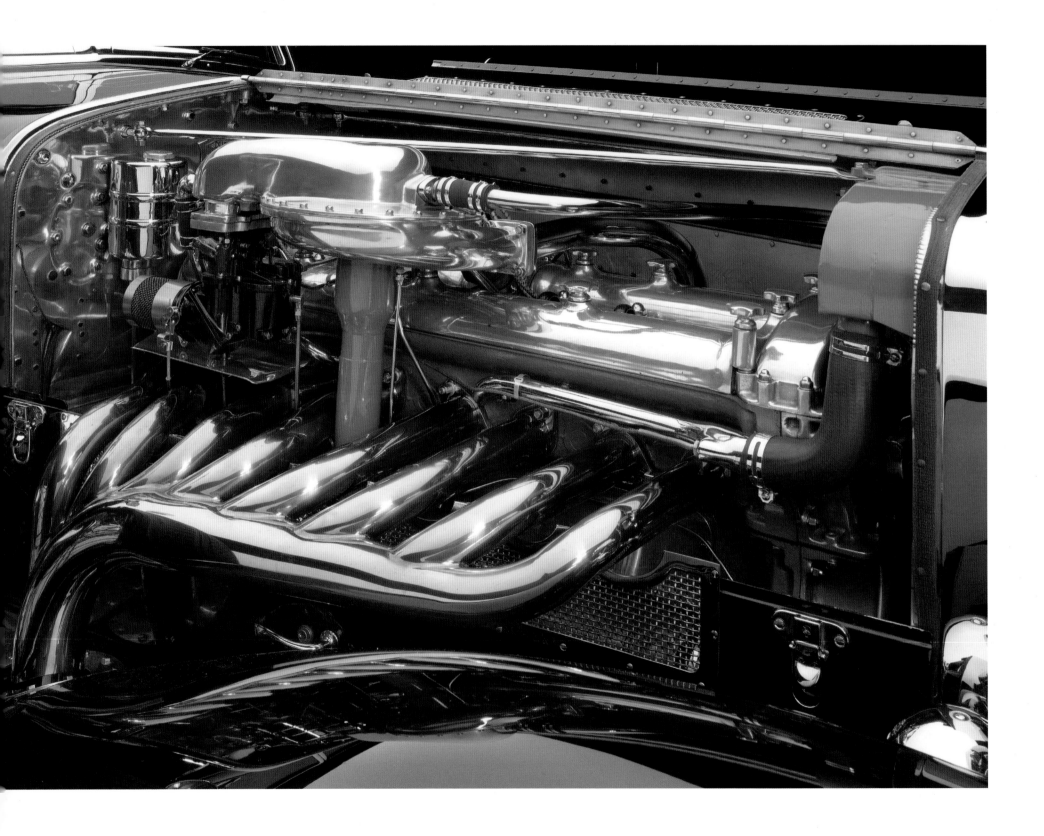

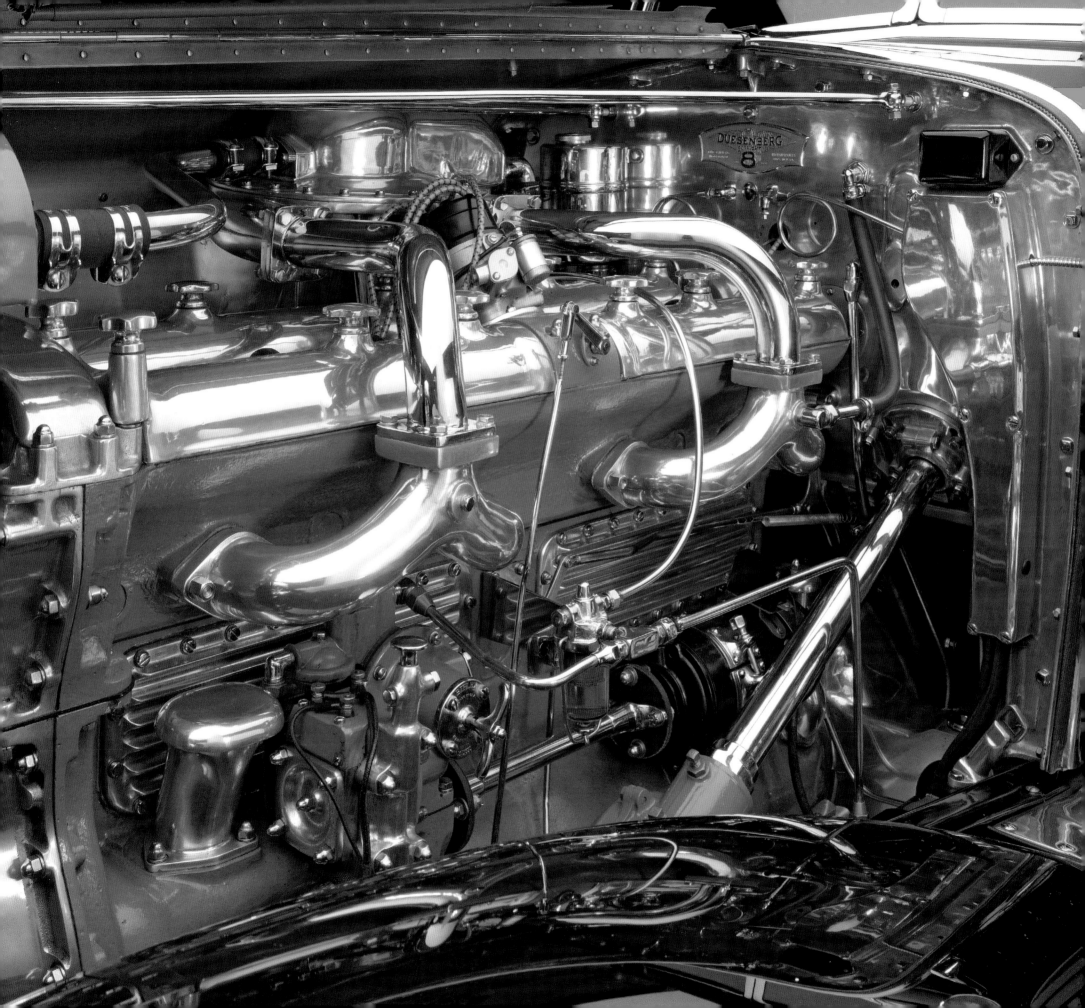

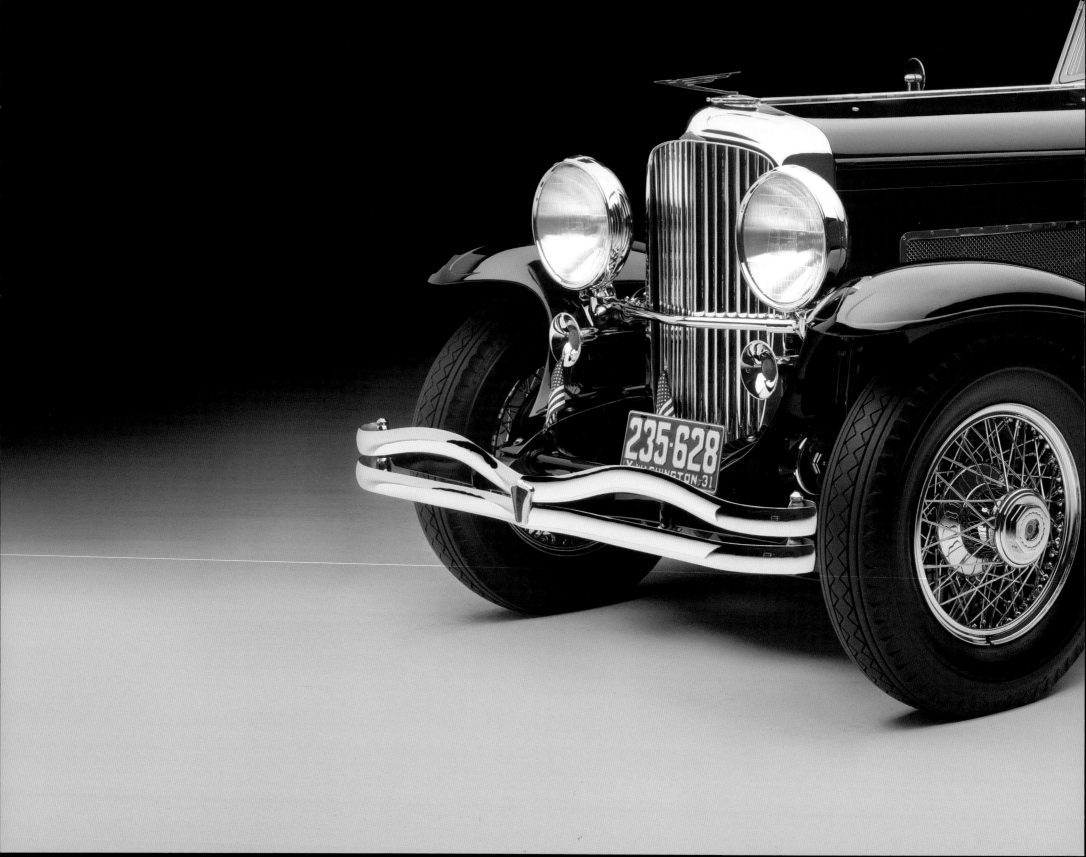

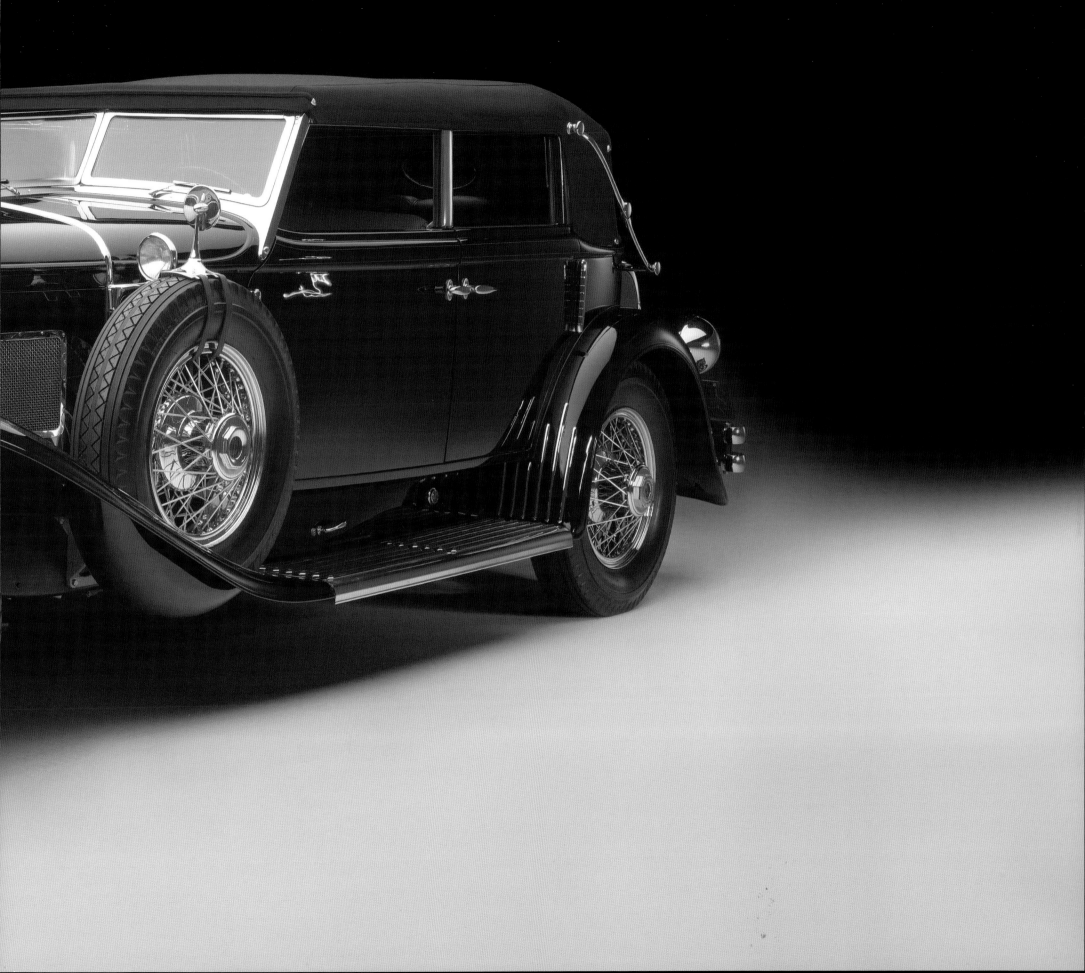

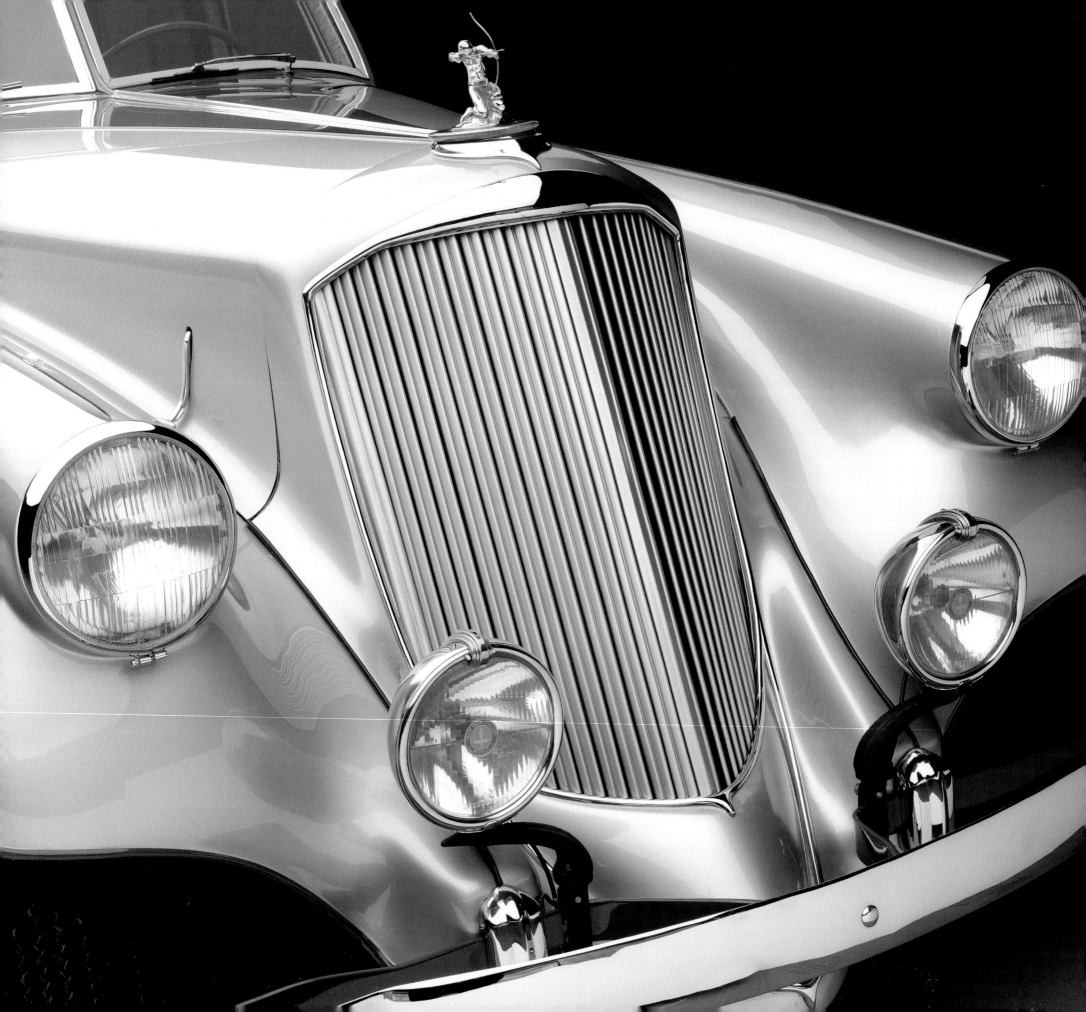

1933
Pierce-Arrow Silver Arrow

◆

Pierce-Arrow built fine luxury cars from 1901 through 1938—a remarkably long time in an era of great attrition among auto manufacturers. The firm did eventually succumb during the long years of the Great Depression, but not before it produced a luxury car to top all its previous efforts—the Silver Arrow.

Only five Silver Arrows were produced, and only three examples survive today. This car, the first Silver Arrow to be publicly auctioned since 1973, was sold for $2.2 million at the January 2012 Barrett-Jackson auction in Scottsdale, Arizona.

Introduced at the New York Auto Show in 1933, the Silver Arrow broke new ground with its forward-thinking styling. Most notably, the Silver Arrow did away with running boards; instead, its front fenders flowed straight back into a slab-sided body, an arrangement other manufacturers would soon imitate (though usually without hiding spare tires within said fenders,

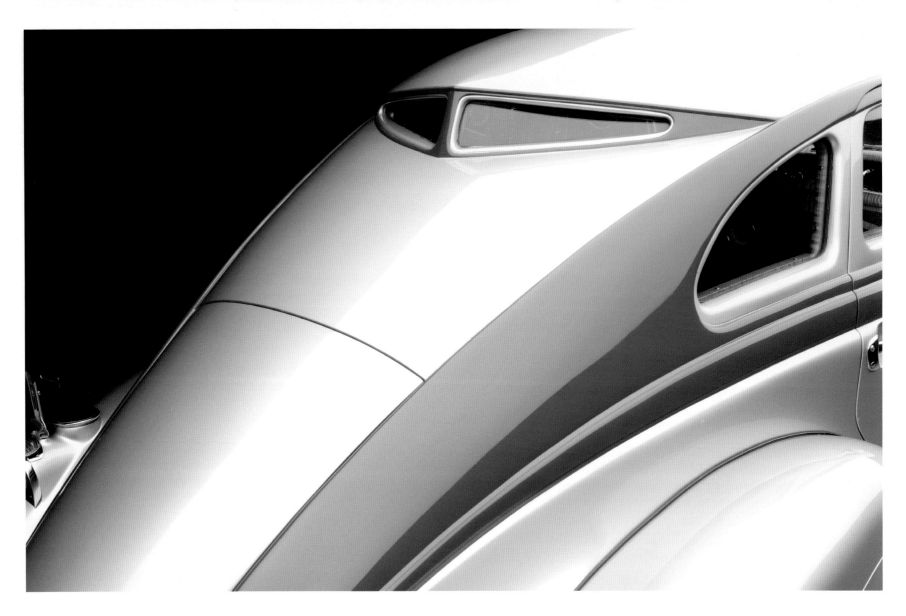

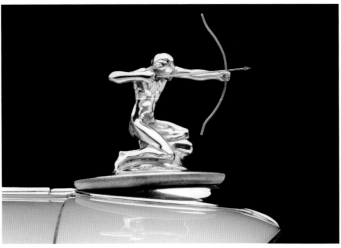

as the Silver Arrow did). The fenders also integrated the car's headlamps, as opposed to the conventional practice of mounting the lamps on separate brackets.

At the very front of the car was a dramatically leaned-back waterfall grille that added to the car's sensation of speed. The defining feature of the rear was the pair of tiny, triangular rear windows mounted up high—a clear example of form trumping function, as can happen with any vehicle so stylish.

A long V-12 lay under the car's hood, providing 175 horsepower—enough grunt to push the big car past 115 mph, and enough to earn the vehicle pace car duties for the 1933 Indianapolis 500.

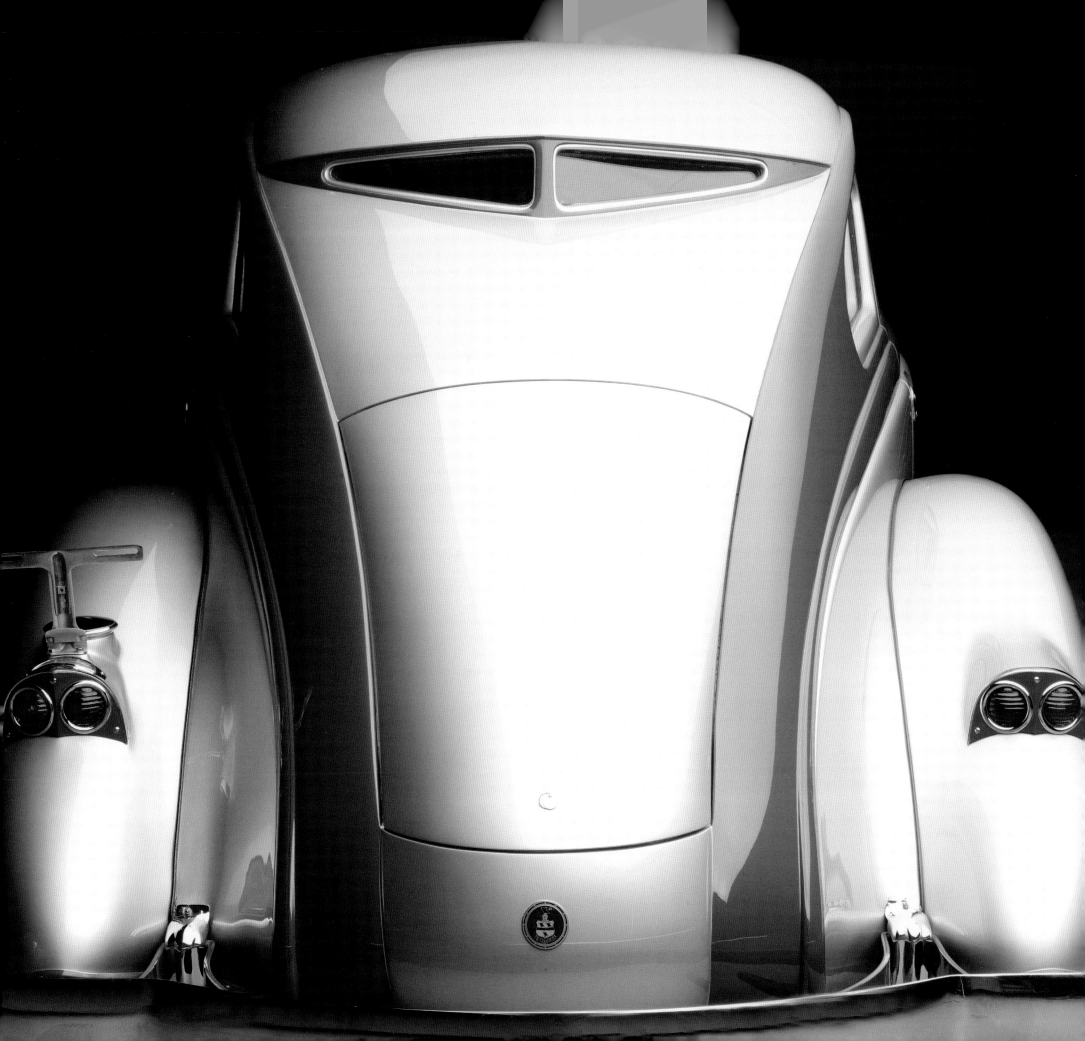

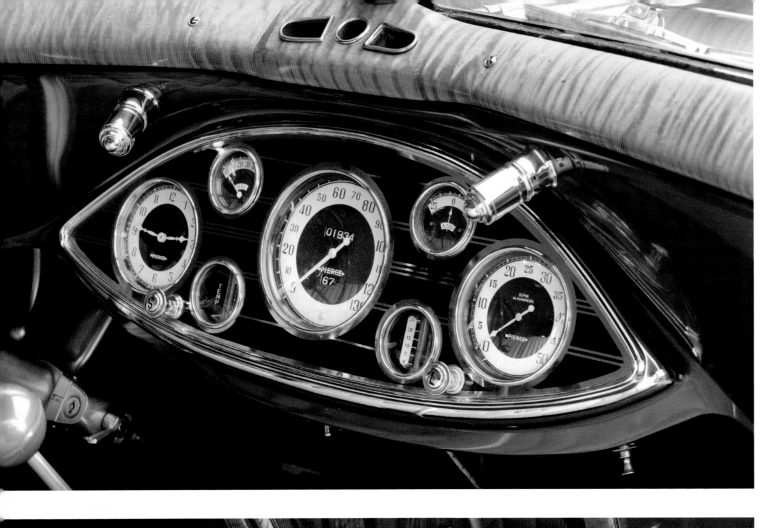

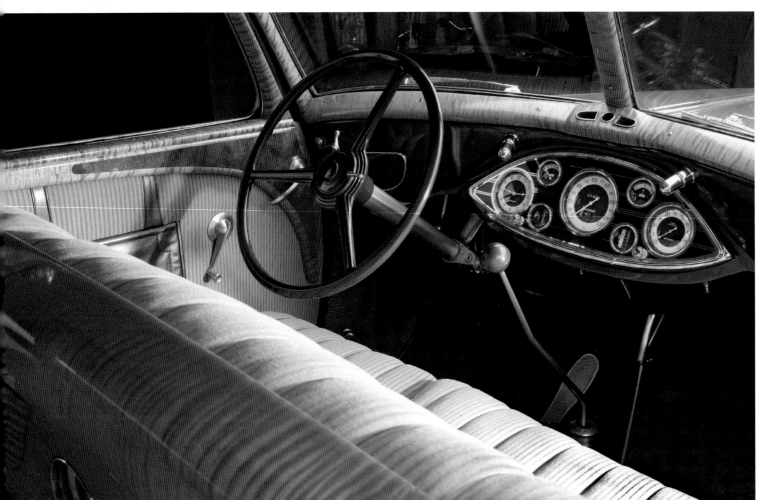

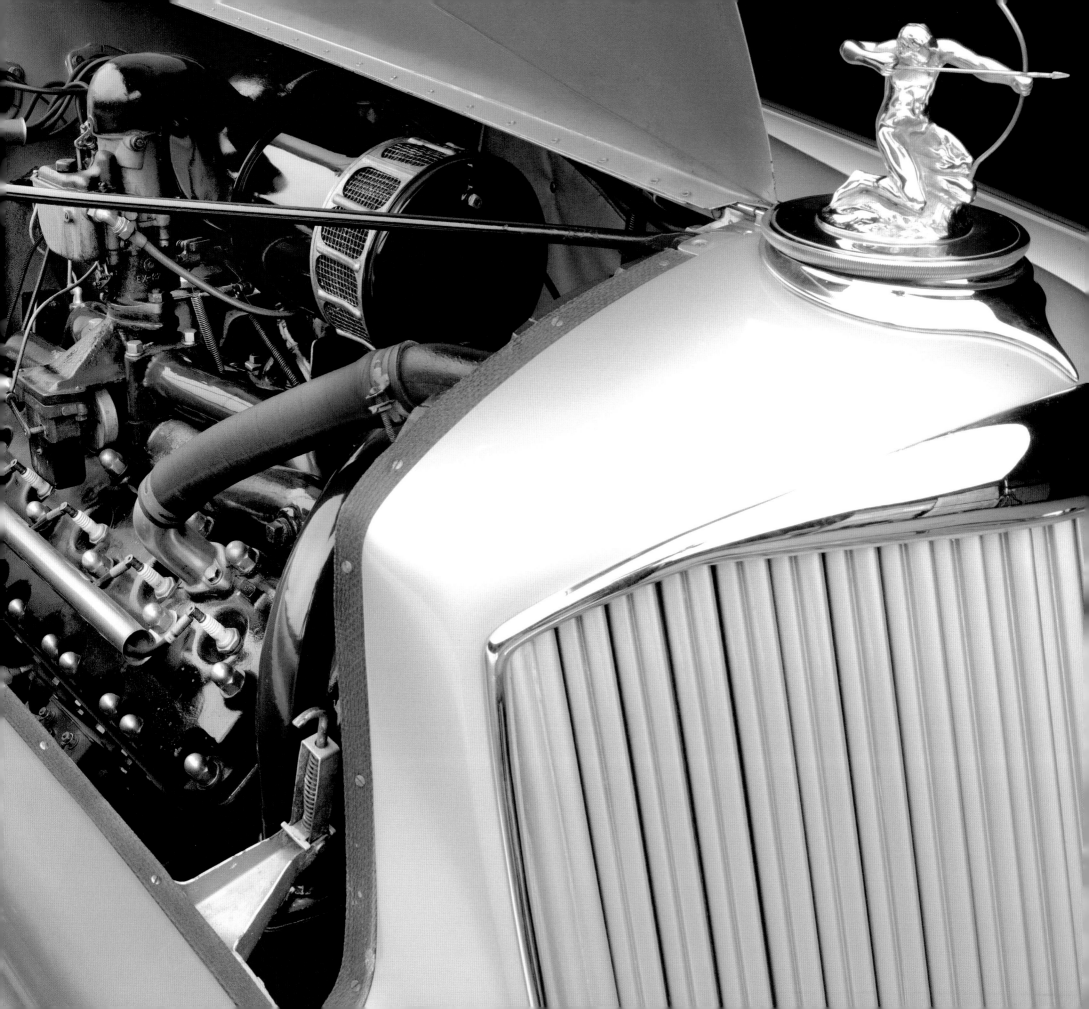

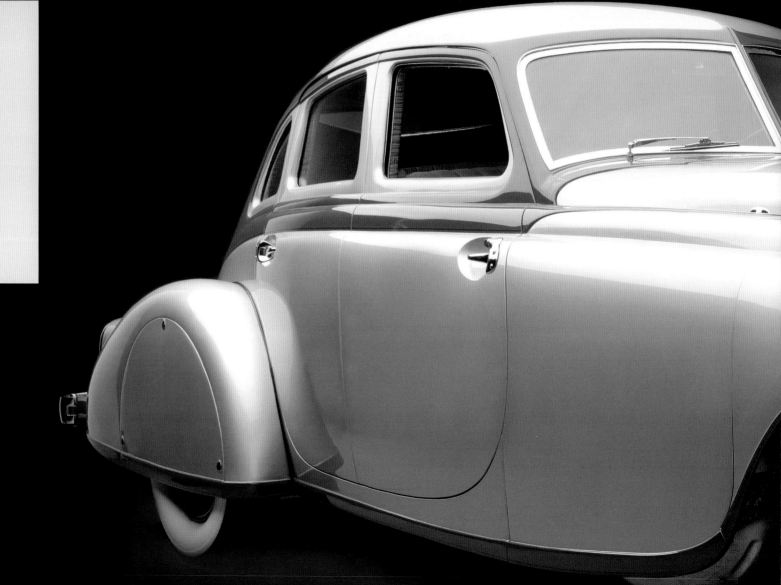

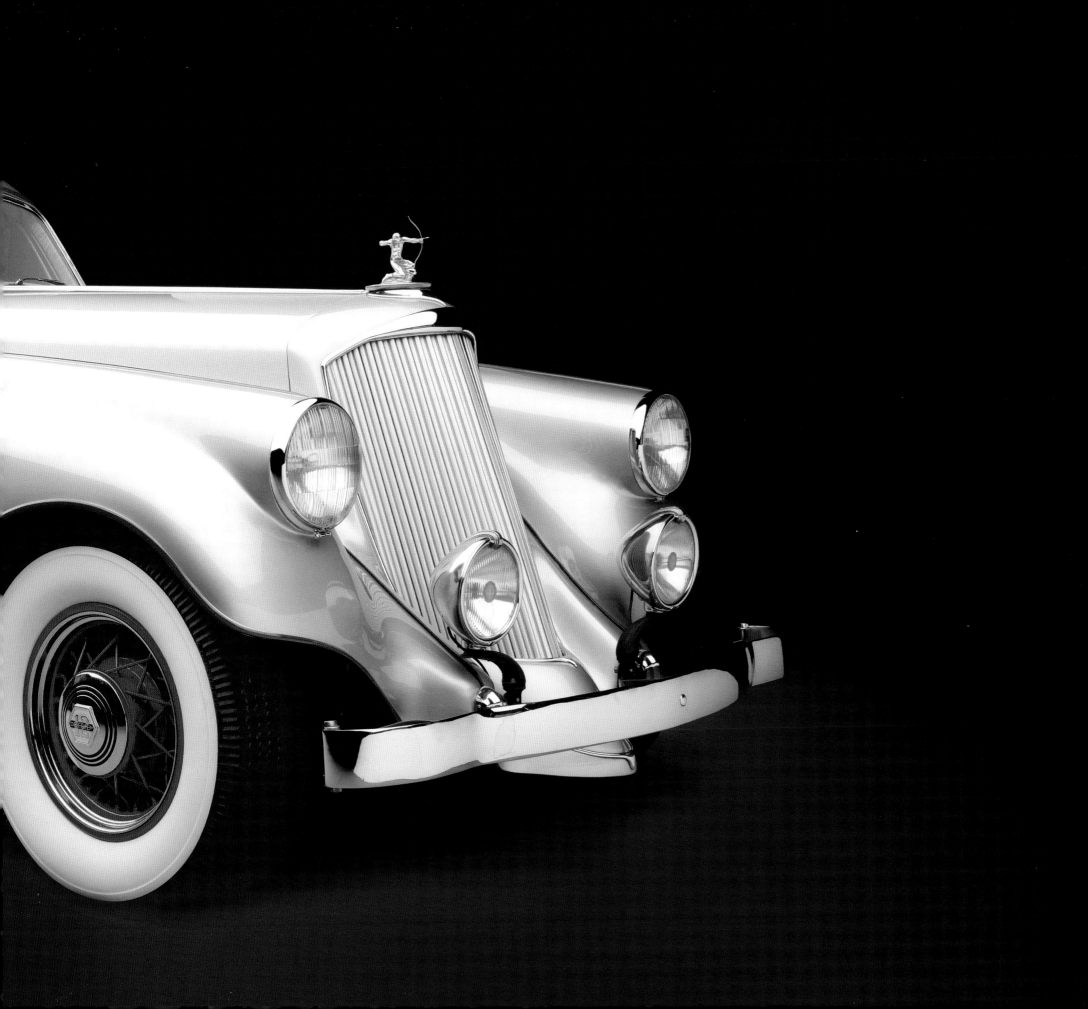

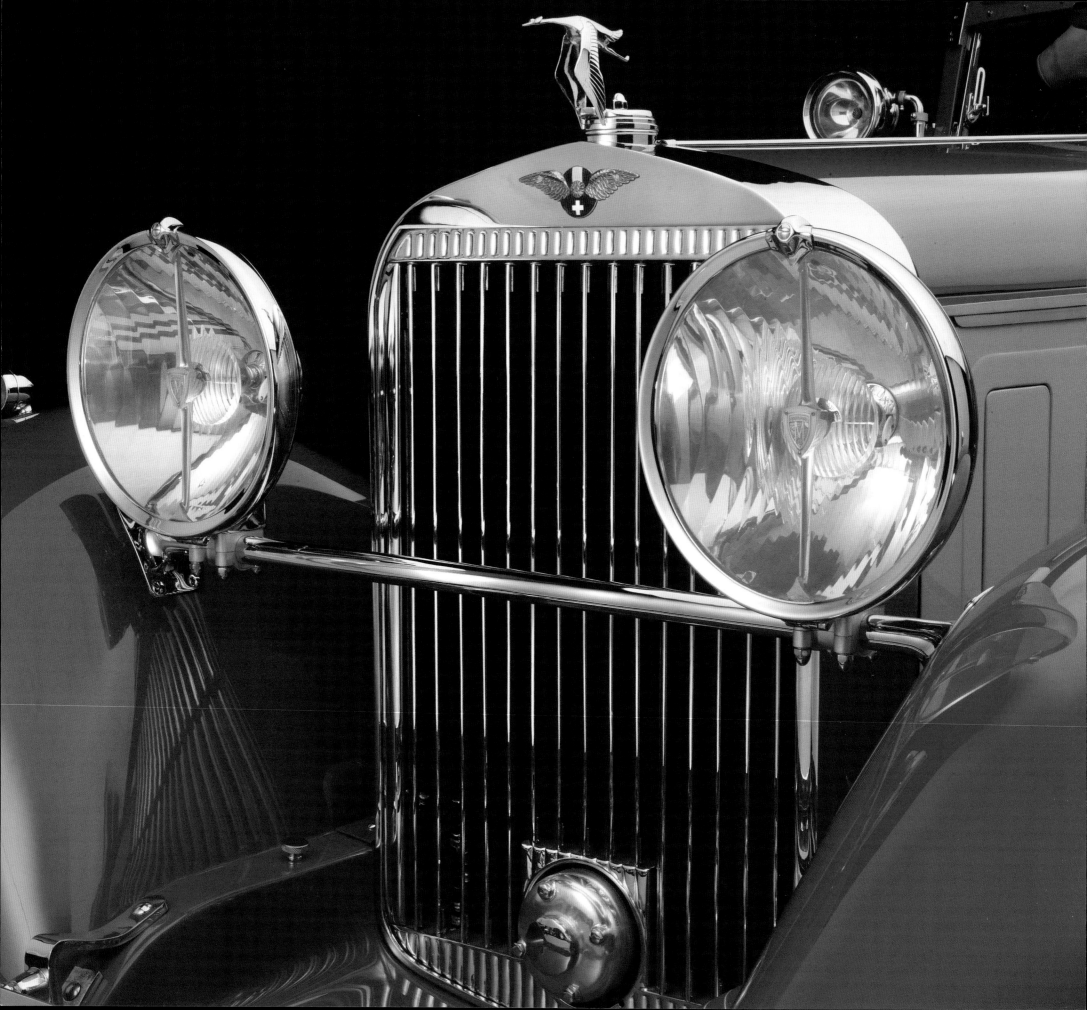

1934
Hispano-Suiza J-12 Sedanca

♦

To modern-day readers, the words *town car* conjures the rectangular-bodied Lincoln sedan popular with real estate agents and mid-level managers of the 1980s. Lincoln borrowed the name to recall its original meaning, that of a four-door car with an open front seat and a closed rear compartment—in other words, something you'd have a chauffeur drive for you. In Europe a town car was called a *Sedanca de Ville*, and in this line of classification, the Hispano-Suiza J-12 was called a Sedanca Drop-Head Coupe, having only two doors but the open-front, closed-rear styling of a town car.

The custom body of this car is from Fernandez & Darrin, the Paris firm of American Howard "Dutch" Darrin and Argentinian-born J. Fernandez. Fernandez & Darrin built many cars on Hispano-Suiza chassis, which was among the most expensive of the day. They spared little expense in outfitting their bodies, specifying high-grade cast hinges, closely fitted

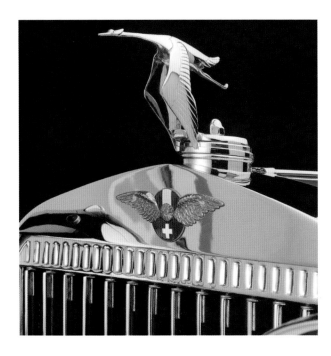

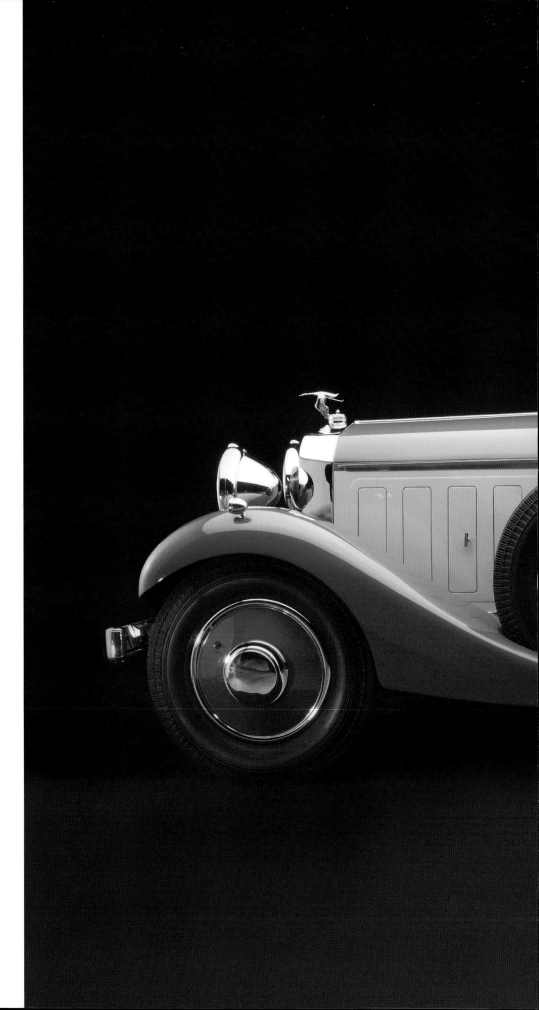

bodywork, and a distinctive, polished brass belt molding. The company produced about 300 bodies during its seven years of existence, but very few of them survive.

The V-12 engine that Hispano-Suiza introduced in its J-12 in 1931 is remarkable for its size (nearly 10 liters, with a square, 100mm bore and stroke) and its smooth power delivery—paramount for providing a VIP with a comfortable yet speedy ride to his or her destination. Each engine was milled straight out of a 700-pound aluminum billet.

A seven-main-bearing crankshaft weighing about 70 pounds no doubt helped the coupe move more like a locomotive than a passenger car. It needed 12 seconds to reach 60 mph, but could motor on up past 100 miles per hour. While Hispano-Suiza had previously produced advanced overhead cam engines, the J-12 engine reverted to an in-block camshaft and overhead valvetrain to reduce the amount of mechanical noise emitted from the engine. Only approximately 120 examples of this exclusive, expensive automobile were produced before production ended in 1938.

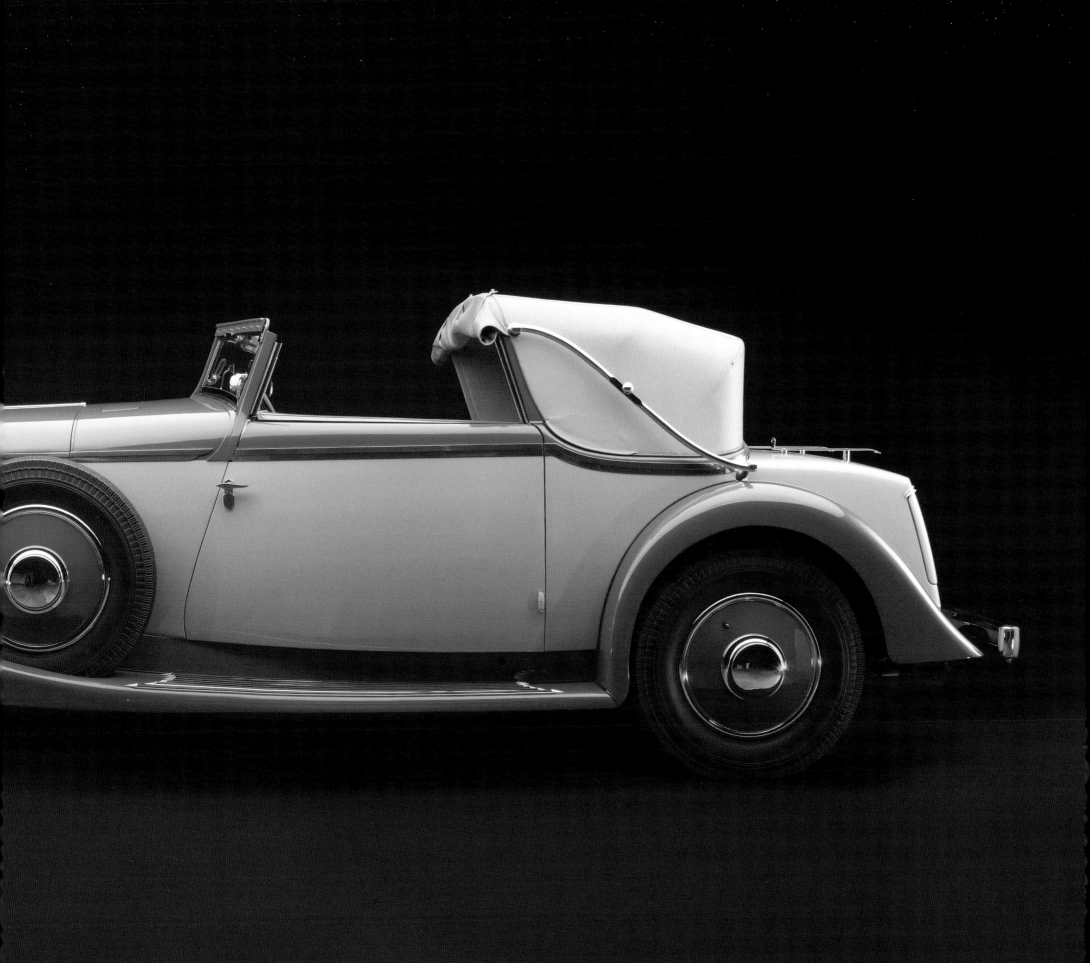

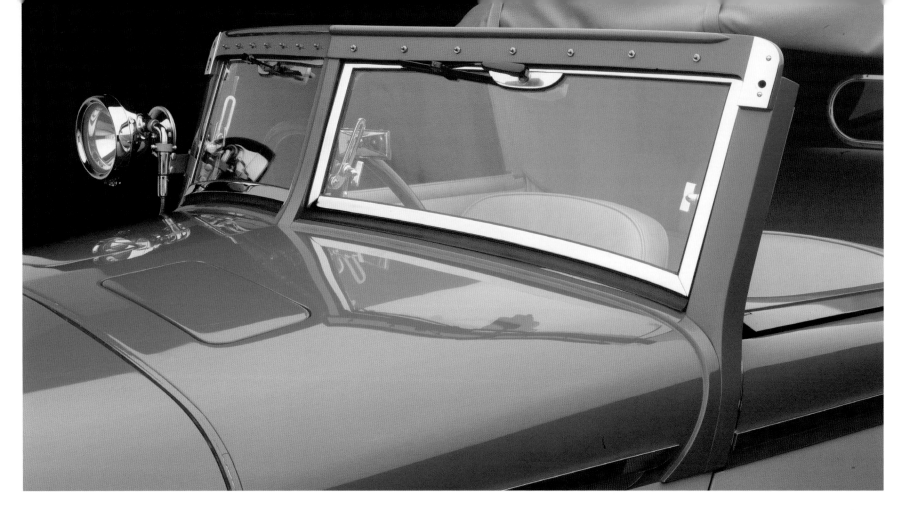
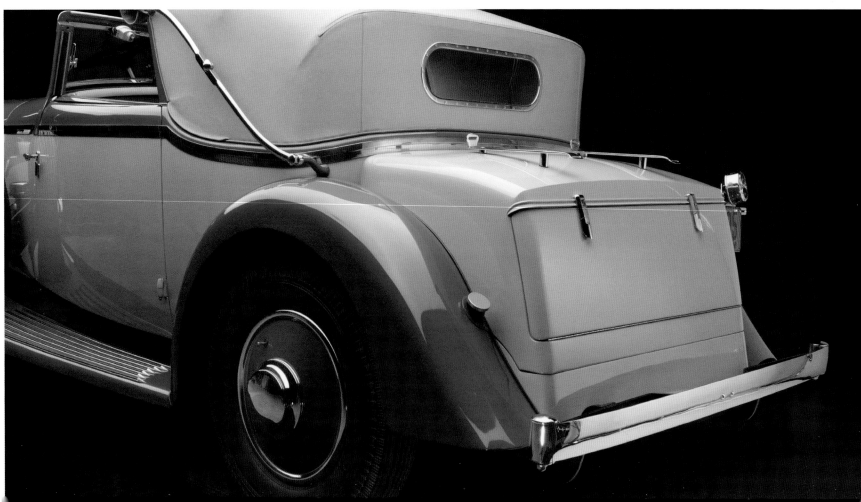

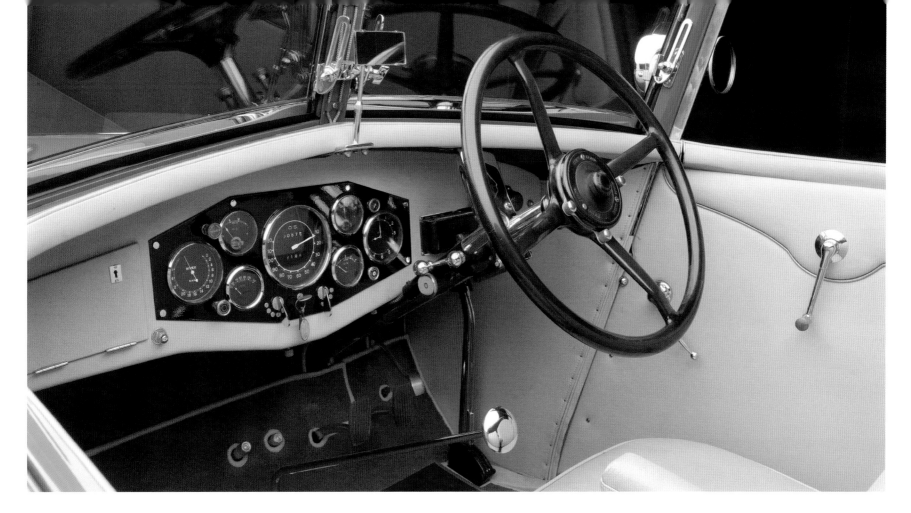

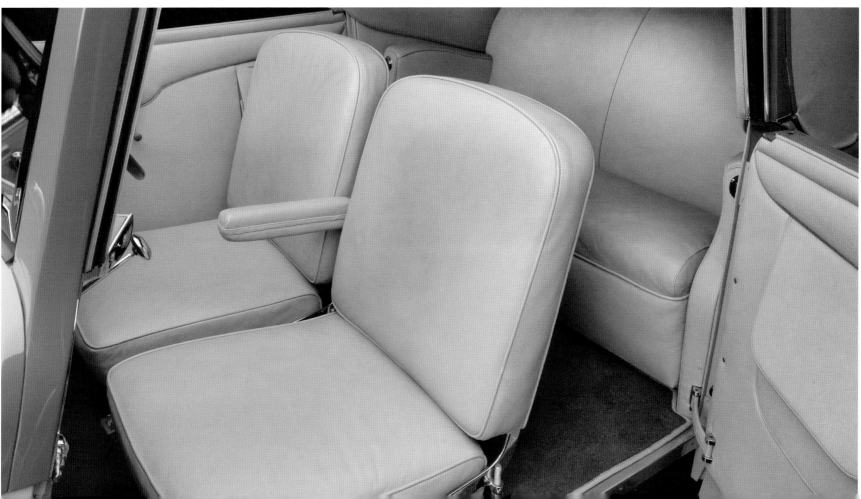

SPECIFICATIONS OF INTEREST

ENGINE
574ci/ 9.4-liter, 60-degree
 V-12, OHV

POWER
220 bhp

CARBURETION
Dual Solex downdraft

IGNITION
Dual Scintilla magnetos

BRAKES
Servo-assisted mechanical drums

TRANSMISSION
Three-speed synchromesh manual

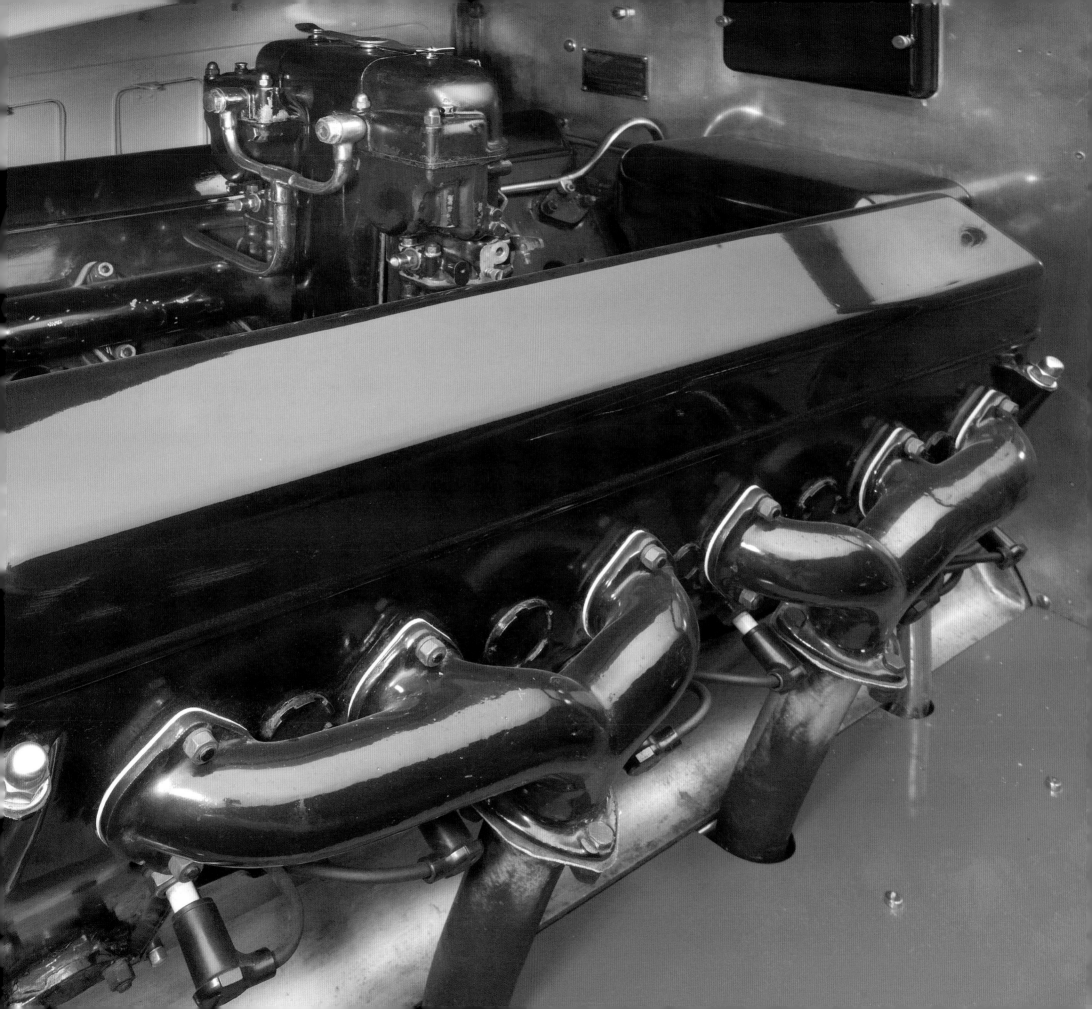

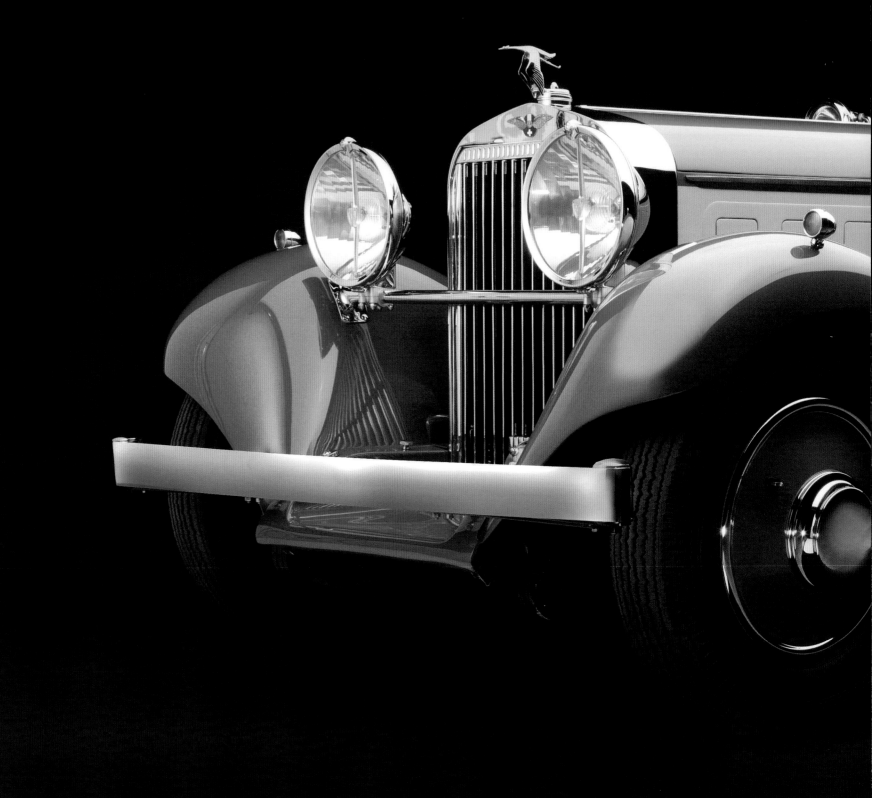

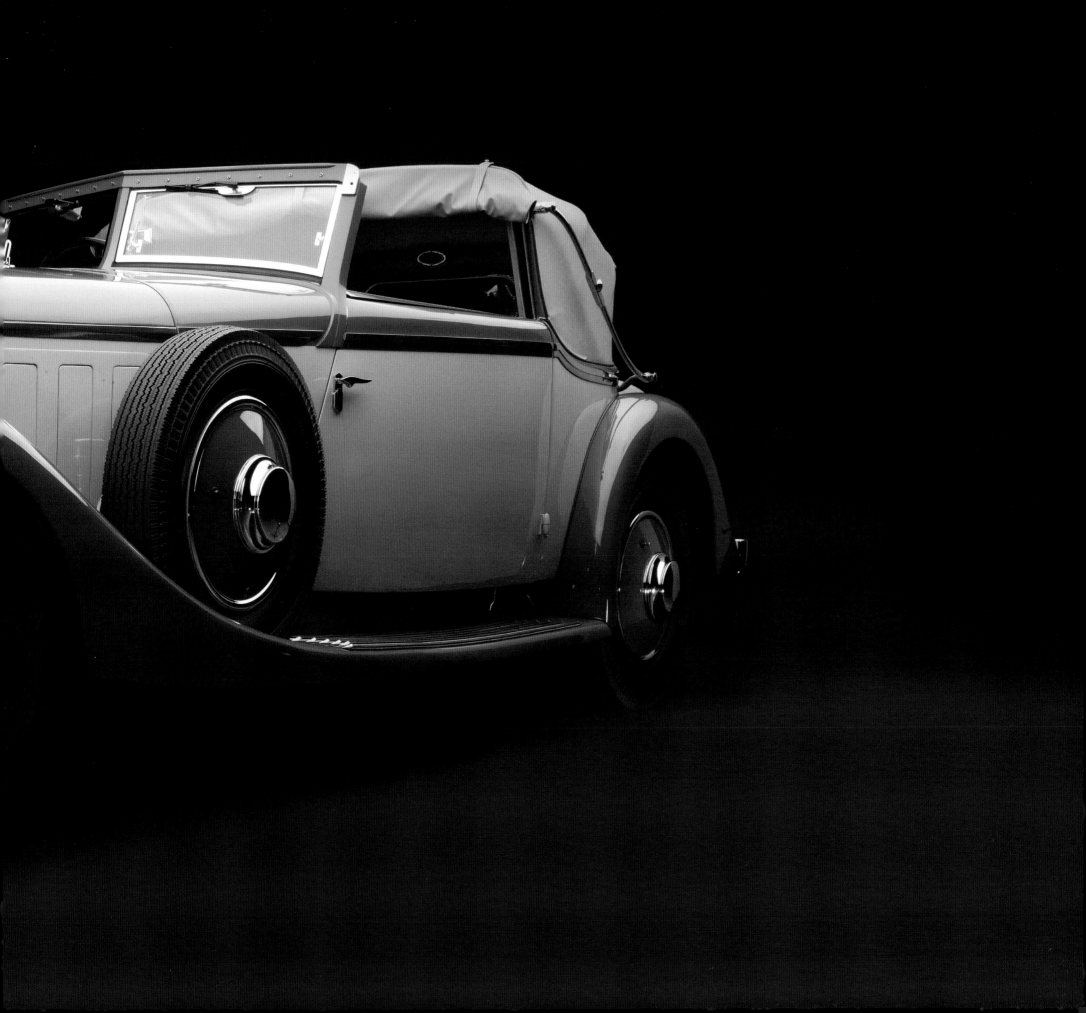

1936
Cord 810 Model C92
Beverly Sedan

◆───────◆───────

When it was introduced, this car seemed to embody the future of the automobile. The 810 kept the front-wheel-drive technology from earlier Cord cars but wrapped it in a striking Art Deco–style body that eschewed running boards and featured innovative, crank-operated, concealed headlights. It was intended to slot above the Auburn and below the Duesenberg in the marketplace, and was priced similarly to a Cadillac.

Gordon Miller Buehrig, an in-house designer for the Auburn-Cord-Duesenberg company, directed the creation of this beautiful car. In lieu of a separate front grille, the front of the car was equipped with louvers that ran below the hood line on one side of the car, wrapped around the front of the car and down the other side, and ended at the cowl.

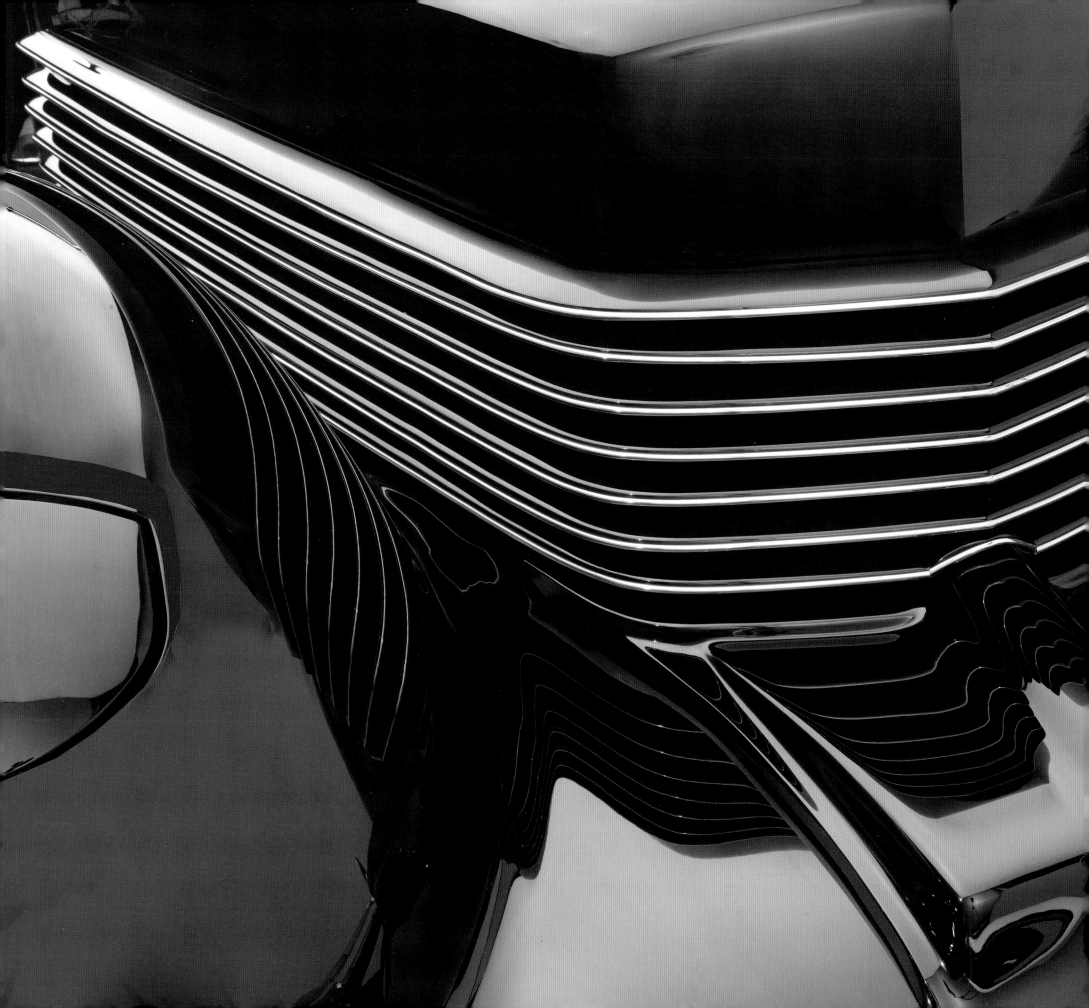

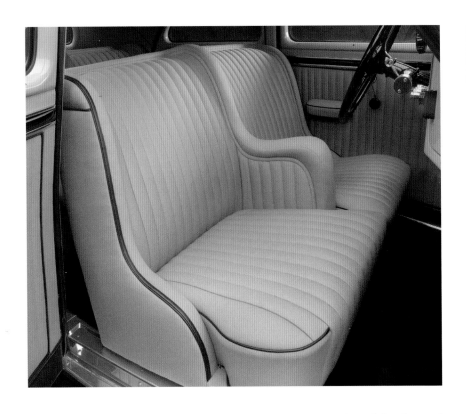

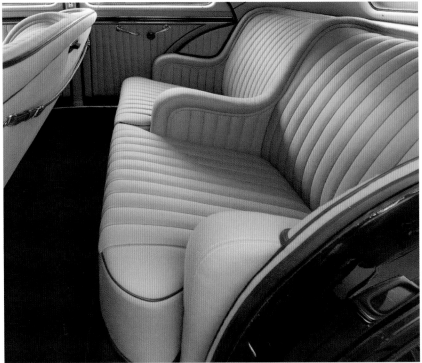

Among the other unique advances were a unitized body and independent front suspension beneath its pontoon fenders. All four doors were stamped using the same die, saving money and adding to the car's unique look.

Coupe Cord 810s were called "Westchester" or "Beverly"; this car was called an "armchair" Beverly because, inside the car, each of the four passenger seats was an individual unit equipped with its own armrest. The driver also enjoyed a tachometer, and the dash had a built-in radio. A preselector gearbox controlled the flow of power from the Lycoming engine back to the driven rear wheels.

While the Cord 810 was quick, with its 125-bhp V-8 engine, and the following year's 812 model, equipped with a centrifugal supercharger, was legitimately fast, it wasn't enough to propel the Auburn-Cord-Duesenberg company into the future. The company went out of business in 1937, having finally been ground down by the Great Depression.

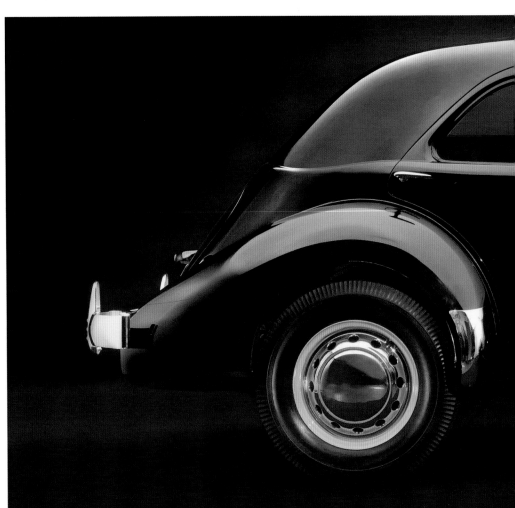

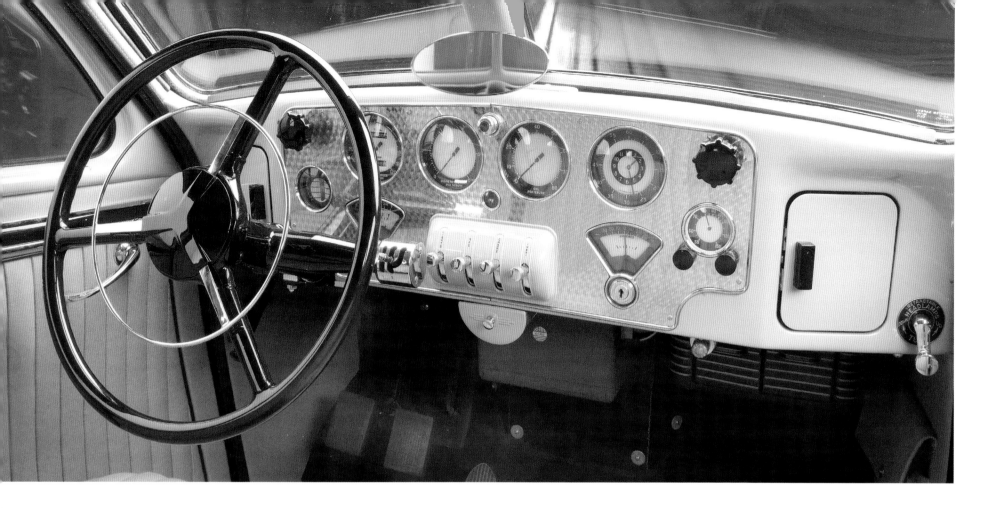

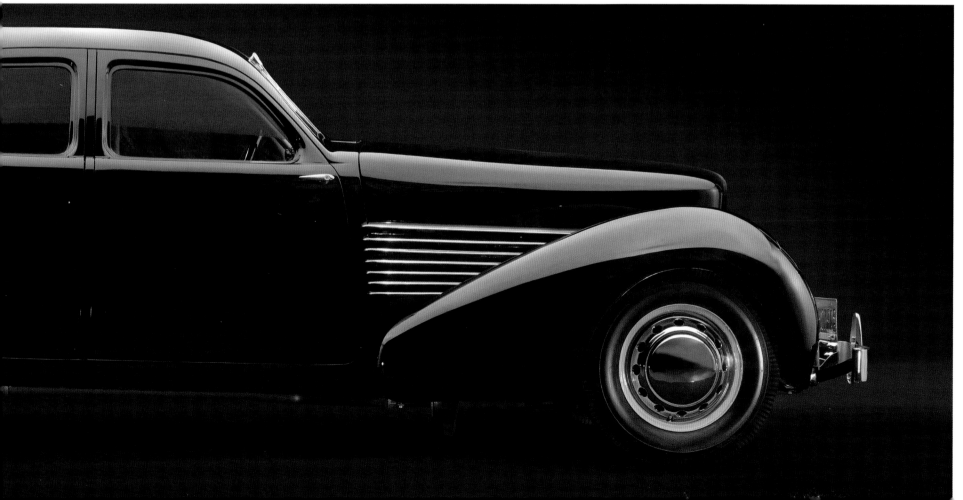

SPECIFICATIONS
OF INTEREST

ENGINE
90-degree V-8, aluminum
heads, 288 ci/4.7 liter

TRANSMISSION
Four-speed preselector, vacuum/
electric shifting

TOP SPEED
90 mph/144 kph

0–60 MPH/0–96 KPH
20 seconds

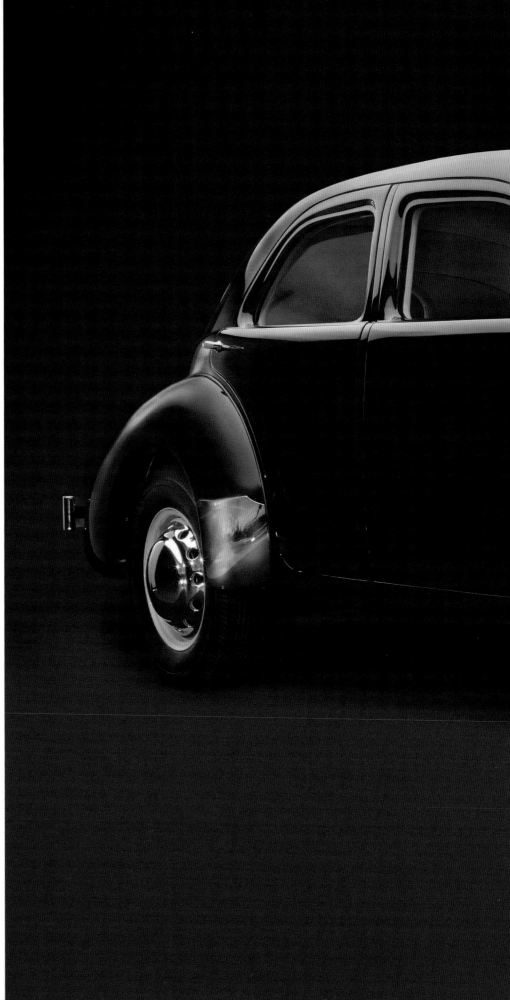

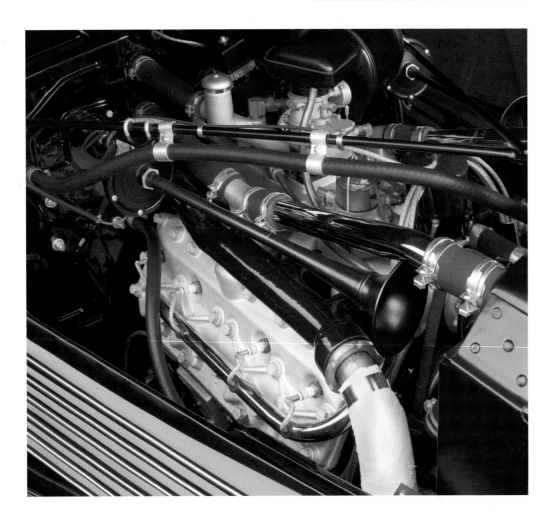

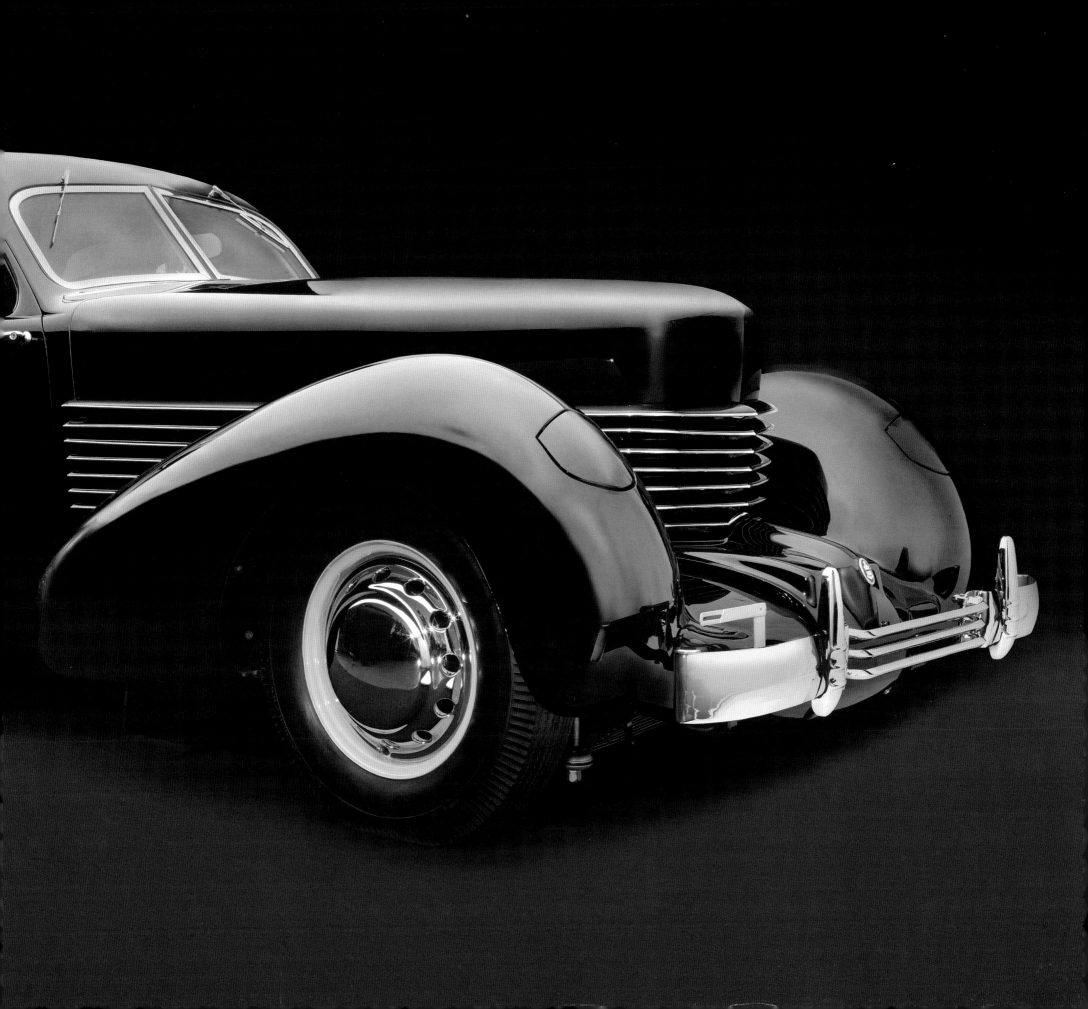

1941
Chrysler Town & Country

◆

This "woody" wagon may seem like a bit of an outlier among the other cars in this book. I would argue that, when looked at in a certain way, it is a bridge between the past and the present.

First, it is the latest car built within these pages, from 1941, before the United States entered World War II. It is not a coachbuilt, one-of-a-kind car, nor is it a run-of-the-mill production car, given its extensive and beautiful wood body. Once upon a time wood was a common material to use in cars, even as structural pieces. Today you'd have trouble finding something other than a Morgan using wood in such a way. The Town & Country was also hand-built—another common attribute in the classic era that is quite uncommon today.

The Town & Country's shape was a departure from other wagons—with its stylish fastback roof (a.k.a., barrel back), and the low-mounted, dual side-hinged rear doors, one might

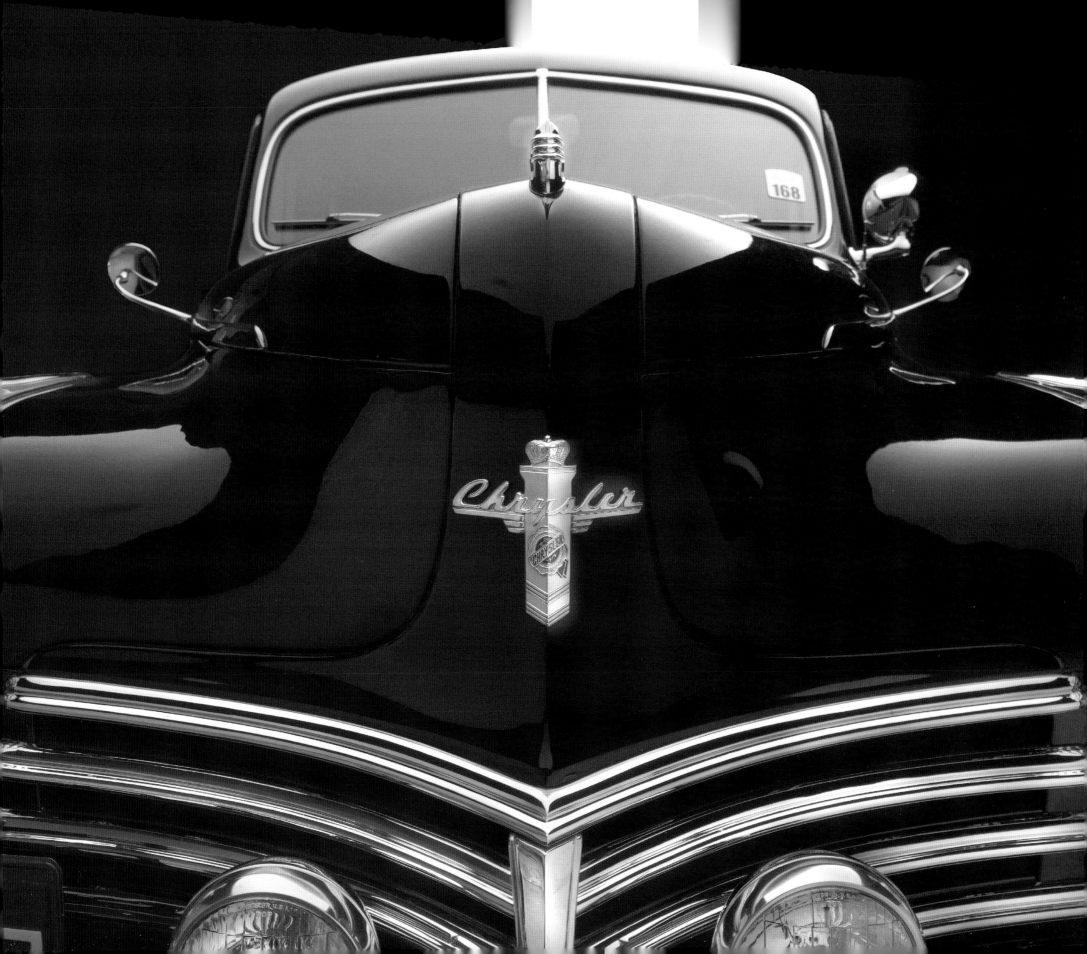

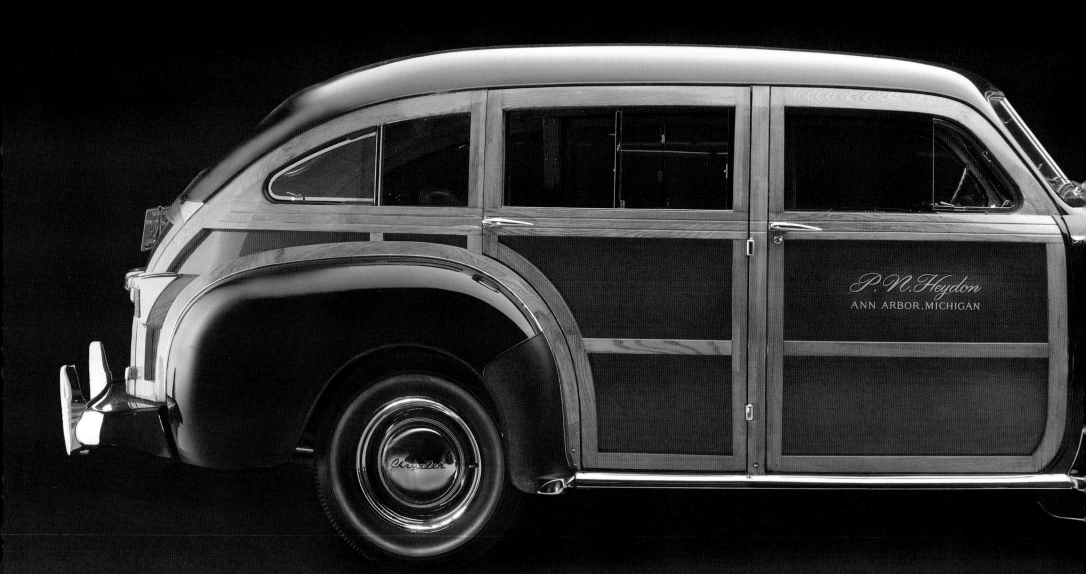

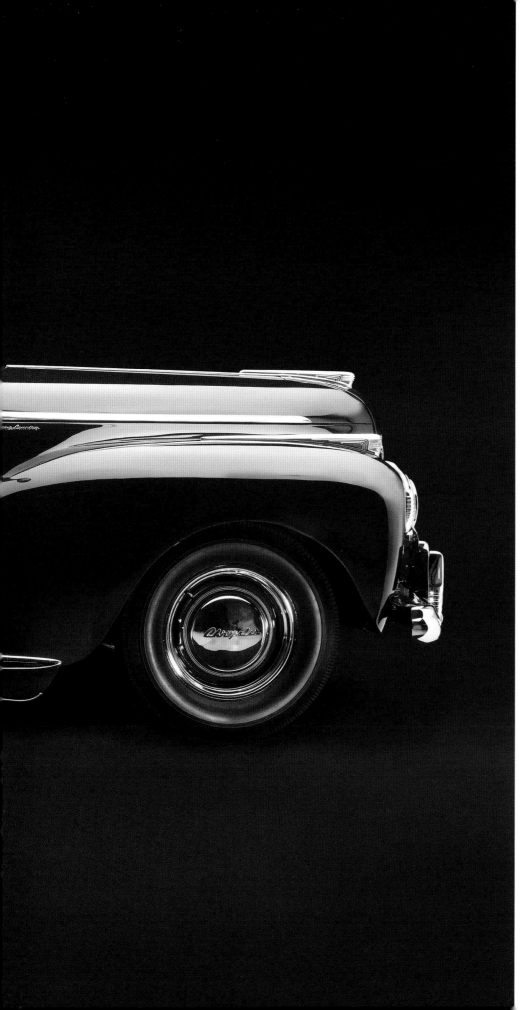

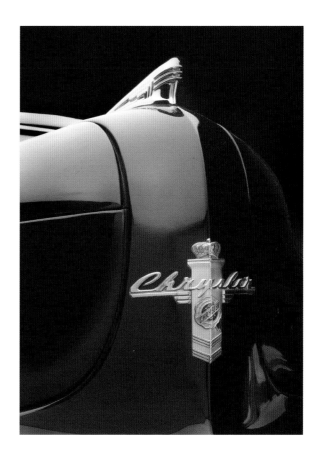

consider it something other than a wagon altogether. The metal roof encompassed the rear window and sloped down to the beltline above the luggage doors. The rest of the body between the roof and fenders was made of wood—white ash for the structural pieces and beautifully contrasting Honduran mahogany for the darker, inset panels.

Only 997 of these were manufactured; 797 were nine-passenger versions like this one. However, the Town & Country registry lists fewer than 20 nine-passenger survivors.

The Town & Country, being a high-end luxury model, was equipped with Chrysler's Fluid Drive. It consisted of a fluid coupling between the engine and clutch that allowed the driver to stop or start the car, and to shift between first and second gears, without using the clutch—perfect for easy around-town driving.

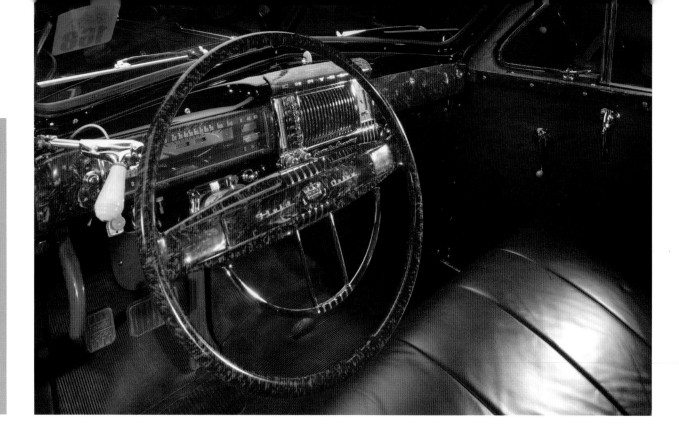

SPECIFICATIONS OF INTEREST

ENGINE
Flathead "Spitfire" straight six,
242 ci/4 liters

POWER
112 bhp

TORQUE
196 lbs-ft

WHEELBASE
121.5 inches/300cm

WEIGHT
4,330 lbs/1,964kg

PRICE
$1,475

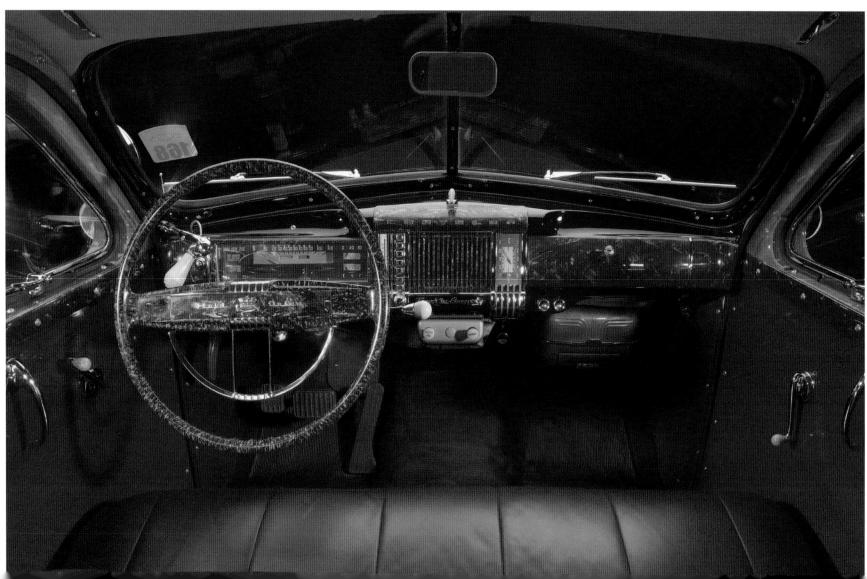

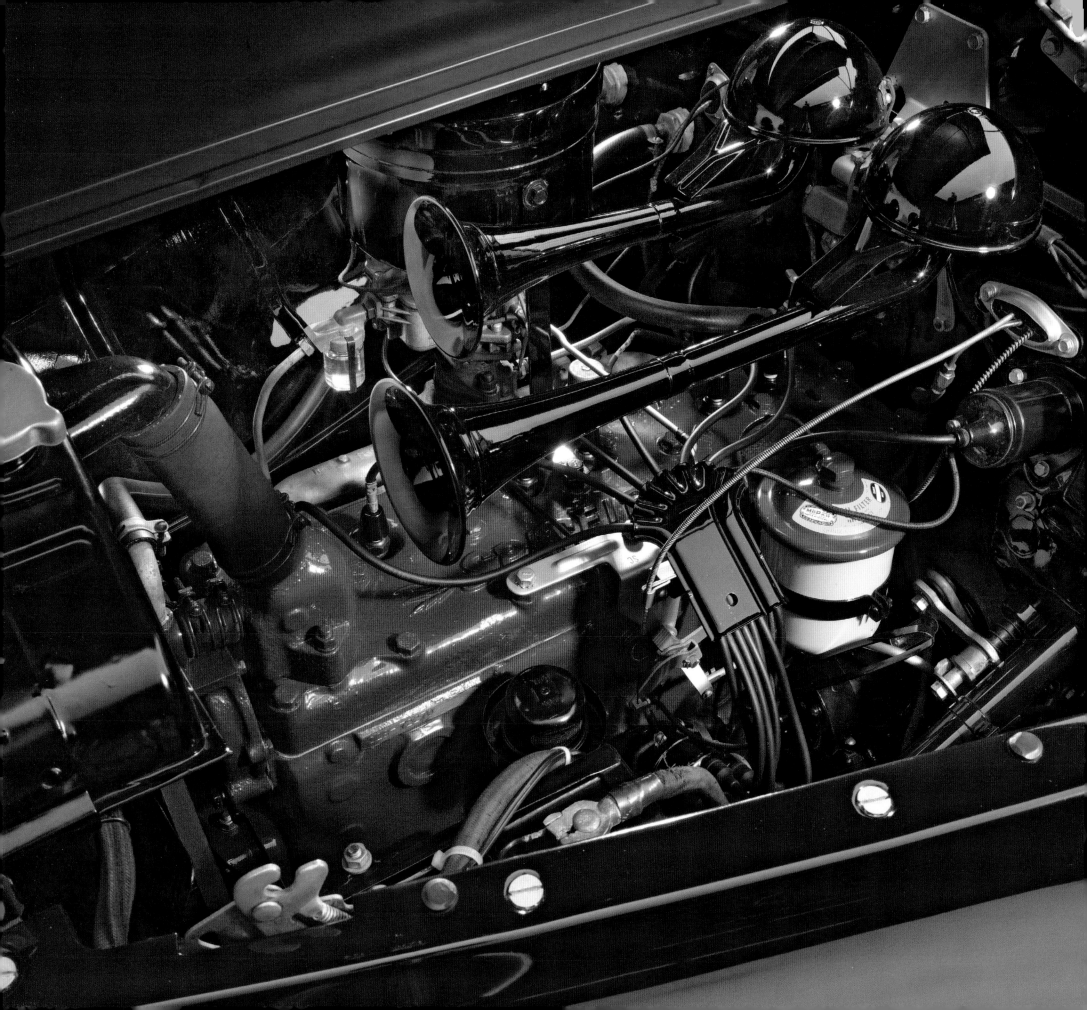

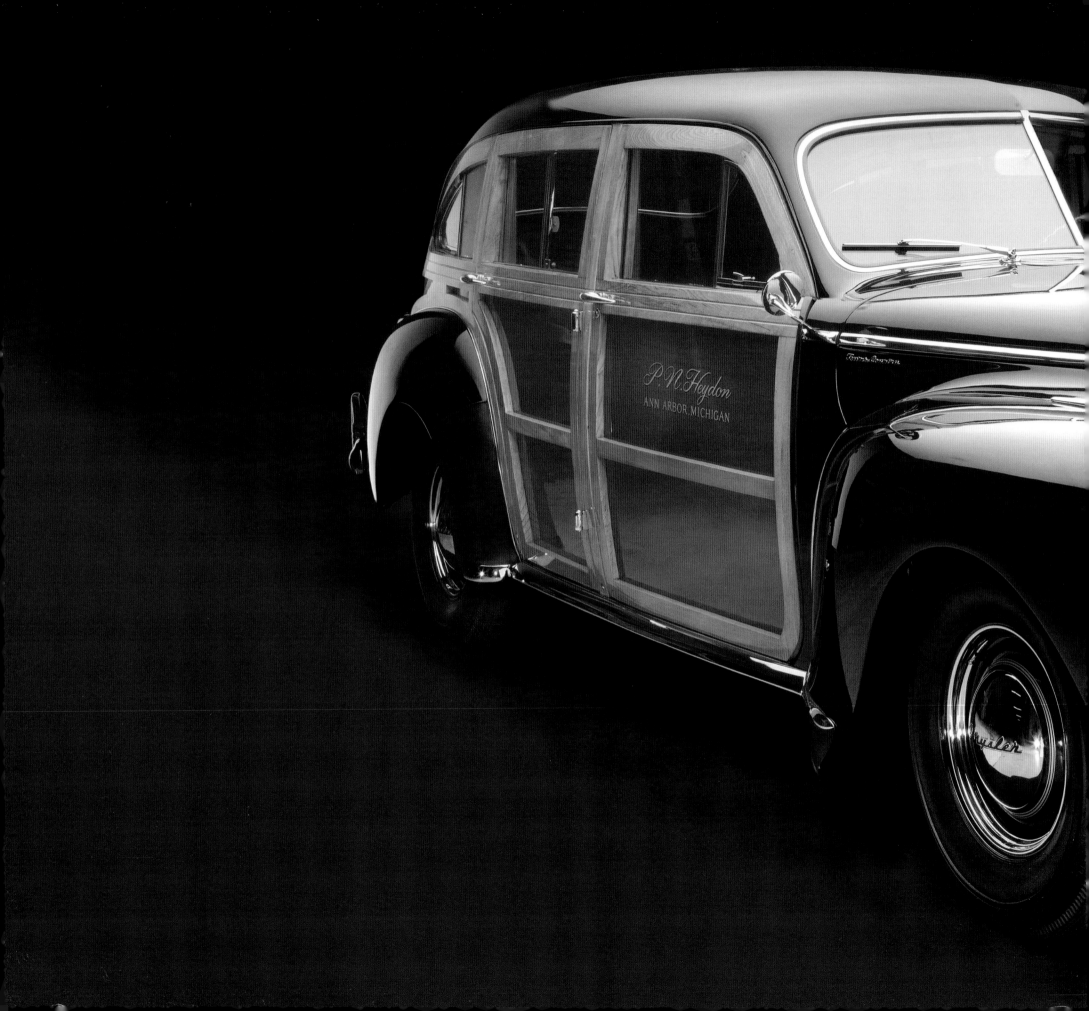

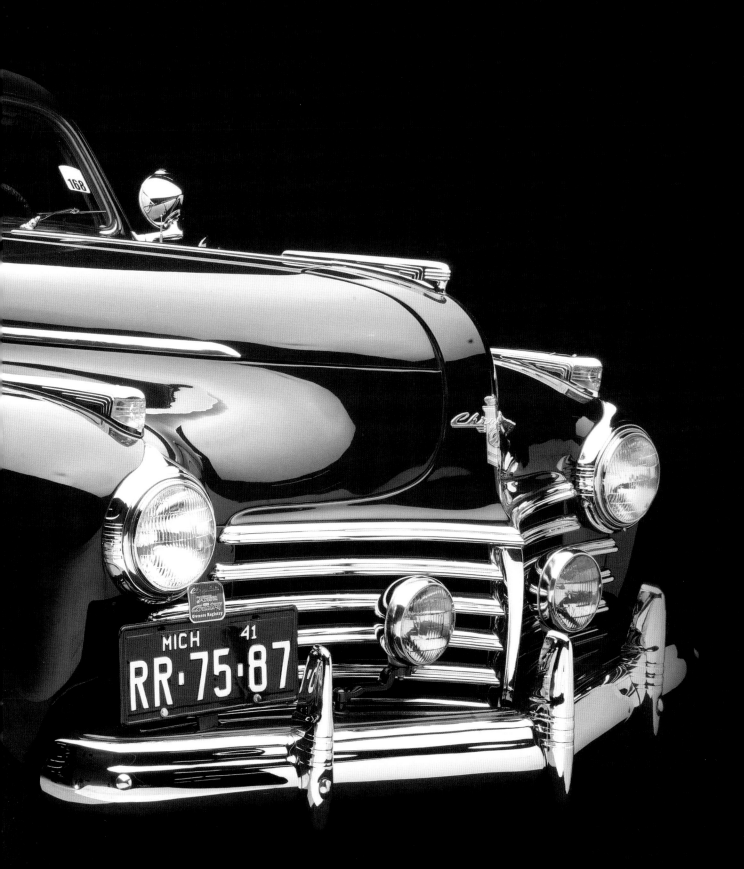

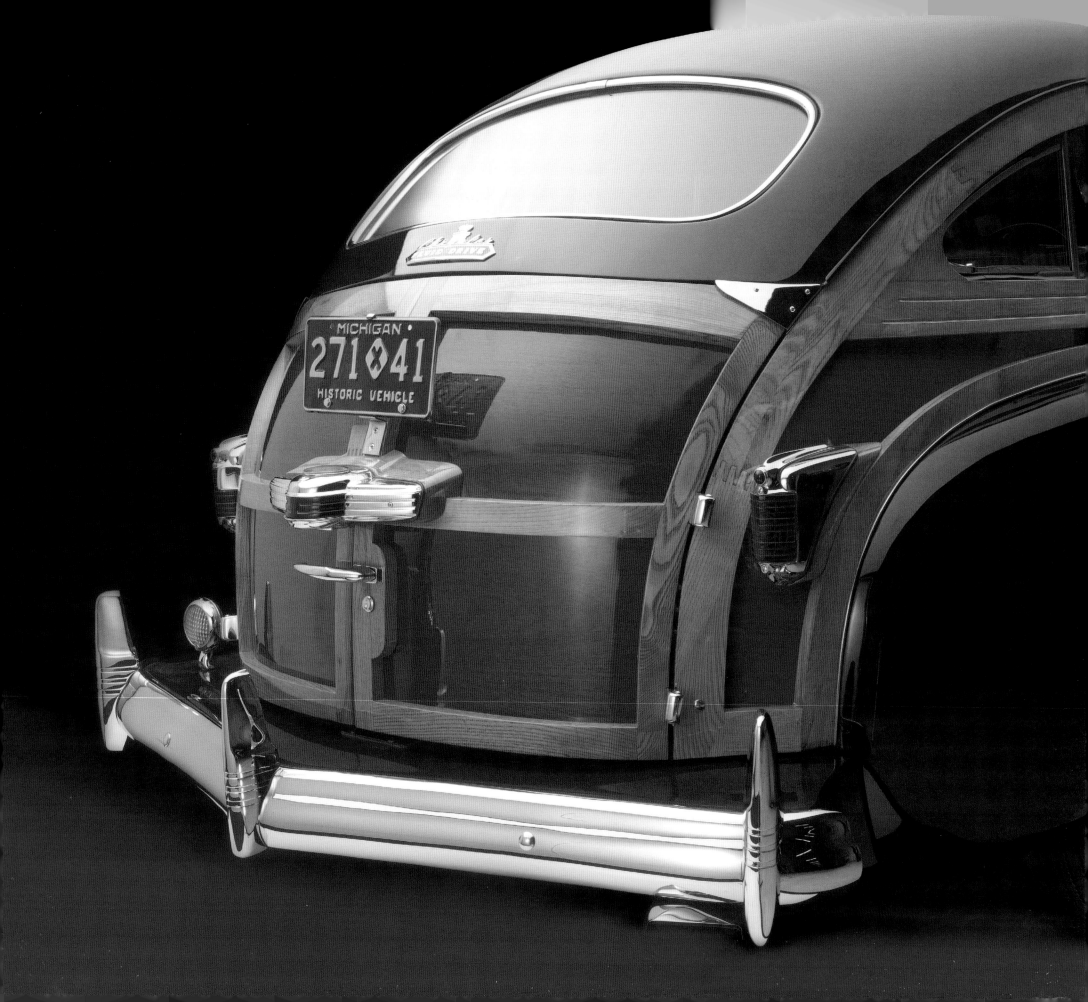

Acknowledgments

◆

We would like to thank the following people for making their historic automobiles available for this book:

Academy of Art University, San Francisco, CA: 1933 Pierce-Arrow Silver Arrow

Tom Armstrong, Issaquah, WA: 1931 Duesenberg SJ Convertible

Auburn Cord Duesenberg Automobile Museum, Auburn, IN: 1930 Cord Cabriolet L-29

Robert and Sandra Bahre, Oxford, ME: 1934 Packard Twelve Runabout Speedster,
1934 Packard Model 1106 V-12, 1934 Hispano-Suiza J-12 Sedanca

William E. (Chip) Connor, Carmel, CA: 1937 Bugatti Type 57S Atlante

Richard and Debbie Fass, Vienna, NJ: 1936 Cord 810 C92 Beverly Sedan

Edsel and Eleanor Ford House, Grosse Pointe Shores, MI: 1934 Edsel Ford Model 40 Special Speedster

John J. and Nora L. Heimerl, Suffolk, VA: 1935 Chrysler Imperial Model C2 Airflow Coupe

Herrington Collection, Bow, NH: 1937 Mercedes-Benz 540K Special Roadster

Peter Heydon, Ann Arbor, MI: 1941 Chrysler Town & Country

Sam and Emily Mann Collection, Englewood, NJ: 1935 Duesenberg JN Roadster, 1937 Delage D8-120S Cabriolet

Bruce and Jolene McCaw, Redmond, WA: 1930 Bentley Speed-Six *Blue Train Special*

Peter Mullin Automotive Museum Foundation, Oxnard, CA: 1937 Dubonnet Hispano-Suiza "Xenia" Coupe

The Nethercutt Collection, Sylmar, CA: 1933 Cadillac Fleetwood V-16 Aero-Dynamic Coupe

Jim Patterson/The Patterson Collection, Louisville, KY: 1936 Delahaye Model 135M Coupe

Price Museum of Speed, Salt Lake City, UT: 1911 Mercer 35R Raceabout, 1916 Stutz Bearcat

The Revs Institute for Automotive Research at the Collier Collection, Naples, FL: 1937 Delahaye 135MS Roadster

John W. Rich, Jr., Frackville, PA: 1939 Delage D8-120S Cabriolet

Jon and Mary Shirley, Bellevue, WA: 1938 Alfa Romeo 8C2900B

Edmund J. Stecker Family Trust, Pepper Pike, OH: 1930 Jordan Speedway Series Z Ace

Harry Yeaggy, Cincinnati, OH: 1935 Duesenberg SJ *Mormon Meteor I*

First published in 2013 by Motorbooks, an imprint of MBI Publishing Company,
400 First Avenue North, Suite 400, Minneapolis, MN 55401 USA

© 2013 Motorbooks
Photography © 2013 Peter Harholdt

The information in this book is true and complete to the best of our knowledge.
All recommendations are made without any guarantee on the part of the author or Publisher,
who also disclaims any liability incurred in connection with the use of this data or specific details.

We recognize, further, that some words, model names, and designations mentioned herein
are the property of the trademark holder. We use them for identification purposes only.
This is not an official publication.

Motorbooks titles are also available at discounts in bulk quantity for industrial or sales-promotional use.
For details write to Special Sales Manager at MBI Publishing Company,
400 First Avenue North, Suite 400, Minneapolis, MN 55401 USA.

To find out more about our books, visit us online at www.motorbooks.com.

Library of Congress Cataloging-in-Publication Data

Bodensteiner, Peter.
 Art of the classic car / by Peter Bodensteiner.
 p. cm.
 Includes index.
 Summary: "Art of the Classic Car showcases the most beautiful
 and in some cases rare vehicles of the early 20th century.
 Each car is showcased with breathtaking photography
 and coupled with explicit, informative prose detailing
 the particular history of each model"—Provided by publisher.
 ISBN 978-0-7603-4415-6 (hc w/flaps)
 1. Antique and classic cars. 2. Automobiles. I. Title.
 TL15.B57 2013
 629.222—dc23

 2013008756

On the front cover: 1937 Mercedes 540K
On the back cover: 1935 Duesenberg SJ *Mormon Meteor I*
On the frontis: Jordan Speedway Series Z Ace
On the title page: 1936 Figoni & Falaschi Delahaye 135M
Competition Coupe

Acquisitions Editor: Darwin Holmstrom
Creative Director: Rebecca Pagel
Designer: Chris Fayers
Cover designer: Simon Larkin

Printed in China
10 9 8 7 6 5 4 3 2 1

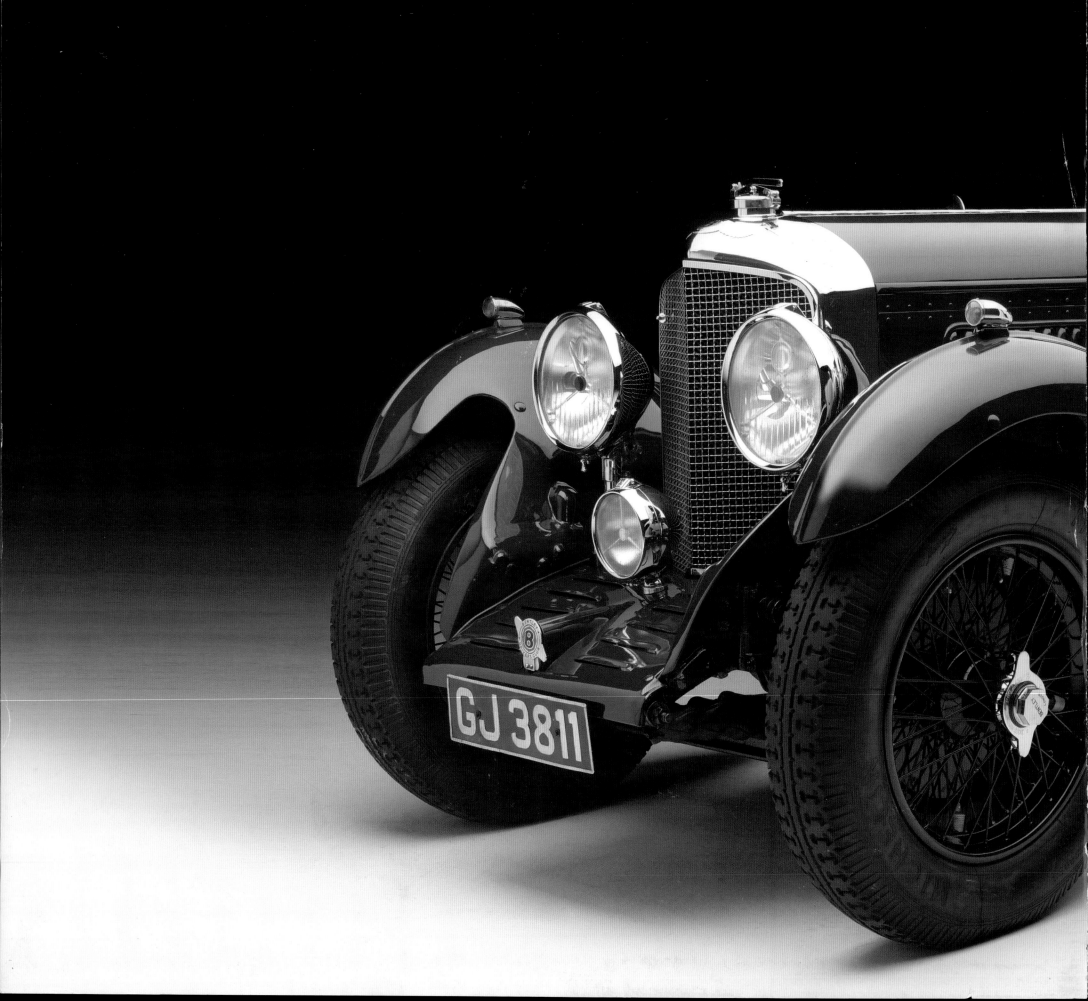